D0098005

HISTORICAL DICTIONARIES
OF LITERATURE AND THE ARTS
Jon Woronoff, Series Editor

Historical Dictionary of Animation and Cartoons

Nichola Dobson

Historical Dictionaries of Literature,
and the Arts, No. 34

The Scarecrow Press, Inc.
Lanham • Toronto • Plymouth, UK
2009

4/5/12
Leb
#90 -

Published by Scarecrow Press, Inc.
A wholly owned subsidiary of The Rowman & Littlefield Publishing Group, Inc.
4501 Forbes Boulevard, Suite 200, Lanham, Maryland 20706
http://www.scarecrowpress.com

Estover Road, Plymouth PL6 7PY, United Kingdom

Copyright © 2009 by Nichola Dobson

All rights reserved. No part of this book may be reproduced in any form or by
any electronic or mechanical means, including information storage and retrieval
systems, without written permission from the publisher, except by a reviewer who
may quote passages in a review.

British Library Cataloguing in Publication Information Available

Library of Congress Cataloging-in-Publication Data
Dobson, Nichola, 1976–
 Historical dictionary of animation and cartoons / Nichola Dobson.
 p. cm. — (Historical dictionaries of literature and the arts ; no. 34)
 Includes bibliographical references.
 ISBN 978-0-8108-5830-5 (hardcover : alk. paper) — ISBN 978-0-8108-6323-1
(ebook)
 1. Animated films—Dictionaries. I. Title.
 PN1997.5.D63 2009
 791.43'3403—dc22
 2009017015

♾ ᵀᴹ The paper used in this publication meets the minimum requirements of
American National Standard for Information Sciences—Permanence of Paper for
Printed Library Materials, ANSI/NISO Z39.48-1992.

Printed in the United States of America

For my husband, Jonny

Contents

Editor's Foreword

Once upon a time animation was a relatively simple matter, using fairly primitive means to produce rather short films of subjects that were generally comedic and often quite childish. Much of this was just filler for more serious stuff. Since then, things have changed—and they keep on changing at a maddening pace that looks like a cartoon being fast-forwarded. One new technique after another has made it easier, faster, and above all, cheaper to produce the material. This material has taken on an increasing variety of forms—not just drawings but also clay and plastic bricks and other solid matter—that are now being leapfrogged by computer-assisted techniques and other advanced technologies that provide different and usually better viewing. Sound has also improved phenomenally. But the real revolution has been in content. With all due apologies to Donald Duck and friends, we now have not only feature-length films—which is nothing really special since it is only a question of a longer showing time—but also increasingly sophisticated stories, many still amusing (nothing has truly replaced comedy) but others quite serious, dealing with heavier issues like the environment, personal and generational conflicts, warfare, and indeed, the end of life as we know it. Wow! This is almost mind-boggling, except that there is certainly more to come, with games and interactive animation and things we cannot even conceive of yet.

So it is not only a pleasure but almost an obligation to include a *Historical Dictionary of Animation and Cartoons* in the Literature and Arts series. It starts by tracing the path of animation from its rather simple beginnings about a century and a half ago to the complicated and hectic pace it is setting at present. The introduction helps put things in perspective and not only considers the past and the present but also peers into the future. The bulk of the information comes in the dictionary section. Many of these entries deal with leading figures on the technical, creative,

and production side and on some of the companies and groups they have formed. Others, and this is only fair, deal with the memorable characters and films they have generated and that sometimes overshadow them. Then there are entries on the situation in different parts of the world, and not only the United States, where most—but hardly all—of the action can be found. The other major contingent presents the various techniques and technological advances. Along with this there is a bibliography that is particularly useful for readers who want to follow up on any specific aspects.

This volume was written by Nichola Dobson. Over the past decade, she has been studying, teaching, and writing on media studies, with a major focus on animation. Her doctoral thesis at Queen Margaret University in Edinburgh dealt with one of the more intriguing recent forms, namely the anicom. Now Dr. Dobson is active doing research on animation and television studies, including recent participation in a joint project between Scotland and Catalonia on national identity in television soaps. A member of the Society for Animation Studies, she is the founding editor of its journal *Animation Studies*. Having compiled this excellent guide to animation, she is bound to take on other challenging tasks of her own choosing as an independent scholar. Meanwhile, anyone interested in this increasingly lively and intriguing corner of cinema will be greatly aided by the insight she has provided here.

Jon Woronoff
Series Editor

Preface

As an aid to researchers, students, teachers, and others with an interest in animation, this book explores the development of animation, an area of moving-image history that is often overlooked in favor of cinema history. The extensive history and rapidly changing technology is reflected in the detail of the chronology. The introduction provides an overview of some of the issues surrounding animation, particularly for readers who are less familiar with some of the debates.

This *Historical Dictionary of Animation and Cartoons* is not intended to be an exhaustive encyclopedia or a record of all animation; rather, it acts as a comprehensive resource. It focuses on the studios, animators, and films that have played a significant part in the development and success of animation internationally. Space constraints limit the inclusion of all animated products, and many worthy films and animators may have been omitted.

Problems of selection in a text of this nature means that there is a focus on Western animation, particularly on the United States and Great Britain, and inevitably — but not intentionally — animation based on my own subjective criteria and expertise. There are other texts available that examine international animation, notably Giannalberto Bendazzi's excellent and comprehensive *100 Years of Cinema Animation* and Jerry Beck's (ed.) *Animation Art*. This dictionary does not try to replicate these works but complements them and includes areas outside the realms of cinema and television animation.

Acknowledgments

I would like to thank the following people who have made this book possible: my husband, Jonny, without whose support I would never have been able to complete this work, and my family and friends for their patience while I undertook this task. I would like to thank Paul Ward for his initial suggestion that I write this book and for his support thereafter. Thanks also to Paul Wells for his continued encouragement and importantly for permission to reproduce (and adapt) the chronology from his book *Animation: Genre and Authorship* (2002). There are several people who have made the illustration of this book possible: Maureen Furniss; Jim Walker, and his colleague Kerry Drumm for their invaluable contacts, who put me in touch with several animators who were kind enough to supply me with their wonderful images; Peter Firmin (and Karen Edwards at Licensing by Design Ltd.), Vivien Halas, Barry Purves, Tom Lowe, and by extension, Bob Godfrey. Thanks to Tony Dalton and Ray Harryhausen, Bill Plympton, Joanna Quinn, and J. J. Sedelmaier, all for their excellent images and support. I would also like to acknowledge my friends in the Society for Animation Studies, whose excellent work in the field has inspired, and in some cases contributed, to this book. Finally, I would like to thank Jon Woronoff at Scarecrow Press who has provided guidance with great patience.

Acronyms and Abbreviations

2D	Two-dimensional
3D	Three-dimensional
ABC	American Broadcasting Company
ASIFA	Association Internationale du Film d'Animation, or International Animated Film Association
BAFTA	British Academy of Film and Television Arts
BBC	British Broadcasting Corporation
BFI	British Film Institute
CalArts	California Institute of the Arts
CBS	Columbia Broadcasting Service
CGI	Computer-generated imagery
DVD	Digital video disc
HB	Hanna-Barbera
ILM	Industrial Light and Magic
ITV	Independent Television
JJSP	J. J. Sedelmaier Productions
LAW	Leeds Animation Workshop
MGM	Metro-Goldwyn-Mayer
MOMA	Museum of Modern Art (New York)
MPAA	Motion Picture Association of America
MTV	Music Television
NBC	National Broadcasting Company
NFB	National Film Board of Canada
PCA	Production Code Administration
SAS	Society for Animation Studies
UPA	United Productions of America
WB	Warner Brothers

Chronology

1798 Etienne Gaspard Robertson creates the phantasmagoria, a sophisticated "magic lantern" to project moving images.

1830 Michael Faraday creates the revolving wheel to enhance visual illusions.

1833 Joseph Antoine Plateau consolidates his theories on the persistence of vision by making a phenakisatascope, in which a revolving disk with images on it appeared to put those images in motion.

1834 William Horner creates the zoetrope, a revolving drum with observation slits where the sequence of pictures inside appears to move when the cylinder is spun.

1839 Henry Langdon Childe enhances the "magic lantern" to incorporate dissolving images, and the first implications of one movement to another.

1853 Franz Von Uchatius creates the kinetiscope, which projects the illusion of movement in drawings.

1866 L. S. Beale devises the choreuscope, which enables a magic lantern slide to project moving drawings.

1877 Émile Reynaud patents the praxinoscope, which uses mirrors within a spinning cylinder to create the illusion of moving images. He advances his work a year later with the Théâtre-Optique praxinoscope. By 1880, he creates a projection system.

1890 American print journalism embraces the first cartoon strips, including Richard Outcault's "Yellow Kid."

1895 Robert Paul's theatograph, Thomas Edison's vitascope, Max Skladanowsky's bioscope, and the Lumière brothers' cinématographe project moving-film images.

1896 Georges Méliès uses stop-motion animation—the creation of movement frame by frame—as part of his repertoire of trick effects. Méliès is also a "lightning cartoonist" who accelerates the movement of drawings by manipulating camera speeds.

1897 The Vitagraph Company, cofounded by Albert E. Smith and J. Stuart Blackton, uses stop-motion animation to create *A Visit to the Spiritualist*. *Humpty Dumpty Circus* is a stop-motion animation using small jointed figures and moving objects.

1898 The Edison Company patents a stop-motion animation, *The Cavalier's Dream*, in which an environment changes while a man is sleeping.

1900 Albert E. Smith and J. Stuart Blackton become increasingly sophisticated in noticing how the new film medium works, and in consequence, create effects using stop motion to enhance "lightning cartooning" as it was executed in vaudeville routines. Their film *The Enchanted Drawing* shows a man smiling while drinking and smoking. Georges Méliès makes *Le Livre Magique*, where the drawings appear to become human beings.

1902 Méliès uses stop motion as part of his armory of fantasy effects in *A Trip to the Moon*. In *Fun in a Bakery Shop*, Edwin S. Porter uses stop-motion animation to show loaves made from clay being sculpted into the faces of famous people.

1905 Spaniard Segundo do Chomón is one of the first filmmakers to use models in animated shorts, seen in his films *Train Collision* and *The Electric Hotel*. He also works with Italian film director Giovanni Pastrone on a sequence in *The War and the Dream of Momi* (1916).

1906 J. Stuart Blackton's important transitional film *The Humorous Phases of Funny Faces* shows the way animation can enhance the principles of the "lightning sketch." Vitagraph's later film, *The Haunted Hotel* (1907), used stop-motion object animation and establishes a market for this kind of distinctive filmmaking process.

1908 *The Sculptor's Nightmare* is Billy Blitzer's stop-motion creation of busts of political figureheads laughing and smoking. French filmmaker Émile Cohl's groundbreaking *Fantasmagorie* is released based on the surrealist principles of the *incoherent* artists.

1910 The first example of cameraless animation is used by Arnaldo Ginna, whose technique of painting directly on film is later adopted by Len Lye and Norman McLaren.

1911 Landislaw Starewich's three-dimensional (3D) model animation *The Cameraman's Revenge* using insects in a love-triangle story makes self-reflexive comments on the voyeuristic aspects of cinema itself. Winsor McCay and Walter Arthur produce a film called *Winsor McCay Makes His Cartoons Move* early in 1911, profiling McCay's technique of using rice-paper cels. McCay's *Little Nemo in Slumberland* is about a little boy's surreal dreams based on his own *New York Times* comic strip.

1913 John R. Bray and Raoul Barré simultaneously evolve systematic quasi-industrial processes for the production of cartoons in a Fordist "assembly line" manner. Bray produces *The Artist's Dream* (1913) as a pilot for a system that would become an industry standard.

1914 Willis O'Brien produces a short stop-motion animated film, *The Dinosaur and the Missing Link*. Winsor McCay releases his celebrated film *Gertie the Dinosaur*, featuring Gertie, a creature that is characterized by a full range of personality traits and gestures, like that in his earlier *The Story of a Mosquito* (1912). J. R. Bray and Earl Hurd apply for patents on their "cel-animated" production process.

1915 Gregory La Cava supervises cartoons based on the Hearst International comic strips, "Krazy Kat" and "The Katzenjammer Kids." Paul Terry produces his first *Farmer Al Falfa* cartoon. The Edison Company releases Raoul Barré's *Grouch Chaser* cartoons. The Fleischer brothers experiment with the process of "rotoscoping": animating over live-action footage.

1916 As part of an increasingly industrialized process in studios, new innovations speed and enhance the work. Bill Nolan, for example, creates a moving background beneath foreground cel-animated figure action.

1917 Argentinean Quirino Cristiani's hour-long myth about social redemption, *El Apóstol*, may be recognized as the world's first animated feature. Dudley Buxton of Britain produces *Ever Been Had?* a film within a film, anticipating the idea of the last man on Earth after a wartime apocalypse. Japanese animation pioneers in 1917 were Seitaro Kityama, Junichi Kouchi, and Oten Shimokawa, who would inspire later generations of internationally successful animators. Viking Eggeling creates experimental abstract animation in the spirit of a modernist avant-garde.

1918 Winsor McCay makes *The Sinking of the Lusitania*, which is arguably the first animated documentary, although this may have been preceded by a film made in Britain about the same event that has since been lost.

1919 Pat Sullivan and Otto Messmer make the first *Felix the Cat* film, *Feline Follies*. Messmer's authorship of the *Felix* films is not acknowledged, however, until much later. In *Out of the Inkwell*, Max Fleischer introduces his part-animated, part live-action series featuring Koko the Clown. One of the first properly organized animation studios in France is established by Richard Collard (known by the pseudonym "Lortac"), providing animated inserts for newsreels.

1920 Paul Terry introduces the series *Aesop's Fables*, which is arguably influential on the Disney "animal" universe and is initially distributed by RKO.

1921 Hans Richter completes his first abstract experimental work, *Rhythmus 21*, partly in collaboration with Viking Eggeling. Oskar Fischinger also begins experimental work, animating changes in color and shapes as he removed slices from a prepared wax cylinder. Fischinger also worked with cutouts and silhouettes. Walter Ruttman released his first abstract animation, *Lichtspiel Opus 1*, which anticipated his *Opera* series in the following two years. Walt Disney's first cartoons, the *Laugh-O-Grams* series, were adaptations of fairy tales, two of which—*Puss in Boots* and *The Four Musicians of Bremen*—actually feature Disney's own animation.

1922 John R. Bray releases a series of cartoons, *Colonel Heeza Liar*, based on the exploits of President Teddy Roosevelt. Viking Eggeling creates his most influential work, *The Diagonal Symphony* (1922).

1923 The Fleischer brothers make a groundbreaking four-reel educational film, *Einstein's Theory of Relativity*. Walt Disney forms his own company and produces *The Alice Comedies*; he reverses the Fleischer brothers' conceit in the *Out of the Inkwell* series and puts the live-action figure of Alice in an animated environment.

1924 Painter Fernand Léger's influential avant-garde work, *Ballet Méchanique*, which includes full animation painting directly onto film, is released. The *Song Car-Tunes*, a series of films made by the Fleischer brothers, displays popular songs featuring a "bouncing ball" device that moved along the lyrics while cinema audiences sang along to the piano accompaniment.

1926 Lotte Reiniger's lyrical silhouette cutout animation *The Adventures of Prince Achmed* has a significantly different aesthetic from the emergent animated cartoon in the United States, and lasts some 65 minutes.

1927 Walt Disney introduces *Oswald the Lucky Rabbit*, a character series, whose design anticipates the far more successful Mickey Mouse. The prolific Japanese animator Yasuji Murata uses cel animation and creates a Disneyesque animal universe.

1928 The first known pornographic cartoon, *Eveready Harton in Buried Treasure*, was released, probably made in New York by a cross-studio ensemble of notables that may have included Max Fleischer, Paul Terry, and Walter Lantz, and possibly made for Winsor McCay's birthday party or as a stag film. The Disney Studio releases *Plane Crazy*, *The Gallopin' Gaucho*, and *Steamboat Willie*; these Ub Iwerks–designed and animated shorts defined the Disney style and echoed contemporary events—*Plane Crazy*, Lindbergh's Atlantic crossing; *Gaucho*, the prominence of Valentino; and *Steamboat Willie*, which remains a landmark in animation as the first fully synchronized sound cartoon and is known for the introduction of a mischievous Mickey Mouse.

1929 Walt Disney's *Skeleton Dance* is released as the first of the *Silly Symphonies* series. Paul Terry establishes his own studio, Terrytoons, producing over 1,000 cartoons by 1952.

1930 The first Metro-Goldwyn-Mayer Looney Tune, *Sinkin' in the Bathtub*—an obvious parody of Disney's *Silly Symphony*, features Bosko, by Harman-Ising. Max Fleischer creates his first incarnation of

34443433 xxii • CHRONOLOGY

Betty Boop in *Dizzy Dishes*, though her features later changed. Walter Lantz produces the first Technicolor cartoon sequence in a full-length live-action color feature, *King of Jazz*.

1931 After leaving Walt Disney, Ub Iwerks releases *Flip the Frog*, less successful than his Disney series, that is distributed by MGM. The first *Merrie Melodies* cartoon, *Lady Play Your Mandolin*, is a further example of animation's intrinsic relationship to popular music.

1932 Mary Ellen Bute and Leo Thurmin experiment with the concept of drawing with electronically determined codes, the first form of computer animation. Oskar Fischinger continues his experiments with "visual music," including *Composition in Blue* (1935), which is arguably an inspiration for Disney's *Fantasia* (1940). Disney won the first Oscar for Animated Short Films with *Flowers and Trees*, which had been three-quarters made in black and white and was ordered to be remade into fully three-strip Technicolor.

1933 Disney produces the most fully formed "personality" animation with *The Three Little Pigs*, whose signature ditty, written by Frank Churchill, "Who's Afraid of the Big Bad Wolf?" became a rallying cry against the damaging effects of the Depression. The Fleischer brothers' surreal take on the Snow White fairy tale, *Betty Boop's Snow White*—featuring Betty, Koko, and Bimbo as well as a rotoscoped performance from Cab Calloway singing "St. James Infirmary Blues"—is released and labeled "cartoon noir." Max Fleischer also introduces Popeye the Sailor, the popular blue-collar sailor.

1934 *Honeymoon Hotel* was released as the first *Merrie Melodies* cartoon. Donald Duck appeared in his first film, *The Wise Little Hen*, and became the Disney Studio's most popular character. Alexander Alexieff and Claire Parker create their first "pin screen" animation, *Night on Bald Mountain*, utilizing the lighting effects upon a 1,000-pin screen, where different levels of pins were raised to create an image and photographed one frame at a time. Hugh Harman and Rudy Ising create the first Harman-Ising cartoon, *The Discontented Canary*, for MGM, called "Happy Harmonies."

1935 Alexander Ptushko's politicized puppet animation, *A New Gulliver*, made with molded wax dolls, updates Swift's story with Gulliver as a

champion of an oppressed proletariat and demonstrating the benefits of modernization in the industrial landscape. The first color Mickey Mouse cartoon, *The Band Concert*, is produced and may be viewed as a summation of Disney's stylistic combination of personality animation, situational story-telling and gag construction, and image–music synchronization. Len Lye's stylish and innovative abstract film *A Colour Box*, sponsored by the General Post Office (Great Britain) and culminating in information about parcel post costs, is produced.

1936 Walt Disney explores a town-and-country theme in *The Country Cousin*, comparing rural innocence with urban sophistication. The Fleischer brothers produce the first extended-length cartoon short, *Popeye the Sailor Meets Sinbad the Sailor*. Len Lye completes a puppet film, *The Birth of a Robot* (1936), and *Rainbow Dance* (1936), featuring a human figure and varying color combinations.

1937 Norman McLaren's abstract film *Love on the Wing* advertises air mail and is viewed as "too Freudian" by a British government minister who saw sexual connotations in the imagery. Walt Disney inaugurates the first use of the multiplane camera in a short animation, *The Old Mill*, to create realistic perspective and movement through the depth of field. Disney also releases *Snow White and the Seven Dwarves*, first thought of as "Disney's folly," though it advances the animation medium. A strike occurs at the Fleischer brothers' studio, signaling the first full impact in the struggle for unionization within the animation studios, a fate that befalls the Disney Studio four years later.

1938 A prototypic "Bugs Bunny" appears in *Porky's Hare Hunt*, but Frank Tashlin has argued that the real design basis for Bugs was in Disney's *The Tortoise and the Hare* (1935).

1939 The Fleischer brothers release their first full-length feature, *Gulliver's Travels*. Hugh Harman's part-Disneyesque "cute," part-documentary "real" evocation of the consequences of war is seen in *Peace on Earth*. The film is nominated for an Oscar and the Nobel Peace Prize, and endorsed by many social contexts for its antiwar message. Disney releases *Pinocchio*, arguably their masterpiece, described as a gothic tour-de-force exploring the moral, social, and material world, and illustrating the complex processes of redemption and fulfillment.

1940 Paramount signs émigré George Pal to produce a series of 3D puppet animations, *Puppetoons*, using his replacement technique of creating multiple different body parts as they move through a sequence; he was assisted by Ray Harryhausen. The Bauhaus movement influences John Halas and Joy Batchelor, who establish Halas and Batchelor Studios in England. The Larkins' studio also opens. Tex Avery creates Bugs Bunny and his signature catch phrase, "What's up, Doc?" in *The Wild Hare*. Hanna-Barbera creates the first Tom and Jerry cartoon, *Puss Gets the Boot*. Walter Lantz introduces Woody Woodpecker in *Knock Knock*.

1941 Walt Disney's controversial feature *Fantasia*, using animation to illustrate different pieces of classical music, is released. Critics argue that the film summarizes the best and worst of Disney's art. John and James Whitney create experimental animation allied to synthetic electronic sound tracks in *Variations*. The Fleischer brothers introduce a series of hyperrealist, modern graphic cartoons in *Superman*. French master animator Paul Grimault's debut film, *The Passengers of the Great Bear*, is released. Frank Tashlin makes an outstanding cartoon, *The Fox and the Crow*, for Columbia's Screen Gems series. The Disney strike effectively ends the first Golden Age of the animated cartoon in the United States. Striking workers who leave his studio move to work for UPA, effectively becoming the first radical splinter group. UPA then goes on to modernize the cartoon short.

1942 Paul Terry's Terrytoons introduce *Mighty Mouse*. *Weatherbeaten Melody* by Hans Fischerkoesen, who may be regarded as one of the most important artists working in Germany during the war, is released. Chuck Jones uses "smear animation" to move more abstract figures from extreme pose to extreme pose in *The Dover Boys*. Disney's wartime propaganda shorts feature Donald Duck in *The New Spirit*. Disney animation was also used in Frank Capra's *Why We Fight* series throughout the war. Paramount buys out the Fleischer brothers and establishes Famous Studios, but continues to produce the popular *Popeye* and *Superman* cartoons.

1943 Norman McLaren establishes the Animation Unit at the National Film Board of Canada, one of the world's most significant producers of innovative and amusing animation thereafter, and produces

Hen Hop. Tex Avery consolidates his key themes of sex, speed, status, and Disney-bashing in *Red Hot Riding Hood*, a modern revision of the fairy tale. Avery also makes his first Droopy cartoon, *Dumb-Hounded.* Bob Clampett's take on the Snow White story in *Coal Black and de Sebben Dwarves*, featuring a range of black caricatures, is released. Warner Bros. makes the *SNAFU* series of cartoons for the armed services, featuring an inept recruit. More affecting, if problematic, Warner Bros. propaganda can be seen in *Daffy and the Commando* (1943). Leon Schlesinger sells his studio to Warner Bros., after which all *Looney Tunes* and *Merrie Melodies* are produced in color.

1944 The Industrial Film and Poster Service, forerunners to United Productions of America (UPA), produces *Hell Bent for Election* on behalf of Franklin D. Roosevelt, directed by Chuck Jones. Warner Bros. continues to produce propaganda with *Herr Meets Hare* (1944), *Plane Daffy* (1944), and famously, *Bugs Bunny Nips the Nips* (1944), with its controversial "grenade ice creams."

1946 Disney's controversial part-animated, part-live-action retelling of the "Uncle Remus" stories, *Song of the South*, is released and attracts National Association for the Advancement of Colored People (NAACP) protests. United Productions of America (UPA) is established and releases *The Brotherhood of Man*, a racially sensitive film that brings the studio national attention. ENIAC, the world's first programmable electronic computer, is introduced by the U.S. military at the University of Pennsylvania.

1947 Oskar Fischinger uses oil painting on Plexiglas to animate color and form synchronized to Bach's *Brandenburg Concerto* in *Motion Painting #1*. Jordan Belson, one of America's West Coast avant-garde, completes a silent black-and-white movement painting on film, *Transmutation.* Jiri Trnka's puppet animation *The Czech Year* signals the rise of a new Eastern European animated tradition.

1948 Norman McLaren's experimental film *Begone Dull Care*, described by painter Pablo Picasso as "Finally, something new," is released. Tex Avery modernizes his work in *Little Rural Riding Hood.* Chuck Jones makes the first of his existential fables featuring the Road Runner and Wile E. Coyote. *Crusader Rabbit* is the first cartoon made specifically for television by Jay Ward and Alex Anderson.

1951 Robert "Bobe" Cannon and UPA radicalize the cartoon with *Gerald McBoing Boing*, using modern art principles and new conceptions of story-telling to challenge the dominance of the Disney, Warner Bros., and MGM styles. This new graphic style wins an Oscar.

1952 Norman McLaren's antiwar film *Neighbours*, using pixilation—the animation of live-action movement frame by frame—is released.

1953 Ray Harryhausen creates extraordinary 3D creature animation in *The Beast from 20,000 Fathoms*, elevating a throwaway B movie to commercial and artistic success. Disney's short history of music, *Toot, Whistle, Plunk, and Boom*, adopts a similarly modern graphic style as UPA. Disney did not approve of this departure from the established aesthetic, although it did win the Oscar. Chuck Jones deconstructs the cartoon form in *Duck Amuck*, one of Jones' best known. 3D cartoons are introduced in *Melody*, the "Adventures in Music" short released by Disney.

1954 Halas and Batchelor release a persuasive full-length feature adaptation of Orwell's parable about the Russian Revolution, *Animal Farm*. Disney closes its cartoon shorts division.

1955 James Whitney, brother of John, makes a visual tour-de-force optical invention that seeks to evoke the spiritual agenda of the "sacred machine" alluded to in the title of *Yantra*. Art Clokey's abstract clay animation *Gumbasia*, which anticipated his *Gumby* television series, is released. John and Faith Hubley form Storyboard Studios, advance animation practices, and create films addressing global social problems. Paul Terry sells Terrytoons to CBS, and Gene Deitch restructures the studio.

1956 Zagreb Studios is established, prioritizing modernist art principles in its "reduced animation" strategy; *The Playful Robot* by Dusan Vukotic is the first film released by the studio. MGM closes its short cartoons unit.

1957 Chuck Jones directs *What's Opera Doc?* his classic compression of Wagner's 14-hour "Ring" cycle, into seven minutes. Hanna-Barbera ushers in the era of television animation with *Ruff and Ready* and the cost-effective "limited animation" processes that drew from UPA and Zagreb aesthetics, but found less favor with the artists of the

Golden Age. John Whitney created the first primitive analogue computer graphics.

1958 Bugs Bunny's only Oscar-winning cartoon short, *Knighty Knight Bugs*, is released.

1959 UPA makes its first full-length feature, *1001 Arabian Knights*.

1960 *Heaven and Earth*, an extraordinary extended film artwork made over 10 years between 1950 and 1960 by Harry Smith, one of the postwar West Coast avant-garde group, is released. Hanna-Barbera's *The Flintstones* becomes the first animated prime-time sitcom, and a vindication of the company's cost-effective reduced-animation techniques. Disney uses the Xeroxing process in its production of *Goliath II* for the first time and uses it throughout its feature *101 Dalmatians*.

1961 Czech Karel Zeman adapts Gottfried Bürger's novel *Baron Munchausen*. Zagreb artist Dusan Vukotic's film *Ersatz* becomes the first animated short from outside the United States to win an Academy Award.

1962 Ivan Sutherland at MIT creates Sketchpad, a software program with enhanced computer graphics.

1963 *Jason and the Argonauts* is released, probably the zenith of Ray Harryhausen's career, including a sequence in this where the Argonauts do battle with six animated skeletons. *Astro Boy* is the first Japanese animated series to appear on American television, directed by Osamu Tezuka at Mushi Animation Studio.

1964 Hanna-Barbera produces *Jonny Quest*, one of the best science fiction series on television for children. *The Pink Panther* is the first DePatie/Freleng "Pink Panther" cartoon for theatrical distribution.

1966 Filmation introduces *Superman*, another version of the superhero cartoon.

1967 Norman McLaren's masterpiece *Pas de Deux*—the animation and photographic manipulation of a dance sequence—is released. Terrytoons/Paramount closes its animation studios.

1968 John Whitney's computer-generated masterpiece *Permutations*, made during a period of research for IBM, is released. George Dunning

and his British-based team radicalize the animated feature with *The Yellow Submarine*, using the Beatles' songs, modern graphic design principles, and the full embrace of counterculture activities and outlook.

1969 Scooby Doo is introduced, one of Hanna-Barbera's most popular and enduring cartoon characters. Experimental animator Jules Engel heads the department of animation at the influential California Institute of the Arts (CalArts). Warner Bros. ceases the theatrical distribution of cartoons.

1972 Ralph Bakshi radicalizes American cartoon animation by the explicit depiction of adult themes and behavior in the guise of his counterculture cat in *Fritz the Cat*. Walter Lantz's studio closes, having been one of the longest surviving from the Golden Age. George Gerbner's research group finds that animated cartoons are the most violent television genre.

1974 John Whitney Jr. continues his father's work, establishing a company to explore the possibilities of 3D computer-generated imagery for entertainment applications.

1975 Veteran British animator Bob Godfrey's inspired musical documentary of Isambard Kingdom Brunel, *GREAT*, featuring innuendo, pathos, and politics—the calling cards of Godfrey's long career in British animation—is released. Evan and Sutherland Computer Co. produces the first fully computer-generated (CG) images to the U.S. Maritime Administration for research and development in training situations (the company had been established in 1968 to develop and exploit burgeoning CG technologies). George Lucas founds Industrial Light and Magic (ILM) to create computer-controlled effects for *Star Wars*. Will Vinton establishes Claymation as a crossover method between cartoon principles and avant-garde modern expression, radicalizing both in *Closed Mondays*.

1976 Caroline Leaf's adaptation of Mordecai Richler's autobiographical writings, *The Street*, uses a sand-on-glass metamorphosis technique, which enhances the representation of recollection and stream-of-consciousness association. The International Telephone and Telegraph Company funds Richard Williams' film *Raggedy Ann and*

Andy in order to revitalize the animation industry. This was an unsuccessful initiative.

1978 *Asparagus*, arguably one of the finest animated films of all times, is Suzan Pitt's challenging piece that vividly explores the creative process of women artists in sensual colors and provocative imagery. Craig Decker and Mike Gribble form Mellow Manor Productions, a streetwise underground promotions company that literally took to the streets to distribute handbills about pop concerts and animation programs.

1979 Voted the greatest animated film of all time by fellow animators, Yuri Norstein's *Tale of Tales*, an elegiac contemplation of childhood, memory, and indigenous cultures, has a luminescent Rembrandt-like aura, and works as a vindication of art as the most truthful embodiment of human feeling. Don Bluth and a number of colleagues leave the Disney Studio in protest at the decline of standards and investment. Bluth establishes his own studio and seeks to continue the Disney tradition in a more classical style.

1982 The first full-length feature to include 3D computer animation, *Tron*, is released by the Disney Studio, but *Tron*'s self-reflexive engagement with a narrative based in a computer itself, and its pioneering aesthetic, proved too innovative for Disney audiences. Czech Jan Svankmajer releases *Dimensions of Dialogue*, a masterpiece of political allegory partly based on the mannerist style of Prague painter Archimboldo. Channel 4 in Britain uses a pioneering computer-generated imagery (CGI) logo; Channel 4 becomes a significant sponsor, funder, and promoter of animation in Britain.

1984 The Disney Studio produces its first computer-animated test short, *Wild Things*. Over 25 minutes of computer-generated animation was included in the feature adventure *The Last Starfighter*.

1985 Students at the University of Montreal take three years to create *Tony de Peltrie*, an emotive short of a pianist singing a torch song; while capturing a human figure successfully, the short merely emphasizes the difficulties of creating a persuasive human face in CGI. The short did, however, inspire the then-industry-standard Softimage 3D animation software. John Lasseter's pioneering Pixar short *The Adventures of André and Wally Bee* is produced, seeking to align new

computer graphic idioms with the traditional cartooning skills of the Golden Age. Richard Abel's CGI advertisement *Brilliance* brings CGI into the commercial mainstream, as the distinctive software created by Abel was later purchased by Wavefront.

1986 Jimmy Murakami's TVC production of Raymond Brigg's antinuclear story *When the Wind Blows* is released. Japanese feature auteur Hayao Miyazaki creates a spiritual masterwork, *Laputa, the Flying Island*, engaging with childhood innocence and the enduring power of nature. Joanna Quinn's *Girls Night Out*, a hilarious film featuring a middle-aged Welsh housewife Beryl on a mischievous night out at a male strip show, is released. The Quay brothers produce one of their most well-known films, *Street of Crocodiles*, an adaptation of Bruno Schulz's short story.

1987 Ralph Bakshi and John Kricfalusi, among others, makes a new series of *Mighty Mouse: The New Adventures*, modernizing the mouse and making many pop cultural references. Alison de Vere's dreamlike philosophical enquiry *The Black Dog* is made.

1988 Katsuhiro Otamo's breakthrough anime, *Akira*, is released, depicting a violent postapocalyptic world, and state-of-the-art sequences of science fictional invention. Robert Zemeckis and Richard Williams create the then state-of-the-art combination of cartoon and live action in *Who Framed Roger Rabbit*, celebrating the Golden Age of cartoon production by combining many cartoon characters from different studios in one film. The Outrageous Animation Festival emerges out of the Tournée initiative, which had been extant since 1965 and endured in various guises, privileging each development in animated and avant-garde cinema.

1989 *The Little Mermaid* is the first of the Ron Clements/John Musker trilogy of films that reinspired Disney's fortunes in the feature market by returning to a "classical style" but augmenting it with what was traditionally a Warner Bros. type of "knowingness" and irony. The pseudopod created for James Cameron's *The Abyss* by ILM anticipates Cameron's *Terminator 2: Judgment Day* in foregrounding the use of CGI as a character/narrative device on its own. ILM's work wins the Best Special Effects Oscar in 1992.

1990 America's most dysfunctional family, *The Simpsons*, radicalizes the American sitcom, and returns animation to prime time for the first time since *The Flintstones*. Disney's aesthetic makes a significant shift in using CGI coloring techniques in *The Rescuers Down Under*.

1991 Nick Park's first Oscar-winning animation, *Creature Comforts*, is part zoo documentary, part hidden-camera show; the film establishes Aardman Animation, a company founded by Peter Lord and David Sproxton, on the world stage. John Kricfalusi's *The Ren and Stimpy Show*, a knowing revision of TV-era cartoons in the spirit of more radical work from the Golden Age—most particularly, the Fleischer brothers and Bob Clampett—initially revitalizes television animation but is ultimately censured for its provocative and sometimes extreme content.

1992 Disney's fairy-tale *Beauty and the Beast* becomes the first full-length animated feature to be nominated for an Oscar in the feature section. The film encompasses CGI that is highly successfully in its ballroom dancing sequence between Belle and the Beast. Turner's Cartoon Network begins broadcasting.

1993 Fully persuasive computer-generated dinosaurs in *Jurassic Park* prompt the debate about the ways in which the drive for "realism" both enhances yet hides the craft of the animator and the art of animation. Henry Selick's dark Christmas allegory *The Nightmare before Christmas* promotes 3D stop-motion animation as a contemporary feature aesthetic, and features Jack Skellington, a tribute to Ray Harryhausen's skeleton warriors. *Reboot* is the first fully computer-generated animation television series.

1994 Disney's phenomenally successful, Hamlet-influenced African myth *The Lion King* provokes controversy in relation to its representation of "black" characters.

1995 Mamoro Oshii's persuasive exploration of postmodern cyberculture, *Ghost in the Shell*, addressing posthuman identity and the search for an authentic sense of "soul"—the "ghost" in the 21st-century machine—is released. The first fully computer-generated animation feature film, *Toy Story*, is released, featuring Woody, the pull-string cowboy, and Buzz Lightyear, a gadget-laden space astronaut. Richard

Williams' 30-year investment in creating his own auteur vehicle, *The Thief and the Cobbler*, ends in profoundly disappointing circumstances as additional footage and re-editing by new owners and distributors undermines and invalidates the ambition and considerable achievement of the film.

1996 *Toy Story* wins a Special Achievement Oscar.

1997 *I Married a Strange Person*, by Oregon iconoclast Bill Plympton, moves on from his deadpan Tex Avery in shorts like *Your Face* (1987) to fully consolidate his excessive and surreal depictions of sex and violence, here working as a none-too-veiled attack on media-driven consumer culture. John Lasseter's *A Bug's Life* reworks *The Seven Samurai* while DreamWorks SKG's *Antz* explores social metaphor in its engagement with the role of the individual in a hierarchical, highly conformist social infrastructure.

1999 Part live-action, part CGI story, *Stuart Little* features a state-of-the-art computer-generated mouse who seamlessly integrates with the codes and conventions of his live-action environment. BBC's quasi-documentary series *Walking with Dinosaurs*, featuring persuasive dinosaurs in their natural habitats, is broadcast. Barry Purves' exemplary musical biography *Gilbert and Sullivan*—using puppet animation, an important interrogation of "Britishness," and a theatrical tour-de-force—is released. John Lasseter releases his sequel to *Toy Story* in *Toy Story 2*. Former *Simpsons* director Brad Bird makes *The Iron Giant*, an adaptation of Ted Hughes' poetic novella, using CGI.

2000 Disney's first all-digital feature, *Dinosaur*, a film respectful of the "dinosaur" tradition in animation, heralds the creation of a new digital facility. Internet animation grows exponentially. Icebox, an online animation studio, presents the subversive *Zombie College*, created by *Futurama* producer Eric Kaplan. Unbound Studios consolidates online work with Nickelodeon. John Kricfalusi creates animation on his "Spumco" website. Mickey Mouse returns to his first cartoons since the 1950s in *Mickey Mouseworks*. Don Bluth's failed postapocalyptic feature *Titan AE* is allegedly responsible for the closure of Fox's Animation Unit.

2001 Hironobu Sakaguchi's feature *Final Fantasy: The Spirits Within* uses photorealist performance animation, echoing the aesthetic of its

video-game source; enhancing the television series using computer game aesthetics coupled with "motion capture" are *Roughnecks: Starship Troopers Chronicles, Max Steel,* and *Dark Justice.* Damon Albarn creates a 2D cartoon pop-vehicle with *Gorillaz,* which recalls a whole tradition of animation from the early 1930s onward in which the illustration of songs is the underpinning aspect of the cartoons. The first Animated Feature Oscar is awarded to *Shrek,* by DreamWorks SKG. *Waking Life,* directed by Richard Linklater, combines live action with rotoscoping by animator Bob Sabiston, adds to the development of animation for an adult audience, and highlights the technology.

2003 Warner Bros. star cartoon characters Bugs Bunny and Daffy Duck (among others) are revived in the part live-action, part animated feature *Looney Tunes: Back in Action.* Sylvain Chomet directs *Les Triplettes de Belleville (Belleville Rendezvous),* which was highly praised for its unique style and minimal dialogue.

2004 *The Polar Express* becomes the latest animated feature to attempt to re-create photorealistic characters by using a process involving motion capture. Though the film was successful at the box office, it was criticized by many for its eerie characters, due to the lack of movement in the eyes.

2005 Aardman Animation and Nick Parks produce *Wallace and Gromit: The Curse of the Were-Rabbit,* the first feature-length film starring Parks' award-winning and highly popular duo.

2006 Richard Linklater makes his second feature using digital rotoscoping, *A Scanner Darkly,* based on Philip K. Dick's science fiction novel.

2007 *Persepolis,* an adaptation of Marjane Satrapi's autobiographical comic book about growing up in Iran, is released to critical acclaim; the film is mostly in black and white with a distinct visual style to emulate the original drawn comic and is nominated for an Academy Award.

2008 Director Ari Folman's biographical feature-length documentary *Waltz with Bashir,* depicting the confusion and horror of the 1982 Lebanon war, is released to critical acclaim.

Introduction

This *Historical Dictionary of Animation and Cartoons* is intended to provide an overview of the animation industry and its historical development. The animation industry has been in existence as long (some would argue longer) than cinema, yet it has had less exposure in terms of the discourse of moving-image history. This book introduces animation by considering the various definitions that have been used to describe it over the years. A different perception of animation by producers and consumers has affected how the industry developed and changed over the past hundred years.

The global dominance of the Disney Studio from the United States has also had an impact on how people see and understand animation. By looking at the origins of animation, we can chart the development of a global industry, examine how different countries have influenced others, and explore the impact that new technology has had on the changing industry. This introduction goes on to discuss issues faced by the industry largely concerning perceptions and definitions, and in recent years, suitability of content, and ends with some considerations for the future of animation in terms of the technological developments that have always driven the industry and the changing attitudes to the art form.

The dictionary continues to address many of these themes and issues by looking at specific examples in animation and attempts to contextualize them within the larger medium of moving images. One of the key categories of entries in the book is that of the producer or director of animation, the artist without whom the movement would not be created. Likewise, there is an emphasis on the different types and methods of animation, all of which can produce very different results and each with its own problems of time and cost. Considerable space is also dedicated to the pioneers of animation, as the history of the form has

been extremely influential and is important to consider when looking at more modern issues.

DEFINING ANIMATION

The definition of animation has long been the subject of some debate, increasingly so as new technologies blur the boundaries between animation and live-action cinema. One of the most basic definitions of animation comes from a dictionary definition outlined by Philip Denslow at the fourth Society for Animation Studies conference, as

> a: a motion picture made by photographing successive positions of inanimate objects (as puppets or mechanical parts), b: animated cartoon, a motion picture made from a series of drawings simulating motion by means of slight progressive changes. (Pilling 1997, 1)

Though this is the simplest and most common understanding of what animation is, Denslow admits it has limitations in describing the versatility of the form. But even animation scholars find it difficult to agree upon a clear definition. Many favor the well-known definition posited by animator Norman McLaren, "Animation is not the art of drawings-that-move, but rather the art of movements-that-are-drawn" (Solomon 1987, 11). Likewise the very definition of "animate"—with its origins in Latin, *animatus*, to give life to—is a very simple notion of bringing movement to the inanimate. This is also problematic, as it has been argued by Alan Cholodenko (1991) that, if this is the case, then all film is actually a form of animation, rather than the commonly assumed opposite position. The dictionary definitions refer to animation in terms of the process itself rather than as an art form separate from live-action film, and these definitions can vary depending on history, production methods, audience perceptions, and advertising.

Consequently, some prefer a more useful definition provided by the Association of International Film Animation (ASIFA), namely that animation is any film that is "not live action." This definition is of particular use as technology advances and animation forms develop away from "traditional" dictionary-inspired terms. As new technology has developed, the industry too has developed to adopt the new techniques

and methods. However, this explanation becomes problematic when computer-generated special effects are heavily used in live-action films. The definition of animation is once more complicated by the dominance of live-action cinema. The animated effects used within can become secondary to the live action, further marginalizing the animated form in audience perceptions, as a tool for effects rather than a form in its own right.

The lack of a clear definition of animation is not just a problem for animators when describing and marketing their product, but it also presents difficulty for the audience, whose perception is a key element in genre definition. Animation has long been subject to the hegemony of the Walt Disney Studios, with a large part of audiences automatically associating animation with the ubiquitous studio's output. Connected to that is the perception of the form as something that is solely a form of children's entertainment. For a long time, the majority of animation literature concerned the work of the Disney Studio, which—though it clearly played an important role in animation history—suggests to scholars and audiences that it is the *only* animation worthy of examination.

Another problem of definition is that animation has different meanings to those who produce it and those who receive it. For example, many animators consider animation an art form that is highly creative, while others who produce films with clear narrative structures often consider animation as a filmmaking technique as well as an art form. There is also the marginalization of animation as a lesser art form by live-action filmmakers. This marginalization in favor of live-action film and the difficulties of definition, even between animation scholars, has led to a relatively narrow range of literature being produced on the subject, though this is gradually changing. Literature on the topic is fairly limited, with the majority of texts either focusing on historical accounts of the studio systems (particularly Disney, Metro-Goldwyn-Mayer, and Warner Brothers), animation techniques, or on specific animators. Those texts that discuss genre in animation have not generally included television animation.

With all of these issues surrounding an agreed definition of animation, some would argue that it is necessary to have one specific definition in order to signal to those outside the animation community what the form is. However, it could also be argued that it is the very fluid

nature of the form, and the resulting study of it, that attracts interest, and that one single definition is not necessary. Likewise, the changes in the technologies for image manipulation and creation would suggest that definitions would need constant updating in order to take these advances into account.

In this book, animation is considered to be all of the above definitions: it is movement that is drawn, inanimate objects brought to life through models and drawings, and film that is "not live action." By including all of these definitions, the book demonstrates the variety and scope of animation as an art form, a narrative filmic device, and a tool for creating what cannot be captured in live action.

HOLLYWOOD'S GOLDEN AGE AND THE DOMINANCE OF DISNEY

Since the first sound-synchronized animated cartoon, Disney's *Steamboat Willie* in 1928, the Walt Disney Studio has largely dominated the animation industry worldwide. The film was made at a turning point in cinema technologies when new studios were desperately competing and Warner Brothers had released the first "talkie," *The Jazz Singer* (1927). Many of the U.S. studios reacted by emulating the antics of Mickey Mouse and his sound films, and popular music was used as a narrative device in Disney's *Silly Symphonies* series, quickly followed by the other animation studios, including, perhaps more famously, Warner Brothers' *Looney Tunes* and *Merrie Melodies*. Likewise, when Disney moved into features with *Snow White and the Seven Dwarves* (1937), other studios, such as that of the Fleischer brothers, ventured into that area with *Gulliver's Travels* (1939). This period, generally described as the Golden Age of animation, is celebrated among some historians as a time when a great quantity of animation was produced, at a reasonably high level of quality, innovation, and comedy. It should also be considered that the audiences for animation were cinemagoers who saw these (short) films as part of a larger group of films. Still, the opportunities to create animation through the studio system rose to significant heights in the 1930s and 1940s. It was during this time that some of the most loved and lasting stars of animation—such as Bugs Bunny, Daffy Duck, Tom and Jerry, Donald Duck, and of course, Mickey Mouse—were established.

As the popularity of these characters increased, the animators who created them became well known and were treated as stars themselves; Chuck Jones, Tex Avery, the partnerships of Harman Ising and Hanna-Barbera, as well as Walt Disney all became the biggest names in animation. The period also saw an early dominance of Disney globally as the films were exported throughout the world, and in many cases proved to be quite influential—all the more so since there were so many of them, both features and short films or "cartoons."

During World War II, the foreign markets essentially became closed, and afterwards many other countries sought an expansion in their domestic animation production. Disney, like other studios, faced industrial unrest and experienced a strike that saw the departure of many of its finest talent and the entry of a new workforce that required training.

The Golden Age came to an end and with an increase in costs, the rising popularity and competition from television saw studios such as Warner Brothers and MGM closing their animation divisions in the late 1950s and early 1960s.

However, despite these changes (and many ups and downs over the years), the Disney influence has continued; the company remains internationally successful, with the ability to adapt to new technologies and redirect its efforts into projects that generate income, such as merchandise, theme parks, television productions, and more recently the re-release of its back catalogue on DVD. It has also continued to act as a distributor, including recently forging an important relationship with the extremely popular Pixar studio, the Disney name appearing large alongside the animation studio, essentially maintaining its dominance over the most successful contemporary studio in the United States.

Disney's position in the animation industry has also led to a (largely Western) view of animation as being solely a form of children's entertainment, particularly in the past 50 years. In many cases, animated productions are indeed intended for a young audience, but animation did not start out that way. Trick films and lightning sketches were generally performed to an adult vaudeville audience. Though some films were made with children in mind, many animators applied the yardstick of a successful gag: if it made them laugh, it was good. The studios (particularly Warner Brothers and MGM) were full of adults making films that they would enjoy, and because the films were part of a feature bill, a large part of the audience would have been the same age as those

who created them. During the World War II years, the studios produced propaganda films for the troops, with a particular focus on their adult male target audience. Disney's features did have frightening elements within them (particularly early on), but its films were increasingly made for families and children and were marketed accordingly.

Despite a decline in the industry in the 1980s, the Disney Studio continued to try to capitalize on its legacy; the "house of mouse," as it is known, has increasingly diversified its market, not least dominating children's and preteens' entertainment. Disney's continued presence reinforces the perception of animation in general audiences who have not perhaps had access to any alternative animation. Similarly, since 2000, other studios have been trying to emulate Pixar's success by creating family friendly features using computer-generated imagery (CGI). Despite this increase in films, they are all trying to capture the same family market, again dominating the cinemas (and television) with mostly child-oriented animation.

THE STORY OF ANIMATION

Animation shares its origins with film history because both emerged from experiments into the creation of the moving images that were abundant in the late 1800s. Many of the earliest technologies were European inventions to create and project images, and these developed rapidly until the turn of the century. Touring acts brought the magic of the moving image to the world by the Lumière brothers, Emile Reynaud, and Thomas Edison, all demonstrating the wonder of the new technology while constantly trying to improve their machines. Eventually, the two forms diverged—film captured and projected live action, and animation created movement from inanimate objects, particularly drawings and models.

The animation industry took off around the world (in varying stages) with the pioneers trying to discover the best, most efficient, and cheapest methods to create and exhibit the new moving pictures. It began with "trick" stop-motion films and then moved on to the filming of thousands of drawings with incremental movements, the technique preferred by Winsor McCay and seen in his *Little Nemo* (1911). One of the key sources of material for the new animators was the newspaper

comic, or cartoon, strip; many people had previously read them and now audiences were keen to see the familiar characters move. Likewise, many new animated characters were later translated into comic strips as a form of merchandise.

The technology developed quickly with cel animation coming into use as early as 1914, only 10 years after J. Stuart Blackton's "lightning sketches" using crude stop-motion. This new technique had an enormous impact on the industry, and numerous studios and individual animators were able to create moving drawings quickly without having to reproduce every single movement. The process—still in use—became shorthand for drawn animation, commonly referred to as simply "cel."

The technology continued to develop with the Fleischer brothers' early motion-capture device, the rotoscope, and later with Walt Disney's multiplane camera that enabled the animator to create depth of field on a flat film background. The next development was sound synchronization, which brought new life to the silent era films accompanied by musical scores and dialogue cards. The new use of sound was the making of some studios and the undoing of others, such as that of Pat Sullivan, who disliked the new technology despite the popularity of his star, Felix the Cat.

The 1930s and 1940s saw the start of a boom in Hollywood animation, and around the world new studios began to follow from the imported images they saw. During World War II, studios consolidated their efforts to create war-effort propaganda, after which studios continued under new government regimes in Eastern Europe and the Soviet Union, whereas largely in the West they returned to commercial business as usual.

New modern art forms were influencing animators and inspiring experimental avant-garde films, as well as lending a new modernist aesthetic to more mainstream productions such as the new United Productions of America (UPA) studio's *Gerald McBoing Boing*. This change in style was very popular and saw a shift in the dominance of the hyperrealist principles set by the Disney Studio.

As the new technology of television became more popular, the demand for children's and animated programming increased, initially met by repackaging popular old shorts. However, the effect of this new broadcasting technology was a decline in cinema audiences; several animation studios closed. Out of the remains of MGM, the newly founded

Hanna-Barbera studio began creating series specifically for television audiences, both for children and later for families, with their prime-time hit *The Flintstones* in 1961. Throughout the 1960s and 1970s, there was an increase in children's programming, mainly scheduled on Saturday mornings and after school, although these shows arguably declined in quality as they increased in production volume.

In the 1960s and 1970s, Disney feature animation slowed production, as Walt concentrated on other projects; with his death in 1966, the studio experienced a decrease in releases, and those that were made were for children. This changed somewhat in 1968 with George Dunning's *Yellow Submarine*, based on the music of the pop group the Beatles, and for a young adult audience. Ralph Bakshi produced *Fritz the Cat* (1972), the first X-rated animated feature, based on Robert Crumb's counterculture comic. The film generated strong reactions but Bakshi took this as a positive outcome and followed up with other adult features. This essentially demonstrated that there was an audience for adults and encouraged less of a focus on children's stories in animation, though the idea was slow to reach the mainstream.

During the 1970s, animators were experimenting with computer technology to generate images. The applications of this were applied at filmmaker George Lucas' purpose-built studio to create visual effects for his live-action science fiction epic *Star Wars* in 1977. Lucas' new company, Industrial Light and Magic (ILM), went on to further develop the technology that would lead to fully computer-generated animation being used.

Disney also ventured into computer technology and in 1982 released the science fiction movie *Tron*, which was a mixture of CGI and live action, the first feature to use fully computer-generated effects. Disney continued experimenting with the technology; meanwhile, Disney alumnus John Lasseter was one of the founders of the new digital animation studio Pixar in 1984. Developed out of ILM, the new studio began creating fully digitally animated shorts with *The Adventures of André and Wally Bee* in 1985.

Television animation in the United States was firmly rooted in children's cartoons in the 1980s. Several new studios competed in this market and changes in broadcast and advertising regulations saw an increase in shows that were direct-marketing tools for toys and other merchandise, notably Filmation's *He-Man* series.

A significant development in the 1980s was the launch of the U.S. Music Television network MTV, which not only showcased animated music videos such as Peter Gabriel's *Sledgehammer* (produced by the British studio Aardman Animation) but also provided an outlet for independent animators such as Bill Plympton and Mike Judge. This support encouraged a new generation of animators to create films for an adult audience that could be different and cutting-edge.

In 1989, a series of animated shorts was developed into a half-hour sitcom structure and the landscape of television animation, and animation audiences, changed. Matt Groening's *The Simpsons* revitalized a forgotten genre and popularized animation on television for adults. At the same time, feature animation and the Disney Studio experienced a resurgence in success, first seen with *The Little Mermaid* (1989) and later with *The Lion King* (1994), which was at the time the highest grossing animated feature.

This renewed excitement in feature animation (in the West) reached new heights in 1995 when Pixar released its first feature, the fully computer-generated *Toy Story*. The film was extremely successful and produced a sequel in 1999. Featuring a fairly sophisticated narrative and engaging and charming characters, the film was enjoyed by adults as well as children, and once more it seemed that adults could enjoy animated features at the cinema. Pixar became dominant in feature animation in the United States, and its success inspired a number of other studios to try to capitalize on this with their own adult (or rather, family) features, such as DreamWorks' *Shrek* (2001) and its sequels. *Shrek* was a successful comedy with enough satire to keep adult audiences entertained, but later sequels were less successful and the copycat films from other studios were poor in comparison to the Pixar productions.

Animation became increasingly popular with more and more animated segments in live-action films, more animated advertisements, and generally more animation in theaters and on television. This is due not only to the renaissance in television animation and theatrical features but also to the audiences, which are largely comprised of people who grew up with the Saturday morning cartoons and are accustomed to animation in all forms. These fans have become the producers of animation and have knowledge of animation history. Animators such as John Kricfalusi show the influence of earlier works through their own efforts.

The industry's development and growth was recognized when the Oscars introduced a new Academy Award for Animated Feature in 2001, which was awarded to *Shrek*. The new category saw international films given recognition in Hollywood, with the second award to one of the top Japanese directors, Hayao Miyazaki, for *Spirited Away* in 2002. The industry has continued this progression; more animated features have been released and more animation has been produced for television worldwide at the end of the 20th century and into the 21st. New technological advances have undoubtedly had an impact on this, just as the initial technology did at the turn of the 20th century.

GEOGRAPHIC SPREAD

Although those aforementioned developments largely focused on the United States, the global animation industry was developing at a similar rate. In Europe, the early moving-image pioneers in France and Great Britain led to the quick development of animation industries throughout those countries, though less popularized and exported than the animation from the United States. Some of the earliest European animation was the most diverse in terms of style and production methods, such as German animator Lotte Reiniger's cutout silhouette puppets and the abstract shapes of Swede Viking Eggeling. In general terms, the animation in Europe in the early days of the industry was much more experimental and perhaps more concerned with the artistry of the technique rather than the drive for entertainment that was found in the United States.

Although there were some differences in the animation produced in Europe, much of this became influential in the United States, and as such played a large part in the development of the industry overall. German animator Oskar Fischinger was known for his abstract films, which he described as "visual music," and was invited by Walt Disney to contribute to the epic feature *Fantasia* (1940). A number of European animators such as Alexandre Alexieff from Russia and Norman McLaren from Scotland (and later Paul Driesson from the Netherlands) moved to Canada and were pivotal in the development and success in the new animation division of the National Film Board (NFB).

During World War II, Europe and Asia, much like the United States, saw an increase in the use of animation in propaganda and information

films. The use of government funding continued in many areas after the war and played a key role in supporting the industry, particularly in Eastern European countries such as Poland and Hungary and those in the Soviet Union. After the war, the political and monetary fallout could be felt in much of the animation produced, with many films containing political messages, either deliberately for the ruling government or by way of the artist's subversion.

In Asia, the animation industry was largely closed due to the devastation of the war, but by the mid-1950s there was a resurgence, which—in Japan, in particular—saw vast developments in animation and the introduction of TV animation. Elsewhere in the region, homegrown industries began developing; in South Korea, there was such an increase in production that they have become one of the biggest producers of animation, much of which is produced for other countries. In Japan, the animation industry continued its successful growth in television and feature animation, and in 1988 found international acclaim with the science fiction feature *Akira*. The film brought anime to international attention, establishing a relationship that would develop over the next 20 years, to the point where anime films would be some of the most influential animations and Japan one of the world's leading producers of animation.

In Britain, the majority of commercial animation in the 1960s and 1970s was produced for children's television in a variety of genres from adaptations of classic fairy tales to comedy series, and thanks to Gerry Anderson's extremely popular *Thunderbirds* series, science fiction. In the 1980s, British television's Channel 4 was instrumental in the development of the careers of several animators who would go on to win awards around the world. In the case of Aardman Animations, their early work with the channel set them on a course of success that continues.

The technological developments in animation have largely followed the same pattern throughout the world; in many areas, such as India, these new computer technologies helped to build an industry that was slower to develop than some of its neighbors. Globalization essentially helped the spread of animation as new audiences acquired access to it. This helped to raise awareness of diverse animation styles and techniques and has improved the market for transnational viewing. What was once perhaps a hallmark of a national "style" of animation is now influencing other animators, seen most obviously in the Japanese anime style now widely adopted in the United States.

ISSUES AND PROBLEMS

Despite this long and varied history—which in terms of quality of production, volume of production, and levels of commercial and artistic output, runs parallel to cinema history—animation history is often overlooked, as either part of a larger film history or on its own as a separate entity. This can be largely attributed to issues of definition, which as previously suggested is often confusing to scholars and audiences alike, and raises issues with perceptions of animation outside the industry.

Animation has often been looked upon as film's "poor cousin" due to its comedic content and its "cartoony" appearance so appealing to children, and was not taken seriously. The majority of early animated films were vaudeville-style gags (there are also examples from the silent era of animated pornographic films, thought to have been created for stag parties) for an adult, cinema-going audience. Although the majority of early animated series were adaptations of fairy tales or fables, there was no specific "children's" audience in the way that has developed since the 1950s and 1960s.

The codes and regulations that censor and govern film content only came into being when cinema really took off in the 1930s, but even then cartoons was largely perceived by those in the regulatory committees as "harmless," and no close attention was paid to them until the mid-1930s when animation increased in production and thus visibility. The audience has been varied throughout the development of animation but, as previously suggested, the dominance of the Disney Studio's output for children created a perception of animation as something less than film. This attitude was perhaps reinforced with the rise of television animation that was aimed specifically at children and had merchandising to go with it. Though Ralph Bakshi's *Fritz the Cat* and George Dunning's *Yellow Submarine* found their intended adult audiences in the late 1960s and early 1970s, these were not mainstream changes. In Eastern Europe, many films were made for children but with more subversive political agendas essentially smuggled into the highly regulated industry. Japanese animation has received more positive attention, with distinct genres and markets for different, varied audiences.

With the success of the prime-time series *The Simpsons* and MTV shorts, adult audiences in the West became more accepting of the form in the late 1980s, and many more shows were produced over the next

20 years. In 2001, the Cartoon Network recognized this market and launched "Adult Swim," a nighttime slot dedicated to broadcasting new and innovative animation specifically for an adult audience. The success of this time slot was replicated throughout the world with other versions in Italy, Latin America, Australia and New Zealand, Germany, South Africa, and Great Britain.

The increasing use of CGI and animation in features—such as Richard Linklater's *Waking Life* (2001) and *A Scanner Darkly* (2006) and the Wachowski brothers' *The Matrix* (1999)—has led to a renaissance of the form and with it a more accepting view of animation as something distinct from Disney cartoons. There is a danger that as more CGI is used in live action, animation will become "part" of film, with little to distinguish it. However, the more ubiquitous animation becomes, the more attitudes may change, and perhaps the literature will reflect a change in status.

FUTURE PROSPECTS OF ANIMATION

Since the first experiments in image making, animation has constantly evolved with new technologies and continues to do so into the digital age. Digital animation has taken off with studios solely working on computer technology; even Disney has closed its traditional hand-drawn animation studio in favor of digital technology. The technology enables efficient creation and manipulation of the images, with the ability to quickly correct errors or change something without ruining too much work. It also allows animators to create 3D worlds more easily than if they were drawn.

The boundaries between animation and live action have begun to blur with the increasing use of CGI to the point that it is often difficult to distinguish what is CGI and what is live action. Although there are concerns that animation will lose its distinctiveness in the commercial sector, live-action film could also be said to face the same challenges if the animated effects are more efficient and cost effective than using real sets and models. As animators strive to re-create perfect photorealism, they may eventually make actors redundant; however, this seems to be a long way from happening. Several attempts in feature films and even in shorts prove that there are still issues in the process where the "actors"

are unconvincing with an odd "dead-eye" appearance. This push for realism is only one aspect of the future of animation; others use digital technology to create other production techniques such as Bob Sabiston's Rotoshop method. Likewise, artists are using digital technology to create virtual puppets that are manipulated by computer rather than by hand, or to produce 2D animation more efficiently.

Despite the drive to digital production methods, many animators remain unconvinced and prefer more traditional methods. Several animators known for their "sketchy" style, such as Bill Plympton and Joanna Quinn, still produce their animation by hand and with great success. Likewise, the Japanese Studio Ghibli continues to produce features using hand-drawn animation, which it feels has a better look. Animation is becoming so ubiquitous that there seems to be an audience for a variety of methods and styles. It appears that animation in commercials is increasing, as is the use of animated segments in live-action shows, though this is often in comedy. Animated art installations are also increasing, changing how people perceive both art and animation's part in it.

One of the major developments in animation since 2000 has been in changes in broadcast methods. The rise of multichannel television has provided more space for animation, both traditional comedy and more alternative productions on specific comedy channels and animation-based networks. Cable channels face fewer broadcasting restrictions than traditional networks (particularly in the United States) and as such are able to provide suitable platforms for animation. As well as increased television channels, the Internet is increasingly becoming the home of cutting-edge animation.

Previously, most animation was exhibited by theatrical release, festivals, or on television, but the rise of computer technology has seen an increase in independent animation distributed on the Internet. This animation is then seen worldwide, free from the restrictions of traditional broadcasting and costs. Any creator of animation can show his or her work in this manner, finding new audiences in a way that was previously impossible, and receive more immediate feedback and fan interaction. This new form of distribution has seen a large variety of animation types from the increasingly popular Flash animation to stop-motion using Lego bricks to the manipulation of other animation in video games to create new narratives known as *machinima*.

Animation in video games is also becoming increasingly sophisticated, and the two markets are experiencing convergence in the creation of new computer-generated environments that allow users to create their own narratives. These applications have inevitably attracted attention from the traditional broadcast networks, which seek to promote these new creations. Thus, Web animation provides more commercial opportunities for those animators who want to move into more traditional forms of exhibition. Still, many Web animators prefer to use the space to express themselves without any forms of censorship or control, and through merchandising they can generate income. It also provides space for educational development where students can utilize the interactivity of the Internet to display their works in exhibition formats.

All of these new technological opportunities for animation contribute to the continued history of this very dynamic form. The animation industry could arguably be in the throes of a new Golden Age worldwide, though this will be difficult to assess fully without the benefits of hindsight.

REFERENCES

Cholodenko, Alan, ed. 1991. *The Illusion of Life: Essays on Animation.* Sydney: Power Institute of Fine Arts.

Pilling, Jayne, ed. 1997. *A Reader in Animation Studies.* London: John Libbey.

Solomon, Charles. *Enchanted Drawings: The History of Animation.* New ed. New York: Random House Value, 1994.

The Dictionary

– A –

AARDMAN ANIMATION STUDIO. The studio was founded by Peter Laird and David Sproxton and was established in Bristol, **Great Britain**, in 1976. The studio specializes in **three-dimensional** (3D) **stop-motion** animation using Plasticine, a type of modeling **clay**. The studio wanted to create animation that would appeal to all age groups and began by creating *The Amazing Adventures of Morph* as part of the **British Broadcasting Corporation** (BBC) children's art program *Take Hart* (1977–1983).

The studio was commissioned in 1982 by the British **television** network **Channel 4** to make a series of films based on real-life conversations. Entitled *Conversation Pieces*, these five-minute **shorts** were similar to films Aardman Animation had previously made for the BBC in 1978. In 1985, animator **Nick Park** joined the studio full time, at which point he was able to finish his grad-school film *A Grand Day Out*, starring his most well-known characters, **Wallace and Gromit**.

The studio continued to work on a wide variety of projects, including in 1986 the award-winning music video for Peter Gabriel's *Sledgehammer*, collaborating with David Anderson and the **Quay brothers**. But it was a return to the films based on conversations that put them in the spotlight, after Channel 4 commissioned a series of five-minute films, *Lip Synch*, using vox pops.

The series included Nick Park's *Creature Comforts*, which won the **Academy Award** for Best Animated Short in 1990. Park was able to follow this success with his next film starring Wallace and Gromit in 1993's *The Wrong Trousers*, which earned Park his second

Academy Award. The third installment featuring the duo, *A Close Shave*, in 1995 was also awarded the Best Animated Short Oscar.

In 1998, the studio returned to television with its first postwatershed program, *Rex the Runt* (directed by Richard Goleszowski) for BBC2. In the late 1990s, Aardman Features was established in a separate Bristol studio to produce **feature-length** films. It produced *Chicken Run* in 2000 (directed by Peter Lord and Nick Park), which was at that point the most successful British film ever. Following this success, the studio joined with U.S. studio DreamWorks to jointly produce features, moving into **computer-generated imagery** (CGI) with the feature-length *Flushed Away* (2006), though this agreement ended in 2006.

The studio created an Internet series, *Angry Kid*, in 2003 and in 2005 followed up the highly successful *Creature Comforts* film with a new series for ITV. In 2005, Aardman released its second feature film, *Wallace and Gromit: The Curse of the Were-Rabbit*, directed by Nick Park and Steve Box. The film was highly successful and won the Best Animated Feature Oscar. The studio continues production, though it suffered a warehouse fire in October 2005 in which a great number of old props were lost though no new material. In 2007, Aardman signed a three-year distribution deal with Sony Pictures Entertainment. The studio continues to produce advertisements, which it has been making since the company began.

ABSTRACT(ION). The term *abstraction* is a relative one but in animation terms can be described as the creation of images that suggest a concept rather than an attempt to be representative of real life. The films tend to focus on rhythm and movement themselves and how they relate to each other, using a variety of shapes and forms; as such, abstract films are considered by some historians as "true animation" (Moritz in Wells 1998, 28). There is often a lack of a clear narrative structure; the films are intended to be interpretive and representative of the artist. Examples include **Norman McLaren**'s *Hen Hop* (1940), **Oskar Fischinger**'s *Kriese* (*Circles*, 1933), and **Len Lye**'s *A Colour Box* (1935) and *Particles in Space* (1979).

McLaren's *Boogie Doodle* (1940) has been described as a film that emphasizes expression as a response to "external stimuli" rather than

derived from a structured narrative. The images rely on the response of the viewer. **John** and **James Whitney** were also well known for their abstract films such as *Lapis* (1965), which mixed new computer technology with old film techniques to create the series of images in the film.

Abstract animation has a tendency to be classified as art as opposed to theater and **television** animation that is created for mass audiences and as such is displayed and consumed differently. It is generally created by independent animators whose work is not widely distributed. The films are also often classed as "experimental films" rather than animation, even though elements of the image can be animated.

ACADEMY AWARDS. The Academy Awards, or Oscars as they are commonly known, are the annual awards given by the Academy of Motion Picture Arts and Sciences in the **United States** for achievement in the film industry since 1929. Awards are presented in a ceremony held in Los Angeles every January. Awards are determined by secret ballots of Academy members derived from a short list of nominees. The awards ceremony has grown in popularity from the once-private event to radio broadcast, and in 1953, **television** broadcast. The number of awards has increased over the years from an initial 15 to 25 with the addition of Best Animated **Short** Film in 1931 (though it was originally called "Short Subjects, **Cartoons**") and Best Animated Feature category added in 2001. The awards range from technical aspects of filmmaking such as editing and sound to acting and direction. The biggest award is considered to be Best Picture, though the only animated film to be nominated in this category was Disney's *Beauty and the Beast* (1991).

Walt Disney won 22 awards in his career, including a posthumous award in 1968, and he earned an Oscar in each of the first 12 years. **Metro-Goldwyn-Mayer**'s (MGM) *Tom and Jerry* series won seven Oscars during the series' run. The awards were largely dominated by U.S. productions until the 1960s, with the exception of the nomination of **Norman McLaren**'s *A Chairy Tale* in 1957. The nominees and winners since the 1960s have included productions from around the world and represent a wide range of different animation styles and techniques.

ADAPTATION. Stories remade or adapted from their original (often literary) source or remade in the same format—for example, a film of a film—are adaptations. Some of the earliest animated **cartoons** were adapted from newspaper comic strips such as **Winsor McCay**'s "Little Nemo" and Charles Bower and **Raoul Barré**'s "Mutt and Jeff" series.

Adaptations are commonly seen in animation from folklore and fairy tales typified by the **Disney Studio**, such as the Brothers Grimm (*Snow White*) and Hans Christian Andersen stories (*The Little Mermaid*). Adaptations of fables were common in early animation, specifically the *Aesop's Fables* series produced by **Paul Terry** and later **Van Beuren**.

Other literary sources adapted in animation include Charles Dickens' *A Christmas Carol*, which has been adapted by numerous studios and animators over the years from Disney to **Jim Henson**'s Muppets, *Gulliver's Travels* by the **Fleischer brothers**, *Animal Farm* by **Halas and Bachelor**, and J. R. R. Tolkien's *The Lord of the Rings* adapted by **Ralph Bakshi**, to name a few.

In **Japan** it is common to adapt **manga** into **anime**, such as **Hayao Miyazaki**'s *Nausicaä of the Valley of the Wind* (1984). Other examples include Dr. Seuss films, such as *How the Grinch Stole Christmas!* produced by **Chuck Jones**, and recently Philip K. Dick's *A Scanner Darkly* (2006) by Richard Linklater and **Bob Sabiston**.

In **Western Europe**, adaptations have been very successful, with the best-known examples being *Astérix* from the immensely popular series of books by René Goscinny and Albert Underzo from **France**, and the long-running Belgian series *Tintin* by Hergé. Both characters have lasted longer than many of their contemporaries and have appeared in various formats, including animated features in the case of *Astérix* and an animated **television** series of *Tintin*.

ADULT SWIM. In 2001, the **U.S.** cable channel **Cartoon Network** launched a late-night slot branded "Adult Swim" with a tag line "no kids in the pool." The time slot runs from 11 p.m. until 6 a.m. and broadcasts new and cutting-edge animation, generally **comedy**. The slot opened with the **anicom** *Home Movies*, which was later joined by *Family Guy*. As well as comedy animation series, Adult Swim

also aired several **anime** series, including *Cowboy Bebop*, though the frequency of anime has been reduced over the years. The slot has become something of a showcase for new animation and has become internationally successful with other subsidiary Cartoon Networks adding it to their lineup. In some countries, other channels are given licenses to air the section, such as in **Great Britain** where it was broadcast on the cable channel Bravo until July 2008. Adult Swim is shown in Latin America, Canada, South Africa, **Australia** and **New Zealand**, **Germany**, **Spain**, **Russia**, and **Italy** among others.

ADVENTURES OF PRINCE ACHMED, THE. *Die Geschichte des Prinzen Achmed*, by German animator **Lotte Reiniger**, was released in 1926 and was the first **feature-length** animated film in Europe (predating **Walt Disney**'s *Snow White and the Seven Dwarves* by 11 years). The film was animated using Reiniger's signature silhouette **puppets**, accompanied by a background by abstract filmmaker **Walther Ruttman**. Carl Koch (Reiniger's husband) and their friend Berthold Bartosch were also involved in making the film that Reiniger had been invited to make by a Berlin banker named Louis Hagen. Hagen had seen Reiniger's previous film, made while she was part of the Institute of Cultural Discovery, and wanted her to make the film for him independently of the institute. He created a studio for her near his home.

The animation technique was cutout puppets in black paper, backlit to create "shadows." The people, animals, and objects were animated using the technique, also known as "Chinese shadows."

The film was very successful, particularly in **France**. It consisted of several fables from *The Thousand and One Nights* that were **adapted** for the film. The story featured chases and escapes by princesses, love stories, and fights between good spirits and devils. The film was accompanied by narration and was said to have mixed drama with the sense of gentleness that Reiniger was known for.

ADVERTISING. Animation has been used in advertising since the early days of the industry. Many early studios produced advertising materials or contributed to them, such as the **Fleischer brothers**' use of their "**bouncing ball**" sing-along **cartoons** to advertise for

the Oldsmobile Car Company. The form is well suited to advertising due to its flexibility in **short** form and the ability to "dramatize the fantastic" in a way live-action cannot.

Animation's appeal to a wide audience was capitalized on to create advertisements throughout the world, with many well-known animators beginning (or often near the end of) their careers producing commercials over the years, including **Raoul Barré**, **John Halas**, **John Hubley**, **Art Clokey**, **Bob Godfrey**, and **Jim Henson**. By the end of the 1940s and the early days of **television**, the major producers of animated advertisements included **Shamus Culhane** Productions.

The increased use of limited animation in television production suited the advertising industry due to its economic viability. Many early animated ads in the **United States** consisted of little more than comic strips with minimal animation, but by the 1960s the limited animation such as that pioneered by **United Productions of America** **(UPA)** and used on television by **Hanna-Barbera** was commonly used. The production values and budgets improved in the 1980s, with the company Kurtz and Friends producing advertisements in full animation for clients such as Levi, Chevron Oil, and AT&T.

A variety of types of animation has featured in advertisements through the years from **three-dimensional** (3D) **puppet** and **clay** animation, **cel**, and more recently, **computer-generated imagery** (CGI). The range of production methods matches the range of products advertised, and in many cases the animated "stars" of the commercials became almost as well known as the actual product. **Will Vinton**'s California Raisin Men of 1989 were spun off into a series of their own. The popular Tetley Tea Men in **Great Britain** were featured in merchandise, and their long-running characters developed as technologies did. The **Aardman** *Creature Comforts* characters featured in a series of advertisements in Britain for Heat Electric and though the characters were already popular, the ads brought them further into the mainstream and the popular consciousness.

Animated advertisements are still produced by contemporary animators, both well known and those starting out. British animator **Joanna Quinn** divides her work between her own films and creating ads for such companies as Charmin and United Airlines, and French animator **Sylvain Chomet** also divides his studio's work between the dual pursuits of commercials and personal filmmaking. ***J. J. Se-***

delmaier Productions in the United States produces animation for television as well as advertisements.

AKIRA. *Akira*, released in 1988, was directed by Katsuhiro Otamo, based on his **manga** of the same title, and was one of the first major **anime feature-length** films to break the Western market. The film is set in a violent postapocalyptic Tokyo, 2019, that features secret government and military testing. A motorcycle gang discovers this secret, and lead character Tetsuo ends up with hallucinations and a painful transformation of his body into cyborg parts. Tetsuo attempts to find out about Akira, which he believes can relieve his pain. Akira turns out to be a child who was the original test subject for the government, when he was found to have the psionic abilities that led to the destruction of Tokyo in 1988. He returns at the end of the film without a physical body, during a battle between Tetsuo and a rival gang member, Kaneda, and triggers another explosion. Another group of test children known as "The Espers," who have similar powers to Akira and now Tetsuo, appears and attempts to control the situation by removing Tetsuo from an expanding energy sphere that threatens to destroy Neo-Tokyo. Instead, Tetsuo is killed and the city remains, with Kaneda and his gang members left to start again.

The film's main themes of the nature of corruption, growth and maturity, the historical fears of nuclear destruction, and social unrest all permeate throughout the fairly complicated plot. The film's success in the West brought new audiences to manga and anime, which has continued to be successful. A live-action version of the film, starring Western actors, is planned for release in 2011. *See also* JAPAN.

ALICE. **Jan Svankmajer**'s interpretation of the Lewis Carroll story *Alice in Wonderland*, *Alice* (1988) features a live-action girl who interacts with animated objects. The film took over two years to create, six months to build the props, one year to shoot the film, and another year to edit. The funding came in part from **Great Britain**'s **television** network **Channel 4** and was made when Svankmajer was particularly discouraged from filmmaking in his native Prague. The story has the subjectivity of a dream and is told though the voice of a child. All aspects of her new world are **violent**, as she is hit on the

head by objects that bring an element of horror and uncanniness to the film and make it very different from the **Walt Disney** version. Here, fantasy and reality are presented as the same thing, and the film is not aimed at a children's audience.

AMERICAN BROADCASTING COMPANY (ABC). The American Broadcasting Company was a forerunner in the evolution of U.S. **television** network history. The network was often the first to make the changes and decisions that had an impact on the TV landscape. The network began when the Federal Communications Commission (FCC) carried out a monopoly probe in 1938–1941 of radio networks. The existing two, NBC and CBS, were accused of monopolistic practices and the broadcast networks were split up. ABC was created and shared radio earnings and power. In 1948, it was granted a TV station license, though there were some problems in the transition from radio to television, and business difficulties saw the network changing ownership. The network is now part of the **Disney** group. It is notable here as the first network to commission and broadcast prime-time animation, **Hanna-Barbera**'s *The Flintstones* (1960–1966), which essentially launched the animated **sitcom genre**. This was followed by *Top Cat* in 1961, *The Jetsons* in 1962, and initially *Hong Kong Phooey* from 1974–1976 until it moved to NBC. ABC has continued with varying success over the years, but it was the newer network Fox and cable station **Comedy** Central that became the home of prime-time animation from the 1990s onward.

ANDERSON, GERRY (1929–). Born in Hampstead, London, Gerry Anderson began his career in a photographic studio, which gave him an interest in working in film. Anderson went to work at the Colonial Film Unit, a branch of the Ministry of Information, as a trainee and found he had a talent for editing. He went on to work at Gainsborough Pictures, where his debut was in an assistant editing position on the 1946 film *Caravan*.

In 1947, Anderson undertook his National Service in the Royal Air Force. Also in 1947, Anderson began working at Pinewood Studios as a dubbing editor. He formed his own studio, AP Films, went on to work with a variety of studios doing commercial work, and was commissioned to make the **puppet** series *The Adventures of Twizzle*

(1957). This was followed by another successful series, *Torchy the Battery Boy* (1957), and led to Anderson branching out to make his own show, the western *Four Feather Falls*. Supported by ATV head Lew Grade, Anderson created the series *Supercar*, which was very successful and led to a second series and sale to the **United States**. His technique for this puppet series was his own pioneering method known as "super marrionation." This involved the use of wires and machinery that would synchronize mouth movements to spoken dialogue. Series that used this technique included *Fireball X15*, *Stingray*, and his most well-known series, the **science fiction** adventure ***Thunderbirds***, which remains incredibly popular long after its 1966 debut. The series was followed by a **feature-length** version and has recently been remade as a live-action film (2004).

After the success of the *Thunderbirds* film, AP Films developed into Century 21 Organization, incorporating Century 21 Film Studios and acquiring the rights for several popular **television** series. The studio produced the puppet series *Joe 90* (1968–1969) but then went on to create live-action sci-fi series, including *UFO* (1970–1971) and *Space 1999* (1975–1977). In 1981, Anderson ventured back into puppet animation with the television series *Terrahawks*. Anderson is currently working on a **computer-generated imagery** (CGI) fantasy adventure series.

ANICOM. A term to describe the animated **sitcom**, a specific **genre** of **television** animation. It uses the particularities of animation to be distinct and separate from the live-action sitcom but follows the same generic conventions of narrative space, narrative structure, and character types. The animated form allows the anicom to push back boundaries and address a variety of themes and settings, though it commonly follows its live-action counterparts with regard to domestic, workplace, and occasionally **science fiction** venues. The term first appeared in print in the *Animation Journal* article "Nitpicking 'The Simpsons': Critique and Continuity in Constructed Realities" (Dobson 2003) and has been used since. The term is included here as a contribution to the historical development of the diversity of genre in animation.

The first example of an anicom was **Hanna-Barbera**'s *The Flintstones*, which first aired on the **American Broadcasting Company**

(ABC) network in 1960. Modeled on the popular live-action **comedy** format, the studio produced several series over the years with the same format, including *The Jetsons*, *Top Cat*, and *Wait 'til Your Father Gets Home*. After utilizing other comedy genres, animation moved to the sitcom as the logical format as television became more prevalent and popular. The shows were created to appeal to a family audience and initially aired in prime time, the first animations to do so.

During the 1980s, the anicom disappeared from television but was revived in 1989 with **Matt Groening**'s *The Simpsons*. Like *The Flintstones* before it, *The Simpsons* led to a whole new generation of anicoms and included shows such as *The Critic, *Futurama, King of the Hill*, *Dr. Katz: Professional Therapist*, **South Park**, *Family Guy*, and *Home Movies*, to name a few. Many of the new shows only lasted a short time but several have continued on prime time, with *The Simpsons* recorded as the longest running sitcom in **U.S.** television history in 2007.

ANIMAL FARM. Directed by **Halas and Batchelor**, and produced by their studio in England, *Animal Farm* (1954) was the first British animated **feature-length** film. It is based on George Orwell's (1945) satirical allegory of communist totalitarianism where farm animals revolt against their owner to create an equal society, only to have the pigs take over and run the farm as a dictatorship. American producer Louis de Rochemont approached Halas and Batchelor with the idea to make the film in 1951, two years after Orwell's death.

The film was originally intended to reflect the **political** ideology of the original text, but the studio decided to make the story accessible to a wider audience. The film was still for an adult audience but did not have the same propaganda as the original text. It took two years to make and had 70 people working on it. The film was critically acclaimed, though the ending was changed at the request of de Rochemont to be more positive; the original saw the pigs becoming ever more humanized and joining with the enemies of animal kind, but in the film the animals are seen once again rising up, about to revolt once more. The characters are not sentimentalized or portrayed as cute, as are animals in other animated films, such as those from the **Disney Studio**.

ANIMATRIX, THE. *The Animatrix* (2003) is a collection of nine **short** animated films detailing the back story of the live-action **science fiction** film *The Matrix* (1999). Directors Andy and Larry Wachowski, who were longtime fans of **anime**, wanted to develop the mythology of their very successful film, which had become a trilogy. They collaborated with **Japanese** (and **U.S.**) animators, the brothers writing some of the stories and others left in the hands of the directors. Yoshiaki Kawajiri, Mahiro Maeda, Koji Morimoto, Shinichiro Watanabe, and Takashie Kaike were joined by U.S. director Andy Jones and Korean-born Peter Chung. The segments feature a variety of styles and aesthetics, reflecting the direction as well as the created aesthetic and universe featured in *The Matrix*. The film has often been described as a "live-action anime" and features a large amount of **computer-generated imagery** (CGI) effects.

The segments are *Beyond*, *A Detective Story*, *Kid's Story*, *Matriculated*, *Program*, *The Second Renaissance Parts I and II*, *The Final Flight of the Osiris*, and *World Record*. The films were shown in varied order, and often individually, throughout the world in 2004, in some countries on **television** and in others in theaters. The whole collection was released on DVD and is also supplied with the boxed set of the *Matrix Trilogy*. *The Animatrix* was extremely popular internationally.

ANIME. Simply put, *anime* is Japanese for animation. However, the term is commonly used in the West to refer to a particular style of Japanese animation that has become popularized since the crossover films/series such as ***Astro Boy*** (1963–1966) and the popular **science fiction** feature ***Akira*** (1988).

Anime is often classed, in the West, as an animation genre; however, while the animation from **Japan** does have a distinctive style and several shared features, there are several genres represented. For example, there is **science fiction** anime, fantasy anime, and police anime to name but a few. It has been suggested that most literary or cinematic genres are represented in anime.

The drawing style in anime is very detailed, though this is not practical in terms of animating processes. **Osamu Tezuka** was said to have simplified the processes, similar to that of **Walt Disney**, in

order to produce the work fairly quickly. The result, a form of **limited animation**, saw reused backgrounds and dialogue sequences with only animated mouths. The films typically counter this limited approach by including scenes of great detail where more effort has been put into the animation, thus elevating the quality of the film. There are studios that produce anime with higher production values, such as **Studio Ghibli** as seen in *Spirited Away* (2001), or in such features as *Ghost in the Shell* (1995) or *Akira* (1988).

Although most animators have their own distinctive styles, a common feature in anime, and one that has become something of a stereotype in the West, is the use of large eyes drawn on many of the characters, often paired with a large head and small body. There is also the use of exaggerated facial expressions for surprise or anger in many of the characters.

ANTHROPOMORPHISM. The endowment of human attributes, such as the ability to walk upright and talk, on animals (or other creatures). It can be used to redefine or draw attention to characteristics that are taken for granted in live-action human representations. An early example can be seen in *Gertie the Dinosaur*, and anthropomorphism informed much of **Walt Disney**'s work and indeed many of the characters from **Warner Brothers'** *Merrie Melodies* and *Looney Tunes*. The trait is seen in several animation stars such as **Felix the Cat**, **Mickey Mouse**, Daffy Duck, **Bugs Bunny**, and Porky Pig. It is suggested that it has origins in animism where native story-telling traditions suggest animals can embody human spirits. The use of anthropomorphized animals continues in **feature-length** and **television** animation; in the **Pixar** feature *Cars* (2006), it is the vehicles that are anthropomorphic, though this was perhaps less successful than the animal or toy characters that Pixar had previously featured.

ASIA. The animation industry in Asia has had varying levels of development, with a turbulent history marked by war and **politics**. Two of the most prolific producers of animation are **China** and **Japan**, and as such have their own entries. The early days of the industry were largely influenced by imports from the **United States** that provided inspiration for the development of a new industry. The

development was marred in the early 1940s with World War II as well as conflicts within the continent. In North Korea, for example, the industry faltered in the postwar period, only finding its place in the mid-1980s when it established the Children's Film Studio of the Democratic People's Republic of Korea as an overseas facility, creating animation for **French**, **Italian**, and **Spanish** companies as well as children's films for the domestic market.

In South Korea, the mid-1950s saw the earliest animation in **advertisements**. In 1960, Shin Dong Hun set up his own studio and established an industry for features in South Korea. Between 1976 and 1985, 62 features were produced in the country. By increasing production for overseas studios, South Korea became the third-largest producer of animation after the United States and Japan. Undoubtedly, Japan is the biggest contributor of animation in the region in terms of output volume and also in the effects and impact that animation from Japan has had on the world.

The Taiwanese animation industry began in the 1960s with the production of **shorts**, and the sector was dominated by only a few companies such as Tse-Hsui Art and Production, Ying-Jen Ads Company, and perhaps one of the most successful, the Wang Film Production Company (also known as Cuckoo's Nest). Wang was established in 1978 by James Wang, who had trained in the United States and formed a partnership with **Hanna-Barbera** (HB). They produced many of HB's popular series, including *Yogi Bear*, *Scooby Doo*, and features such as *The Care Bears Movie*. The industry has continued to develop with support from the government, which is encouraging the use of digital technology.

Vietnamese animation, like that of Taiwan, came to the fore in the early 1960s with the state-sponsored Hanoi **Cartoon** Studio. It has produced a variety of animation over the years using different production methods, including **cel**, cutout, and **puppet**. The studio's first film was a **propaganda** piece by Le Minh Hien and Truong Qua called *What the Fox Deserves* (1960), though it was Ngo Manh Lan's *The Kitty* that gave the studio international attention in 1966. Over the years, the studio has varied its output with fables as well as propaganda. In the early 1990s, foreign companies began to base themselves in Vietnam and the industry started expanding into computer animation.

Animation in Thailand has been influenced by outside forces, such as the sponsorship of anticommunist films in the late 1950s and early 1960s by the United States. One of the major figures in Thai animation is Payut Ngaokrachang, who made his first film, *The Miracle Incident*, in 1955. His (and Thailand's) first feature was *The Adventures of Sud Sakorn* (1979). He spent much of his time teaching animation. Other animation in Thailand came from offshore studios that attempted to develop the industry further, but with a small domestic market there is an emphasis on reaching a wide audience when producing animation for film or **television**.

In the Philippines, the majority of animation was produced for foreign companies though there was some interest in homegrown television advertisements and **shorts** in the early 1950s. In the early 1980s, several foreign studios, particularly from **Australia** and the United States, established facilities in the Philippines, but while they produced several popular television series, the industry has never been consistent in its production.

While India's animation is not as well known as its live-action film industry, there have been many developments since the 1950s when it has been suggested the "modern" industry began with the formation of the Cartoon Film Unit of the Ministry of Information Films Division. One of the key animators of the division is Ram Mohan, who worked there from the mid-1950s until the late 1960s, going on to form his own studio, Ram Mohan Biographics, in 1972. His studio provided training for new artists and later merged with United Studios Ltd. forming UTV Toons. The industry was slow to develop, though, until the 1990s when small independent companies began to emerge. Broadcasting networks **MTV** India and **Cartoon Network** India encouraged the growth of the market for Indian animation, aided by the increasingly adept workforce in digital technology. The increase in animation production for an international market was fueled by several small studios such as Pentamedia and Toonz Animation India. Two key figures in the contemporary industry are Cyrus Oshidar and Arnab Chaudhuri, who are often commissioned by companies to create innovative short works using a variety of animation techniques.

ASSOCIATION INTERNATIONALE DU FILM D'ANIMATION
(ASIFA). The Association Internationale du Film d'Animation, or International Animated Film Association, was founded in 1960 in Annecy, **France**, by the most famous animation artists of the time, including **Norman McLaren**. Today the association has more than 30 chapters all over the world. The association was founded in the belief that the art of animation can be enriched and developed through close international cooperation and the free exchange of ideas, experience, and information among all concerned with animation. It describes the art of animation as "the creation of moving images through the manipulation of all varieties of techniques apart from live action methods" (ASIFA website).

The worldwide association establishes communication and promotes and disseminates knowledge of animation. ASIFA organizes meetings, conferences, and assemblies, and publishes bulletins, reports, and studies. It grants patronage to **festivals** to provide support for international exchanges. The membership consists of artists, writers, directors, distributors, studio personnel, theorists, scholars, critics, students, and those who have made a substantial contribution to animation. The members pay annual dues, and there is an executive board and general assembly.

ASTÉRIX. Created by René Goscinny and Albert Underzo, Astérix is the lead character in a series of extremely popular books and comics in **France**. The series first appeared in the magazine *Pilote* in 1959 and after a slow start and a move to production in longer forms, the series took off. Astérix is described as a "feisty Frenchman" living in the Roman-occupied France. He has been compared to **Popeye** in terms of his appearance as relatively diminutive but possessing great strength, though in Astérix's case it is the result of drinking a magic potion rather than eating spinach. He is aided by his large friend Obélix, who was said to have fallen into the potion and became superstrong as a result. They try to protect their peaceful village from Roman invaders, and the **comedy** is in the form of visual gags and puns. In 1967, an animated **adaptation**, *Astérix the Gaul*, was made. The film was originally intended for **television** but was eventually

shown in cinemas. Another adaptation was released in 1968, *Astérix and Cleopatra*. Over the next 20 years, several animated adaptations were made, though it has been said that they were not as high quality as the original books, lacking "vibrancy." In 1999, a live-action adaptation was made, *Astérix et Obélix contre César*, and this was followed up in 2002 with *Astérix et Obélix: Mission Cléopâtre*, largely featuring the same cast. The success of Astérix in France has been phenomenal, to the extent that a theme park, Parc Astérix, was opened in 1989 outside Paris. Though never as successful outside France, Astérix is a good example of an adaptation that has essentially transcended the medium it was originally conceived in.

ASTRO BOY. *Astro Boy* was the first animated series on Japanese **television**. The **science fiction** series was directed by **Osamu Tezuka**. The series was based on Tezuka's **manga** *Tetsuwan Atom* from the 1950s and **adapted** for television. It ran from 1963 to 1966 (193 episodes) and was stylistically very influential in the West and in **Japan**. In order to fulfill the demands of the television schedule, Tezuka used **limited animation** techniques and developed a particular style that has been widely used in **anime** since. The series was originally broadcast in black and white, and in 1982 a new color version was made with 50 episodes produced. The main character, Atom, is a robot boy who was created by a scientist to replace his son who had died. He takes on the role of a superhero endowed with seven powers, including "100,000 horsepower," powerful searchlight eyes, lasers in his fingers, and super hearing as well as a heart and soul that he uses to help humans in peril. The series was shown around the world, dubbed into English in the West, and has remained popular since its first appearance. A new **feature-length** film of *Astro Boy* is planned for release in 2009 and is said to be animated using **computer-generated imagery** (CGI).

AUSTRALIA. *See* AUSTRALASIA.

AUSTRALASIA. Despite Australian cinema being one of the world's first with the first live-action feature in 1906, the animation industry did not emerge until World War I with the production of political **shorts** by Harry Julius, using cutouts. There were animators working

in the 1920s and 1930s, though little evidence of their work remains, with the exception of Eric Porter, considered to be the father of Australian animation. He was impressed by **Mickey Mouse** and began producing animated advertisements while trying to develop animation for the cinema. He began his first major work, *Waste Not, Want Not*, in 1938 but was disrupted by World War II and could not distribute it until after this period; during the war, he made **propaganda** films. Porter continued to try and develop an animation industry but it was not until the 1950s that any progress was made. Eric Porter Productions made programs for **U.S.** and Australian **television** as well as advertisements. In 1972, he produced the first Australian **feature-length** animation, *Marco Polo Jr. vs. the Red Dragon*. The film had mixed reactions from audiences and critics. Unfortunately, the studio was not successful in the long term and had to close down. Despite this lack of success, Porter was a key figure in helping establish the Australian animation industry and training new animators.

One of the largest studios in Australia was **Hanna-Barbera** (HB) Australia, which was founded in 1972. The satellite company produced 25 percent of the overall global output for HB and developed the **advertising** market. Air Programs International was founded in the 1960s by Walter and Wendy Hucker. In 1966, it released *King Arthur and the Square Knights of the Round Table*, a 39-episode series, which was the first Australian animated television series. In 1969, the studio released an **adaptation** of Charles Dickens' *A Christmas Carol*, which led to a series of English classics. The studio also produced episodes of the series *Funky Phantom* for HB before it established its Australian studio. Burbank Film produced adaptations for the cinema in the 1980s, such as Charles Dickens' *The Old Curiosity Shop* and *Oliver Twist*. Other studios of note include Film Graphics, Graphic Animation, Raymond Lea Animation, and Second Banana Film. Studios that concentrated on small projects and television productions during the 1970s and 1980s were Jollification **Cartoon**, Fable Films, Nicholson Cartoon Productions, and ATAM Animation Studios.

As well as the studios, there were several independent animators of note, including Bruce Petty, who began his career as a comic-strip artist in London. On return to his home, he developed an interest in animation; among his best-known films are *Leisure* (1976), which won an **Academy Award**, *Karl Marx* (1977), and *The Movers*

(1986), which was a mixture of live action and animation. Denis Tupicoff began by releasing shorts and making animated advertisements. His first film was *Please Don't Buy Me* in 1976, and in 1983 he released his most successful film, *Dance of Death*. Other animators working in this period include Max Bannah, Bruce Currie, David Johnson, Lee Whitmore, Sonia Hofmann, Julie Cunningham, and Pamela Lofts. Experimental artists of note are Dusan Mareck, Albie Thomas, and David Perry.

Animation in New Zealand began with the New Zealand Film Unit (NFU) in the 1940s, a state producer of documentaries and short films intended to promote and document New Zealand culture, similar to the **National Film Board of Canada** (NFB). Animators of note who began there were Robert Morrow from Scotland (who had moved to New Zealand) and Fred O'Neill, who produced several films before going on to make a series for New Zealand national television.

In the 1960s, the television and advertising markets grew, with Sam Harvey, Texan-born John Ewing, and Tom Rowell leading the field. Animation production took off in the 1970s, and Murray Freeth found success on the international **festival** circuit with *The Boy Who Bounced* in 1978 and again in 1986 with *Number One*.

New Zealand's animators were often inspired by the native Maori culture, with Joe Wylie, Susan Wilson, and Nicki Dennis all creating films featuring Maori philosophies and imagery. Independent animators Murray Reece, Robert Jahnke, and Mark Winter found success in the 1980s and early 1990s featuring a variety of subjects. The first New Zealand feature-length animation was Murray Ball's *Footrot Flats—The Dog's Tale* (1986), based on his newspaper comic strips. The film was very financially successful though it had to be produced in Australia due to a lack of facilities in New Zealand. Larry Nelson and Robert Stenhouse of the NFU both found success in the 1980s, particularly Stenhouse, whose 1986 film *The Frog, the Dog and the Devil* was nominated for an Oscar. It was one of the last animated films to be produced by the unit. The NFU was privatized in the 1990s and in 1999 was purchased by live-action filmmaker Peter Jackson. A new facility was built and named Park Road Post in 2005, which holds the NFU archive, though most of the work is in postproduction and in terms of animation, generally **computer-generated imagery** (CGI) used for visual effects in live-action films.

AVERY, TEX (1908–1980). Fred "Tex" Avery, a Texas native, perhaps one of the most well-known animators of the so-called Golden Age of studio animation, was renowned for his work at a variety of studios and made his mark at each one. Avery began his career as an inker and painter for **Walter Lantz** at Universal Pictures in the early 1930s and moved quickly up to the position of animator. After losing his job at Universal in 1935, he joined **Leon Schlesinger** at **Warner Brothers**, a position he is probably best known for. He began working on the *Merrie Melodies* series and then started to develop *Looney Tunes*. In 1935, the character of Porky Pig was debuted in *I Haven't Got a Hat*, after which he developed the character into a star and redesigned him.

Avery preferred to include "impossible and unreal situations" in his gags and wanted to challenge the ideas of **cartoons** established by **Walt Disney**. The situations and gags became more unreal as he continued working on the *Looney Tunes* series and his style became distinctive. He introduced Daffy Duck in 1937's *Porky's Duck Hunt*. After developing his **comedy** in *Looney Tunes*, he was promoted to director of the *Merrie Melodies* series in 1937.

Avery used burlesque in *Uncle Tom's Bungalow* (1937) and *Little Red Walking Hood* (1937), and most of the films he made between 1938 and 1941 were burlesque. After 1938, he began making parodies of travelogues and **documentaries**, live-action **shorts**, and movies. The gag was the most important thing to Avery; the quality of animation was irrelevant. However, by 1940, this was catching up with him and as the quality in other work in the studio improved, the lack began to show up in his films. Despite this, in 1940 he directed the **Bugs Bunny** film *A Wild Hare*, which, after several attempts by other animators, essentially settled Bugs' design and character. The film was slower than his previous Warner Bros. cartoons and, with better animators in his unit, the quality of the films improved, though the pace was slower throughout his work and it seemed that he was holding himself back.

In 1941, Avery left Warner Bros. and went to work at **Metro-Goldwyn-Mayer** (MGM), where his unit had several ex-Disney employees. His third MGM film was *Red Hot Riding Hood* (1943) and, though controversial, was very popular, to the point that in 1945 he made three more *Red* cartoons. He introduced the character of

Screwball Squirrel in 1944, which he hoped would be a star. By his third year with the studio, Avery was beginning to assert himself and his influence was seen in the *Tom and Jerry* series. His pace once again picked up in 1946, and in *Slap Happy Lion* (1947) he had returned to his distinctive style, which was even more evident in *King Size Canary* (1947). However, Avery seemed to be uncomfortable with collaboration and took some time off. He returned to MGM in 1951 and his work showed an influence from **United Productions of America** (UPA). Though he took a sabbatical between 1952 and 1953, he left MGM in 1953 when it closed the animation division.

In 1954, Avery rejoined Walter Lantz, this time at Lantz's own studio, and elevated the studio's reputation, writing and directing *Crazy Mixed Up Pup*, which was nominated for an **Academy Award**. After making four films, he left Lantz in 1955, after which he began to make commercials. He briefly worked with his old MGM colleagues **William Hanna** and **Joe Barbera** at their own studio in the late 1970s but little has been documented about this period. He died in California in 1980.

– B –

BAKSHI, RALPH (1938–). American animator (born in Palestine, his family migrated to New York after World War II) who is perhaps best known for *Fritz the Cat* (1972). Bakshi was hired by **Terrytoons** (under CBS ownership) in 1956 at the age of 18, where he worked his way up in the studio from **cel** polisher to animator to director, until he became studio supervisor. In 1966, he revived the old Terrytoons character Mighty Mouse and featured him in *The Mighty Heroes* series, which lasted for 26 episodes. In May 1967, he moved to the ailing **Paramount Cartoon Studios** where he took over production of their *Spiderman* series, but the studio was already in trouble and closed in December that of year.

Bakshi's approach to the classic **cartoons** was subversive and satirical and reflected the counterculture he had become interested in, which would be seen in his adaptation of Robert Crumb's underground comic "Fritz the Cat." The film was the first X-rated animated feature, and despite the criticisms against the drugs and

sex in the film, Bakshi was pleased that the reaction was against the content and not the animation. He followed up the success of *Fritz* with two similarly themed films, *Heavy Traffic* (1973) and *Coonskin* (1975). In 1977, he **adapted** the J. R. R. Tolkien novel *The Lord of the Rings* (1977), which featured the use of the **rotoscope** along with his stylized **cel** animation.

In 1988, Bakshi once again revived Mighty Mouse, this time in *Mighty Mouse, The New Adventures*, of which he directed four episodes. He continued producing animation for **television** and cinema; in 1992, possibly following the success of the live-action/animated feature *Who Framed Roger Rabbit* (1988), Bakshi directed *Cool World*, which followed the live-action animated crossover. Despite an impressive cast, the film was not very successful at the box office. Since then, he has produced numerous animations for television and in 1994 directed the live-action TV movie *The Cool and the Crazy*. He has also created animated **shorts** for the **Cartoon Network**. Bakshi's first film in 11 years, *Last Days of Coney Island*, was said to be in production in 2008, though its future is unclear according to Bakshi's own website due to funding problems.

BALLET MÉCHANIQUE. This 1924 film by **French** artist Fernand Léger is an example of **fine art** animation, here using a combination of techniques including full animation, painting directly onto film, and **Georges Méliès**–like special effects, as well as live action. It has been suggested that the film was intended as a statement about "making art works which foregrounded their own artifice and used objects as a challenge to the machine culture and consumerist ethic of the modern industrial environment" (Wells, *Animation*, 2002, 117). It was one of the earliest examples of the use of film and animation as an art form.

BARBERA, JOSEPH (1911–2006). Joseph Barbera was a New Yorker who began his career with the **Fleischer brothers** painting and inking **cels**. Finding little chance of advancement, he moved to **Van Beuren** as an in-betweener but showed great enthusiasm for **comedy** and skill in creating gags. When Van Beuren's studio closed, Barbera moved to **Paul Terry**'s studio until 1937, at which time he moved to **Metro-Goldwyn-Mayer** (MGM) to work at the new

animation division. Barbera started in the story department and was found to have a great ability to sketch comedy ideas. He began working with **William Hanna** at MGM in a partnership that would last until they died. Joe's comedy writing and animation complemented Bill's sense of timing and together they created *Tom and Jerry*, which first appeared in their debut film *Puss Gets the Boot* (1940). The series earned them several **Academy Award** nominations over its 15-year run and won seven (their first for *Yankee Doodle Mouse* in 1943). They produced their last run of *Tom and Jerry* **cartoons** in 1955 and 1956, including some of their best.

In 1957, MGM closed and Joe and Bill decided to continue their partnership and open their own studio. **Hanna-Barbera** became one of the most successful studios and concentrated on producing animation series for **television**, which was becoming increasingly popular. Together they created and produced *Yogi Bear*, *Huckleberry Hound*, *The Flintstones*, *The Jetsons*, *Top Cat*, *The Hair Bear Bunch*, *Wait 'til Your Father Gets Home*, and *Scooby Doo*, among many others. They were also responsible for the first prime-time animated **sitcom** with *The Flintstones* and helped develop the new genre in animation that would be successfully developed in the 1990s with *The Simpsons* and others.

They sold the studio to different companies over the years but always maintained a controlling interest, and Barbera was largely involved in the design of most of the characters; until his death in 2006, he was involved in the production of animation for the studio (though under Warner Bros. at that time).

BARRÉ, RAOUL (1874–1932). A Montreal native, Raoul Barré moved to New York in 1903, where he began his career as a painter and **cartoonist**. Between 1912 and 1913, he collaborated with William C. Nolan to produce and direct animated **advertisements**. When they set up their own studio, they were joined by other animators including Gregory La Cava, Frank Moser, and **Pat Sullivan**.

Barré was innovative in creating systems to aid animators on their work and introduced the use of standard perforations in drawing paper that provided registration, as well as introducing the **slash system**, also known as the slash-and-tear system. This system used a drawn background laid over another sheet that contained the moving

elements with a space cut out so the images on the sheet underneath could be seen. Done in progressive phases of movement with any figures that moved requiring retracing, the backgrounds could be re-used, saving time and the work of having to retrace every image. The system was used at several studios throughout the 1920s and worked as a variation of **John R. Bray**'s method of overlaying images on cels or translucent paper.

In 1915, Barré produced *The Animated Grouch Chasers*, distributed by Thomas Edison, and combined live-action film clips with animated sections. Barré was commissioned in 1916 by the International Film Service to film seven fables based on the T. E. Powers comic strips. In the same year, Barré worked in partnership with Charles Bowers to produce an animated version of "**Mutt and Jeff**," Bud Fisher's newspaper comic strip.

Barré left the studio in 1919 and created *Soda Jerks* in 1920. He later returned in 1926–1927 to animate *Felix the Cat* for Pat Sullivan. After this period, Barré moved back to Montreal, where he lived until his death in 1932.

BATCHELOR, JOY (1914–1991). British-based animator who founded the Halas and Batchelor studio with John Halas in 1940. Batchelor's father was a lithographer and encouraged her drawing skills as a child. Despite some difficulties in her childhood, Batchelor won a school scholarship, which helped with her ambition to become an artist, attending art school in Watford. Her studies were successful but due to a lack of money she was unable to continue and instead began to work. She took a job with a new animation studio in-betweening and within a week was promoted to animation. She worked well in the company for three years until it closed, after which she found work at a printing company as a poster designer. She remained with the poster company for six months before answering an advertisement for a new animation company and met John Halász (later Halas).

After a short trip to John's native Hungary, they returned to Britain where in 1940 they founded Halas and Batchelor **cartoons**, and later married. The studio was essentially taken over by the Ministry of Information during the war, creating **propaganda** and information films. By the end of the war, Batchelor's involvement in the studio,

which had been equal with Halas, was lessened by the birth of her first child. When their second was born in 1949, they were able to get help and Joy was able to return to work.

In the 1950s, the studio began work on *Animal Farm* (1954), which became one of its best-known films as well as Britain's first **feature-length** animation. The pair continued developing techniques and produced a variety of films throughout the 1960s and 1970s, including some very early computer animation.

As Batchelor got older, her health deteriorated with arthritis, which prevented her from drawing. Instead, she taught animation at the London Film School and was governor until she died in 1991.

BEAVIS AND BUTTHEAD. Animated **television** series created by **Mike Judge** based on a 40-second **short** entitled *Frog Baseball* that Judge had made in 1992. Early shows were animated by **J. J. Sedelmaier Productions**. The television series ran for four years, from 1993 until 1997, on the **Music Television** network MTV, but with a running time of only 15 minutes the show was neither classed as a short nor as a **sitcom**. The show featured two teenage boys, Beavis and his friend Butthead. The pair first appeared in *Frog Baseball*, using a frog in place of a ball, and the series followed similar exploits. The narrative was largely absent in early episodes that saw the titular lead characters watching a music channel and commenting on the "live" videos shown in a particularly monosyllabic style. The show featured a number of supporting characters, including Tom Anderson, who was an early version of Hank Hill and who would later feature as the lead character in Judge's animated sitcom *King of the Hill* (1997–). The character of Daria, Beavis and Butthead's classmate, starred in a spin-off series, *Daria*, which ran from 1997 until 2001 and had a longer running time of 22 minutes.

Despite the late time slot on a cable channel, the show was said to be a bad influence on children who were alleged to have attempted to copy some of the characters' antics. Butthead's love of fire was of particular concern to some people who complained about the show. The series included a disclaimer at the start of the episodes that stated that the characters were animated and that their behavior should not be copied. The series was later adapted to a **feature-length** version, *Beavis and Butthead Do America* (1996), though this was the last

production featuring the pair before Judge moved on to *King of the Hill.*

BEGONE DULL CARE. Directed by **Norman McLaren** and **Evelyn Lambart,** *Begone Dull Care,* released in 1949, is an interpretation of jazz music by the Oscar Peterson Trio, with a running time of 7 minutes 40 seconds. The images were painted directly onto film in an excellent example of **cameraless animation.** It was created by the pair when they were at the **National Film Board** (NFB) of Canada and demonstrates the kinetic qualities of the sound and studies the nature of movement. The film was made by recording the soundtrack and then cutting lengths of film to match the music. In 1950, Norman McLaren won a Special Award at the Canadian Film Awards, and in 1951 both animators won the Silver Plaque at the Berlin Film **Festival** for Best Documentary/Cultural Film.

BELGIUM. *See* WESTERN EUROPE.

***BELLEVILLE RENDEZVOUS* (LES TRIPLETTES DE BELL-VILLE).** *The Triplets of Belleville* (English-language title, 2003) is the first animated feature from French animator **Sylvain Chomet.** Chomet, who is also a comic book artist, made the film in Montreal over a period of five years; after distribution in over 33 countries, the **feature-length** film was nominated for an **Academy Award** for Best Animated Feature and Best Song.

The film, 80 minutes long, is largely without dialogue and evokes strong emotion throughout. The plot features a small older lady with a club foot named Madame Souza, as she prepares her orphaned grandson, Champion, to be a world champion cyclist by supervising his strict training regimen. During the mountain stage of the Tour de **France,** Champion is kidnapped by men from the French mafia and taken across the Atlantic to the city of Belleville (which is constructed as a mixture of New York, Montreal, and Quebec). Madame Souza and her beloved dog Bruno travel across the ocean to rescue Champion and are assisted by a song-and-dance trio, the elderly Belleville Sisters.

The hand-drawn animation gives the film a sense of history as it evokes the style of much older animation, but this adds to the atmosphere of the story. There are parodies of both the French and the

Americans in the film, and Chomet pays homage to French comedian Jacques Tati. The film was well received internationally.

BETTY BOOP. Betty Boop is an enduring character created by the **Fleischer brothers** that was particularly popular in the early 1930s but has remained an iconic character long after the films ceased production. The character was very successful even though her design changed several times between 1930 and 1932 due to a lack of a permanent story department at the studio. Betty was animated with a sense of **realism** by Grim Natwick, who was a specialist in female characters and was particular about anatomy. Her design was based on the fashionable 1920s flapper girl of the jazz era. She had sex appeal with a pout, large eyes, a short flapper-girl hairstyle, and a short strapless dress that revealed a garter belt. In the original drawings, Betty was more of a human–dog hybrid similar in style to many of the other **silent era** stars. However, over time she became more human, and while she had a childlike innocence, would at the same time dance in a sexy way. Betty originally had a companion, the Fleischers' other big star **Koko the Clown**, but he was later replaced by a puppy named Bimbo. Her most famous films were *Minnie the Moocher* (1932) and *Snow White* (1933). These films both used **rotoscoping** to animate the characters, particularly the dancing scenes. In 1935, complaints from small-town cinemagoers led to censoring her clothing, so her skirt was lengthened and she became more demure and domestic in her behavior. The series of films ended in 1939, though her image has remained popular.

BIRD, BRAD (1957–). Born in Montana, Brad Bird is an animator and director who began his career in 1981 on **Disney**'s *The Fox and the Hound*. Bird followed this experience by going to work with Steven Spielberg on his *Amazing Stories* series in 1985. Bird worked extensively on the **television** animated **sitcom** *The Simpsons* and on *The Critic*. He was also a consultant on **Mike Judge**'s *King of the Hill*. His first **feature-length** animation was *The Iron Giant* in 1999. Though the animation was of a very high quality, the film was not successful at the box office. His next feature film, *The Incredibles* (2004), was produced by **Pixar** and was very successful both finan-

cially and critically, with Bird winning his first **Academy Award** for the film in the Best Animated Feature category in 2005.

BLACKTON, JAMES STUART (1875–1941). Born in Sheffield, England, Blackton moved to New York at the age of 10 where he later worked as a journalist and illustrator. He interviewed Thomas Edison after seeing a demonstration of the vitascope, one of the earliest film projectors. Edison was impressed by Blackton's drawings and made the **cartoon** film *Blackton, the Evening World Cartoonist* (1896). Blackton bought a kinetoscope from Edison and set up the Vitagraph Production Company in New York with Albert E. Smith and later William T. Rock. They made and acted in films together and found success with a variety of types including **comedy, adaptations** of William Shakespeare and Charles Dickens, and coverage of local events. They moved to a purpose-built studio in Brooklyn where Blackton pioneered his stop-frame animation technique with which he produced one of his most famous films, and one of the earliest animated films, ***Humorous Phases of Funny Faces*** (1906). He also developed editing and filming techniques to aid their production. Blackton's other films using similar techniques include ***The Enchanted Drawing*** (1900) and *Haunted Hotel* (1907). Blackton essentially created trick films using **stop motion** to give his "lightning" drawings the appearance of movement as well as mixing live action with animation; he often used a magic lantern in his shows.

In 1917, Blackton left Vitagraph and formed his own company to make patriotic films. He returned to England and directed live-action costume dramas. Blackton was still as great a showman as he had been when "demonstrating" his animation, but the technology in filmmaking had developed beyond his abilities. He moved back to the **United States** in 1923 and directed several more films, but when **Warner Brothers** took over Vitagraph in 1926 he retired. Unfortunately, Blackton lost his money in the 1929 stock market crash and was forced to return to work, ending his career at the Anglo American Film Company before he died in a car accident in Hollywood in 1941.

BLUTH, DON (1937–). Born in El Paso, Texas, Don Bluth began his animation career with the **Disney Studio** in 1956 when he joined the

studio as an assistant to John Lounsbery. During this time, he worked on *Sleeping Beauty*. He remained in this role for a year and a half, after which time he took a break from animation for 10 years. After this fairly lengthy hiatus, Bluth joined **Filmation** in 1967 as a layout artist. In 1971, he was rehired at Disney, where he worked on *Robin Hood* (1973), *The Many Adventures of Winnie the Pooh* (1977), and *The Rescuers* (1977) and was animation director on the live-action and animated *Pete's Dragon* (1977). Bluth was developing a **television** series, *Bango the Woodpile Cat*, but the studio ignored his efforts. In 1979, he complained of what he and many other artists perceived as a decline in the quality and the traditional values of the studio (as well as lack of support for his own projects). Along with many colleagues, he left the studio and formed his own independent production company.

Bluth's first independent film was *The Secrets of Nimh* (1982) and in the same year he produced his *Bango* series. Bluth also expanded his interests by working on animation for the video games *Dragon's Lair* (1983) and *Space Ace* (1983). His next feature was a coproduction with Hollywood director Steven Spielberg, *An American Tale* (1986). Following this success, they were joined by George Lucas to produce *The Land before Time* (1988) when Bluth moved to Dublin to reduce production costs. The relationship with Spielberg and Lucas was volatile and Bluth continued to produce work on his own. *All Dogs Go to Heaven* (1989) marked a decline in Bluth's successful run and his following films—with the exception of *Thumbelina* (1994)—*Rock-a-Doodle* (1991), *A Troll in Central Park* (1994), and *The Pebble and the Penguin* (1995) lacked the appeal of his previous films and Bluth left during the production of *The Pebble*, which has no director credit.

After this, Bluth moved to 20th Century Fox Animation Studios in Arizona. His first film there, *Anastasia* (1997), was successful, though the follow-up *Bartok the Magnificent* (1999) and the expensive *Titan A.E.* (2000) were poorly received. This marked the end for the Fox Animation Studio. In the meantime, Bluth has released books on the production techniques of storyboarding and drawing for animation.

BOUNCING BALL **SERIES.** Popular series produced by the **Fleischer brothers**, the *Bouncing Ball* series of films ran from 1924 until approximately 1938. Sing-along series had been popular in cinemas, but this series featuring **Koko the Clown** as bandleader was the first to bring movement to the format. The early films were framed with Koko but the ball was not animated—it was a live-action film with a Fleischer employee who would use a white luminescent ball on a stick like a pointer to follow the lyrics and tell the audience what to sing. It was used like a drum but the pointer part was invisible and only the ball was seen. The ball was replaced in the second or third chorus with a character hopping over the words with amusing visuals to go with the song. The introductions to the songs also had amusing animated sequences.

The series later incorporated live-action performers such as Ethel Merman and Rudy Vallee who would invite the audience to sing along. The series, known as *Song Car-Tunes* (which lasted until 1926), was relaunched as *Screen Songs* after the studios converted to talking pictures. These were distributed by **Paramount** from 1929 until 1938. *See also* ADVERTISING.

BRAY, JOHN RANDOLPH (1879–1978). American animation pioneer who was dominant in the early decades of the form. Bray was a successful **cartoonist** and illustrator in New York (from 1906 until 1907) and it has been suggested he was inspired by the animation of **Winsor McCay**. Seeing the commercial potential in animation, Bray began experimenting with techniques and made his first film, *The Artist's Dreams*, in 1913. He tried to print the backgrounds rather than draw them by hand to save production time. Pathé, a visiting French film producer, was impressed by the film and offered Bray a six-month contract.

He formed Bray Studios and produced films for commission, including training films for the American government during World War I. After his studio was established, Bray began to hire animators to do the work and he was able to focus on the business. He concentrated on trying to develop the technical aspects of production and applied for several patents, including the use of transparent celluloid

for the backgrounds. However, **Earl Hurd** had already successfully patented a similar technique that was better than Bray's. Rather than compete, Bray went into business with Hurd and formed the Bray-Hurd Patent Company that sold licenses to companies to use the patented techniques and were profitable for the company until the patents expired in 1932.

Bray released the first color animated film in 1920, *The Debut of Thomas Cat*. However, despite the film's success, the two-color technique was too expensive to continue to use. The studio was successful with the series of **Colonel Heeza Liar** cartoons, which began in 1914, and Earl Hurd's *Bobby Bumps* series. In 1917, Bray hired the **Fleischer brothers**, who stayed with the company until 1921. Bray continued experimenting and branched out into live-action **comedies**, newsreels, and educational films. In 1927, he closed the entertainment division to concentrate on the educational films. *See also* CEL.

BRICK FILM. *See* LEGO FILM.

BRITISH BROADCASTING CORPORATION (BBC). The British Broadcasting Corporation is **Great Britain**'s public service broadcaster and, after originating in radio, provided the country's first **television** channel in 1936 (though during the war years the channel essentially closed down until 1953). A second channel was commissioned in 1964 and became BBC2, with the original channel renamed BBC1. As part of its public service remit to "inform, educate and entertain," the corporation included children's programming that featured animation. From the early *Watch with Mother* strand in the 1950s with presenters accompanied with **puppets** such as *Muffin the Mule* (1946–1955), the channel has always provided a platform for, and encouraged the development of, a variety of animated series, including *Andy Pandy* (1950), *The Flowerpot Men* (1952–1954), **Smallfilms'** *Bagpuss* (1976) and *The Clangers* (1969), *Camberwick Green* (1966), and **Bob Godfrey**'s *Henry's Cat* (1982–1993) to name a few. By 1985, the children's strand had been renamed to Children's BBC (CBBC by the mid-1990s), which continued to show animation among other programming in a dedicated time slot. When

the BBC expanded into digital television, the strand got its own channel, which is available during the day.

BUGS BUNNY. The biggest **cartoon** star of the **Warner Brothers** (WB) studio made his first appearance in *Porky's Hare Hunt* (1938) and was directed by Ben Hardaway, and by his third appearance in *Hare-um Scare-um* he had been given his name. The character evolved over time; he was originally a white rabbit but by 1939 was grey. His creation can be attributed to Hardaway as well as **Chuck Jones**, **Tex Avery**, **Bob Clampett**, and **Friz Freleng** who all directed cartoons with Bugs over the years, and his character and design was affected by whomever was making the film.

His initial design was suggested to have been influenced by **Walt Disney**'s Max Hare, and when he first appeared his character was fairly manic with a crazy laugh, similar to the other well-known WB character Daffy Duck, who also changed over the years. Bugs was voiced by Mel Blanc, who made the character famous with his trademark question "What's up, Doc?" In 1940, Chuck Jones directed *Elmer's Candid Camera* and Bugs changed slightly but it was also the cartoon in which the characters' relationships were fully realized, such as Bugs continually tormenting Elmer while he is hunting him. Tex Avery directed his first starring role in *A Wild Hare* in 1940 and made him less of a loony and more mischievous. This film established Bugs Bunny as a star and is often credited as Bugs' first film. The character was also directed by **Frank Tashlin** and Robert McKinson, the latter being the creator of a model sheet for Bugs in 1943 that became the standard for his design. Some of the best films over the years were said to be those directed by Bob Clampett. Bugs' antagonists varied over the years and included Elmer Fudd, the Tasmanian Devil, Yosemite Sam, and Daffy Duck, whom he tormented as the unseen animator in *Duck Amuck* (1953).

Bugs was made part of the war effort in 1944 when Friz Freleng directed an anti-**Japanese** film, *Bugs Bunny Nips the Nips*. His most famous cartoon was *What's Opera Doc?* Chuck Jones' 1957 film featuring Bugs and Elmer in a six-minute version of Wagner's epic opera *Ring Cycle*. Friz Freleng was awarded an **Academy Award** in 1958 for *Knighty Knight Bugs*. By 1960, the theatrical **shorts** were

ending and **television** was becoming the home of cartoons. **American Broadcasting Company** broadcast *The Bugs Bunny Show*, which consisted of a compilation of six-minute films in a half-hour series. Bugs Bunny appeared in 175 shorts over the years, though the WB studio stopped distributing them in 1974; in 1979, he returned in the **feature-length** *The Bugs Bunny and Road Runner Movie*. He also starred in the live-action/animation movie *Space Jam* in 1996 and in 1998 was given the privilege of appearing on a U.S. postage stamp.

BULGARIA. *See* EASTERN EUROPE.

BURTON, TIM (1958–). Burton grew up in Burbank, California, and is perhaps better known as a director of live-action feature films, though he trained as an animator and attended the **California Institute of the Arts** in 1976 on a **Disney** fellowship. He later joined the studio as an animator where he worked on *The Fox and the Hound* (1981) and *The Black Cauldron* (1985). During this time, he wrote the story for *The Nightmare before Christmas*. His directorial debut was the animated **short** *Vincent* (1982), narrated by his childhood hero Vincent Price, and won the audience award at the Ottawa International Animation **Festival**.

Burton made his first live-action short, *Frankenweenie*, for Disney before leaving to direct his first **feature-length** film, *Pee Wee's Big Adventure* (1985). His live-action films have retained a certain graphic visual aesthetic; examples include *Beetlejuice* (1988), *Batman* (1989), and *Edward Scissorhands* (1991). He produced *The Nightmare before Christmas* (1993), directed by **Henry Selick**, and went on to produce Selick's *James and the Giant Peach* (1996). In 2005, he directed the animated feature *Corpse Bride*, which was stylistically similar to *Nightmare*, using the same **stop-motion** technique and echoing some of the gothic imagery in his earlier work.

BUTE, MARY ELLEN (1906–1983). American abstract filmmaker described as a pioneer woman in animation. Bute studied art at the Pennsylvania Academy of **Fine Arts** and then moved to New York, where she learned stage lighting at the Intertheatre Arts School. She attended Yale in 1925 and in 1926 got a place on the ship *Ryndom*, the first floating university, taking in 33 countries in eight months.

The experience left Bute feeling that film was too commercial; she decided she wanted to work in abstract animation, inspired by the work of artists Wassily Kandinsky and **Oskar Fischinger**. She experimented with a variety of techniques and made her first abstract film, *Rhythm in Light*, in 1934. Many of Bute's films were influenced by pieces of **music** and she became very interested in the relationship between line and color as counterparts to compositions in sound. Her filmmaking and painting continued to explore this and she began to use new technologies such as the oscilloscope to create animated patterns. Other films include *Synchrony No. 2* (1935), *Escape* (1938), and a series of **shorts**, including *Spook Spot*, which was animated by **Norman McLaren**. Many of her films were produced by her husband, Tim Nemeth, and in 1965 she made the award-winning *Finnegans Wake* as a reaction to the James Joyce novel; the film was very successful and was shown commercially.

– C –

CALIFORNIA INSTITUTE OF THE ARTS. The California Institute of the Arts or CalArts was the first **U.S.** institution to offer degrees in visual and performing arts. It was established in 1961 by **Walt Disney** through a merger of two professional schools, the Los Angeles Conservatory of Music (founded in 1883) and the Chouinard Art Institute (founded in 1921). CalArts moved to its permanent home in Valencia in 1971. Since its founding, it has been recognized internationally as a leader in every discipline in which it provides instruction. Its faculty and alumni have defined and continue to expand the very forefront of creative practice. Disney's original plans for the school began in 1960 with the founding in 1961. In 1964, it received accreditation from the Western Association of Schools and Colleges and was introduced to the public by Disney in a fund-raiser at the Hollywood premiere of *Mary Poppins*. In 1966, Walt Disney died but his plans continued through his family and benefactors, and in 1969 CalArts accepted its first students and hired its new faculty, including **Jules Engel**, who would go on to provide the first animation courses in the country. In 2006, CalArts became the first U.S. film school to be honored with a full retrospective at the Museum of Modern

Art (MOMA) in New York. Notable alumni include **John Lasseter, Henry Selick, Brad Bird**, and **Joanna Priestly**, among others.

CAMBERWICK GREEN. *Camberwick Green* was part of an inter-related trilogy of **television** series that aired on British television in the 1960s as part of *Watch with Mother*, a children's strand. Created by **puppeteer** Gordon Murray, who had previously been successful at **British Broadcasting Corporation** with *The Woodentops* (1955–1957) and several one-off adaptations of fairy tales, such as *The Emperor's Nightingale* (1958), the series was formed from a pilot he created in 1966. Working with **stop-motion** animators Bob Bura and John Hardwick, the three men produced a series that became iconic in British television animation history, particularly in the use of puppets without visible strings as had previously been seen on television. *The Trumptonshire Trilogy* ran from 1966 to 1969 and comprised *Camberwick Green*, *Trumpton* (1967), and *Chigley* (1969), each set in a different area of the same county. The series featured the lives of the village, town, and industrial hamlet respectively; they focused on the old versus new ways of life in 1960s Britain and were narrated by popular children's television presenter Brian Cant. The series was shown in reruns and though it has not aired for over 30 years, there are still references made to the series, either in **advertisements** or in television drama, demonstrating the longevity of the show.

CAMERALESS ANIMATION. This method of animation is also known as "direct on film animation" and is made by working directly on the surface of a clear, white, or black film or on pieces of "exposed and developed film which [might] contain other images" (Furniss 1998, 40). One of the earliest uses of this technique was by Arnaldo Ginna, who painted directly onto film. Ginna believed that color and form could develop in the same way as musical notes and chords. He suggested that a "chromatic motif"—the progression of color combinations through an animated time sequence—was similar to a "musical motif" that developed through a piece of **music**. Some animators work in this method frame to frame, whereas others use the film as a whole canvas to work on. A wide variety of effects can be achieved from linear, horizontal, and random images that can be drawn, painted, or scratched onto the surface of the film. The method

can be difficult due to the size of the film stock (though larger stock can be used), and the level of detail required is very time consuming. No assistance can be given to the animator in the way that **cel** animation, for example, can be traced by one artist, painted by another, and filmed by yet another.

Examples of this method can be seen in **Norman McLaren**'s *Fiddle Dee Dee* (1947) and *Begone Dull Care* (1949), which he produced while he was at the **National Film Board**. For the latter film, created with **Evelyn Lambart**, he recorded the sound and then cut the film into lengths to match the musical score. He also used this method in *Lines Vertical*, *Lines Horizontal* (1960) and *Mosaic* (1965). **Caroline Leaf** also uses cameraless animation, both scratching and painting onto the film; her film *Two Sisters* (1990) was made by scratching the emulsion from the surface of the film. **Len Lye** created *A Colour Box* (1935) using this method, and experimental filmmaker Stan Brakhage created images by burning the film.

CARTOON. The term *cartoon* has become a ubiquitous name for anything animated but its origins come from print media and earlier types of illustration. The modern style of the cartoon was generally found in newspaper comic strips, often in the form of **political** satire or short gags. The accompanying text was presented as speech bubbles or lines of dialogue below the picture panel.

Many newspaper cartoon strips were used as the basis for early silent animations, and the artists are among the pioneers of animation, such as **John Randolph Bray** and **Winsor McCay**. McCay's "**Little Nemo** in Slumberland" began as a newspaper serial cartoon and thus the artists were known as cartoonists (also included in this group is *The Simpsons'* creator **Matt Groening**, who began his career as a print cartoonist), a term that transferred to those who produced animated cartoons. In the 1930s and 1940s, "cartoon" referred generally to the **short** animated films produced by studios such as **Warner Brothers**, **Metro-Goldwyn-Mayer**, and **Paramount**, rather than the **feature-length** "films" by **Disney**.

The interchangeable term is somewhat problematic in that while it correctly refers to the short **comedy** animation, it has also become aligned with animation for children and assumed as such. Any other animation, such as **abstract**, experimental, or in broadcast media for

an adult audience that is called "cartoon" has a sense of inferiority to other filmic or art forms. This is a historical problem that the industry and scholars have long since attempted to rectify, particularly as technology blurs the definitions between live-action film and animation.

CARTOON NETWORK. Cartoon Network is a cable **television** channel in the **United States**, created by Turner Broadcasting and dedicated to showing **cartoons**, that premiered in October 1992. Ted Turner's cable TV conglomerate had acquired the **Metro-Goldwyn-Mayer** film library that included several old **Warner Brothers** films, and Turner Network had acquired an audience when they purchased **Hanna-Barbera** Productions. Cartoon Network was created as an outlet for this back catalogue of animation. Initially, it was set up as a classic animation channel, and in 1996 Time Warner purchased Turner Broadcasting (TBS), which brought access to the rest of the Warner Bros. library from the 1950s and 1960s, increasing the choice of cartoons they could broadcast.

In 1993, Hanna-Barbera held a storyboard competition with Cartoon Network. The *What a Cartoon!* program was designed to give new animators an opportunity and creative freedom that had not been available since the Golden Age. In 1994, 30 storyboards were chosen for a final competition based on the criteria of originality of concept, character, and humor. Hanna-Barbera would negotiate rights with 10 winners. The short subjects were shown as *World Premier Toons*, and Cartoon Network became a place for opportunity and new animation. Winners include *Dexter's Laboratory* (1996), Genndy Tartakovsky; *Cow and Chicken* (1997), David Fleiss; *Jonny Bravo* (1997), Van Partible; and *The Powerpuff Girls* (1998), Craig McCracken. All of these shows enjoyed associated merchandising and a level of fame unseen on television for a number of years.

The channel branched out with international versions including **Great Britain**, **Japan**, **India**, and Latin America, showing similar cartoons and a block "Toonami" featuring **anime**. A spin-off channel, Boomerang, began to show the older cartoons that the Cartoon Network started with as they were filling their schedule with newer animation. A late-night block **Adult Swim** began in 2001 to show-

case new animation that was not suitable for children, as it had been recognized that there was an adult market for animation.

CEL. Cel or celluloid is the use of a transparent substrate to create and film animated movement; the term is now shorthand for traditional two-dimensional (2D) drawn animation. The earliest forms of animation of the lightning sketch and **stop motion**, such as **J. Stuart Blackton**'s *The Enchanted Drawing* (1900), led to an increase in animators, largely former comic-strip artists, developing techniques to produce moving, animated images. One of the most famous animators of this early period was **Winsor McCay**, who would produce thousands of drawings on rice paper, a very thin paper on which he would create his animations. Each of the pages would feature the character with slight changes in position that, when filmed, would have the appearance of movement. A good example of this can be seen in *Gertie the Dinosaur* (1916) in which McCay combines drawn animation with stop-motion techniques.

Animators in the early days of the industry worked to speed up the production process and in doing so developed new techniques. In 1914, **Earl Hurd** applied for a patent on a process called celluloid, or cel, animation. This involved a stationary background painted onto paper with characters painted onto various layers of celluloid, a transparent substrate, that would be laid on top. The process saved time as previous methods had involved all of the elements drawn onto translucent paper that was laid over others. Hurd's use of celluloid was developed further by **John R. Bray**, who in 1916 patented a similar technique but instead painted the background on celluloid as well. This enabled the characters to move behind images in the background as well as in front of them.

Other animators tried to improve on this method but it has remained largely the same since 1916. This standard was generally used in what was becoming an emerging industry. The only changes in the technology were improvements in the registration process, but the cel itself remained essentially unchanged.

Cel has become one the most recognizable and widely used (mainstream) forms of 2D animation, popularized by the success of **Disney**, **Warner Brothers**, and **Metro-Goldwyn-Mayer** (MGM),

as well as other studios in the 1930s and 1940s, such as those of the **Fleischer brothers**, **Terrytoons**, and **Walter Lantz**. Cel animation was originally exhibited in short format before **feature-length** films or in packages with other **shorts**, but with the development of the medium and industry it has become popular in both feature-length animation released theatrically in its own right and, since the 1950s, in **television**. Popular examples of cel animation in short form are the Warner Brothers' *Looney Tunes* and *Merrie Melodies* series and MGM's *Tom and Jerry* series, though all shorts from the 1920s onward were produced in this way.

In feature animation, Disney pioneered the use of the **multiplane** camera that could provide a depth of field to the flat cels. Though tested in *The Old Mill* (1937) and developed in various forms by other animators, Disney's first feature, *Snow White and the Seven Dwarves* (1937), utilized the multiplane and revolutionized the scope of what cel animation could look like. The film's success also paved the way for more feature productions of cel animation from competing studios.

The form has developed over the years from the original, fairly slow method of painting on the cels to more recently using digital technology to produce and print the images onto the cels, as well as photograph them. The technology has allowed the form to be produced with more detail in the images and with better flow between the frames.

Newer examples of cel animation using digital technology include television series *Futurama* and the feature-length movie by **Brad Bird**, *The Iron Giant* (1999). The images still take on the same appearance as their earlier counterparts, with the cel animation becoming a style more than a production method. In the case of *The Iron Giant*, the film has a historical narrative and therefore the animators deliberately colored the animation to give it an older appearance of an original "cel" animated film.

The benefit of using the digital technology to produce something that has the appearance of the traditional is thus recognizable, familiar, and widely accepted by audiences. Digital technology, although expensive (though the cost is always coming down), enables the animator to produce the film more efficiently. The drawings are often still made initially by hand and then scanned or drawn on computer,

but the images can be manipulated quickly and different poses can be tried without having to redo all of the original images.

Many animators continue to produce 2D animation either fully hand-drawn such as **Sylvain Chomet**'s *Belleville Rendezvous* (2003), or using a mixture of digital and traditional cel techniques, as preferred by the **Japanese** animation **Studio Ghibli**.

CENSORSHIP. The introduction of the Production Code Administration (PCA; also known as the Hays Code) in the **United States** in 1934 was the beginning of censorship in the American film industry. The code outlined suitable content for motion pictures and could affect the content of a film or stop distribution if the film failed to meet the standards.

Precode animated **cartoons** included drawings of sex (implied and otherwise), drug usage, nudity, swearing, stereotypes, homosexuality, extreme **violence**, toilet humor, and gags that were considered to be in very bad taste. Live action was essentially the same at this point, though there are indications that when the code first emerged the animations were looked upon as less consequential than the live-action films, as there was an assumption that the animated status (and inherent lack of **realism**) made the films relatively harmless.

A comparison of pre- and postcode shows the effects of the censorship, the lengthening of **Betty Boop**'s skirt being one notable example. *Snow White and the Seven Dwarves* (1937) was not subject to as much censorship in the United States as it was in other countries—for example, **Great Britain** gave it a "16" certificate and in **Australia** sections of the film were cut out. The **Disney Studio** had little trouble with censors, though it self-censored a lot of its work. However, in *Fantasia* they were instructed to cover the centaurs' bodies, despite their mythical origins, and there were problems with the language in *Song of the South* (1946).

Broadcast standards in **television** deal with such areas of concern as violence, sexual content, issues of replication, offensive language, and suitability for family viewing. **Ralph Bakshi**'s series *Mighty Mouse: The New Adventures* (1987) fell foul of the censors for a scene in which the lead character sniffs a crushed flower and gets pollen on his nose. Television watchdogs suggested that this connoted drug use and led to the scene being cut from future airings. **John Kricfalusi**'s

Ren and Stimpy series was accused in 1991 of being "outrageous" and "raunchy," though he refused to self-censor and was fired from his own show. The long-running animated **sitcom** *The Simpsons* is occasionally censored—often depending on what time of day it is broadcast, as it is repeatedly rerun. The computer-generated *Reboot* was not allowed to show characters in "jeopardy," and there are strict guidelines on showing nudity or guns.

1960s **Japanese** cartoons were sanitized in order to be shown on U.S. television in the 1970s, with censors more concerned about the language and sex than violence in the animation. Content regulation became stricter in the 1980s with increasingly conservative **politics** within the Federal Communications Commission (FCC) and pressure from religious and parent groups. In **China**, the Cultural Revolution essentially closed down production of animation altogether until 1976, after which animation studios were free to produce creative animation such as A Da's *One Night in an Art Gallery* (1978), which caricatured the infamous "Gang of Four."

Elsewhere, in **Eastern Europe**, **Jiri Trnka**'s film *Ruka (The Hand*, 1965) was a commentary on state censorship and a feature of many of the films produced in Eastern Europe and Russia. Many of the countries in Eastern Europe and the **Soviet Union** had state-sponsored production companies. As a result, no criticism of the government was allowed in the animation and the producers had to practice a form of self-censorship, though some animators used subversion to include satirical messages. Czech animator **Jan Svankmajer** moved to Great Britain so he could produce films free from the censorship of his native government. *See also* PROPAGANDA; VIOLENCE.

CHANNEL 4. Founded in 1981 after parliamentary legislation gave a license to a new public service channel on British **television**, the channel included the public service ethos but was funded by **advertising**. The main aim of the channel was to encourage innovation and experimentation and commission programming from outside companies. Channel 4 began broadcasting in 1982 and the animation it showed was largely aimed at an adult audience. The channel deliberately tried to differentiate itself from the other three channels on British television at that time, and animation for adults was rarely seen. Channel 4 was instrumental in the production of some

remarkable films of the 1980s from the works of David Sproxton and Peter Lord of **Aardman**, those of the **Quay brothers**, and Jimmy T. Murakami's *When the Wind Blows* (1986) to Alison De Vere's *The Black Dog* (1987).

After the success of Sproxton and Lord's films, the channel went on to commission the animated adaptation of Raymond Briggs' *The Snowman*, which first aired on Boxing Day 1982 and has aired virtually every Christmas period since. In the mid-1980s, it funded more and more animation from the Quays, in particular *Street of Crocodiles* (1986), and incorporated Candy Guard's work into a current affairs documentary.

In 1989, Channel 4 appointed a full-time commissioning editor for animation, Claire Kitson, and set up the Animate! initiative in partnership with the Arts Council of England. This quickly reinforced the channel's reputation as an innovative animation broadcaster, and gained international acclaim by sponsoring animators' work, including **Nick Park**'s *Creature Comforts* (1989) and *Bob's Birthday* (1993) by Alison Snowden and David Fine. It also began to commission new work from foreign talent, including **Jan Svankmajer**.

In 1994, the animation budget was increased and a number of animated series appeared on the channel, including *Crapston Villas*, *Bob and Margaret*, and *Pond Life*. Kitson left in 1999 and her position was not replaced, with animation coming under the remit of the commissioning editor for arts and music; as a result, the animation became a marginal concern. However, it still supports new animators through the Animate! program, and new **comedy** series *Modern Toss* (2006–) has renewed some interest in the form on the channel.

CHINA. Animation has a long history in the **Asian** continent, with the Chinese animation sector developing in the early 1920s, inspired by what had been produced in the **United States**. One of the earliest examples of Chinese animation demonstrates Western influence. *Uproar in an Art Studio* (1926) was created by the Wan brothers of Shanghai, twins Wan Lai-ming (1899–1997) and Wan Gu-chan (1899–1995), Wan Chao-chen (1906–1992) and Wan Di-huan (1907–), who had taught themselves animation. Their film was a mixture of live action and animation, inspired by the **Fleischer brothers'** *Out of the Inkwell* series. Their next film, *A Paper Man Makes Trouble* (1930), used the

same technique. Chinese animation continued to develop with their first sound **cartoon**, *The Camel's Dance* in 1935, produced by the Wan brothers, who began to work for the Mingxing Film Company. Chinese animation contained anti-Japanese feelings due to the conflicts, and the capture of Shanghai by the Japanese in 1937 closed the Mingxing studio. The Wans relocated to Wuhan Province and made anti-Japanese **propaganda** films, though they were not commercially successful. Wan Lai-ming and Wan Gu-chan were invited to set up an animation studio in Shanghai by the Xinhau United Film Company. They were inspired by **Walt Disney**'s **feature-length** achievements and in 1941 made the first Chinese animated feature *The Princess with the Iron Fan*. Though the Chinese **Cartoon** Association was established in Hong Kong in 1941, the only film to be produced was *The Hunger of the Stupid Old Dog*. Once the Japanese occupied Hong Kong, production ceased. The industry was essentially shut down due to World War II, stopping in 1941; nothing was produced again until 1947.

The changing **political** landscape led to encouragement for the animation industry from the communist-controlled northern China, which subsidized satirical animation. In 1950, the government aided further development with the creation of the large Shanghai Film Studio, which became the dominant producer of animation, primarily for a domestic audience. It was encouraged to create a distinct Chinese style of animation. The studio was successful and found international success with their second feature, *Havoc in Heaven* (1961). Others were also successful with a mixture of films being produced using **cel**, cutout, and **puppet** animation, including the traditional puppet film *The Peacock Princess* (1963) by Jin Xi. The Cultural Revolution saw the close of the major studios in 1965. However, after 10 years of repression and the end of the revolution, the Shanghai Film Studio returned and a so-called second Golden Age of Chinese animation began. The studio divided into three sections, each concentrating on a different production method—puppet, cutout, or cel. One of the most successful films was *The Three Monks* (1980) by A Da (1934–1987), who was a dominant figure in the Chinese animation industry in the 1980s. He was responsible for creating the first animated film for adults, *Butterfly Spring* (1983), and he continued working until he died in 1987. The Shanghai Studio continues to be successful and

new studios have opened in China, though there is more competition now from foreign imports such as **television** animation from **Japan**. The production rate has increased and new computer animation was first produced in 2000. Despite overseas competition, the Chinese animation industry continues to produce award-winning, internationally recognized animation.

CHOMET, SYLVAIN (1963–). French animator Sylvain Chomet earned his diploma from the comic book school of Angoulême and published his first comic book, *Le Secret des libellules* (*The Secret of the Dragonflies*), in 1986. He then **adapted** Victor Hugo's first novel, *Bug-Jargal*, into a comic book.

Chomet began his career in animation in September 1988 when he went to work as an assistant at Richard Purdum's studio in London. He moved on to work freelance for several London animation studios, during which time he directed animated **television advertisements**. He continued writing and publishing comic books and in 1989 began his first animated **short**, *La Vielle Dame et les Pigeons* (*The Old Lady and the Pigeons*). This was completed in 1996 and in 1997 was nominated for an Academy Award.

In 1997, Chomet briefly worked for the **Disney Studio** in Toronto, until he was given the go-ahead by his producers to start a storyboard for his first animated feature, *Les Triplettes de Belleville* (*Belleville Rendezvous*). The film was made in Montreal and took five years to complete. It was sold to over 33 countries worldwide and in 2004 was nominated for Best Animated Feature and Best Song at the **Academy Awards**.

In 2004, Chomet moved to Scotland and founded his flagship animation studio, Django Films. The studio's latest project, *L'Illusioniste* (*The Illusionist*), is a two-dimensional (2D) animated feature based on an original script by French comedian Jacques Tati, due to be released in 2009. As well as work for his own studio, Chomet collaborated on the feature film *Paris Je T'aime*, which was his first project writing and directing live action. The success of his five-minute section in the film inspired him to write a live-action **musical** feature set in Paris in the 1970s. Django also works on **advertisements** that are produced by the London-based company Thing.

Chomet includes **Nick Park, Hayao Miyazaki**, and **John Lasseter** among contemporary artists he admires, though he prefers traditional hand-drawn 2D animation to computer animation.

CLAMPETT, BOB (1913–1984). Born in San Diego, California, Clampett began working as a newspaper cartoonist before he went to work for **Harman-Ising** at **Warner Brothers** in 1931. He worked at the studio alongside **Tex Avery, Chuck Jones**, and Bobe Cannon. In 1937, he began supervising his own **cartoons**. Clampett was responsible for creating Tweetie Pie and commissioned a new design for Porky Pig. In 1938, he directed *Porky in Wackyland*, inspired by the Lewis Carroll story *Alice in Wonderland*; he references the work of **surrealist** artist Salvador Dali and cubist Pablo Picasso, and took full advantage of the medium. Clampett's reputation as a director was reinforced between 1942 and 1946 when he is said to have made his best films for the studio, including *Coal Black and de Sebben Dwarves* (1942). Clampett's version of the *Snow White* story was controversial, though it has been suggested that it could be seen as a film of its time, with excellent performances by black artists and first-class animation—though it may also be viewed as the perpetuation of racial stereotypes. *Tortoise Wins by a Hare* (1943) and *The Great Piggy Bank Robbery* (1946) demonstrated his attention to detail and at the same time the fast pace he set for his work. In 1946, he left Warner Bros. to work at **Screen Gems** for a short time. In 1949, he moved into **television** animation with the series *Time for Beany*, featuring a boy called Beany and his friend Cecil, a sea serpent who was seasick, animated with **puppets**. In 1962, he produced a 72-episode series, *Beany and Cecil*, but this time the show was **cel** animated. He is perhaps better known for his work with Beany and Cecil than his work at Warner Bros., but critics and historians suggest that this was in fact some of his best work, though largely forgotten.

CLAY. A **three-dimensional** (3D) animation technique using modeling clay, often referred to as Claymation. Plasticine, the oil-based clay substance, is used commonly, as it does not dry out in the same way as water-based clay used in **fine art**. Clay animation generally falls under the category of **stop motion**, as the models are filmed frame by frame as in **puppet** animation. The clay models or pup-

pets are moved in small increments, each filmed separately and then compiled into a film. When the film comes together in a continuous form, the individual movements are barely detectable, giving the model or puppet life.

When **Will Vinton**'s **Academy Award**–winning film *Closed Mondays* (1974) used the technique and the term *Claymation* was trademarked in 1981, the technique became a consolidated, recognized animation technique. Vinton's **documentary** *Claymation* (1978) addresses some of the key aspects of clay animation, illustrating its malleability and consistency, as well as its ability to be manipulated from a colorless mass into moving forms. Another example of clay animation in the **United States** is **Art Clokey**'s *Gumby* series, which ran for a number of years on U.S. **television**.

Probably the most well-known, recent example of clay animation is the ***Wallace and Gromit*** series by British animator **Nick Park** at the **Aardman Animation** studio. The studio has been producing clay animation for many years, becoming the most familiar example of the form, from their early *Lip Synch* series that featured the highly popular ***Creature Comforts*** and their award-winning music video for Peter Gabriel's *Sledgehammer*. Other examples from Aardman include the popular **short** series *Morph* and the **feature-length** *Chicken Run* (2000).

Clay was also used in the short-lived television series *The PJ's* (1999–2001) and to particularly great effect in the popular **Music Television** (MTV) series *Celebrity Deathmatch* (1998–).

CLOKEY, ART (1921–). Born in Michigan, Clokey is considered a pioneer in **stop-motion clay** animation. He studied under Slavko Vorkapich at the University of Southern California, and began using stop-motion techniques when working on an **advertisement** for Anderson's Pea Soup. Other companies such as Coca Cola and Budweiser then hired him to make similar advertisements for them. Clokey is probably best known for his clay character Gumby, who first appeared in the experimental **short** film *Gumbasia* (1955), which used a jazz soundtrack. A representative of 20th Century Fox was impressed by the film and asked for a children's **television** show that he hoped would "improve" children's TV. After the pilot, the show ended up on the National Broadcasting Company (NBC) as the

series *The Gumby Show*, which ran from 1956 to 1957. The model was made using a wire armature under the modeling clay that could be manipulated in a variety of ways. Clokey and his wife, Ruth, had met at seminary school and their values were passed on in the series.

These views were particularly evident in their next series, *Davey and Goliath* (1960–1962, 1969–1971), which featured a young boy and his moral, talking dog. The show was funded by the Lutheran Church. For this series, Clokey moved away from clay and began using soft foam rubber over armatures. In the 1960s, they moved to a new studio space in Glendora, California. In the 1970s, Clokey produced *The Clay Peacock* (1963) for NBC and the film *Mandala* in 1964. He also remarried in the 1970s, at which point Ruth closed the studio; he then created a toy called "Moody Rudy" that was a bendable figure. After Gumby reaired on the **Disney** channel in the 1980s, there was a new interest in merchandise and Gumby became something of a cult classic. Clokey and his new wife, Gloria, toured college campuses and in 1987 to 1988 they created 99 new episodes with their new company, Premavision, and Lorimar Studios. In 1995, they made *The Gumby Movie* after Nickelodeon began showing the episode in the early 1990s. In 2000, the distribution company Rhino released the series on DVD. This increased interest in Clokey's work over the years and even saw the creation of a new series of *Davey and Goliath* in 2004, produced by Clokey's son, again funded by the Lutheran Church.

COHL, ÉMILE (1857–1938). French caricaturist often credited as the father of the animated **cartoon**. Born Émile Courtet, he changed his name once he became an artist. Cohl was jailed in 1879 for a caricature he drew of the French president. After working in caricatures, Cohl became interested in **puppets**, particularly *fantoche*, which featured a puppeteer's head stuck through a black sheet with a puppet's body below. He became aware of moving pictures and, after seeing **J. Stuart Blackton**'s *Haunted Hotel* in Paris in 1907, he was inspired to create *Fantasmagorie* (1908), said to be the first true animated film, for the Gaumont Studio. The film featured 700 drawings on an illuminated plate, giving the impression of a chalkboard and similar in appearance to the *fantoche*. There is no distinct narrative; the film

is made up of a sequence of moving images. Cohl continued to make films in this style and was very successful in Paris and in the **United States**, though in 1910 he began making live-action films. He moved around between a variety of studios, and in 1911 moved to the United States to work as an animator. However, after the outbreak of World War I, Cohl and his family returned to Paris where he eventually made his last film, *La Maison du fantoche* (*The Puppet's Mansion*), in 1921.

COLONEL HEEZA LIAR. Silent era character that featured in **John R. Bray**'s second film based on the stories of Baron Munchausen. *Colonel Heeza Liar in Africa* (1913) sees the character in a parody of American President Teddy Roosevelt's travels in Africa. The character was a late middle-aged man, a type of boaster who told impossible stories. He was drawn as fairly short and rotund. The supporting dialogue track is a commentary in rhyming verse and was the first commercial **cartoon** release. The beginning of the series of films was seen as a turning point in animation development and history. The films were later animated by **Walter Lantz**. Scenes from the *Colonel* series were used in Bray's patent application for his background techniques. There were 59 cartoons in the series, the last one being *Colonel Heeza Liar's Romance* in 1924.

COLUMBIA AND SCREEN GEMS. Charles Mintz made a distribution contract with Columbia Pictures in 1930 to distribute his Screen Gems animation. This came at the same time as many studios were converting to sound, and Mintz moved away from his previous distributor, Paramount. Mintz transferred his studio from New York to Los Angeles, and his reputation of getting Oswald the Lucky Rabbit from **Walt Disney** led to rivalry and success. In 1932, Disney left its distribution deal with Columbia, leaving Mintz's Screen Gems the sole animation producer.

The *Krazy Kat* series continued, though the studio was never as successful as Disney. Mintz was not concerned with the production process, which afforded the animators a form of autonomy, though he did want to limit the dialogue in order to increase foreign sales. A new star, "Scrappy"—a little boy with good characterization—was added to the Screen Gems output. Many animators came through the

studio in the 1930s but there was little opportunity for development of their skills and many moved on. The studio made the move into color in 1934 with the *Color Rhapsodies* series.

Financial problems with Screen Gems led to Columbia taking over responsibility, though Mintz remained in charge until ill health forced him to leave in 1939. Over the next eight years, there were seven different managers, including Mintz's brother-in-law, and in 1941 **Frank Tashlin** joined as writer and director. Tashlin took advantage of the strike at Disney and hired many of the staff, including **John Hubley**. The new team brought a new look to the **cartoons** but after one year Tashlin left and was replaced by Dave **Fleischer**. His stay was also brief and again the studio went through various management changes. In 1946, **Leon Schlesinger**'s "right-hand men," Henry Binder and Ray Katz, came on board from **Warner Brothers** and brought **Bob Clampett** with them. The studio never regained the early success and by 1948 Columbia was working more and more with **United Productions of America** (UPA) and let Screen Gems fade into the background, essentially killing off the studio. Columbia found success with UPA.

COMEDY. Comedy is often considered the generic dominant in animation, informed by the history and dominance of the **cartoon**. The comic-strip basis for many of the **silent era** cartoons set a precedent for the subject matter, which most studios followed. Once **feature-length** animation became more frequent, **adaptations** of literature and fairy tales became more commonplace and saw a slight shift from comedy. However, the dominance of the cartoon was such that the term *cartoon* became the descriptive noun for all animation, despite it only referring to comedic animation. From **J. Stuart Blackton**'s *Humorous Phases of Funny Faces*, **Betty Boop**, **Felix the Cat**, **Mickey Mouse**, and the *Looney Tunes* series to the animated **sitcoms** such as *The Flintstones* and *The Simpsons*, comedy has remained an important factor in animation, particularly that which cannot be described as **abstract** or experimental, drama or **documentary**.

The language of animation lends itself to comedy and according to Paul Wells (1998) can be used for the following comedic devices: unexpected or surprise actions; comic performance and caricature; visual puns and satire; exploitation of expectation; alienation and the

shaggy dog story; literal, verbal, and visual gags; and objects brought to life.

COMPUTER-GENERATED IMAGERY (CGI). Digitally produced animation has its origins in the development of simulation graphics in the military and industrial sectors. Computer technology has become more sophisticated, from the earliest programmable computer in 1946 (developed by the **U.S.** Army at the University of Pennsylvania) to the development of more powerful and efficient processors. In animation, it was **John Whitney** who became a pioneer in the field with his Motion Graphics Inc., making analogue computer-generated light effects. His son John Whitney Jr. took these experiments and developed the technology while working with computer companies. By 1964, with the first digital recorder, the **abstract** computer image became a reality.

John Whitney Sr. continued with his experiments and in 1975 made *Arabesque* with Larry Cuba, also a computer graphics pioneer, with *First Fig* (1974). Another pioneer, Ed Emshwiller, made *Sunstone* (1979), a three-minute **three-dimensional** (3D) computer graphic film using frame-by-frame methods. These experiments with geometric patterns in the 1970s led to interest from the entertainment industry, notably George Lucas who founded **Industrial Light and Magic** (ILM) to create CG effects for his **science fiction** epic *Star Wars* (1977). This company led Steve Jobs (of Apple Computers) to form **Pixar** in 1985.

By 1982, **Disney**'s *Tron* became one of the first **feature** films to fully utilize the applications of CGI. *Star Trek: The Wrath of Khan*, also in 1982, used the technology to create the opening segment in the film. John Whitney Jr. moved on with his development of CGI and created 25 minutes of footage for the live-action science fiction feature *The Last Starfighter* (1984). By this time, the use of the technology in terms of the aesthetic and economic values was becoming established. By 1985, **John Lasseter**'s *The Adventures of André and Wally B*, among others, was demonstrating the potential for the technology. However, initially the costs and the lack of standardization in the technology slowed the mainstream execution. In 1991, James Cameron's *Terminator 2: Judgment Day* demonstrated the extent to which CGI could be useful in story-telling.

Gradually, the software became standardized and CGI became a commonly used tool in video games and multimedia applications, as well as film. The effects used in *Jurassic Park* (1993) showed how useful the tool was to live-action film. The process of animation practice also changed, with much of the production work being done on a computer, such as painting, lighting, and eventually camera work. Postproduction also increasingly used computers. The technology became the normal process quickly, particularly with advances from Pixar, from the early **shorts** *Tin Toy* and *Luxo Jr.* to the groundbreaking, first fully CGI-animated feature *Toy Story* (1995), the success of which arguably brought CGI animation to the mainstream audience.

On **television**, *Reboot* became the first CGI series to be broadcast, with the characters living inside a computer (recalling *Tron*). As the technology improved, other studios in film and television have tried to capitalize on Pixar's success with new animation in CGI such as *Antz* (1998) and *Shrek* (2001). Attempts to create perfect photorealism have also been an issue, seen in the poor reception of *Final Fantasy: The Spirits Within* (2001) and the more successful financially, but still poorly received, *The Polar Express* (2004). In 2003, Disney announced that all future feature animations would be produced using digital technology, essentially ending the era of traditional animation, which Disney had championed since the **silent era**.

In terms of production, the industry suggests that CGI is very similar to traditional filmmaking:

Perhaps the best way to understand CGI is to consider it a merger of two methods of filmmaking: 2D animation and live-action. The process for generating CGI animated projects is very similar in many ways to traditional animation, with some subtle but significant differences in production procedures. Unlike hand-drawn animation, in CGI, artists must create a three-dimensional world in the computer. Three-dimensional sets must be built, lit and painted, much in the way that sets are constructed for live-action films. CGI also resembles live-action filmmaking in terms of spatial conceptualization, lighting, cinematography, scene hook-ups and blocking of actor's movements. To get from idea to screen, however, CGI follows the traditional animation model in which the artist must go through a series of steps to first create and then define the image. The main advantage to CG animation is that it is a non-linear process. (Winder and Dowlatabadi 2001)

These advantages have become firmly entrenched in many parts of the animation and filmmaking industries, with features becoming so full of CGI that audiences increasingly find it hard to determine the difference between live action and animation.

COSGROVE HALL. Studio based in Manchester, **Great Britain**, that is one of Europe's largest and most prolific animation companies and one of only a few studios in the world that produce animation in hand-drawn/2D, **stop-motion**, **puppet**, and **computer-generated imagery** (CGI) under one roof. The studio was founded in 1976 by Brian Cosgrove and Mark Hall, who had worked together at Granada Television, which they left to set up Stop Frame Animation. In 1972, they began creating the title sequence to the children's **television** series *Rainbow* with Thames TV, of which they became a subsidiary in 1976 and changed their name to Cosgrove Hall.

The studio has grown to become one of the world's premiere animation studios, producing countless hours of animation each year. With sales to over 150 countries, it has a worldwide appeal that is reflected in the numerous awards the studio has won. Over the years, the titles have included *Noddy*, *Jamie and the Magic Torch*, *Chorlton and the Wheelies* (1976), *Cinderella* (1979), *Danger Mouse* (1981), *The Wind in the Willows Special* (1983) and the subsequent 1984 series, *Count Duckula* (1988), *The BFG* (1989), *Discworld* (1996), *Bill and Ben* (2001), *Engie Benjy* (2002), *Fifi and the Flowertots* (2005), *Doctor Who—The Scream of the Shalka* (2005), and *Pocoyo* (2006). This list of titles covers a range of techniques and age ranges from preschool to teen and several long-running television series. Though the founders retired in 2003, they continue to support the studio, which employs 80 people.

CREATURE COMFORTS. In 1989, **Channel 4** commissioned **Aardman Animation** to make a series of five-minute films, *Lip Synch*, which used vox pop recordings. The series included **Nick Park**'s *Creature Comforts*, which won an **Academy Award** for Best Animated **Short** Film in 1990. The short features a number of animals that are interviewed about their living conditions while living in a zoo. The comments were made by people talking about their own living conditions. The voices and dialects were "matched" to animals

and given distinct personalities, which is also emphasized in the movements of the animals. The film strongly exhibits the **anthropomorphic** tendencies of **Walt Disney** in **three dimensions** (3D). Humor derives from the tension between the ordinariness of the opinions and the visual gags. The animation technique is 3D **clay** animation using Plasticine. The lighting and camera style is designed to give a **documentary** feel to the film.

The characters were used later in a series of **advertisements** for Heat Electric and were again revived in autumn 2003 when *Creature Comforts* made its debut as a series for the British **television** channel ITV, with a second series broadcast in 2005.

CULHANE, SHAMUS (1908–1996). James "Shamus" Culhane, who was born in Massachusetts, had a career in animation that reads like the history of animation on its own. Throughout his long career, he worked with a variety of studios and individuals, including **Bray**, **Fleischer**, **Disney**, **Ub Iwerks**, **Paramount**, and **Walter Lantz**, as well as at one time running his own studio.

Culhane moved to New York as a child and very quickly identified the desire to become an artist. His school friend Michael Lantz introduced James to his brother, Walter Lantz, who hired him to work at Bray Studios. Culhane carried out a number of different jobs at the studio and was able to try his hand at animation, completing his first film by the age of 17. He was employed as an inker for **Charles Mintz** on the *Krazy Kat* series, but when the studio moved west, Culhane preferred to stay in New York. He found employment at the Fleischer Studio, and due to many of its staff leaving, was quickly promoted, even filling the role of head animator on some of its films.

In 1932, Culhane decided to head west to California, like many animators before him, and went to work for Ub Iwerks, working on the *Flip the Frog* series. Despite the initial move to the West Coast, Culhane moved back to New York and for a brief time worked at **Van Beuren**'s studio. However, he did not like the quality of the work being produced and returned west to work for Disney. His time there was described as a "grueling apprenticeship" (Langer 1992), though he went on to animate on *Snow White and the Seven Dwarves* (1937).

After becoming ill, Culhane left Disney and moved to Miami to work with the relocated Fleischer Studio in 1939, where he worked on the **feature-length** *Gulliver's Travels* (1939). This led to yet another transfer to the West Coast, where he worked briefly for **Chuck Jones** at **Warner Bros**. During World War II, Culhane worked with Lantz for the war effort, and developed an interest in educational and children's projects. He started his own company, Shamus Culhane Productions, with operations on the East and West coasts. This venture collapsed in the 1959–1960 recession, after which he worked with **John** and **Faith Hubley**. Between 1966 and 1967, Culhane was the head of **Paramount Cartoon Studios**.

He returned again to making educational films for children and wrote books about his experiences, *Talking Animals and Other Funny People* (1986) and *Animation: From Script to Screen* (1988). He returned to New York where he continued to work, and became an educator. In 1986, he was awarded the **Winsor McCay** Award at the Annie Awards. He worked in New York, where his career ended with his death in 1996.

CZECHOSLOVAKIA. *See* EASTERN EUROPE.

– D –

DEITCH, GENE (1924–). Chicago-born animator who joined **United Productions of America** (UPA) in California in the late 1940s as an assistant to Bill Hurtz, where he was trained and later became principal director at its New York studio. The progressive design style he learned at UPA carried through his work elsewhere, and he became artistic director at **Terrytoons** from 1956 to 1958, after CBS took over the studio from **Paul Terry**. Deitch founded his own company in New York in 1958, but this was absorbed by Rembrandt Films two years later, though during this time he made *Munro* (1960), which won an **Academy Award**. Between 1961 and 1962, Deitch turned out 13 new *Tom and Jerry* films for **Metro-Goldwyn-Mayer**. He moved to Prague, where he married and set up a new studio and has made films for the **U.S.** market with **Czech** animators.

DESTINO. *Destino* is a film made in collaboration in 1946 between the **surrealist** painter Salvador Dali and **Walt Disney**, which began when Dali painted in Hollywood for a time in the 1940s. Storyboarding for the film took place for eight months in 1946 but was abandoned. The **short** film consisted of numerous images that morphed into each other, like a series of Dali paintings dissolving into one another, to the soundtrack of a Mexican ballad.

The film contains signature Dali imagery such as figures and objects morphing or "melting" into other forms, and was brought to life when Roy Disney, Walt's nephew and the executive producer of the **Disney Studio**, came across the drawings when working on *Fantasia 2000*. The film was not legally the studio's until it completed the film, so it was decided to try to complete it retaining Dali's vision. The studio still had some of the original drawings and storyboards and began to reconstruct the film, using drawings and **computer-generated imagery** (CGI) that were seamlessly blended together. The new version was directed by French director Dominique Monfrey at Disney's Paris studio, who was initially reluctant to take on the project but after encouragement to re-storyboard the film, he agreed. The completed film premiered at the Annecy Animation **Festival** in June 2003 and has since been shown as part of Dali exhibitions.

DISNEY STUDIO. Possibly the most well-known animation studio in the world, the Walt Disney Studio was founded by **Walt Disney** in partnership with his brother Roy, the studio having emerged from Walt's previous attempts in the industry. In 1923, Walt moved to Hollywood where he found a new distributor and went into partnership with Roy. For four years, they worked on the *Alice* series before bringing **Ub Iwerks**, Hugh **Harman**, Rudolph **Ising**, and **Friz Freleng** on board. After the loss of copyright of Walt's first character, Oswald, he set about creating his most famous starring character, *Mickey Mouse*. Premiering in *Plane Crazy*, Mickey made history when he appeared in *Steamboat Willie* (1928), the first sound-synchronized animated **cartoon**. Walt was inventive and developed a variety of techniques to aid the development of his animation. He developed the **multiplane camera** that created a depth of field in the animation.

The studio was successful in the production of **shorts** and expanded its business by creating spin-off companies, eventually coming together as Walt Disney Productions. It found particular success with the *Silly Symphonies* series and with *The Country Cousin* in 1936, which **Frank Tashlin** said "featured a mouse that would be a prototype for all cute mice in cartoons thereafter." In 1937, it released *Snow White and the Seven Dwarves*, the first **feature-length** animated film in the **United States**. The success of the film changed the animation market and led to the production of several features over the years. Following these successes, the studio expanded from 6 employees in 1928 to 187 in 1934, and by 1940 the studio had over 1,600 staff members. As a result, the company moved to larger premises.

By 1938, having spawned a variety of spin-off costars, Mickey Mouse was essentially retired and the studio began to focus on a new type of **realism** that, having studied facial expressions and details, would endow characters with individual personalities, as had been seen in *Snow White*. Disney wanted to hire the best animators in the market but many did not want to work to his philosophy, and so the company began to hire and train new animators. In seven years, it screened 35,000 applicants for a Disney art school that until 1941 educated animators and introduced them to new styles and technical principles. New methods of production and the rationalization of labor led to specialized teams in animation, scene design, layout, scripts, effects, inking, overlaying, and filming. A main storyboard was used to keep the films under control. The company was structured to reflect the founders' personalities. In 1961, Walt and Roy Disney established the **California Institute of the Arts** (CalArts) through a merger of two professional schools, the Los Angeles Conservatory of Music (founded in 1883) and the Chouinard Art Institute (founded in 1921), to offer education in visual arts and particularly animation.

The company continued to thrive, though it had its first significant failure with *Fantasia* in 1940. The film had been very expensive and time consuming to create and with a different approach than audiences had previously seen. This, combined with the outbreak of World War II that essentially closed the overseas market, led to a very poor box-office result.

In 1941, the studio was hit again, but this time by an animators' strike. The staff had issues with wages and contracts and even when it was resolved many left, including **John Hubley**, uncomfortable with what was perceived as a change in the mood. The studio then became involved in the war effort with the government and military after Pearl Harbor. It produced training films and was permitted to keep the studio, during which time it released *Dumbo* (1941), *Bambi* (1942), *Saludos, Amigos* (1943), and *The Three Caballeros* (1943). The production of shorts included anti-Nazi **propaganda**.

After the war, animation became less popular and the production of shorts was reduced to cover the rising costs of producing features. Disney began to branch out into production of **documentaries**, live-action children's films, and **television**. Walt spent less time on the production part of the business, leaving his "Nine Old Men"—Milton Kahl, Marc Davis, Eric Larson, Wolfgang Reitherman, Les Clark, Ward Kimball, John Lounsberry, Frank Thomas, and Ollie Johnston—in charge. The term was coined by Walt, who said they reminded him of the nine justices of the U.S. Supreme Court. Following Walt's death in 1966, Reitherman oversaw the completion of Walt's last film, *The Jungle Book* (1967).

The studio continued after the death of its founder, though the name was changed to Walt Disney Enterprises in 1968 (and is currently known as the Walt Disney Company, encompassing all the ventures under the umbrella ownership) and began the 1970s with *The Aristocats* (1970) and *Robin Hood* (1973). The style had changed and the material was thought to be weaker. The studio was facing increasing pressure from rising costs and staff issues; no new staff had been hired after *Sleeping Beauty* (1959), which was four years overdue and very expensive. Staff was lost due to death and retirement, and as a result new features were only released every three years. The studio began recruiting from art schools and Eric Larson took charge of a new training program.

In 1977, *The Rescuers* was released and marked the end of the era of the old animators. Roy took over the running of the company but was not as innovative as Walt had been. However, in 1982 the studio released *Tron*, which marked a significant point in the development of **computer-generated imagery** (CGI). A new generation of anima-

tors came on board and produced *The Fox and the Hound* (1981) and *The Black Cauldron* (1985), but these films were not successful. The studio went through management changes with Ron Miller, Walt's son-in-law, replaced as CEO by Michael Eisner, and the original studio was moved. Its next release, *The Great Mouse Detective* (1986), did better and the studio improved again when they collaborated with Steven Spielberg's Amblin Entertainment to produce **Who Framed Roger Rabbit** (1987), directed by Robert Zemeckis and Richard Williams. The film was a major success and capitalized on nostalgia for classic animation.

In 1989, *The Little Mermaid* was released and was the first film since *Sleeping Beauty* to feature a princess. It was very successful and the end of the 1980s marked the beginning of a new era of hits for the studio. The 1990s saw the success continue with *Beauty and the Beast* (1991), which was the first animated feature to be nominated for an **Academy Award** for Best Picture. Their next film, *Aladdin* (1992), was even more successful at the box office and in 1994 **The Lion King** set the record for the highest grossing traditionally animated film. However, in 1995, *Pocahontas* marked the start of another decline in Disney animation as the film lacked the warmth and success of *The Little Mermaid*.

Other late 1990s releases—*Hercules* (1997), *Tarzan* (1999), and *The Emperor's New Groove* (2000)—were similarly received. The company had opened a satellite studio in Florida to increase production, and it produced *Mulan* (1998), which did quite well, as did *Lilo and Stitch* (2002), but *Brother Bear* (2003) was to be its swan song and the Florida studio closed in 2004. At the same time, the size of the California studio was reduced and management decided to abandon drawn animation in favor of computer animation. It released *Dinosaur* in 2000, attempting to the push the boundaries of digital animation. The film featured more than 30 separate species, mapped into real location shots. A flexible motion control "Dinocam" was used, attempting to give the film a documentary feel. The studio even created new computer software to create realistic lemur fur. The film is considered to have made a significant development in computer-generated "realism" with thousands of "naturalistic" character shots. *Home on the Range* (2004) marked the end of the

traditional animation as practiced by Walt Disney. After agreement with **Pixar** and the success of *Toy Story*, the Walt Disney Company now has a stake in Pixar as well as a variety of other enterprises in television and film. The international reach of the company now includes theme parks around the world as well as film and television broadcasting networks, production companies, and distribution firms. The company also owns shares in sports teams.

DISNEY, WALT (1901–1966). Walt Disney is probably the most famous animator of all time, with the most influential and successful studio. Walt was born in Chicago but his family moved around frequently when he was a child. A brief stay in Missouri is said to have been a particularly happy time and the idyll of farm life and pastoral themes are often represented in his early films. In 1918, he volunteered for the Red Cross and was sent to **France** where he developed his drawing skills with caricatures, popular with the soldiers. Upon returning home, he decided to become a comic-strip artist. He moved to Kansas at age 19, where he met **Ub Iwerks** and together the pair began animating for the Kansas City Film Advertising Company producing animated **advertising** reels. Disney became enterprising and inventive with his work and Iwerks was a talented animator. In 1922, Disney resigned and founded Laugh-O-Gram Films, and he hired Iwerks and Hugh **Harman** and Rudolph **Ising**. They began producing fables but the distributors were bankrupt and though they produced a series pilot, *Alice in Cartoonland*, Disney ran out of money and filed for bankruptcy too. In 1923, Disney moved to Hollywood and Margaret J. Winkler, who distributed films for the **Fleischer brothers** and **Pat Sullivan**, placed an order for the *Alice* series. Some of the films were the last Disney himself animated, leaving this task to Ub Iwerks and Rollin Hamilton. Walt went into partnership, founding the **Disney Studio** with his brother Roy, who would be his business partner throughout their careers, and he resumed work on the *Alice* series. Initially, Walt worked alone but was again joined by Iwerks, Harman, Ising, and **Friz Freleng**. In 1927, he created *Oswald the Lucky Rabbit*, which was fully animated with no live actors and distributed by **Charles Mintz** for Universal; however, Mintz obtained copyright of the character.

After this loss of a star character, Disney worked to come up with another one. Stories have suggested that he drew a mouse that he named Mortimer, but his wife suggested Mickey. The credit for the creation of **Mickey Mouse** should be shared with Iwerks, who first drew the character fully. Mickey's first appearance was in *Plane Crazy*, but after the release of *The Jazz Singer* (1927), Disney sensed an industrial revolution and created a makeshift system to synchronize sound with animation. He used this in *Steamboat Willie*, Mickey's third film and the first sound-synchronized **cartoon**. After some technical problems, the film was first shown at the Colony Theatre in New York on 18 November 1928. This film was extremely successful and Disney patented Mickey's name and this time retained the rights.

Disney collaborated with musician Carl Stalling, who wrote the **music** for Mickey's films, and the music dominated their new series, *Silly Symphonies*, with the first film *The Skeleton Dance* (1929). Disney continued developing technology and techniques and in 1933 began producing films in color. By 1943, Disney had won 11 **Academy Awards** (22 during his life and one posthumous), Mickey Mouse became a phenomenon, and as the years went by Disney turned his attention to "drawn actors" with carefully studied features and gestures. His characters were to have full personalities and obey the logic of reality. This form of **realism** became dominant in the studio; as he strived toward better representations, he developed the **multiplane camera** and **feature-length** animation with full narratives, first seen in *Snow White and the Seven Dwarves* (1937).

As the studio became more successful, Disney was keen to train new animators to conform to his style of working and he set up an art school to help develop new talent. He came to organize his company in a very particular way and hired people who shared his sensibilities. Disney had the same impact on animation as sound did to live-action cinema; his successes led to more company developments and relocation.

Disney's most sophisticated and ambitious work was *Fantasia* (1940), but the war-torn European market was closed to him and the film failed at the box office. In 1941, Disney clashed with staff over pay and contracts, resulting in a strike. Disney took this as a personal

attack on his leadership and he took a trip to South America, during which time the strike was resolved. Though he lost some of his staff, Disney continued production through the war, supporting the war effort.

Disney again sensed changes in the industry following the war and in the 1950s and 1960s he began producing live-action children's films and **documentaries** and developed **television** shows, once more becoming an industry leader. In 1961, Walt and Roy Disney established the **California Institute of the Arts** (CalArts) through a merger of two professional schools, the Los Angeles Conservatory of Music and the Chouinard Art Institute.

Disney began to take less interest in the studio and concentrated on his project to build an amusement park, Disney Land, in California. He left more responsibility to his lead animators, or "Nine Old Men" as he dubbed them. Walt died in 1966 and one year later the last film he had worked on, *The Jungle Book*, was released. Walt Disney Productions continued operating with large profits and his amusement park was so successful that another was opened in Florida. More movies were made in the Disney style.

Disney was defined as a complicated man who was said to be often harsh and distant with his employees but was also a good husband and father and was generous to old friends. He demanded high quality and was ambitious, never losing sight of the commercial potential of his product. He felt that he shared the aspirations and social origins of his audience. His films set a standard that was dominant for a long time; however, due to this, he has been criticized for creating hegemony in the industry and spreading a particular American ideology throughout the world. Despite these criticisms and those against his character, he remains one of the most innovative animators in history whose contribution to the medium was vast and lasting.

DOCUMENTARY. Though animation cannot present the "live" element that is generally thought of in documentaries—to present real events—it can be used subjectively to present the emotion of the subject. Live-action documentaries are often edited to present a particular point of view and are not always entirely objective either, so in this respect animation is no different from live-action footage. A very early example of an animated documentary is **Winsor**

McCay's *The Sinking of the Lusitania* (1918), which depicts what
happened as factually as any newsreel but injects emotion through
the visuals. Marjut Rimmerien's film *Slow Protection* (1987) docu-
ments the experiences of a woman who has suffered great anxiety
due to past abuse and the film shows her perception of the reality of
a variety of events in her life. Peter Lord of **Aardman Animation**
used **clay** to produce *Going Equipped* (1989), an interview with a
young man in prison, and presents a **realist** agenda using real voice
footage with the animated characters. Paul Wells (1998) suggests
that there are four modes of documentaries that can be used in
animation:

- imitative—such as the newsreel or travelogue
- subjective—individual perspectives or social narratives
- fantastical—which repositions the social or historical subject to
 offer a different point of view
- postmodern—where the social or cultural narrative may be sub-
 ject to no proven authority but may offer a relevant truth

Since 1997, **Bob Sabiston**'s Flat Black Films has helped popularize
animation as a medium for documentary in such films as *Snack and
Drink* (1999), which uses his digital **rotoscoping** technique over live-
action documentary footage. *See also* GENRE.

DUCK AMUCK. One of the most famous of the *Looney Tunes* series
from the **Warner Brothers** studio, directed by **Chuck Jones** and
written by Michael Maltese. The 1953 film stars Daffy Duck and
begins with him fencing; as he lunges toward the screen, he moves
past the painted background and into blank white space. He then ad-
dresses the unseen animator. As they discuss and argue over the miss-
ing backdrop, it keeps changing, along with Daffy's costumes and
voice, which increasingly annoys Daffy. After feeling very harassed,
he pleads with the animator to stop and asks to see who is responsible
for his torment. The animator is revealed to be **Bugs Bunny**, who
then addresses the audience and says, "Ain't I a stinker?" The film's
use of the break in the fourth wall with the interaction between the
character and animator and the direct address to the audience refers to
the **Fleischer brothers'** *Out of the Inkwell* series where **Koko** would
interact with his animator-master.

DUNNING, GEORGE (1920–1979). Dunning was a Canadian animator who attended Ontario College of Art and later became a member of the **National Film Board**, where he worked on a team editing films with **Norman McLaren.** Dunning's early films include *Grim Pastures* (1944), *Three Blind Mice* (1945), and *Cadet Rouselle* (1946, in collaboration with Colin Low). In 1946, he went to Paris but returned to Canada to cofound his own production company in Toronto with his former colleague Jim McKay. In 1956, Dunning joined **United Productions of America** (UPA) in New York City. He then moved to London to open a production company with John Coates in 1957. Dunning's films from that period included *The Apple* (1962), *Moonrock* (1970), *The Maggot* (1973), and *Damon the Mower* (1972).

Dunning is perhaps best known for directing **Yellow Submarine** (1968), which was inspired by and set to the music of the pop group the Beatles. It was described as groundbreaking and featured the psychedelic images and stylized movement that influenced commercial design for many years. The film inspired a reemergence of **feature-length** animation, which helped the **Disney Studio.** The success of *Yellow Submarine* led Disney to reissue *Fantasia*, which it described as "the ultimate visual experience," to reach the youth market who would be interested in the psychedelic nature of the imagery.

– E –

EASTERN EUROPE. The historical divide of Eastern and **Western Europe** has been varied and is largely geopolitical, particularly since the end of World War II. The majority of the animation produced in Eastern Europe has been postwar; however, there were a few notable exceptions. Istrán Kiszly Kató was considered to be the father of Hungarian animation, making cutout animated **cartoon** news films in 1914. He moved on to producing **short** films and animated **advertisements.** In 1928, a school for art of promotion was set up and from it emerged a new studio, founded by former students Gyula Macskássy and János Halász in 1932. They produced over 100 animated advertisements using various techniques, though János Halász moved to England and became **John Halas**, and György Marczincsak became

George Pal. Few of the artists remained in Hungary and the industry
lacked an identity or an audience until after the war.

In Yugoslavia, **Zagreb** would be the defining studio and later
school of animation throughout the postwar years. The Bulgarian
state-run film studio started its animation division in 1948. The first
Bulgarian animation was by Dimitar Todorov-Jarava, *It's His Own
Fault* (1949), followed by *Wolf and Lamb* (1953) and the first color
film, *Woodland Republic* (1954). **Puppet** animator Dimo Lingurska
made his first film, *The Terrible Bomb*, in 1951 and set the ground-
work for the industry, though there was a lack of funding and the
animation was fairly crude. Todor Dinov is considered to be the
father of Bulgarian animation; he studied under Soviet animator Ivan
Ivanov-Vano. His first film was *Marko the Hero* (1955), though his
career was short-lived due to **political** interference.

Ladislas Starevitch (1882–1965), though born in Russia (and
included in the **Soviet Union** entry), was born to Polish parents
and is often claimed as a Polish animation pioneer for his puppet
animation. There was no organized animation industry in Poland
until after World War II, and what there was, was considered to be
less "serious" than live-action film. Zenon Wasilewski, a prewar ani-
mator, wanted to finish a film he had started in 1939 that had been
interrupted by the war, and moved to Lodz where he established an
animation company, which later became the well-known puppet stu-
dio Semafor. A drawn-animation studio was established in Katowice
in 1947 though the ruling communist government kept a close eye on
the productions. It followed the Soviet model, which was dominated
by **propaganda** and folk tales, though training was available. This
training led to Witold Giersz's debut in 1956, *The Mystery of the Old
Castle*, and *Little Western* (1960). The duo Wlodimierz Haupe and
Halina Bielinska made Poland's first feature animation, the puppet
film *Janosik* (1954). This was followed by *Changing of the Guard*
(1959), which won the Palme d'Or at the Cannes Film **Festival**. In
1955, the Arsenal Art Exhibition in Warsaw featured Polish **fine art**,
which was very different from the usual "social **realism**." It proved
to be very inspirational to Jan Lenica (1928–2001) and Walerian
Borowczyk (1923–2006), who went on to collaborate on several
films. The Polish state restrictions were gradually relaxed and new
studios emerged such as Studio Miniatur Filmowych, making short

films by young artists. Lenica and Borowczyk made five films together in the late 1950s. The pair later went their separate ways but had brought a new sense of graphic design to Polish animation. Two of Czechoslovakia's most notable animators, **Jiri Trnka** and **Karel Zeman**, are featured in their own entries, both creators of groundbreaking puppet animation.

Bulgarian animation took off in the 1960s and became one of the most creative studios in Eastern Europe, the Sofia Animation Studio. Joining Todor Dinov were Zdenka Doycheva, Pencho Bogdanov, Radka Buchvarova, and Roman Meitzov. The studio was divided into two sections headed by Donio Donev and Stoyan Dukov, who brought morality and humor to the animation, seen in Donev's popular *Three Fools* series and Dukov's *The Blackest Mouse* (1971).

The Hungarian film industry nationalized in 1948 and animation slowly came with it, though only a few films were made initially. *The Little Cock's Diamond Halfpenny* (1951) by Gyula Macskássy and Edit Fekete was made for children and was the first Hungarian film in color. The 1950s saw the development of the Pannonia Film Studio under the guidance of Gyorgy Matolcsy. It gained international attention in 1960 with the award-winning *Pencil and India Rubber* and *Duet* by Gyula Macskássy. Jósef Nepp's *Passion* (1961) was the first animation to move from folk tales to feature contemporary issues. In the 1960s, the **television** series *Gustavus* was sold to more than 70 countries from 1964 into the 1970s, consisting of over 160 episodes. Ambitious shorts and good new animators coming through brought a new dark humor to much of the animation produced. In 1968, economic reforms led to the studio having to find its market. In the 1970s, Pannonia continued to create shorts and television animation. One of the most successful animators of the 1960s and 1970s, Marcell Jankovics released *Deep Water* in 1971, *The Fight* (1977), which won the Palme d'Or at the Cannes Film Festival, and *The Son of White Mare* (1980). Throughout the 1970s and 1980s, television production reached new heights and saw 20 features produced, with many new talented animators such as Csaba Varga, Ferenc Cokó, and Gyula Nagay. In 1986, Pannonia Cartoon and Animated Film Studio became an independent company, Pannonia Film Company, with artists holding rights to their work, though they also had to face new competition from the new Varga Studios.

Poland in the 1980s saw the emergence of two notable animators, Zbigniew Rybczynski (1949–), who won an **Academy Award** for Best Animated Short with *Tango* (1981), and Piotr Dumala (1956–), whose notable works include *The Black Hood* (1983) and *Freedom of the Leg* (1989).

After a decline in Bulgarian animation production in the 1970s, there was a comeback in the 1980s with Anri Kuler's *Labyrinth* (1984), Nikolai Todorov's *Successful Test* (1984), Boyko Kanev's *A Crushed World* (1986), and Pencho Kanchev's *Romance of the Wind* (1986).

All of the Eastern European animation industries encountered some difficulties after the collapse of the Soviet Union and communism in 1991, but Poland, Hungary, Bulgaria, Zagreb, and the newly "European" Estonia found success in television animation and international collaboration, and continually supported emerging new talent.

In Prague in the 1990s, the fall of communism led to a lack of guaranteed work for the animation industry. However, one studio that managed the change was Kratky Film's Brati v Triku. U.S. émigré **Gene Deitch** helped the studio's continued success over the years, bringing in many international clients. The studio production included the **adaptation** of Dutch author Dick Brunna's *Miffy* stories.

ENCHANTED DRAWING, THE. **J. Stuart Blackton**'s first film, *The Enchanted Drawing* (1900), was presented as a vaudeville lightning sketch. The film shows Blackton standing at a blackboard on which he draws a man in a top hat and proceeds to interact with him. He draws a glass of wine and the man smiles but Blackton "removes" the glass and drinks from it himself and the man frowns. Blackton then gives him a cigar and he happily puffs smoke, which appears onscreen. There is no animation as such, it is a trick film but it is worthy of inclusion as it was influential in the development of animation, not least in Blackton's next film, *Humorous Phases of Funny Faces* (1906).

ENGEL, JULES (1909–2003). Born in Budapest, Hungary, Engel moved to the **United States** as a child and grew up in Illinois. He

moved to Los Angeles in 1937 hoping to attend one of the universities but ended up working as an assistant to a local artist, drawing landscapes. Engel moved into animation through **Charles Mintz** at **Screen Gems** and was hired by **Walt Disney** in 1938 to choreograph a sequence in *Fantasia*. He continued with Disney, where he worked as a colorist and on the storyboard for *Bambi* (1942). During World War II, Engel worked on army training films with Hal Roach and many other Hollywood animators.

Engel cofounded **United Productions of America** (UPA) after the war and was involved in the development of *Gerald McBoing Boing*, *Madeline*, and *Mr. Magoo*, among others. Engel left the studio in 1959 and, with former UPA colleagues Herb Klynn and Buddy Gezler, formed Format Films and produced several popular **television** series. He was also a painter and after 1945 had several exhibitions of his work, which was said to have been inspired by modernist artists Wassily Kandinsky and Piet Mondrian.

In 1962, Engel moved to Paris and directed *The World of Sine* and codirected *The Little Prince*. He also directed his first live-action film, *Coaraze* (1965), which was award winning. He returned to America, where he directed both live-action and animated films, winning several awards; in 1968, he created the first experimental animation program at the **California Institute of the Arts**, which he directed from 1970 to 2001. He was an inspirational teacher and taught several well-known animators, including **Henry Selick** and **John Lasseter**.

– F –

FAMILY GUY. This **anicom**, which airs on the Fox network in the **United States**, was created by Seth McFarlane (who also voices many of the characters). The series is similar in its domestic **sitcom** structure to *The Simpsons* with a family of 2.5 children. The family consists of Peter Griffin, an overweight buffoon, though far more grotesque than Homer Simpson; his wife, Lois; and their children, Chris, Meg, and baby Stewie. The main differences are Stewie, who is something of a megalomaniacal figure intent on killing his mother,

and the family dog, Brian, who walks upright, talks, and has a very high IQ and love of culture. The show began airing in 1999 but was cancelled in 2002. After a campaign by fans and strong DVD sales (as well as successful rerun airings on **Cartoon Network**'s **Adult Swim** slot), Fox recommissioned the series in 2005, and the sixth season began in 2007. The **comedy** is lowbrow and focuses largely on parody and a satire of U.S. culture, specifically **television** and film.

In 2005, McFarlane released *American Dad*, similar in style to *Family Guy* but the father is a Secret Service agent, and instead of a talking dog, the family has an alien living with them. The premiere of the sixth season of *Family Guy*, which aired in September 2007, presented the characters in an hour-long edited version of the **science fiction** epic *Star Wars*. Titled "Blue Harvest," the episode was released on DVD.

FAMOUS STUDIOS. Company formed in 1942 out of the previous Fleischer Studio, which Paramount Pictures had foreclosed on. The brothers were forced out and Paramount took the existing staff back to New York, from Miami, where the studio had relocated. Paramount's original company name was Famous Players, so they renamed the Fleischers' studio as Famous Studios. The quality of the Fleischers' work was retained and the business was initially doing well until Paramount backed out of series production, leaving Famous in a rut. After the 1943–1944 movie season, all Famous **cartoons** had to be made in Technicolor, including **Popeye**. As a result, the **Superman** series was dropped and the studio introduced *Little Lulu*, another **adaptation** of a popular comic strip. This proved to be very successful for the studio and the cartoons were increasingly aimed at the children's market. Several of the Fleischers' old films were reworked to create more output. The series *Casper the Friendly Ghost* did well on **television** and in 1956 Famous was dissolved and the name was changed to **Paramount Cartoon Studio**. *See also* FLEISCHER BROTHERS.

FANTASIA. **Walt Disney**'s most sophisticated work, which consisted of the illustration of eight pieces of classical **music**, was released in 1940. Despite the ambitious scale and scope of the project as well as

the length of time the project took to complete, the film failed at the box office; it was suggested that the music and images clashed. **Oskar Fischinger** was known to have created drawings used by the animation team, though he was not credited because he had left the studio. Among the other staff on the film were Preston Blair as animator and **Jules Engel** on choreography. The segment entitled *The Sorcerer's Apprentice*, which starred **Mickey Mouse**, was made first (1938) and treated as special and separate to the Mickey Mouse **shorts**. Leopold Stokowsky, a celebrity conductor, was brought in to collaborate on the project and create what was originally titled "A Concert Feature." However, theaters were not equipped to play the "Fantasound" soundtrack, which was considered a unique experiment within the industry. Fantasound was a stereo sound system developed by the studio to create a dimensional sound environment. The music selections used in the film included *Toccata and Fugue in D Minor* by Johann Sebastian Bach, *Nutcracker Suite* by Pytor Ilyich Tchaikovsky, *The Rite of Spring* by Igor Stravinsky, *Pastoral Symphony* by Ludwig van Beethoven, *Dance of the Hours* by Amilcare Ponchielli, *Night on Bald Mountain* by Modest Mussorgsky, *Ave Maria* by Franz Schubert, and *Claire de Lune* by Claude Debussy (though this was recorded but not used).

Audiences were divided; the masses were put off by "highbrow" connotations, and the result was a commercial failure. There were also problems due to the war and the loss of the European market. When *Fantasia* was reissued in 1969, the film did better with youth audiences, partly due to the previous success of **George Dunning**'s *Yellow Submarine*. In the late 1970s and early 1980s, management changes at Disney saw a rerecording of the soundtrack with Leopold Stokowsky and the commentator.

The 50th anniversary edition was reissued in 1990 with the original "Fantasound" soundtrack. The film was also re-released, after being remastered in 2000, in an original "uncut" version featuring all of the elements that had previously been cut in 1942 and 1946; it was the full 124-minute 1940 version.

FANTASMAGORIE. Fantasmagorie (1908) was the first animated film in **France**, made by French filmmaker **Émile Cohl**, and was first shown at the Théâtre du Gymnase on 17 August 1908. There

is little narrative in the film; rather, it is made up of sequences that morph into each other. However, they actually move across the screen, animated, unlike **J. Stuart Blackton**'s *Humorous Phases of Funny Faces* (1906), which used **stop motion** as more of a trick film. *Fantasmagorie* was made up of 700 drawings on an illuminated plate; the black lines were filmed on paper and printed in negative so it looks like a chalkboard. This is considered by many historians to be the first fully animated film.

FEATURE LENGTH. A longer form of animation, with a typical running time of over 40 minutes (though commonly lasting over an hour) that is shown theatrically as the main feature, unlike the **short**, which was historically packaged as part of a film bill, or lined up and shown alongside the live-action main feature. One of the first feature-length animated films came out of Europe with **Lotte Reiniger**'s silhouette-puppet-animated *The Adventures of Prince Achmed*, which was released in 1926.

The first **U.S.** feature-length animation was **Disney**'s *Snow White and the Seven Dwarves* (1937), and the success of this film led to the development of more features from the studio with its next feature, *Pinocchio*, in 1940. In the meantime, the **Fleischer brothers** entered the market with their adaptation of *Gulliver's Travels* in 1939. The first British feature-length animation was **Halas and Batchelor**'s *Animal Farm* (1954), though Disney continued to dominate the market.

In 1972, **Ralph Bakshi** directed the first ever X-rated animated feature for adults, *Fritz the Cat*, which he followed up with *Coonskin* (1975). **Hanna-Barbera** contributed to the feature market in 1974 with *Charlotte's Web*, adapted from the popular children's book, though it later produced feature-length versions of its **television** series. The use of **adaptations** continued to be popular with *Watership Down* in 1978.

Over the years, Western audiences lost interest in the form, though they continued to be produced. The **Japanese** market continued to include feature-length and television animation, and *Akira* (1988) proved that there was an audience for **anime** in the West as well as **science fiction** animation in feature length, and was very successful. In 1994, Disney released *The Lion King*, which was so successful it

essentially recaptured the studio's previous success, which had been declining. This also marked a resurgence in the popularity of feature animation and was reinforced with the release of the hugely successful *Toy Story* in 1995.

Pixar became dominant in family feature animation over the next few years, though television series and short-form spin-offs saw the production of *Beavis and Butthead Do America* (1996), *South Park: Bigger, Longer and Uncut* (1999), and *Wallace and Gromit: The Curse of the Were-Rabbit* (2005). The release of *Shrek* (2001), which parodied fairy tales and animation, was so successful that it spawned two sequels and several imitators. However, in recent years the attempts by studios to enter the market have resulted in some poor-quality films. The increasing use of **computer-generated imagery** (CGI) in animation made it easier for filmmakers to produce features but also led to an increase in lifelike representations of people in films such as *Final Fantasy: The Spirits Within* (2001) and *The Polar Express* (2004). These films have been criticized for the animation that is not entirely successful in capturing the human actor, and instead lends an uncanny or unsettling quality to the performance.

FELIX THE CAT. Felix was a popular **cartoon** character from the **silent era**. The name was coined by John King, who liked the contrast of "felix" for "felicity" with the tradition of superstition of black cats. The character was created by **Otto Messmer** at Paramount Pictures for **Pat Sullivan**, who had hired Messmer and encouraged him to create something for the studio when other animators were very busy. The first episode of **short** films he appeared in was *Feline Follies* (1919), but he was officially named in his second appearance in *Musical Mews*. Sullivan was the producer of the films and his name appeared on the title as Felix's creator. The success of Felix led to Sullivan leaving Paramount in 1921 and starting his own company, with the distribution of his films by successful distributor Margaret J. Winkler. The films were then released on a monthly schedule, the next one being *Felix Saves the Day* in 1922. Sullivan promoted the films heavily and Felix became very popular in **Great Britain** as well as in the **United States**. The character was merchandised and was featured in a comic strip that Messmer drew.

Felix had a distinct personality and a slightly pensive walk with his head down and his hands clasped behind his back. His tail could turn into a variety of tools, such as a baseball bat, a telescope, or a fishing hook, among others. He was described as, and probably modeled on, the "Charlie Chaplin of cartoon characters" and even met the actor in *Felix in Hollywood*, in which he was accused of stealing Chaplin's material. The cartoon was self-reflexive and saw Felix using his paycheck from Sullivan's studio and going to the movies, only to see himself on the big screen and talking back to his animator.

The success led to an increase in production to 26 a year, and in 1923 Bill Nolan was brought in to help the production; he left in 1925 and was replaced by **Raoul Barré** (who then left in 1927). These cartoons from the late 1920s were described as sophisticated in humor and technique. For example, in *Comicalamaties* (1928), the animator forgets to fill in Felix's body and so the cat fills himself in with boot polish, interacting with the animator.

Once sound emerged in film, the production ended, as Sullivan was unimpressed by the technology and did not want to make the transition; this led to a decline in Felix's popularity. Sullivan had many personal problems with his business and, when he died in 1933, his affairs had not been organized and Messmer could not carry on with the character. There was a brief revival by the **Van Beuren** studio in 1935, but it only produced a few films. Felix did, however, live on in cartoon strip form for another 25 years.

FESTIVALS. Animation festivals play an important role in the industry, particularly for independent animators who do not distribute their work in mainstream venues. Festivals provide the opportunity to reach new audiences and share new work and techniques with peers and critics. They are often the first exposure for filmmakers and can lead to more work and potential success. Though many film festivals include animation sections and accept animation in their programs (such as Cannes, Toronto, and Edinburgh), the first festival dedicated solely to animation was the Annecy International Animation Festival. Annecy was first launched in the French town of the same name in 1960 and was held biennially, though this changed to annual in 1998. It is still regarded as one of the most important festivals in the animation

industry calendar. Another major festival is the World Festival of Animated Films, held in Zagreb (known generally as the Zagreb Festival), which was first held in 1972, again biannually. In 1976, the Ottawa International Animation Festival became the first North American festival and has also become a major part of the festival circuit; it was held biennially until 2004 when it became an annual event. In **Japan**, the International Animation Festival of Hiroshima began in 1985 and is held biennially.

Other international festivals of note include Anima Mundi, Rio de Janeiro and Sao Paolo, Brazil; Holland Animation Festival, Utrecht, **Netherlands**; **Cartoons** on the Bay, Positano, **Italy**, which specializes in **television** animation; Fantoche International Animation Festival, Zurich, Switzerland; and BAF, Bradford Animation Festival, in Bradford, **Great Britain**.

Alternative festivals began to appear in North America as touring festivals in the 1970s, including the International Tournee of Animation, which became Expanded Entertainment in the mid-1980s (though it only lasted until the 1990s). Spike and Mike's Festival of Animation also emerged in the 1970s, and became well known for its "Sick and Twisted" program, which it is often known by. Most festivals have an opportunity for members of the public to view screenings, often accompanied by discussions and lectures, as well as an awards ceremony for achievements in the field.

FILM ROMAN. Animation studio based in Hollywood, California, that animates the **television sitcoms** *The Simpsons* and *King of the Hill*, though some of the animation is done overseas in **Korea**. The animation is an example of contemporary **limited animation**, though they have higher production values for the technique than when it was heavily used in 1960s television.

The studio was founded in 1984 by Phil Roman and is part of Starz Media Company. The studio has won several awards, including 20 Emmy awards, several Annie awards, a Grammy, and a **Music Television** music video award. The studio produces a range of other animated series for television, including *Garfield* and *X-Men Evolution*. It also produces visual effects for live-action television series, including *Law and Order*, effects for studio features (*I, Robot*, 2004), and music videos and commercials.

Previous animated sitcoms also produced by the studio are *The Critic* (1994–1995), **Family Guy**, three seasons of **Futurama** for 20th Century Fox, and *The Simpsons Movie* (2007).

FILMATION. U.S. animation studio founded in 1962 by Lou Scheimer and Norm Prescott specializing in **documentary** and **advertising**. In 1965, it began producing animation series for Saturday morning **television**, including *Superman*, *The Archies*, *The Brady Kids*, and *Gilligan's Planet*. The studio also produced *Fat Albert and the Cosby Kids* (1972–1979) and *The New Fat Albert Show* (1979–1984) starring Bill Cosby.

Filmation produced an animated version of the live-action **science fiction** series *Star Trek* that featured much of the original cast and writers. It used **rotoscoping** and frequently reused the backgrounds, which saved money and time. The studio is perhaps best known for the 1980s series *He-Man and the Masters of the Universe* (1983–1985), which brought renewed success to the studio and a spin-off series two years later, *She-Ra, Princess of Power*. The series was popular in part due to collaboration with the toy company Mattel, which produced a line of toys based on the characters. The show was criticized as a veiled advertising campaign by parent groups, but the studio countered this by inserting moral lessons in each episode. The company employed an exclusively American workforce, not outsourcing the animation to East **Asia** as many other companies did.

The studio changed ownership many times until it was finally purchased in 1988 by L'Oreal and closed in 1989. Since then, a variety of companies have secured the rights to redistribute the old series on VHS and DVD, including *He-Man* in **Great Britain**.

FINAL FANTASY: THE SPIRITS WITHIN. Directed by Hironobu Sakaguchi, creator of the long-running, multiplatform **science fiction** video-game series *Final Fantasy*, on which the feature was based. *FF: TSW* was codirected by Moto Sakakibara and released in 2001. The film is set in the year 2065 A.D. on an alien-infested planet Earth with humans facing extinction. The lead character, Aki Ross, is guided by her mentor, Dr. Sid, and an odd dream that holds clues to saving the human race. Ross must collect spirits who will create a force strong enough to fight the alien Phantoms.

FF: TSW was the first animated feature to try to fully re-create **computer-generated** humans. The result was technically brilliant but fans of the game series did not recognize the story, which was outside their cannon. Likewise, critics and animators were unimpressed by the result, particularly the close-up human features that engendered an uncanny or unsettling feeling in the viewers. *See also* JAPAN.

FINE ART. Despite common misconceptions that **cartoons** are merely popular culture or children's entertainment, there are numerous animators who produce distinct works that can be considered to be, and are often inspired by, fine art. This perception of animation as a children's entertainment form is largely in part due to the great success and dominance of the **Disney Studio** with its largely **comedic** and family films, which are generally taken less seriously than fine art.

Many independent animators have worked as fine artists for years, using various media combined with animation to develop their visions and explore movement; these have perhaps been less well known in the mainstream, which has led to the dismissal of the form. In the 1920s and 1930s, experimental artists in Europe such as Marcel Duchamp (*Anemic Cinema*, 1927), **Hans Richter** (*Rhythmus 21*, 1921), **Walther Ruttmann** (*Lichtspiel Opus I*, 1921), and Fernand Léger (***Ballet Méchanique***, 1924) used animation techniques in conjunction with their other work. **Oskar Fischinger** was a producer of experimental animation as well as a painter, and would use some of his painting techniques in his films.

Animation is increasingly being considered as an art form within the animation industry as well as gradually without. It is developed by art galleries displaying animated films, as well as being used more within art; as such, the boundaries of the forms have become blurred.

FISCHINGER, OSKAR (1900–1967). Born in **Germany**, Fischinger worked as a technical artist in Frankfurt and was inspired by **Walther Ruttmann**'s *Opus I* in 1921 and began making **abstract** films. He moved to Munich in 1922 to become a full-time filmmaker, establishing a production company, where he produced animated **shorts**. However, after some financial problems, he closed down and moved to Berlin in 1927 and began producing abstract animation synchro-

nized to classical **music**. These "studies" were shown in Europe, **Japan**, and the **United States**, and Fischinger's work came to be in demand. By 1932, he had established Fischinger Studios with his brother, wife, and three other employees.

Fischinger pursued the abstract relationship to music and began to use a three-color process, completing his first color film, *Kreise*, in 1933. He attracted acclaim and was offered a contract with Paramount Studios in America in 1936. He then moved to **Metro-Goldwyn-Mayer** (MGM) in 1937 and later the **Disney Studio** from 1938 to 1939, where he worked on *Fantasia* (1940), though at the time he was not credited for his contribution to the film. Fischinger continued to paint, as he was frustrated at not being able to produce independent films in Hollywood. He came under the patronage of Hilla Rebay, curator of the Guggenheim Foundation, who provided him with grants during the war. *Motion Painting No. 1* (1947) was one of his most famous films, using the music from Johann Sebastian Bach's *Third Brandenburg Concerto*. He used a technique of painting on Plexiglas. However, he was never able to secure enough funding to produce another finished work and spent the last 20 years of his life experimenting with, but never completing, another film.

Fischinger's work inspired the **Whitney** brothers, among others, particularly regarding his experimental techniques such as oil paint on glass and wax strata cut. He was also said to have been interested in science, particularly physics, philosophy, and Tibetan Buddhism.

FLASH. Computer animation software developed in 1996 by Macromedia (which was taken over by Adobe in 2005), Adobe Flash is increasingly being used in animation, particularly in **Web animation**. The software is described by the producer of the software as an "authoring environment for creating interactive content for digital, web and mobile platforms." It allows amateur animators to make and display films without expensive technology and equipment. The format is easily distributed through the Internet. A recent example of Flash used in **television** was in the animated **sitcom** *Home Movies* (1999–2004), which produced a very smooth and stylized look. Another good example is in the Web animation *Homestar Runner* (2000), and it has been suggested that there are **feature-length** films being made in Flash.

FLEISCHER BROTHERS. Max Fleischer (1883–1972), the second son of a Jewish family who moved to New York in 1887, was interested in drawing and small mechanical inventions. He invented the **rotoscope** (around 1915) and collaborated with his brothers Dave and Joe. The patent became active in 1917. The brothers showed a **short** sample film to **John R. Bray**, who hired Max and Dave. Max worked on military films during World War I and in 1919 he created a series, *Out of the Inkwell*, which starred *Koko the Clown* (Dave posed in a clown suit for the image). The format was the standard of the time; Max the artist who would create Koko from his inkwell, and Koko would live in the drawn world and try to play tricks on his creator. In 1921, the brothers left Bray and founded their own studio, which was second only to the **Disney Studio** in the **United States** (worldwide until 1942). The studio was a family business with Dave (1894–1979) second in command as artistic director, after Max. The remaining brothers—Charles, Len, and Joe—participated in the company at various times over the years.

In 1924, economic expansion of Out of the Inkwell Studio led Max to found Red Seal Distribution Company to circulate the *Koko, Song Car-Tunes*, **documentaries**, and live-action series, but the company only lasted for two years and Paramount Pictures took over distribution. In 1928, the production company was renamed Fleischer Studios. *Song Car-Tunes* with the *Bouncing Ball* and their educational films did well. The styles of films varied with the animators and studio hierarchy.

The Fleischers' found great success with their **Betty Boop** films, particularly *Minnie the Moocher* (1932) and their new *Popeye* (1933) series. Max's technique of shooting with a great depth of field preceded **Walt Disney**'s **multiplane camera** by two years. In 1939, they produced *Gulliver's Travels*, which was the second **feature-length** animation (after Disney's *Snow White and the Seven Dwarves*).

Until the mid-1930s, the studio lacked a story department and the animators created their own stories; Dave would sign off each one as director. Evolution within the studio was casually paced, especially the transition to sound. In 1937, it faced a strike, the first in a U.S. studio, which led to nine months of intransigence on both sides. Max left New York to move the studio to Florida, where he worked on *Gulliver*. Its second feature, *Mr. Bug Goes to Town* (1941), was re-

jected by the public and contributed to the financial ruin of the studio. The *Superman* series was released, though the unprecedented high budgets of $100,000 per episode were nearly four times the amount spent on comparative **cartoons**. The result was a very impressive series that borrowed heavily from comic book graphics and **modernist abstraction** but retained a sense of **realism**.

Due to insolvency, the studio was acquired by Paramount Pictures in 1942 and Max was dismissed, Dave having left earlier due to a dispute with his brother. The studio was renamed **Famous Studios** and returned to New York, where production continued on *Popeye* and the Fleischers' *Superman* series.

Dave was hired by Columbia for **Screen Gems** and replaced **Frank Tashlin** as production supervisor, but left in 1944. He went to Detroit to make commercials and educational films for the Jam Handy Company, and in 1961 he participated in the production of a new *Out of the Inkwell* series with a former colleague.

FLINTSTONES, THE. The *Flintstones* was produced by **Hanna-Barbera** and premiered in 1960 on the **American Broadcasting Company** (ABC) network and was the first animated **sitcom**, or **anicom**, as well as the first to air in prime time, for a family audience. The show originally ran for six years, though there were a number of spin-off series and **feature-length** movie-style episodes in later years.

The main plot follows husband and wife Fred and Wilma Flintstone, and their neighbors Barney and Betty Rubble, in the same domestic sitcom structure as the live-action series *The Honeymooners*, which was said to have influenced the show, but transposed into a Stone Age, prehistoric setting. Like many live-action sitcoms of the time, such as *The Honeymooners* (1955–1956), *I Love Lucy* (1951–1961), and *The Burns and Allen Show* (1950–1958), the narrative of many of the episodes focuses on male versus female power struggles. As well as the supporting characters, such as Fred and Barney's boss, Mr. Slate, and Wilma's mother, there was another key member of the Flintstone household: the pet dinosaur, Dino. The series incorporated references to social issues of the time with consumerism, fame and celebrity, new technology and popular culture, and the rise of **television** all included in the storylines. Many of the gags in the series were visual and puns on prehistoric versions of "new" household gadgets

that typified the 1950s and 1960s. There were later additions to the show, with Fred and Wilma having a child, Pebbles, and Barney and Betty adopting their son, Bamm-Bamm. When the children were introduced, they became a major part of the episodes with less of a focus on gender power struggles. Toward the end of the run, Fred was joined by the Great Gazoo (created by **Iwoa Takamoto**), an alien whom only he could see or hear, and this marked a clear decline in the series.

As well as following the generic conventions of the sitcom, the show also appropriated features of other forms such as the use of slapstick and parody as well as **anthropomorphism**, traditionally used in theatrical animation but unlike anything seen in live-action sitcom. These features of the anicom, as demonstrated in *The Flintstones*, provided a template for the animated series and would be used to great success with *The Simpsons* in 1989.

FLIP THE FROG. Character created in 1930 by **Ub Iwerks**, who had previously been a producer and animator with the **Disney Studio**. *Flip the Frog* appeared in a series of **cartoons** featuring Flip as a caricature frog who wore a bow tie and had buttons on his chest. The films were distributed by Celebrity Productions. The first film to feature the character was *Fiddlesticks*, though he does not speak but dances, and the film was in two-color Technicolor. Producer Pat Powers was unhappy with the films, and the design of Flip was modified to be less froglike and more **anthropomorphic**, like **Mickey Mouse**. Powers sold the films to **Metro-Goldwyn-Mayer** (MGM) to distribute. The character was never as successful as Mickey, as the style was seen as lacking in **comedic** timing. Thirty-seven **shorts** were produced in total until 1933.

FRANCE. The origins of animation can be traced largely to France, where French pioneers of the moving image such as **Émile Reynaud** and the Lumière brothers, among others, began experimenting and demonstrating their new technologies. **George Méliès'** use of stop motion in *A Trip to the Moon* in 1902 and **Émile Cohl's** *Fantasmagorie* (1908) are among the earliest animation. The early industry was largely driven by **advertising**, but in the 1930s and 1940s animators began experimenting with techniques, producing **shorts**.

Jean Delaurier, who often collaborated with other artists, made *Un concours de beauté* (*A Beauty Contest*) in 1934 with Alain de Saint-Ogan and *Meunier tu dors* (*Miller, You Are Sleeping*, 1931) with Jean Varé. **Fine artist** Fernand Léger experimented with filmmaking and animation to create his influential work ***Ballet Méchanique*** (1924), demonstrating the potential for animation to be used as art.

Animation techniques developed in France when Russian-born Alexandre Alexieff moved to Paris and began experimenting with a pin screen device. *Night on Bald Mountain* (1933) used the painstaking device to create the light effects of the animation. After World War II, he was asked to produce films for the **National Film Board of Canada** (NFB), including *En Passaut* (1943), and the pin screen was used effectively again in *Le Nez* (1965). Painters and illustrators also began experimenting with animation, including André Marty (*Calisto, la petite nymph de Diane*, 1943) and Albert Dubont, who created a series based on his comic strip "Anatole" and was assisted by animator Jean Junca. The film was made during World War II and distributed in 1947.

A key postwar French animator was Paul Grimault (1905–1994) who formed a studio with André Sarrut in 1936. Their studio, Les Gémeaux, produced hand-drawn animation until Grimault was drafted into the war. In 1941, he returned to the studio and in 1943 released *L'Epouvantail* (*The Scarecrow*), which was well received. He joined Jacques Prévert to produce an **adaptation** of Hans Christian Andersen's *The Little Soldier* (1947). Due to differences in the studio, Grimault founded his own in 1951, Les Films Paul Grimault, producing animated advertisements. In the late 1970s and into the 1980s, he returned to producing films, including *Le Roi et l'oiseau* (*The King and the Mockingbird*, 1980), which many consider to be his finest work. His contemporary Jean Image had come to work in France from his native **Hungary** (given name Imre Hajdu, 1911–1989). Image had moved around Europe, including a time in **Great Britain** in 1936, before moving to Paris where he initially worked under his given name. He changed it in 1944 and produced *The Black Plays and Wins* (1944) and *Saturn Rhapsody* (1946), and later he produced the award-winning *Johnny the Giant Killer* (1950). A former collaborator of Grimault, Henri Lacam (1911–1979), made *Les Deux Plumés* (1957) and *Jeu de cartes* (1960). Other notable

animators of this period are Albert Champeaux and Pierre Watrin, who collaborated on several productions such as *Paris-Flash* (1958) and *Villa mon rêve* (1960).

The interest and enthusiasm for animation in France increased in the 1950s and saw the creation of **Association Internationale du Film d'Animation** (ASIFA) and the Annecy **Festival** (second only to Cannes in France). In the 1960s and 1970s, traditional French animation styles remained but new directions in the 1980s saw diversity in productions from animators such as André Martin, Michel Boschet, Jacques Espagne, and Jacques Vausser. A prominent studio in this period was Idéfix, founded by René Goscinny, cocreator of the extremely popular *Astérix* series of comics, which led to the successful animated **feature-length** adaptation, *Astérix le Gaulois* (1967); this was followed by several others over the next 20 years. Artist René Laloux (1929–2004) produced animation based on the work of patients at a workshop in a private psychiatric clinic. This work led to other projects, including *La Planète Sauvage* (*The Savage Planet*, 1973), a **science fiction** film that took three years to complete.

During this time, a new generation of artists had emerged, including Paul Dopff, who released several films with his company, Pink Splash Productions. Bernard Palacios directed *Le cagouince migrateur* (*The Migratory Cagouince*) in 1971 and *Les trouble fêtes* (*The Kill-Joys*) in 1979, among others. Michel Ocelot became successful in the 1980s (and continues to be) with such films as *Les trois inventeurs* (1980) using cutout paper, and *La Princesse insensible* (*The Insensitive Princess*, 1984), a series of five 5-minute shorts. Christophe Villard demonstrated a new dynamic style of animation using graphic line drawings in his films such as *Le rêvoeil* (*The Dreaming Eye*, 1980), *Conte à rebours* (*The Tale of the Cantankerous One*, 1981), and *Néanderthal* (1983).

In the early 1980s, the French government injected some much-needed aid into a somewhat faltering industry. It founded OCTET, a state organization to act as an intermediary between animators, sponsors, and technology. Alongside this were plans to create computer animation for **television** and establish industry standards, as well as decentralizing production. Though not always thriving, the industry was able to become better established and develop with new technology, and increasingly produced animation for television. One of the

most profitable studios, DIC, was founded by Jean Chalopin and operated in the **United States** and **Japan**. The company began by animating advertisements and, as it grew more successful, moved to Paris and became more ambitious in its productions. They made several very successful television series, including *Ulysses 31* (made in Japan) and *Inspecteur Gadget* (coproduced with the United States), before they eventually moved to Los Angeles.

Other key animators from this period were Jean-François Laguionie, who worked with Paul Grimault, Polish-born Pietr Kamler, and fellow Pole Walerian Barowczyk, both of whom immigrated to France and found fame in the French animation industry. In recent years, **Sylvain Chomet**'s success has brought new international attention to the French animation industry, though the animator has established his studio in Scotland.

FRELENG, FRIZ (1906–1995). Born Isadore "Friz" Freleng in Missouri (there are some discrepancies regarding the year of his birth, some sources state 1905 and some 1906), he began his animation career with **Walt Disney** in the **silent era**, working on *Oswald the Lucky Rabbit* in 1927. Freleng worked with **Harman-Ising** in 1928 drawing character layouts for **Warner Brothers** on their *Merrie Melodies* series. He then went to work for **Leon Schlesinger**, though in 1937 he left Warner to work at **Metro-Goldwyn-Mayer** (MGM), before coming back to Warner Bros. in 1939, where he remained until the animation section was closed in 1963. Freleng worked with **Hanna-Barbera** in 1962 on a **feature-length** *Yogi Bear* film. He directed over 300 **cartoons** with Warner, including the development of **Bugs Bunny**, and won five **Academy Awards** for his work.

After Warner's closed the department, Freleng began working with artist David DePatie and they formed a partnership that lasted until the 1980s. They leased Warner's studios and produced new theatrical cartoons under the Warner banner until 1964 (50 cartoons). However, these were not very successful and they finally moved away from Warner Brothers in 1967. They were commissioned to produce the title sequence for Blake Edwards' live-action movie *Pink Panther* (1964). This then led to a *Pink Panther* **television** series that included *The Ant and the Aardvark* and *The Inspector*, though the quality of the production was not as high as the previous animations

Freleng had worked on and he was reported to have not been keen on the series; however, he produced it through the 1970s and into the 1980s with occasional specials. Freleng also directed television specials for Warner Bros. in the late 1970s and a Bugs Bunny feature, *Bugs Bunny's 3rd Movie: 1001 Rabbit Tales*, in 1982.

***FRITZ THE CAT*. Feature-length** animation released in 1972 directed by **Ralph Bakshi** and produced by Steve Krantz. The film was based on Robert Crumb's underground comic book featuring the titular cat and included all of the drug taking and sex that the comic contained. It was the first X-rated **cartoon** feature and Crumb was said to have disliked the film. The film was described as a vibrant personal statement of life in the 1960s that included the **political** and sexual revolution and revealed hypocritical attitudes about "good taste." Bakshi was pleased with the strong reactions to the film, as he felt that they ignored the fact that it was animation and only commented on the content. This was taken as a compliment on the animation, as he wanted to make a feature that, even though it was animated, was taken as seriously as a live-action feature.

FUTURAMA. Following the success of *The Simpsons*, **Matt Groening** created a new animated **sitcom** called *Futurama*, which premiered in March 1999. The series began airing on the Fox network but after its cancellation in 2003 it moved to the **Cartoon Network** until 2007; since 2008, it has been broadcast on the **U.S.** cable channel **Comedy Central**. *Futurama* follows the structure of the workplace-based sitcom and is set in the future, with the main protagonist coming from our time, with an overall **science fiction** theme. The imagined future is much like that of the **Hanna-Barbera** science fiction sitcom *The Jetsons* with many high-tech gadgets. The animation is stylistically similar to *The Simpsons*; however, the people don't have yellow skin and *Futurama* is produced digitally.

The show follows Fry, a pizza delivery boy from the 21st century, who is accidentally cryogenically frozen and woken up at the dawn of the year 3000. Fry befriends an alcoholic robot named Bender and a one-eyed alien woman named Leela. Together they work as a delivery crew on an intergalactic spaceship that is run by Fry's "great-great-great etc." nephew, Professor Farnsworth. There are a number

of recurring characters who also work for the Planet Express delivery company, and whom the group encounters from time to time, providing an ensemble cast that can occasionally become the focus of an episode that offers some variation in the plots.

With its use of science fiction iconography, *Futurama* could be described as a hybrid **genre** combining the sitcom with science fiction and animation, like *The Jetsons* before it. The future is presented with numerous *Star Trek* references, as well as many other sci-fi references from both live-action movies and **television**.

– G –

GENRE. Animation is often wrongly considered to be a genre of film. A genre is essentially a label that categorizes the type of the product, be it film, book, or animation. The genre is largely determined by the producers and directors, who use shared characteristics to emulate success of previous products, to alert the audience to the type, and to provide expectations of what they will consume. The audience must understand what the characteristics of the genres are in order to accept new entries to the genre. Genre can work in cycles and develop new facets that producers can emulate. The most obviously cited examples of film genre are westerns, musicals, and film noir, due to clear characteristics such as location and setting, costume, and style of plot.

There are numerous genres of animation, the most obvious of which are the comedic genres of **sitcom**, sketch/variety show, and vaudeville. The **musical** is represented largely by the features of the **Disney Studio**, though these began with the music hall **shorts** such as *Silly Symphonies* and **Warner Brothers'** *Merrie Melodies* and *Looney Tunes*. **Science fiction** has a fairly long history, notably in **Japanese anime** features and **television** series, such as *Astro Boy*, *Ghost in the Shell*, and *Akira*. In the **United States**, the **Hanna-Barbera** studio began to feature science fiction with *The Jetsons*, *Jonny Quest*, *Birdman and the Galaxy Trio*, and *Space Ghost*, and latterly **Matt Groening's** *Futurama*. In **Great Britain**, **Gerry Anderson** dominated sci-fi with his *Thunderbirds* series.

Animated **documentary** essentially began with **Winsor McCay's** *The Sinking of the Lusitania* (1918). The genre tends to focus more

on representations of the real, examples of which include Peter Lord's *Going Equipped*, **Bob Sabiston**'s *Snack and Drink*, and Marjut Rimmerien's *Slow Protection*.

Although there are perhaps fewer genres of animation than in live-action film, there are examples of the fantasy genre in Japanese anime and **Eastern European** films. Indeed, the work of **Jan Svankmajer** and the **Quay brothers** could be described as horror/fantasy. Though there are dramas, they tend to be less mainstream than the dominant U.S comedies and musical films like **Ralph Bakshi**'s *Fritz the Cat*, or are generally **adaptations**, such as **Brad Bird**'s *The Iron Giant*. Genre is less considered in animation due to the long and dominant history of the **cartoon**. Similarly, the nature of animation lends itself to **comedy** and fantasy/science fiction very well; as such, these become successful examples, with less attention paid to other genres. Film and television animation frequently borrow from other genres to create hybrids, such as sci-fi fantasy, musical comedy, and musical drama.

These examples of genres of animation are restricted to film and television animation, as there are many other forms of animation such as **advertisements**, music videos, **abstract** and avant-garde works, and installations. Thus animation is not merely a type or genre of film.

GERALD MCBOING BOING. Directed by Robert "Bobe" Cannon for **United Productions of America** (UPA), the film, released in 1951, features a small boy named Gerald who cannot speak words but instead makes the sound "boing boing." He is rejected by his friends and his father and is about to leave home to unburden his parents when he is hired by a radio producer to provide sound effects for his programs. The story is based on the record "Gerald McBoing Boing" by Dr. Seuss (real name Theodor Geisel). Geisel had worked with UPA during the war so they already had a connection. The animated version is slightly different from the original.

The animation consists of bold, stylized drawings and colors, and the overall design was critically acclaimed and often referred to as the epitome of the **modernist** style in animation in the 1950s. **Jules Engel** was the supervisor and colorist on the film. The initial success was followed up with *Gerald McBoing Boing's Symphony* (1953),

How Now McBoing Boing (1954), and *Gerald McBoing Boing on the Planet Moo* (1955). These films were as visually striking as the original, though the stories were not as strong. In 1956–1957, the CBS network broadcast the *Gerald McBoing Boing Show*, which was a half-hour showcase of UPA **cartoons**. The character reappeared in two *Mr. Magoo* films, *Magoo Meets McBoing Boing* (1961) and *Mr. Magoo's Christmas Carol* (1962), on **television**. In 2005, the **Cartoon Network** broadcast a television series of 11-minute episodes that aired until 2007 and was produced by the Canadian company Cookie Jar Entertainment.

GERMANY. The main centers of animation and avant-garde film grew up in Berlin and Munich. Early animators include Julius Pinschewer (1883–1961), who worked on **advertising** films and went on to collaborate with some of the best-known German animators. He fled Nazi Germany in 1934 and moved to Switzerland. Another animator who began in advertising was Guido Seeber (1879–1940), who was known for a variety of talents including animated advertisements and **abstract** film.

German animation (and live-action film) was largely influenced by art movements such as expressionism and the Bauhaus. Though often cited as an experimental filmmaker rather than an animator, **Hans Richter** was a member of the Dada art movement. His work is often cited as an influence to both animators and filmmakers. Other pioneering German animators include the Swede Viking Eggeling, who primarily worked and lived in Germany, **Lotte Reiniger** who began creating cutout puppet animation; her masterpiece, *The Adventures of Prince Achmed*, in 1926 was highly influential (and the first **feature-length** animated film in Europe) and her contemporary and one-time collaborator was **Walther Ruttman**, the abstract filmmaker of such films as *Lichtspiel Opus I* (1921), before going on to make documentaries.

One of the most notable German animators of the war period, Hans Fischerkoesen (1896–1973) began with *Das Loch im Westen* (*The Hole in the West*, 1919), using 1,600 individual drawings. He worked on advertisements during the 1920s, and in the 1930s was pressed to move to front the new animation industry at the behest of the Nazi regime to produce **propaganda** films. He declined and was

assigned to work with a newspaper **cartoonist**. The Nazis were keen to develop **three-dimensional** (3D) animation techniques, worked on **multiplane cameras**, and developed stereoptical processes, seen in *Verwitterte Melodie* (*Weatherbeaten Melody*, 1942). Fischerkoesen was imprisoned for a time after the war and then moved to West Germany, where he reestablished his studio and made commercials until 1969.

Due to the level of control by the Nazi government, many of Germany's finest animators emigrated. Among those working through this period were the aforementioned Hans Fischerkoesen and Ferdinand Diehl, who produced **puppet** animated films. Kurt Stordel began his animation career, like so many European animators, in advertising before moving to Berlin and animating fairy tales. He found commercial success in 1938 with *Purzel, Brumm und Quak*, his first color film. He went on to make *Zirkus Humsti Bumsti* (*Humsti Bumsti Circus*) in 1944 and *Rotkäppchen und der Wolf* (*Red Riding Hood and the Wolf*) in 1945.

Oskar Fischinger was making experimental films; he is often considered a pioneer of abstract animation. He created what he termed "visual **music**," such as *Komposition in Blau* (*Composition in Blue*, 1934), bringing him international attention and an invitation from **Walt Disney** to contribute to *Fantasia* (1940).

Of the animators who survived the war or returned to the new West Germany, several found success in the rising entertainment industry, including Hans Fischerkoesen, the Diehl brothers, and Kurt Stordel, who went on to make children's **television** in the 1960s. The animation industry was enhanced in the 1960s alongside new developments in the live-action film industry. Advertising and television were the most lucrative and productive sectors for animation. In the late 1970s, new courses to teach a new generation of animators were developed. This new generation included Wolfgang Urchs, who made satirical films such as *In der Arche ist der Wurm drin* (*The Worm Is in Noah's Ark*, 1988). Acclaimed feature producer Helmut Herbst worked with other animation directors, particularly the husband-and-wife team Franz Winzensten and Ursula Asher, who made numerous successful **shorts** and television series for children such as *Geschichten vom Franz* (*Stories of Franz*, 1971–1975) and *Als die Igel grösser wurden* (*How the Hedgehog Got Bigger*, 1978–1979). Katrin Magnitz

had her own studio in Hamburg that made educational, industrial, and television animation. Twin brothers Christoph and Wolfgang Lauenstein achieved **Academy Award** success in 1990 for their 1989 puppet film *Balance*. Urlich König has done well making television series and feature-length films for large audiences. His series include *Joke on Freud* and *Wonderful Trip to the Past*, and in features, *The Conference of the Animals* (1969), *Greetings, Pharaoh* (1982), and *Harold and the Spirits* (1988). Two of the most prominent production companies are Berlin Film & AV and Film & AV.

GERTIE THE DINOSAUR. Directed by **Winsor McCay**, *Gertie the Dinosaur* (1914) was at one time named as the first animated **cartoon** and at the time of its release it made a big impact on audiences and the industry. The film was advertised as an act in which McCay would make a dinosaur come to life. He would act as a trainer in a vaudeville show and present Gertie to the audience. She would react to his commands and catch a pumpkin that he threw. A longer film in which McCay is seen at the beginning accepting a wager that he could not make a dinosaur come to life was shown, and his dialogue was shown on title cards. The film consisted of 10,000 drawings on rice paper mounted on card and then filmed in one reel. Despite the fairly crude animation, the film still impresses as the character of Gertie was fully realized and given a distinct personality by McCay.

GHOST IN THE SHELL. Directed by **Mamoru Oshii**, this **Japanese feature-length anime** is an **adaptation** of a **manga** series by Masamune Shirow. *Ghost in the Shell* (1995) is set in the future, 2029, and is located in Hong Kong (though in the comic it was set in Tokyo). Artificially enhanced humans are populating both the real and online worlds, and national and physical boundaries have become obsolete. Society is monitored by enforcement agents, "Section 9." Major Motoko Kusanagi, a highly trained female agent, is trying to uncover a new threat in the form of a hacker who is able to infiltrate the minds of its victims. Although they have named the hacker "Puppet Master," it is actually a prototype of an entity created by the Ministry of Foreign Affairs as the ultimate espionage tool. The top secret Project 2501 has become self-aware and is seeking **political** asylum in defiance of its creators and host body. It threatens to expose the government and

solicits help from Kusanagi, who becomes trapped in an artificial cybernetic body and struggles with the nature of humanity and identity. The film has been held up as an example of the best adult anime that is both literary and visually excellent.

GILLIAM, TERRY (1940–). Born Terence Vance Gilliam in Minneapolis, he moved to California with his family in 1951. Gilliam had an early interest in film, in particular **science fiction** and animation, though he was also influenced by radio and comic books. He studied physics at the university and also edited a college journal, which led to an assistant editor position for a New York magazine after graduation. He went on to work in **advertising** and later as a freelance illustrator, but in 1967 Gilliam moved to London where he began meeting **television** producers and started creating animated sections for sketch shows.

Gilliam joined the *Monty Python's Flying Circus* team and created animated sequences, as well as acted, and his **surreal** segments are among some of his best-known work. With the Python team, he developed into a director, codirecting the live-action **comedy** *Monty Python and the Holy Grail* (1974). He maintained his **surrealist** style in his live-action films, particularly in his **adaptation** of *Jabberwocky* (1977).

His particular style was maintained throughout his films: *Time Bandits* (1981), *Brazil* (1985), *The Adventures of Baron Munchausen* (1988), *The Fisher King* (1991), *Twelve Monkeys* (1995), and *Fear and Loathing in Las Vegas* (1998). All of these movies were live action but featured the surrealist style he created in his animated work, and often have an animated quality. *See also* GREAT BRITAIN.

GIRLS NIGHT OUT. British animator **Joanna Quinn**'s debut film, *Girls Night Out* (1987) was developed from an art college film with funding from **Channel 4** and the Welsh **television** network S4C. The film features Beryl, an ordinary Welsh housewife, going out for a quiet drink with the girls where they end up watching a male stripper, who is shown from the female point of view. The character of Beryl is engaging and authentic aided by the **realist** environment and the quasi-**documentary** approach to the subject. The imagery and language is feminized and the film is energetic.

The film has a sexual agenda as Beryl fantasizes about the man of her dreams taking her away to a desert island. These fantasies appear as thought bubbles and blurred images. Her husband is portrayed as a couch potato and Beryl is ignored when she announces she is going out. The film depicts a bored woman who is looking for some excitement in her dull life. The design of the character is of a large middle-aged woman, a figure underrepresented in the media. The film shows the audience life from Beryl's perspective and shares her point of view.

The film's success saw Quinn feature Beryl in her second film, *Body Beautiful* (1990). *Girls Night Out* won several awards, including the Annecy Special Jury Prize 1987 and the Krakow Film **Festival** Silver Dragon Award 1988.

GODFREY, BOB (1921–). Born Roland Frederick Godfrey in West Maitland, New South Wales, Australia, Bob Godfrey was raised in England (his parents returned to their homeland when Bob was six months old). He studied at Leyton Art School at the age of 14, where he developed his love of art, though at that point showed no interest in filmmaking.

Godfrey is perhaps best known to many in **Great Britain** as the animator of the **cartoon television** series *Roobarb* (1974–1975; created by Grange Calveley) and *Henry's Cat* (1982). Godfrey began his career as a graphic artist in the 1930s for Lever Brothers and worked on **advertising** materials. He worked for the GB Animation unit, which was run by David Hand, a former **Disney Studio** director, and worked in London on the Disney-style *Animaland* series. In 1950, Godfrey joined W. M. Larkins Studio and was initially unhappy with the animation aspect of the work there, mainly working on backgrounds, which he felt did not allow him to learn much, although it was there that he made his first animated cartoon, *The Big Parade* (1952). He remained with Larkins for four years, during which time he became a member of the Grasshopper Group, a semiprofessional distribution company for whom he wrote and directed his first animated films.

Godfrey joined with other animators Jeff Hale, Keith Learner, Nancy Hanna, and Vera Linnecar to form Biographic and made some of the earliest advertisements for Britain's third television channel,

ITV, including commercials that aired on the launch night of the ITV channel in the London region. Godfrey was influenced by **music** hall, avant-garde **comedy**, **political** satire, and British attitudes to sex and social conduct, which were recurrent themes in his films, particularly in his first two personal films, *Polygamous Polonius* (1959) and *Do-It-Yourself Cartoon Kit* (1961). The latter film was a particular comment on the practices he disliked in the Disney Studio. The film had an energetic pace that set the tone for his work, which attempted to break away from the dominance of the **U.S.** style of animation and at the same time mock the establishment. It is also often mistakenly credited as being by filmmaker **Terry Gilliam**. The script was developed by Colin Pearson, who wrote the satire *A Plain Man's Guide to Advertising* (classified in Britain in 1960).

In 1964, Godfrey left Biographic to form Bob Godfrey Films and create his own style of films. He produced a series of films that particularly mocked the British attitudes to sex and masculinity in *Henry 9 'til 5* (1970), *Kama Sutra Rides Again* (1971), *Dream Doll* (1979), *Instant Sex* (1980), *Bio-Woman* (1981), and *Revolution* (1988).

Godfrey's biography of the Victorian industrial inventor Isambard Kingdom Brunel, *GREAT* (1975), won an **Academy Award** and satirized Victorian attitudes and Brunel's failures as well as achievements. He was nominated for an Oscar for *Small Talk* (1993) and in 1995 he contributed to the *Know Your Europeans* series by **John Halas**. He continued with his examination of British history in *Millennium—The Musical* (2000), which condensed all of British history into half an hour. Despite repeated criticism of the British government in his films, Godfrey was awarded an MBE in 1986.

Godfrey is perhaps best known, however, among younger audiences, for *Roobarb* (1974–1975), *Skylark* (1978), and *Henry's Cat* (broadcast from 1982–1993). The *Roobarb* series and *Henry's Cat* were very popular on television and have been released on DVD. *Roobarb and Custard Too* began broadcasting on British television on 2005.

GREAT BRITAIN. The history of animation in Great Britain follows a similar path in terms of technology and production as the **United States**; indeed, one of the first animators, **J. Stuart Blackton**, was British by birth and moved to the United States, where he is credited with developing his animation techniques. Likewise, many of the

earliest moving-image devices were developed in Britain at the same time as they were being pioneered in **France**.

The industry proper, though, arguably began with George Studdy (1878–1948), a comic-strip artist from Devon, England, who became established as an artist through his work in *The Big Budget Comic*. In 1914, with the outbreak of World War I, he created a series of **shorts**, *Studdy's War Series*, using stop-motion techniques like the early lightning sketches. His best-known series featured a dog called Bonzo, who starred in shorts released fortnightly from 1924 until 1925. The series was heavily merchandised and was as successful as the contemporary U.S. character **Felix the Cat**. During this period, Anson Dyer (1876–1962) began doing a variety of jobs at the British Colonial and Kinematograph Company and in 1927 produced Britain's earliest feature, *The Story of the Flag*, using cutout animation. Dyer founded his own animation production company, Analysis Films, in 1935 and produced color **cartoons** and **advertisements** for British and U.S. sponsors, using traditional drawn animation. Dyer made government war effort films, after which he made shorts for children, including *The Squirrel War* (1947), *Who Robbed the Robins* (1947), and *Fowl Play* (1950). He retired due to ill health in 1952.

Another prewar animator was Anthony Gross who, with the investment of U.S. financier Hector Hoppin, found some success and began to work in Technicolor, though the war cut short their production output. During and prior to the war, the GPO (General Post Office) Film Unit, established in 1933 and headed by documentary filmmaker John Grierson, was instrumental in the emergence of many of Britain's top animation talent. The public service films were made by **Halas and Batchelor** as well as New Zealander **Len Lye**. Scottish-born **Norman McLaren** produced several films for the unit before moving to the United States in 1949 and eventually heading the new animation unit at the **National Film Board of Canada**, for which he is probably best known.

Halas and Batchelor's films for the GPO (which had become the Ministry of Information) were very successful, and their postwar success was reinforced by their feature **adaptation** of George Orwell's *Animal Farm*, released in 1954. They also moved into commercials for the increasingly popular **television** as well as producing early experiments with computer animation.

In 1944, U.S. native David Hand (1900–1986) moved to England to launch a British animation studio for the Rank Organization, named Gaumant British Animation Ltd. (GMA). The studio established a training school for new animators using ex-**Disney** staff brought over from the United States. GMA was responsible for producing commercials and instructional films, as well as the *Animaland* series in the late 1940s and *The Musical Paintbox* series featuring folk tales. The studio was short-lived as Rank decided in 1949 that it was not making enough money and ceased production; the studio closed its doors in February 1950.

London-based TV Cartoons (TVC), one of the most prolific studios in Britain, was established in 1957 and contributed to the 1960s "flower power" movement by producing **George Dunning**'s psychedelic, Beatles-inspired feature *Yellow Submarine* (1968). In the 1960s and 1970s, one of Britain's most distinctive comic animators, **Bob Godfrey**, emerged working in both children's and adult animation ranging from the very popular series *Roobarb* to *The Do-It-Yourself Cartoon Kit* (1961), and the mock erotic *Kama Sutra Rides Again* (1971). Another notable animator of the period was **Gerry Anderson**, whose unique **puppet** animation series such as *Captain Scarlet* and *Thunderbirds* brought a new aesthetic to television animation and **science fiction** to mainstream audiences.

With the launch of Britain's fourth terrestrial television channel in 1982, **Channel 4**, began its long-running support for independent animation, starting with the perennial Christmas favorite, *The Snowman* (1982), produced by TVC and directed by Dianne Jackson. Channel 4's animation consultant Paul Madden followed this success with other adaptations of Raymond Briggs' work and began to finance the **Quay brothers'** productions, leading to the acclaimed *Street of Crocodiles* (1986). Other successful animators to emerge with Channel 4 backing were Alison De Vere with *The Black Dog* (1987) and notably **Aardman Animation**, whose series of *Conversation Pieces* led to some of the most successful and well-known British animation, such as *Creature Comforts* and the *Wallace and Gromit* films.

Other notable British animators who emerged in the 1980s are Geoff Dunbar, whose early career was working at Halas and Batchelor; satirist Gerald Scarfe, well known for his **music** video for Pink Floyd's *The Wall*; **Barry Purves**, who began with **Cosgrove Hall**

before making his award-winning puppet films; and **Joanna Quinn**, whose early work with Channel 4 and TVC has led to a multi-award-winning output of films and commercials. One of the biggest markets for British animation is children's television, with studios such as **Smallfilms** and Cosgrove Hall both producing a variety of highly popular animation series for children.

The industry was booming in the 1990s but a decline in the support from Channel 4 into 2000 has seen less new talent emerge from the **festival** circuit or big budget cinema. Aardman's continuing success grew with features such as *Chicken Run* (2000) and is probably the best-known British studio in the contemporary animation industry. British animation in the music video sector has increased in exposure and success—in particular, illustrator Jamie Hewlitt's animated band Gorillaz, which emerged in 2001. *See also* LEEDS ANIMATION WORKSHOP.

GROENING, MATT (1953–). Animator and **cartoonist** born in Portland, Oregon, Matt Groening is famous for creating the long-running animated **sitcom** *The Simpsons*. Groening studied art at Evergreen State University, a progressive arts school. In 1977, he moved to Los Angeles where he started writing the comic strip "Life in Hell," which he would hand print and circulate from a local record store. The series was picked up by the magazine *Wet* and became popular underground. In 1980, it was printed in the *Los Angeles Reader* and began appearing weekly. The success of the strip caught the attention of **television** alumni James L. Brooks, and Groening was hired to create interstitial cartoons for *The Tracey Ullman Show*, a new **comedy** on the Fox network.

Groening created *The Simpsons* for the show in 1987, and in 1989 it was picked up as a full half-hour series, which has run since 1989; in 2007 it began its 19th season, becoming the longest running sitcom in **U.S.** television history. In 1993, Groening founded Bongo Comics, which published several spin-off series from *The Simpsons*, including *Itchy and Scratchy*, *Bartman*, and *Radioactive Man*. In 1995, he also launched Zongo Comics, which was an imprint of Bongo but aimed at an older audience. After the success of *The Simpsons*, Groening created another hit animated sitcom, *Futurama*, in 1997, which was a combination of a workplace sitcom and a **science fiction** series.

This series ran on the Fox network for four seasons until it was cancelled. However, it was later picked up by the cable network Comedy Central and new episodes were produced, including a **feature-length** movie. Groening's success with *The Simpsons* increased in 2007 when a feature-length movie was released in cinemas worldwide and was a box-office success. While working in television, he continues to draw his cartoon strip.

GULLIVER'S TRAVELS. Released in 1939, *Gulliver's Travels* was the **Fleischer brothers'** first feature and, though it came after **Disney**'s *Snow White and the Seven Dwarves* (1937), it was said to have been conceived of as early as 1934. The film was the second feature from the **United States** of this scale and the first from a studio outside Disney. The **adaptation** of Jonathan Swift's satire sees Gulliver washing up on an island after a storm, revealed as Lilliput, a land inhabited by tiny people. The people believe Gulliver is a giant and try to enlist his help to defend them from an invading neighbor. Eventually, Gulliver convinces them that the islands should unify and cease the **violence**. *Gulliver's Travels* was filmed in color and, like the Fleischers' other work, used **rotoscoping** for the character of Gulliver. The distribution company Paramount Pictures pressured the studio to release the film for the Christmas market. The film was successful at the box office, though it made no profit. Unfortunately, it suffered the loss of foreign markets due to the outbreak of World War II. *Gulliver's Travels* was directed by Dave Fleischer and produced by Max Fleischer.

– H –

HALAS AND BATCHELOR. British animation studio formed by **John Halas** and **Joy Batchelor** in 1940 after the two artists had previously worked together. The pair married two years later and together produced a number of groundbreaking works in a variety of outputs, from educational and training films, **advertisements**, and **propaganda** to **television** and theatrical releases. They suggested that animation should show what things mean rather than simply how they look; the latter was the job of live-action film.

Their wartime production *Abu* was an antifascist, anti-Nazi film that addressed Middle Eastern audiences and was very highly regarded. They continued to produce films within the war context, producing *Handling Ships* in 1944–1945 for the Admiralty and the *Charley* series in 1946–1947, which conveyed postwar legislation information for the Central Office of Information.

Perhaps their most well-known and acclaimed film was **Animal Farm** in 1954, based on George Orwell's novel and the first **feature-length** animation produced in **Great Britain**. In 1960, Halas and Batchelor began to produce their first television series with *Foo Foo* (33 episodes), *Snip and Snap* (26 episodes), and *Habatales* (6 episodes). They were the first European company to use computer animation in their 1969 film, *What Is a Computer?* and then again with *Autobahn* (1979), *Contact* (1973), and *Dilemma* (1981).

The company was sold twice, once in the 1970s to Tyne Tees Television and then to the German company Telemundi in the 1980s. The latter stripped the company of its assets but John bought the company back to preserve their legacy. The company went on to collaborate with other artists, notably British animator **Bob Godfrey** with *Dream Doll* (1979) and *Know Your Europeans* (1995), made after Joy's death in 1991. The latter was part of a series but was never completed due to John's death in 1995. The archive of the company, one of Britain's best and most innovative animation studios, was left to their daughter, Vivien, who continues to maintain it.

HALAS, JOHN (1912–1995). Born János Halász to a large poor family in Budapest, he began working as soon as he was able. His first job was at a film studio, Hunnia Films, painting sets and copying film posters. He found a natural talent for drawing and learned how to make animated films with **George Pal**, and became his assistant. Pal left the company to develop **Puppetoons** and Halas left as well, moving to Paris where he worked briefly as a sign writer. After a brief return to Budapest, he made his way back to Paris where he found work as a graphic artist. He again returned to Budapest where he attended a graphic arts school that became known as the Hungarian Bauhaus, referring to the German design school.

Halas set up a small animation studio, Colortron, with fellow students and they produced 42 **short** films together, commercial and

experimental, over a four-year period (1932–1936). Their work attracted the attention of a London-based company, British Colour Cartoons Limited, which offered Halas a contract. He moved to London and set up a studio. His first film was to be based on the life of Hans Christian Andersen and in order to complete the project he had to hire animators. In doing so, he met **Joy Batchelor**, who would become his wife and business partner. He hired her again for his second film and they found that they had an excellent working relationship, with Joy writing the scripts, translating John's Hungarian, and planning the production.

The couple spent some time in Hungary, visiting John's native Budapest, but with the war looming they returned to London. They formed **Halas and Batchelor cartoons** in 1940. During the early war years, John and Joy married but had to convince the British government that John was not an enemy, and the studio was taken over by the Ministry of Information and used to create **propaganda** films. He became a British citizen and János Halász became John Halas. They continued to work on films to help the war effort and created the *Charley* series.

In the 1950s, the studio began to work on *Animal Farm*, which became one of their best-known films as well as **Great Britain**'s first **feature-length** animation. The pair continued developing techniques and produced a variety of films throughout the 1960s and 1970s, including some very early computer animation. John was instrumental in the formation of **Association Internationale du Film d'Animation** (ASIFA) in 1960 and served as president from 1976 to 1985, though he continued to promote animation. He wrote a number of books on animation, including *Masters of Animation*, published in 1987. Ill health forced him into semiretirement in 1993 and he died in 1995, four years after Joy. *See also* EASTERN EUROPE.

HAND, THE. Czech animator **Jiri Trnka**'s last film before he was forced to stop working due to ill health, *The Hand*, or *Ruka* (released in 1965), is a dark film that describes the role of the artist and the importance of free expression in spite of totalitarian regimes. The film, using **stop-motion puppets**, features a potter and sculptor who has been commissioned to make a monument by a giant Hand. He refuses but the Hand turns to coaxing, then force. He locks the sculptor in a golden cage; at first, the sculptor abides but then escapes to his home

and finds the flower that he had lovingly made pots for. However, the Hand, a symbol of power, causes the man's death and gives him a grand funeral. It has been suggested that the film is an autobiographical work and reflects a bitterness that Trnka was said to possess at the end of his career. *See also* EASTERN EUROPE.

HANNA, WILLIAM (1910–2001). Born in New Mexico, William "Bill" Hanna began his animation career as a **cel** washer and general office clerk for **Harman-Ising** in 1931, having previously studied journalism and engineering at college. He was keen to work in animation and stayed with Harman-Ising learning the industry until 1937, when he moved to **Metro-Goldwyn-Mayer** (MGM). Hanna began working for **Fred Quimby** in the story department and had ambitions to direct, and admitted that he was never very good at drawing, though he had a good sense of timing. Hanna met **Joe Barbera** after Fred Quimby left the studio and though they had been working on the *Barnaby Bear* series, they were encouraged to develop their own ideas. The pair began working together to create a new series, ***Tom and Jerry***, which first appeared in their debut film *Puss Gets the Boot* (1940). The series earned them several **Academy Award** nominations over its 15-year run and won seven, their first for *Yankee Doodle Mouse* in 1943. They produced their last run of *Tom and Jerry* **cartoons** in 1955 and 1956, including some of their best.

In 1957, MGM closed and Hanna and Barbera decided to continue their partnership and open their own studio. **Hanna-Barbera** became one of the most successful studios, and concentrated on producing animation series for **television**, which was becoming increasingly popular. Together they created and produced *Yogi Bear*, *Huckleberry Hound*, ***The Flintstones***, ***The Jetsons***, *Top Cat*, *The Hair Bear Bunch*, *Wait 'til Your Father Gets Home*, and ***Scooby Doo***, among many others. They were also responsible for the first prime-time animated **sitcom** with *The Flintstones* and helped develop a new genre in animation that would be successfully developed in the 1990s with ***The Simpsons*** and others.

They sold the studio to different companies over the years but always maintained a controlling interest; Hanna remained involved in the production of the shows from the studio (by then under **Warner Brothers'** control) until he died in 2001.

HANNA-BARBERA. In 1957, **Metro-Goldwyn-Mayer** (MGM) closed its animation studio, leaving animators **William Hanna** and **Joe Barbera**, who had worked together producing *Tom and Jerry* cartoons, out of work. The studio closed due to the diminishing market for theatrical **shorts** as support for the main feature and the growing success of **television**, which could attract larger audiences. The production costs for theatrical releases rose while profits fell, prompting the decision by MGM to halt all production on animation, preferring to rely on a library of older cartoons that could be repackaged and resold. Television was a growing industry and thus the logical place for the animators to turn for work. Forming their own company, Hanna and Barbera began to produce **cartoons** specifically for television, initially for the Saturday morning children's market. In order to find a cost effective way of producing a high volume of animation in a short time, they adopted the technique of **limited animation**, which enabled them to reuse backgrounds and, with limited movement, would reduce the amount of images and film that were required. But the studio was subject to criticism by some who felt that the quality of the animation was not as good as the pair had previously produced at MGM. Hanna-Barbera (HB) instead concentrated on the narrative story-telling and good dialogue delivered by the best voice-over artists.

The pair created new characters Yogi Bear and Huckleberry Hound, and their success led **American Broadcasting Company** (ABC) television to commission a prime-time animated series that could appeal to a family audience, rather than just children. By looking to the live-action **sitcom** for examples, Hanna-Barbera came up with *The Flintstones*, the first ever prime-time animated sitcom, which provided a model that many producers would emulate years later. The series was very successful, and they followed it up with two more hits in prime time, *Top Cat* and *The Jetsons*.

In 1967, after several offers, Hanna-Barbera agreed to sell the studio to Taft Broadcasting, with Joe Barbera and William Hanna running the studio and maintaining the name. In the 1970s, Hanna-Barbera only produced one prime-time show, in syndication, *Wait 'til Your Father Gets Home*, but also had success with shows such as *Help It's the Hair Bear Bunch* (1971) and *Hong Kong Phooey* (1974). The audiences' tastes were changing and in order to meet this

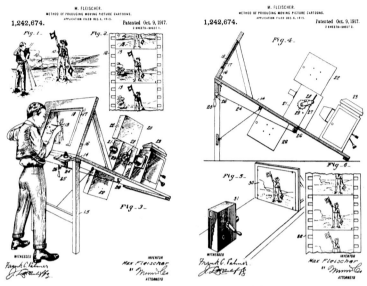

Rotoscope Patent Document. Max Fleischer. Public Domain Image.

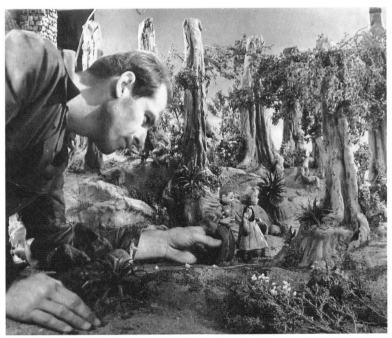

Ray Harryhausen with Hansel and Gretel. Courtesy of the Ray and Diana Harryhausen Foundation.

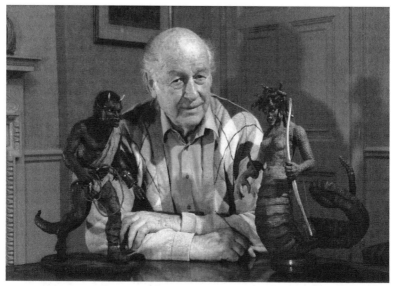

Ray Harryhausen with Medusa. Courtesy of the Ray and Diana Harryhausen Foundation.

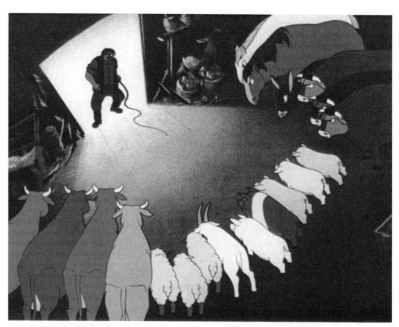

Animal Farm. Copyright RD-DR 1954 renewed 1982. Courtesy of the Halas and Batchelor Collection Limited.

Charley, 1947. Courtesy of the Halas
and Batchelor Collection Limited.

The Clangers. *Copyright 2008 Oliver Postgate and Peter Firmin. Courtesy of Licensing by Design Ltd.*

Bagpuss. *Copyright 2008 Oliver Postgate and Peter Firmin. Courtesy of Licensing by Design Ltd.*

Henry's Cat. *Bob Godfrey Films and Stan Hayward.*

Revolution. *Courtesy of Bob Godfrey Films.*

Girls Night Out. *Beryl Productions International Ltd. Courtesy of Joanna Quinn.*

Dreams and Desires—Family Ties. *Beryl Productions International Ltd./S4C. Courtesy of Joanna Quinn.*

The Death of Patroclus from Achilles, *a Bare Boards production for Channel 4 Television 1995, still by Paul Smith. Courtesy of Barry Purves.*

Hot Dog. *Courtesy of Bill Plympton Studio.*

HAIR
COOL GREY 3

EYEBROWS.
OCHRE 11

FLESH
ORANGE 9

HAIR. GREY ORANGE
YEL. 16
FLESH - FLESH 13
SHIRT. LEMON YEL 15
PANTS. VIOLET 5
SHOES. GREYED
RED 13
EYE GLASS FRAMES
GREY 24

CLUBS - COOL GREY 1
BALL - WHITE

SHIRT. COOL GREY 9
SHOES - LIGHT BROWN 20
PANTS. YELLOW 14

Perot and King for Saturday Night Live. *Courtesy of J. J. Sedelmaier Productions Inc.*

Hanna-Barbera began to create more shows to appeal to children and teenagers with **music** and **comedy** in *Scooby Doo, Where Are You?* (1969), *Josie and the Pussycats* (1970), and an animated version of the live-action **music** show, *The Partridge Family* (1970–1974) in *The Partridge Family: 2200 A.D.* (1974). These shows became hits for Hanna-Barbera and became the templates for many of the shows they produced throughout the 1970s and 1980s.

In the 1980s, however, **advertising** became a dominant force in children's television; cartoons, which had become relegated to Saturday mornings, began to be produced in conjunction with toy manufacturers, and in 1986 HB produced *Pound Puppies*.

In 1991, parent company Taft put the company up for sale and the library was sold to Turner Broadcasting. The company continued production with a name change to Hanna-Barbera Cartoons Inc., and in 1995 it sponsored "World Premiere Toons" with the **Cartoon Network** to help encourage and develop new animation talent. With a merger between Turner and **Warner Brothers** (WB) in 1996, the production division remained but shortly moved to the WB premises. It continued to produce cartoons with Cartoon Network, but when William Hanna died in 2001 the company was absorbed by Warner Brothers where Joe Barbera continued to work until his death in 2006. Over nearly 50 years, Hanna-Barbera had been one of the most prolific producers of animation for television and encouraged and inspired many new shows and talents.

HARMAN-ISING. Partnership of Hugh Harman (1903–1982) and Rudolph Ising (1903–1992). Both men were American animators who started working with **Walt Disney** in Kansas in 1922 and followed Disney's move west to California in 1925. They worked on the *Oswald the Lucky Rabbit* series until the strike in 1928, after which Harman led staff away from Disney. Harman and Ising started working together in 1930 and created Bosko. With this character, Harman produced the first synchronized talking animated **short**, *Sinkin' in the Bathtub*. Making use of this synchronized sound and animation, they teamed with **Leon Schlesinger** and used the back catalogue of songs from **Warner Brothers** to create the *Merrie Melodies* and *Looney Tunes* series of shorts. Harman continued working on *Bosko* while Ising concentrated on the *Melodies*.

The pair split from Warner Brothers in 1933 and they went to **Metro-Goldwyn-Mayer** (MGM), taking *Bosko* with them. There they created *Happy Harmonies*, which were also similar to the Disney *Silly Symphonies*. They left after a disagreement over finances but were unable to get their own studio started properly so went back to MGM in 1939. At MGM, they began to produce the ***Tom and Jerry*** series until **Bill Hanna** and **Joseph Barbera** showed success with the characters.

Harman and Ising began to make other films and among the most notable are *The Old Mill Pond* (1936), *The Blue Danube* (1939), and *Peace on Earth* (1939), which featured a pacifist theme, earning Harman a Nobel Peace Prize nomination and an **Academy Award** nomination. They won an Oscar in 1940 for *The Milky Way*. Ising introduced *Barnaby Bear* for MGM in 1939 in *The Bear That Couldn't Sleep* and continued to work on that series. The pair later worked on army training films, including ***Private Snafu*** *Presents Seaman Tarfu in the Navy* (1946).

HARRYHAUSEN, RAY (1920–). Born in Los Angeles, Ray Harryhausen began his animation career after seeing *King Kong* in 1933. Unable to figure out how the effects were created, he became awestruck by the process and the creator, Willis O'Brien. He started trying to make his own films and began by making a model of a bear from his mother's fur coat (he asked for permission afterwards) and a friend's 16 mm camera. Though he found it difficult to control, he was excited by what he had created and decided to develop his interest by studying photography, drawing, sculpture, ceramics, and life drawing at the University of Southern California's night school.

His father encouraged him by building a small studio in the garage and by 1940 he owned his own single-frame camera and had begun work on his first full-length feature, *Evolution*, based on the origin of the species. The project became overly ambitious and after **Disney** released ***Fantasia***, he gave up on it. He later showed his footage of *Evolution* to **George Pal**, who made **shorts** called ***Puppetoons*** and who subsequently gave him a job. This employment lasted until World War II when Harryhausen was drafted into the Army Signal Corps. However, he was able to continue with his work, as he was charged with making animated segments for orientation films.

After the war, he returned to his home studio and began making fairy tales. His first was a 10-minute film, *Mother Goose Stories*, which was released by Bailey Films. Having earned some money, Harryhausen was able to continue and make other fairy tales. He was able to meet his hero Willis O'Brien in 1939, and in 1946 O'Brien asked him to assist on *Mighty Joe Young*. Harryhausen moved to RKO studios, and the film, released in 1949, won an **Academy Award**. Harryhausen continued with O'Brien but preproduction problems led him back to the garage studio.

He was introduced to producer Jack Dietz and they made *The Beast from 20,000 Fathoms* (1953), which was Harryhausen's first **feature-length** film. Following the film's success, he developed ideas for other films but, without financing, he again returned to his fairy tales. He soon met Charles H. Schneer, a producer for Universal and Columbia. They made *It Came from Beneath the Sea* (1955) and forged a partnership that lasted several years and included *Earth vs. the Flying Saucers* (1956) and *20 Million Miles to Earth* (1957).

At the end of the 1950s, they decided to move away from **science fiction** and into fantasy and myth, producing *The Seventh Voyage of Sinbad*, which was so successful they followed this up with two more Sinbad films, ending the series in 1977. In the late 1950s and early 1960s, they moved production from Hollywood to London to utilize European locations.

In 1963, Harryhausen made his most famous film, *Jason and the Argonauts*, which features his best **stop-motion** animation. Over the years, he continued to contribute to many films, which led to *Clash of the Titans* (1981), the biggest hit of his career. Despite this success, his animation, like O'Brien's, was not properly acknowledged as animated art; instead, it was dismissed as part of the special effects, though in 1992 he was honored at the Oscars for his lifetime achievements. He has continued to work, overseeing colorization of early works and publishing collections of prints of his artwork. Special edition DVDs of his films have been released and collectors' items have been marketed.

HENSON, JIM (1936–1990). **Puppet** animator born in Mississippi, Henson was interested in art from an early age, particularly influenced by his grandmother, who was a painter. His family moved to

Maryland when he was in fifth grade and he began experimenting with art techniques. In 1954, while at high school, Henson began performing with puppets on **television** for a Saturday morning program in Washington, D.C., WTOP TV. In 1955, while studying at the University of Maryland, he began a twice daily, five-minute show, *Sam and Friends*, on an NBC affiliate station, WRC-TV, with Jane Nebel, who would later become his wife. He started using **music**, humor, and television as a stage for his act in which he introduced one of his most famous characters, Kermit the Frog. He began in **advertisements** and was invited to appear on the *Steve Allen Show*.

In 1961, Henson formed Muppets Inc. and in 1963 moved to New York, where he teamed up with Frank Oz. Between 1964 and 1965, they began to produce films. In 1966, he started developing characters for the new Children's Television Network series **Sesame Street**. With financial backing from London-based television pioneer Lord Lew Grade, Henson's best-known series, ***The Muppet Show***, began. With a mixture of his Muppet (puppet) characters and human celebrity guest stars, the show was like a theater revue. The success of the *Muppet Show* led to feature films starring the characters, such as *The Muppet Movie* (1979), *The Great Muppet Caper* (1981), *Muppets Take Manhattan* (1984), and *The Muppet Christmas Carol* (1992), to name but a few.

Jim Henson's Creature Shop, which he had founded in 1979, was used to create similar techniques in the feature films *The Dark Crystal* (1982) and *Labyrinth* (1986), which Henson also directed. The company also produced the 1980s television show *Fraggle Rock* and the **cel**-animated series *Muppet Babies* and *The Storyteller* (1988). The Jim Henson Company was sold to the **Disney Studio** in 1989. In 1990, after a short illness, Jim Henson died. The effects of his influence were felt throughout the world, with separate memorials being held in the **United States** and in **Great Britain**.

The Jim Henson Foundation, the Jim Henson Company, and Jim Henson's Creature Shop continue, with the involvement of his family, and more Muppet films have been produced. Other popular series such as *Bear in the Big Blue House* on the Disney network have kept the style of the Muppets and Henson's legacy alive. In 2004, the Muppets and the *Bear in the Big Blue House* properties were fully

sold to Disney, with the *Sesame Street* characters remaining with the Sesame Workshop.

HOMESTAR RUNNER. *Homestar Runner* is an example of **Web animation**, which has grown in popularity since its first appearance in 2000. The animation was first created by brothers Matt and Mike Chapman, who created the characters in an idea for a children's book. They began creating various animated versions of the story until they began using **Flash** to animate **cartoons**.

Homestar has demonstrated what Web animation is capable of in terms of audience reach and flexibility of output. The website is set up as a world for the characters of the cartoons to inhabit, the star of which is Homestar Runner, a dim-witted athlete, and his friends, with sections dedicated to serial cartoons, in a similar format to those broadcast on **television**. The site also includes interactive games and opportunities to interact with the creators. In this way, the viewers can alter the way they experience the site. By using the Web to distribute the animation, there are no restrictions on content or delivery. Fan numbers have increased steadily over the years and the content on the site has developed to include more cartoons featuring a variety of subjects, though generally they are satires or parodies of popular culture and, in particular, of video games and television. The site is included here as merely one example of the increasing use of the Internet to distribute animation, which can reach wide and varied audiences.

HUBLEY, FAITH (1924–2001). Faith Elliott was a screenwriter and novelist prior to her career in animation; notable work includes screenwriting on Sidney Lumet's *12 Angry Men* (1956). After her marriage to **John Hubley**, Faith took an interest in addressing what they perceived to be problems with figurative art and attended art school. She shared her husband's belief that cinema should have a social content, and together they made a number of films with social and **political** themes, including *The Hole* (1962), *The Hat* (1964), *Windy Day* (1968), and *Everybody Rides the Carousel* (1976), among others. They won an **Academy Award** in 1965 for *Tijuana Brass Double Feature*, which featured the music of Herb Alpert and the Tijuana Brass.

After John's death in 1977, Faith began a solo career and between 1976 and 2001 completed 25 films, including her only **feature-length** film, *The Cosmic Eye* (1985). In 1996, she made the autobiographical *My Universe Inside Out*. Her last film was *Northern Ice, Golden Sun* in 2001, and her work was said to be characterized by her exploration of world mythology and an interest in indigenous cultures. She had a reverence for nature, which inspired much of her work, which she passed on to audiences throughout the world.

HUBLEY, JOHN (1914–1977). John Hubley was raised in Michigan and as a teenager demonstrated his artistic abilities when he won a local newspaper drawing competition. During the Depression, he moved to Los Angeles to live with his uncle, and after graduation he went to work for **Walt Disney**, where he remained from 1935 to 1941. He left the studio during the strike, after which he went to work for **Screen Gems** under Max **Fleischer**.

Hubley contributed to the war effort and in 1944 helped produce a campaign film for Franklin D. Roosevelt with what would soon become **United Productions of America** (UPA). Joining the company at the beginning, he was involved in the debut of the character Mr. Magoo in 1949. His landmark film was *Rooty Toot Toot* (1952), which took its subject from the ballad of *Frankie and Johnny*. The film was heralded as brilliant, ironic, and disenchanted, making revolutionary use of color and drawing, which reinforced the **modernist** aesthetic coming out of UPA. Unfortunately, the studio forced him to resign due to the McCarthy trials, despite his share in the company. However, during this time, he met Faith Elliott and in 1955, the two married. They moved to New York, where they founded their own specialized production company making **advertisements** and educational movies.

The two artists collaborated on *The Adventures of an ** *, an experimental film financed by the Guggenheim Museum. The film was influenced by the work of **Norman McLaren**, whom Faith had met years earlier. *Moonbird* (1959) demonstrated an inventive freedom that John had not previously had. In 1962, they collaborated with Harlow Shapley to make *Of Stars and Men*, an educational feature.

Politics and racism were themes of *The Hole* (1962), and they continued the social and political themes in *The Hat* (1964), *Windy Day*

(1968), *Of Men and Demons* (1970), and *Everybody Ride the Carousel* (1976), which was John's last film. They won an Oscar in 1965 for *Tijuana Brass Double Feature*, which featured the music of Herb Alpert and the Tijuana Brass. They also created animated **shorts** for the **television** series *Sesame Street* (1969) and *The Electric Company* (1971). John died in 1977 and Faith continued to produce animation until her death in 2001.

HUMOROUS PHASES OF FUNNY FACES. *Humorous Phases of Funny Faces*, released in 1906, was one of **J. Stuart Blackton**'s lightning sketches and his most famous production, which uses **stop motion** to create the animated movements. The film features comic portraits of a man smoking and rolling his eyes and the reactions of the woman next to him when he blows smoke in her eyes, which is animated. The film also shows a clown figure with a jumping dog. The artist's presence was only suggested by the appearance of his hand in shot, as opposed to his full appearance in his film *The Enchanted Drawing* (1900), which was more like a chalk talk than an animated film. *Humorous Phases* is generally cited as the first animated film.

HUNGARY. *See* EASTERN EUROPE.

HURD, EARL (1880–1940). Like many other animators from the **silent era**, Hurd was a newspaper cartoonist in New York and Chicago before becoming an animator. He then began as an animator for **John Randolph Bray** when he patented the technique using celluloid, or **cels**, in 1914, which are still used in animation. With Bray, he formed the Bray Hurd Patent Trust, after which license fees were required to be paid by every studio that used cels in their animation. Though probably best known for inventing the cel technique, he also made a series of **cartoons** in 1915 for Universal called *Bobby Bumps*. The cartoons were successful and a forerunner to the **Fleischer brothers'** *Out of the Inkwell* series, with Bobby sitting on the live action (but mostly unseen) animator's hand. These films set a high standard for the industry. However, when Hurd tried to start his own company and make films in 1920, the films were technically good but ultimately unsuccessful.

In 1921, Hurd moved to Paramount with *Bobby Bumps*, leaving Bray. He worked with **Charles Mintz** at **Screen Gems** in the 1930s before he joined **Disney** in 1934, where he worked on *Snow White and the Seven Dwarves* and *Fantasia*. He remained at the Disney Studio until his death in 1940.

– I –

INDIA. *See* ASIA.

INDUSTRIAL LIGHT AND MAGIC (ILM). Part of the Lucas Films Company founded in 1977 by director George Lucas to create the visual effects for the **science fiction** epic *Star Wars*. The effects studio at 20th Century Fox had closed and Lucas needed a California-based effects studio for his movie. Special effects were revolutionized and the studio was the first to use a motion-control camera. In 1979, George Lucas set up a computer division to begin to develop **computer-generated imagery** (CGI). In 1982, they produced the visual effects for the live-action feature *Star Trek II*. In 1986, they set up a division specializing in rendering software that became the basis of **Pixar** films. In 1988, ILM premiered the first "morphing" sequence in the live-action film *Willow*. ILM created the first computer-generated **three-dimensional** (3D) character in *The Abyss* and in 1991 took this further by creating a fully 3D CG character in *T2*. The studio won an **Academy Award** in 1993 for its effects work on *Death Becomes Her*. The effects used to enhance live-action films became more advanced over the years, and in 1999 ILM created the most **realistic** digital human character (to that date) in *The Mummy*. The company is included here due to its contribution to CGI technology, which has influenced the animation industry as well as the effects business.

IRELAND. *See* WESTERN EUROPE.

IRON GIANT, THE. Directed by **Brad Bird** and released by **Warner Brothers**, *The Iron Giant* (1999) is based on the book *The Iron Man* by Ted Hughes (1968), though some of the details were changed

for the film. The story features a boy named Hogarth Hughes who lives with his mother in rural Maine in 1957, at the height of Cold War paranoia. Hogarth befriends a 50-foot giant alien robot who has fallen from the sky. The giant is innocent to the ways of humans and Hogarth attempts to teach him about his life, but while Hogarth tries to keep him a secret, he is eventually discovered. The giant's size causes fear in the town and the army is called in as he is perceived as a threat. The antagonistic treatment of the giant by the army reactivates the giant's weaponry functions, which are inbuilt, and he starts to fight back. The film was made with traditional **cel** animation, though the giant was created with **computer-generated imagery** (CGI). Stylistically, the film has the feel of 1950s **modernist** animation, which suits the period of the story. The film was not as successful at the box office as Bird's later film, *The Incredibles* (2004), possibly due to the darker tone this film has with imagery less suited to a family audience. However, the animation is of very high quality.

ITALY. Like many European countries, Italy's early animators were inspired by the animation from the **United States** and artists such as Gino Parenti (1871–1943), Umberto Spano, Luigi Giobbe (1907–1945), and the Cossia brothers began creating **short** films. Just as **Winsor McCay** and other comic-strip **cartoonists** had made the transition from print to film, Roberto Sgrilli (1897–1985) developed his talents and made an **adaptation** of *Baron Munchausen*, *Il Barone di Münchhausen*, in 1941. During the disruption of World War II, one animator of note who continued production was Nino Pagot, who had founded his own company in 1938 with his brother Toni. During the war, he produced and distributed **propaganda** films. His first film to achieve critical acclaim was the mid-length feature *Lalla, piccolo Lalla* (*Lalla, Little Lalla*) in 1946. He was then able to release his first **feature-length** film, *I fratelli Dinamite* (*The Dynamite Brothers*, 1949), which he had developed during the war. The film was in collaboration with other animators but was not very successful. This led the studio to relocate and concentrate on producing **advertisements**. In the 1960s, the company found success with the **television** series *Calimero*; the titular character remains popular.

Though released in the same year as Pagot's feature, *La Rosa di Baghdad* (*The Thief of Baghdad*, 1949) is considered to be the

first Italian feature animation to be produced. It was also the first Italian film in Technicolor. The film was directed by Antonio Gino Domeneghini (1897–1966) and produced by his studio, Ima-Film Productions; the studio worked throughout World War II. Another key animator of this period was Luigi Veronesi (1908–1998), an artist who used a variety of styles and techniques, including photography, painting, and engraving; his first film used wooden objects. Veronesi had an interest in the Bauhaus and contemporary art and created a series of films from *Film No. 1* to *Film No. 9* made between 1939 and 1941. These **abstract** animations were considered to be experiments in the art form.

In the late 1950s, Bruno Bozzetto (1938–) was one of the first Italians to make "homegrown" animation. He began experimenting with animation at an early age and at age 20 he made *Tapum! La Storie delle Armi* (*Tapum! The Story of Weapons*, 1958) and entered it in the Cannes Film **Festival**, receiving favorable reviews. His first feature was *West and Sodu* (1965), created with hand-drawn animation, and he moved on to other features. By the late 1970s, he had made his third feature, *Allegro Non Troppo* (1977). He continued into the 1980s, producing a variety of work, but always with a satirical perspective.

One of the most successful Italian animators of the 1970s was Osvaldo Cavandoli (1920–2007). He began his career working on Pagot's feature *The Dynamite Brothers*. In the 1950s, he worked on animated advertisements and specialized in **puppets**, though his most successful advertisement did not feature puppets and instead used a line drawing. *La Linea* (*The Line*, 1969) was so successful that he created a television series starring "the line." The series consisted of 88 episodes and featured the animator's hand interacting with the line. This interaction either aided or hindered and annoyed the man, who appeared out of the line in each episode.

Bruno Bozzetto's team member Guido Manuli was an influential artist and successful gag writer. He collaborated with Bozzetto on *Opera* in 1973 and again on *Strip Tease* in 1977. Manuli went on to work freelance and created such works as *Fanatabiblical* (1977), *Count Down* (1978), *Solo un bacio* (*Only a Kiss*, 1983), and *Incubus* (1985), though *Solo un bacio* is considered to be one of his finest. His energetic style was compared to **Tex Avery**.

One of the dominant studios in Italian animation was Gamma Films, well known for their advertisements. The studio's success peaked in the 1960s, at which point it was one of the largest in Europe. Developments in the industry led to the first computer-animated film *Pixnochio* (1982) by independent animator Giuseppe Lagan. Other key studios include Pagot Film (revised after the death of founder Nino in 1972), Paul Film in Modena founded by Paolo "Paul" Campani, Florence-based Studio Limite, and Cooperativa Lanterna Magica.

Other key figures in developing the Italian animation industry were Giorgio "Max" Massimino-Garniér (1924–1985), a director of **Association Internationale du Film d'Animation** (ASIFA), who directed films and collaborated with other artists as a scriptwriter, cartoonist Pino Zac (1930–1985), and painter Stelio Passacantando (1927–).

IWERKS, UB (1901–1971). Born in Kansas City, Ub Iwerks' name reveals his Dutch heritage; his father was an immigrant. His given name was originally Ubbe Ert Iwwerks, simplified to the shorter version in his 20s. At age 19, he went to work for the Kansas City Film Advertising Company, where he worked with **Walt Disney** and later **Harman-Ising**. In 1922, Disney founded Laugh-O-Gram and Iwerks went to work with him. He moved with Disney in 1923 and continued to work with him until 1930. Iwerks created the drawing for **Mickey Mouse**, based on Walt's idea, and animated him in *Steamboat Willie* (1928).

In 1930, Iwerks met Pat Powers with whom he opened his own studio, under Iwerks' own name. His creation ***Flip the Frog*** had been patented while he was with Disney, so he revived the character in a series that lasted for 36 episodes. Between 1930 and 1934, Iwerks supplied **shorts** to **Metro-Goldwyn-Mayer** (MGM). In 1933, he released a series featuring Willie Whopper, but this only lasted one year. The last series that Iwerks produced with Powers was the Comicolor **Cartoons** series that included *The Little Red Hen* (1934), *Humpty Dumpty Jr.* (1935), and *Tom Thumb* (1936), all shot in Cinecolor. The studio closed in 1936 and Iwerks was subcontracted to **Warner Brothers** by **Leon Schlesinger** and **Charles Mintz** at **Screen Gems** from 1936 to 1940. In 1937, he directed *Merry Mannequins* for Mintz.

In 1940, Iwerks returned to Disney where he would remain until his death in 1971. He won **Academy Awards** in 1959 and 1964. Though not known for his **comedy** or story-telling, Iwerks has been heralded for his speed and skill as an animator. He also was responsible for developing a version of a **multiplane camera** years before Disney.

– J –

J. J. SEDELMAIER PRODUCTIONS INC. J. J. Sedelmaier Productions (JJSP) is a design and animation studio based in White Plains, New York. The studio was founded in 1990 by J. J. Sedelmaier (1956–), a Chicago native, and his wife, Patrice. Sedelmaier studied art at college, graduating with a bachelor of science degree, and moved to New York to find work, initially in comics, but instead he found a thriving animation industry. His professional career began in 1980, and he became an animator in 1984, and then a producer and director before opening his own studio.

JJSP produces work for both print campaigns and animated film using a variety of styles and techniques. They are primarily known for their cutting-edge commercial animation and include such clients as such as Slim Jim, Speed Racer, Hotwire, and 7Up, among others. The studio has also been involved with some of the most groundbreaking animation **television** series in the 1990s, animating part of the first series of **Mike Judge**'s *Beavis and Butthead* for **Music Television** (MTV). It also produced animation for the 1993 relaunch of the series *Schoolhouse Rock* for the **American Broadcast Company** (ABC) and was cocreator with Robert Smigel of *Saturday TV Funhouse* **cartoons** for the **comedy** series *Saturday Night Live* on NBC.

JJSP became the exclusive animation house for the first three seasons of cartoons for *Saturday Night Live*, and from 1996 until 2000 engaged in designing characters and animating such series as *The X-Presidents*, *Fun with Real Audio*, *Animated Outtakes*, and perhaps the most well known, *The Ambiguously Gay Duo* (originally designed by J. J. Sedelmaier himself, and created by JJSP and Robert Smigel for the short-lived *Dana Carvey Show*).

JJSP developed the pilot episode of *Harvey Birdman, Attorney at Law*, with **Cartoon Network**, that helped initiate their **Adult Swim** block of cartoons. They also collaborated with Cartoon Network writer Stuart Hill to develop and animate, for the network, a series of interstitial **shorts** based on an ever-present Captain Linger, a superhero character. The studio's most recent television project was the creation of the animation for the first season of the *Tek Jansen* series for the late-night satirical comedy series *The Colbert Report* (2005–). The studio has won numerous awards for animation and print work.

JAPAN. Japanese filmmakers were inspired by films from the **United States** and **France** in the early 1910s. The first attempt at animating chalk drawings was made by Oten Shimokawa (1892–1973), but he failed and painted directly onto the film stock using ink (an early example of **cameraless animation**). His first five-minute **short** was *The Concierge* (1917). The first Japanese animation studio was founded in 1921 by Seitaro Kitayama, beginning with educational films and industrial films for the government, eventually moving on to animated folk tales. The great Kanto earthquake and fire in 1923 destroyed all prints, with the oldest prints dating from 1924–1925. Among the early animators, the most influential were Sanae Yamamoto (1898–1981), Yasuji Murata (1898–1966), and Naburo Ofuji (1900–1974). Murata studied Western techniques and brought **cel** animation to Japan, which began to be used after the late 1920s, by which time they were beginning to use recorded **music** to accompany the films.

In the 1930s, Japanese animation shifted from folk tales to more **political** films and **propaganda** (anti-West), but the production was still done by what was essentially a cottage industry. Between 1934 and 1939, the animation production remained in black and white, and became increasingly nationalistic.

During World War II, Japanese animation concentrated on war propaganda for children and families, including caricatures of the "Anglo enemy" exemplified by Sanae Yamamoto's *Spies Defeated* (1942) and Rjoji Mikami's *Hooray for Japan* (1943). One of Japan's finest animated films, *The Spider and the Tulip* (1943) by Kenzo Masaoka, was made in this period. The only **feature-length** film to

be made until the late 1950s was *Momatoro's Divinely Blessed Sea Warriors* (1945).

The studio Nihon Doga was formed in Japan in 1948 and began the production of shorts but a lack of facilities left films looking dated, especially in competition with the U.S. films being imported. In the 1950s, Japanese **cartoons** moved into color production and a division emerged between popular animation for theater and **television** and **fine art** animation for the **festival** circuit. In 1951, Toei Company Ltd. was founded and grew quickly to become one of the largest producers of live-action films, and an animation division was added in 1955, merging with Nihon Doga into Toei Doga in 1956. This became the country's first major animation studio.

With the success and popularity of television, the Japanese animation industry really flourished, adapting folk tales (both Japanese and European) and **science fiction** and **manga**. The first significant television series was **Osamu Tezuka**'s *Astro Boy* produced by his Mushi Production Company. Other studios found success and diverse subjects from sci-fi, horror, and fantasy to domestic **comedy** were produced. The success began to open international markets and collaborative projects.

Japanese television animation flourished in the 1970s, especially science fiction and as a result of a change in audience from children to young adults. The success continued into the 1980s, including television, direct-to-video releases, and the international market. One of the most successful television franchises was *Dragonball* in 1986 and the follow-up *Dragonball Z*. During this time, **Hayao Miyazaki**, whose career began at Toei, gained increasing success, leading to the founding of **Studio Ghibli**. In 1988, the science fiction feature *Akira* was released, arguably the first feature to really break into the international, specifically Western market.

In the 1990s, the Japanese animation market opened up internationally, in part due to the phenomenal success of the *Pokémon* television series. The features from Studio Ghibli such as *Princess Mononoke* (1997) found international success and elevated the status of anime still further, as did **Mamoru Oshii**'s *Ghost in the Shell* (1995). Miyazaki's next feature, *Spirited Away* (2001), arguably overshadowed other feature releases and the success of television animation continued. Into the 21st century, there was an increase in

coproductions between the United States and Japan with such films as ***Final Fantasy: The Spirits Within*** (2001) and ***The Animatrix*** (2003). *See also* ASIA; JUMPING.

JETSONS, THE. **Hanna-Barbera**'s third prime-time animated series was *The Jetsons*, which premiered in 1962 on the **American Broadcasting Company** network. The situation in *The Jetsons* was a contrast to ***The Flintstones***, as it was set in the distant (or not-too-distant) future, as opposed to the Stone Age era. There were the similar running gags of the household gadgets, but this time they were space age fantasies, with automatic food makers and dressing rooms, rather than a mammoth for a dishwasher as in *The Flintstones*.

As well as the **science fiction** setting and surroundings, the plots differed from the previous Hanna-Barbera animated **sitcoms**. The humor was mainly derived from misunderstandings and farcical situations in the tradition of the comic narrative and the live-action sitcom. The setting for the show was the domestic family sitcom. The family consisted of George and Jane Jetson and their children, teenage daughter Judy and younger son Elroy. Like the Flintstones, the Jetsons also had a family pet, but this time it actually was a dog.

The Jetsons originally only aired for one season, but in the 1980s was revived with new shows, which ran until 1987. *Jetsons: The Movie*, a **feature-length** version of the series, was released in 1990, directed and produced by **Hanna** and **Barbera** but through **Warner Brothers**.

JONES, CHUCK (1912–2002). Born in Washington State, Jones' family moved to Southern California when he was six months old. He attended Chouinard Art Institute, which later became the **California Institute of the Arts** (CalArts). In 1930, after art school, Jones found work in a commercial art studio and in 1931 began his animation career, washing **cels** for **Ub Iwerks**. He began the transition from washing to cel inking and then to assistant animator. He was fired from Iwerks and then had brief employment with **Charles Mintz** at **Screen Gems** and **Walter Lantz**, before going back to Iwerks, though he was later fired again. Jones worked for a time in Los Angeles as a portrait artist, and in 1933 was hired by **Leon Schlesinger**. He stayed at **Warner Brothers** from 1933 to 1963 and advanced from animating to directing.

When **Friz Freleng** joined the company, Jones was assigned to **Tex Avery**'s division with **Bob Clampett**, and when **Frank Tashlin** left, Jones was put in charge of his unit. His prime products were Porky Pig and Daffy Duck. His first directorial achievement was *The Night Watchman* (1938), and in 1940 he was awarded the Best Animated **Cartoon** of the year from Newsreel Theatres for *Old Glory*.

During World War II, Jones collaborated with Theodor Geisel (Dr. Seuss) on the **Private Snafu** series, and 25 years later they worked together again to produce *How the Grinch Stole Christmas!* (1966) and *Horton Hears a Who* (1970). In 1942, Jones directed *The Dover Boys*, which set a method of style and timing for the studio. He worked alongside the staff of what would become **United Productions of America** (UPA) on the Franklin D. Roosevelt campaign film *Hell Bent for Leather*, which he directed in 1944.

After the war, Jones introduced the new characters Road Runner and Wile E. Coyote, Pepe le Pew, and with Friz Freleng and Robert McKimson shared the character drawing and development of **Bugs Bunny**, Daffy Duck, Elmer Fudd, and Porky Pig. Jones won two **Academy Awards** in 1950 for his films. In 1955, he went to work for **Disney** for four months while Warner Bros. was closed, though he rejoined when it reopened. In 1962, Warner Bros. closed the plant completely and he began directing work for commercials. In 1962, he cowrote the story and screen play for *Gay Purree*, with his wife Dorothy. The film was produced by UPA.

Jones was hired by **Metro-Goldwyn-Mayer** in 1964 to make more **Tom and Jerry** cartoons after **Hanna-Barbera** had formed their own company. He also directed the Oscar-winning *The Dot and the Line* (1965) as well as Dr. Seuss films during that period. He was vice president of the **American Broadcasting Company** (ABC) for a year between 1972 and 1973 to try to help develop children's **television**. In conjunction with the **National Film Board** and **Zagreb** School, he produced *The Curiosity Shop*, which consisted of 17 one-hour Saturday morning cartoons. He was also producer for Richard Williams' **adaptation** of Charles Dickens' *A Christmas Carol*.

In 1962, Jones established an independent production company, Chuck Jones Enterprises, which ran from 1962 to 2002 and produced half-hour prime-time television specials, several featuring classic WB characters. He consulted at WB when they returned to animation

production and lectured at a variety of **U.S.** higher education estab-lishments, including Stanford, University of Southern California, University of California Los Angeles, CalArts, and the University of Kansas. In 1978, his first wife died, and he remarried in 1983. Jones was honored by the British Film Institute (BFI) with a three-day retrospective and twice by the Kennedy Film Center and the American Film Institute. He was also honored in a Golden An-niversary exhibition of WB work at the Museum of Modern Art, New York. In 2000, he established the Chuck Jones Foundation to recognize, support, and inspire continued excellence in art and the art of character animation. He died in 2002, aged 89, and was one of the most loved animators in the history of animation.

JONNY QUEST. Prime-time action adventure series produced by **Hanna-Barbera** that aired on the **American Broadcasting Company** network; the series ran from 1964 to 1965. The show was a new style of **television** animation and was very different from Hanna-Barbera's prime-time animated **sitcoms** such as *The Flintstones* (1960–1966) or *Top Cat* (1961–1962). The series design went through changes before it broadcast, and **Joe Barbera** brought in comic book artist Doug Wildey to oversee the series. The show featured an 11-year-old boy named Jonny who had a thirst for knowledge and excitement. He traveled around the world with his father, scientist and inventor Dr. Benton Quest; his mother had died. Dr. Quest was a scientific troubleshooter for the **U.S.** government, which took them around the globe. They were aided by Roger "Race" Bannon, an ex secret agent who took on the role as a companion and bodyguard, as well as being a tutor to Jonny. They were also accompanied by a young Indian boy, Hadji, and their bulldog, Bandit.

There were various villains throughout the series who would try to thwart their work but a recurring villain was an evil mastermind called Dr. Zin, who had plans for world domination. The show cost a lot of money to produce and the ratings were quite low, which led to only a single season. In 1967, the show began to air on Saturday mornings and aired as reruns until 1972 when various parents groups objected to some of the **violent** content. The show was edited and continued to run until 1978 (though it has been rerun on all networks at various times).

In 1996, Hanna-Barbera **cartoon** studio produced an **anime**-style sequel, *The Real Adventures of Jonny Quest*, which consisted of 26 episodes and ran on the **Cartoon Network**.

JUDGE, MIKE (1962–). Born in Ecuador, Judge was raised in New Mexico. Judge studied physics at the University of California, San Diego, and worked as an engineer and musician. He moved to Dallas, Texas, and continued to work as a musician before he began to make animated films; he relocated again to Austin, Texas, where he currently resides.

Judge's first **short**, *Office Space* (1991), was picked up for broadcast by the cable network **Comedy** Central after it was screened at the Dallas Animation **Festival**. In 1992, he made *Frog Baseball*, which featured two characters, Beavis and his friend Butthead, who would become stars of their own series, ***Beavis and Butthead***. The show ran on the cable channel **Music Television** (MTV) from 1993 until 1997 and also spawned a feature film, *Beavis and Butthead Do America*. Judge performed many of the voices for the series.

He left MTV in 1997 and produced his long-running animated **sitcom** *King of the Hill* for the Fox network, again providing many of the voices himself. In 1999, Judge wrote and directed a live-action version of *Office Space* and though it did poorly at the box office its DVD sales were high.

Judge teamed up with animator Don Hertzfeld in 2003 to launch *The Animation Show*, a touring animation **festival** that has become very successful. He ventured into live action again in 2006 for *Idiocracy*, a satire of U.S. culture; however, it was poorly distributed and received no marketing and as a result virtually disappeared. In 2007, *King of the Hill* began its 12th season on Fox.

JUMPING. Directed by **Osamu Tezuka**, *Jumping* (1984) is a six-minute film shot from an unseen protagonist's viewpoint as he or she continually jumps up and down and forward in ever-higher and larger jumps. The film's narrative consists of 30 leaps each up and down, revealing a different view and passage of time. It begins in a road with the credits bouncing up and down. The camera/protagonist jumps up and down along the road, a car passes, and they jump over an oncoming car and then higher over some trees, onto a house, down into a

garden, into woods and a field in which they encounter a grasshopper. A bigger jump takes them into a henhouse, which is disturbed and broken, they jump into and out of a lake, up past a crow in the sky, past an **Association Internationale du Film d'Animation** (ASIFA) sign, over another crow and down into the city past chimneys. As they get further and higher, they jump up to skyscrapers and past airplanes. Eventually, they end up out at sea and jump over a whale, over rain clouds, into a country at war, into an attack, over an H-bomb explosion, and down into hell, from where they then leap back into the street in which they started. The sounds from the last section sound like a young child suggesting who the protagonist might have been, though the creator suggested that by seeing over the world they have a god's-eye view over humanity's fate. The film won the grand prize at the **Zagreb** International Animation **Festival** in 1984.

– K –

KING OF THE HILL. After finding success with *Beavis and Butthead*, **Mike Judge** went on to create the animated **sitcom** *King of the Hill* for the Fox network, and the series premiered in 1997. *King of the Hill* follows the Hill family who live in Arlen, Texas, Judge's home state. The show's situation is a family domestic sitcom with the focus on the father, Hank Hill, a propane salesman (which he proudly tells everyone) and his wife, Peggy, a substitute teacher. They have a son, Bobby, and a pet dog. Early in the first series, niece Luanne was introduced and moved into the household. This created a balance in the ratio of male to female characters and a foil and ally for Bobby as well as an ally for Peggy. There are a number of other characters that feature frequently, including their neighbors and Hank's friends. Hank spends much of his free time in the alley beside his house drinking beer with his friends, Dale, Bill, and Boomhauer. These peripheral characters provide a different type of **comedy**; they are more prone to slapstick behavior, representing some of the stereotypical sitcom characters, whereas Hank and Peggy provide a darker and more observational humor. The animation itself is quite different from *Beavis and Butthead* and indeed other **anicoms**, with the drawing having something of a **realist** quality. The show is largely character driven and in 2007 began its 12th season.

KLASKY CSUPO. Independent animation studio formed by Arlene Klasky and her husband, Gabor Csupo, a Hungarian artist, in their apartment in Hollywood in 1982 (the couple had married in 1979). Klasky Csupo Inc. later moved to new premises at Seward Street in Hollywood. In 1988, they began to animate *The Simpsons* interstitials for *The Tracey Ullman Show* on the new Fox network. They also created **music** videos and TV titles. In 1990, they created interstitials for *Sesame Street* and in 1991, with Paul German, created the long-running series *Rugrats*, helping to launch Nicktoons. They animated the adult series *Duckman* in 1994 for the USA network and *Aargh Real Monsters* for Nickelodeon. In 1995, the couple opened their commercial division.

The studio has been successful in creating animation for all markets and audiences, and in 1998 *The Rugrats Movie* became the first non-**Disney** animated **feature-length** film to break $100 million at the **U.S.** box office. This was followed by a second feature, *Rugrats in Paris*, in 2000. They have also animated the long-running series *The Wild Thornberrys*, *Rocket Power*, and *As Told by Ginger* for Nickelodeon and various other movies.

KOKO THE CLOWN. Koko the Clown is the star of the **Fleischer brothers'** *Out of the Inkwell* series, which Max animated and Dave directed. Koko was aware that he was made of pen and ink and interacted with Max. In each episode, he left the inkwell and tried to explore the studio. Dave was the original model for Koko when he posed in a clown suit. Max was Koko's master and sometimes nemesis. He was referred to only as "the clown" until 1923 when he was named Koko (though the name was changed to Ko-Ko in 1928, due to copyright issues).

In every episode, Koko's appearance out of the inkwell is different; he always uses a new trick to emerge. In *Koko Gets Egg-cited*, he takes a pen and "draws" the live-action background. He was given a dog named Fitz as a sidekick later in the series. He also appeared in the Fleischers' **Bouncing Ball** series and in some of their **Betty Boop** cartoons. Koko was semiretired in 1929 as the Fleischers concentrated on their work on other **cartoons** for Paramount Pictures. However, he was brought back in 1931 to support Betty Boop and her dog, Bimbo, and starred with her in *Snow White* (1933).

KOREA. *See* ASIA.

KRICFALUSI, JOHN (1955–). Born in Quebec, Canada, John Kricfalusi started working on Saturday morning **cartoon**s such as *The Jetsons* revival. In 1987, he was hired by mentor **Ralph Bakshi** as supervising director on *The New Adventures of Mighty Mouse.* The show was cancelled due to controversy over a scene where Mighty Mouse sniffed a flower and got pollen on his nose; this was read as drug use by some groups.

Kricfalusi created the **television** series *The Ren and Stimpy Show* and founded the company Spumco. He sold the show to children's television network Nickelodeon in 1988, where it aired in 1991 to great success. Kricfalusi was fired in 1992 after several years of network executive interference with demands for changes in content, though the show remained with the network. In 1996, he created *The Goddam George Liquor Program*, a **Flash**-animated **Web** cartoon. Despite his problems with Nickelodeon, he returned to working with children's television in 2001, creating *The Ripping Friends* for the Fox Kids network.

Kricfalusi has revisited *Ren and Stimpy*, creating a new adult show that was released on the cable network Spike, and has been released on DVD. He keeps an online blog with which he chats with fans and posts educational information about animation history and discusses his new work. He is a fan of **Bob Clampett**, whose influence can be seen throughout his work, particularly in the **music** of *Ren and Stimpy*, which he suggests is key to the success of the show.

– L –

LAMBART, EVELYN (1914–1999). Canadian animator encouraged in art by her father, who was a photographer, and her mother, a botanist. Evelyn Lambart studied commercial art at Ontario College of Art. She spent a year and a half after graduation working on Canada's "Book of Remembrance" doing illuminations. This was delicate work that showed her skill with fine work and color. She then went to work at the **National Film Board of Canada** (NFB) in Ottawa in 1942. It was here where she began to work with **Norman McLaren**, at first assisting him, then working as his partner.

Lambart began creating maps and diagrams for the *World in Action* series and in 1947 began her first solo work, *The Impossible Map* (1947). She resumed her partnership with McLaren in 1949 with **Begone Dull Care** (1949), which was a very inventive film and is often thought of as the partnership's best film. They continued to work well together but in the 1960s McLaren's interest in dance films grew and Lambart began making her own films. She began to use a technique of paper cutouts transferred onto litho plates and then painted and animated. This was used to make seven award-winning films, including *Fine Feathers* (1968), *The Hoarder* (1969), *Paradise Lost* (1970), *The Story of Christmas* (1973), and *Mr. Frog Went A-Courting* (1974).

She retired from the film board in 1975 and moved to the country, where she made her last film, *The Town Mouse and the Country Mouse (Le Rat de maison et le Rat des champs,* 1980).

LANTZ, WALTER (1900–1994). An American animator from New Jersey, he moved to New York at the age of five. Walter Lantz started his animation career in the **silent era** with William Randolph Hearst in 1916 but was hired by **John Randolph Bray** in 1921, where he worked for four years; during this time he made his directorial debut. He made *Dinky Doodle* in 1923 and would act in his films in a combination of live action and animation. In 1929, he began to make films for distribution at Universal, including *Oswald the Lucky Rabbit*, which had previously been made by **Walt Disney**. He did well at Universal with *The King of Jazz* (1930) and *Depression* (1933).

Lantz started his own studio in 1936 but closed it in 1940 to recoup losses. He did this again when business was slow, reopening when things were favorable. In the early 1930s, Lantz hired **Tex Avery** to work for him. Lantz is perhaps most famous for his *Woody Woodpecker* films, which first appeared in 1940 with *Knock Knock*. His studio lasted longer than most of that era, finally closing in 1972 due to high production costs, and he instead concentrated on merchandising.

LASSETER, JOHN (1957–). John Lasseter was born in Hollywood, California, and attended the character animation program at **California Institute of the Arts**, where he was awarded two student

awards for *Lady and the Lamp* (1979) and *Nitemare* (1980). Lasseter worked for the **Disney Studio** for five years. While he was working on *Mickey's Christmas Carol* in 1983, when *Tron* was being made, he was invited to view some of the early footage. Lasseter was very impressed by the computer animation and felt that it was the future of animation. He left Disney in 1984 and went to work at Lucas Films, where he made *The Adventures of André and Wally B* (1984).

Lasseter wrote and directed a series of **shorts** over the years, including *Luxo Jr.* (1986), *Red's Dream* (1987), *Tin Toy* (1988), and *Knickknack* (1989). He demonstrated the computer technology that was purchased by Steve Jobs (of Apple Computers) in 1986 and named Pixar after the computer they had used. Lasseter used Pixar's **three-dimensional** (3D) software Renderman to create his films, and they formed the **Pixar** animation studio. *Tin Toy* won an **Academy Award** for animated short.

After the initial success in shorts, Lasseter moved on to **feature-length** animation and directed the first fully computer-animated feature-length animation, ***Toy Story*** (1995), which earned him a Special Achievement Oscar for "inspired leadership of the Pixar Toy Story Team resulting in the first feature-length computer animated film." This was followed by *A Bug's Life* (1998), *Toy Story 2* (1999), *Monsters Inc.* (2001), *Finding Nemo* (2003), *The Incredibles* (directed by **Brad Bird**, 2004), and *Cars* (2006). Lasseter was honored by the Art Directors Guild in 2004 for Outstanding Contribution to Cinematic Imagery. He is currently chief creative officer of Pixar and Disney Animation Studios.

LEAF, CAROLINE (1946–). Born in Seattle, Caroline Leaf studied visual arts at Radcliffe College (affiliated with Harvard University). Leaf was encouraged into animation, though initially reluctant, but after experimenting found she enjoyed working with a "sand on glass" technique. She found she preferred animating objects rather than drawings—the movement was what was important. Her first film was *Sand or Peter and the Wolf* (1968). After she graduated, she moved to Rome for a year.

Leaf returned to America with a fellowship at Harvard and made the film *Orfeo* (1972) by painting on glass. She worked freelance while living in Cambridge and made *How Beaver Stole Fire* (1972)

for a St. Louis company; however, they disagreed when the company wanted to alter the animation. Leaf joined the **National Film Board of Canada**'s (NFB) English Animation Studio, and went to work in the far north, inspired by Inuit tales. She returned to the NFB in 1974 and made *The Owl Who Married the Goose: An Eskimo Legend* using sand on glass and won 11 awards.

Leaf's next two films, *The Street* (1976) and *The Metamorphosis of Mr. Samsa* (1977), brought international acclaim and awards, including 22 for *The Street*. For this film, she used paint mixed with glycerin so it would not dry and would have the same consistency on the glass as sand. *Metamorphosis* used the sand technique and won 10 prizes.

Leaf worked with experimental filmmaker Veronika Soul to make *The Interview*, with each woman illustrating her perceptions of her filmmaking techniques. She tried **documentary** with *Kate and Anna McGarrigle* (1981) but preferred to work on fiction, and in 1982 made an educational drama for the Canadian Labour Congress.

Leaf took a hiatus of nearly 10 years and then she began trying new techniques, including the **cameraless** technique of scratching directly onto film. *Two Sisters* (1990) won the best **short** film at Annecy and she was once again in the international spotlight. In 1996, Leaf was awarded a Life Achievement Award at **Zagreb** International Animation **Festival**. She has spent some time teaching at Harvard (1996–1998) and since 2001 has lived in London, **Great Britain**, continuing to animate and paint.

LEEDS ANIMATION WORKSHOP (LAW). A British film collective founded in 1978 to produce animated films on social issues, Leeds Animation Workshop has produced 24 **short** films as well as title sequences for **television** programs. The group, based in Yorkshire, **Great Britain**, was formed as a women's collective, committed to feminist and collectivist principles and an integrated practice of production. The group has five members—Jane Bradshaw, Terry Wragg, Stephanie Munro, Janis Goodman, and Milena Dragic—and together they combine their artistic and educational skills, and media and cultural work experience to work together on all aspects of filmmaking, from the initial ideas stage to distribution of the final film.

The workshop has organized international **festivals** for women and ethnic minority filmmakers and runs workshops in animation for community groups. They have been sponsored by a variety of bodies from **Channel 4** to the British Film Institute and local and regional arts councils. Their first production was *Who Needs Nurseries? We Do!* (1978), which was an eight-minute film promoting child care provision for preschool children. Other films have dealt with domestic **violence**, homelessness, harassment, racism, bullying, and environmental concerns, to name a few. The films have been repeatedly shown in a variety of locations from government and public organizations to schools and hospitals. The films are useful training tools as they are accompanied by discussion notes.

The animation is used to convey some serious subjects in an accessible way, and the films are often entertaining. The Leeds Animation Workshop has continued to maintain its initial purpose and make films that promote its principles.

LEGO FILM. Lego or "brick" film is **stop-motion** animation using Lego bricks. A movement emerged when independent animators began using the plastic toy building bricks to re-create animated versions of live-action films in the mid-1980s. Though it was not actively encouraged by the toy manufacturer, the company responded to the demand in 2000 by creating a "Lego Steven Spielberg 'Movie Maker' Set" that encouraged people to try to make films using the bricks. However, although the set was not popular, the films continued to be made. Largely through Web distribution, a community formed to share films. The technique is relatively easy to use as the pieces themselves are durable plastic and accessible, as well as providing a fairly iconic look, which gives the films a certain aesthetic.

The form lends itself to stop motion and appeared in the mainstream when **music** video director Michel Gondry used the bricks to create a video for the **U.S.** band *The White Stripes*. The video was played on **Music Television** in heavy rotation and the phenomenon began to increase in popularity. Another good example is the *Camelot* musical sequence, which was created based on the Monty Python live-action **comedy** *The Holy Grail* and which stars Lego

brick men instead of the actors performing the songs. The **short** is available on the live-action film's DVD release. The popularity of the *Star Wars* Lego films led to the creation of video games that use the principles of the animated films in their graphics. The Lego Company now hosts a website that allows filmmakers to display their work. The site includes over 600 films by over 32 filmmakers actively distributing their work through the site, with other animators starting to use the technique. What began as a small, male-dominated group has grown and become influential in the mainstream.

LIMITED ANIMATION. The term *limited animation* is at its most basic definition a quantitative measure where cycles of animation are utilized or backgrounds are reduced to save time and often money. It uses fewer images per increment and includes extensive camera movement instead of character or background movement. The camera may be used to pan over the background to create a sense of movement. The narrative is frequently driven by sound and narration or dialogue, though often with a lack of detailed lip-synching.

Although limited animation can save time and money, it also creates a particular stylized effect on the finished animation and first became commonly used in the mainstream at **United Productions of America**, whose **modernist** aesthetic lent itself to a more minimalist approach. The technique was more frequently used as a labor- and time-saving device in **television** animation, particularly by **Hanna-Barbera**. Despite the high quality of writing and dialogue in many of Hanna-Barbera's series, it became heavily criticized as lacking in visual quality in comparison to the theatrical **cartoons** of **Metro-Goldwyn-Mayer**, **Warner Brothers**, or the **Disney Studio**. This opinion became dominant and the term has virtually become synonymous with poor quality animation. However, in **Japan** there has been less of a stigma attached to using limited animation and the stylized **anime** has used the technique for many years, a good example of which is **Osamu Tezuka**'s *Astro Boy*.

Limited animation has remained in use in television production but recent examples such as *The Simpsons* or *King of the Hill*, like Hanna-Barbera's series, include good writing and dialogue that enhance the overall quality of the programs.

LION KING, THE. In the early 1990s, the **Disney Studio** enjoyed a brief renaissance with its **feature-length** productions, following the release of the very successful *The Little Mermaid* (1989) and *Beauty and the Beast* (1991). This was followed by *The Lion King* (1994), an **anthropomorphized** animal tale, a loose **adaptation** of William Shakespeare's *Hamlet* with lion cub Simba trying to avenge his father's death. The film was directed by Roger Allers and Rob Minkoff. *The Lion King* broke the box-office record for the highest grossing traditionally animated film. Despite this success, it was also the subject of some criticism for its unacknowledged close resemblance to Osamu Tezuka's *Kimba the White Lion* (1965). The studio was said to have been unconvinced that the film would be a success but it proved to be so successful that a spin-off **television** series, *Timon and Pumbaa* (1995–1998), was launched featuring two popular sidekicks from the film.

Unfortunately, the triumph of *The Lion King* also led to an increase in the production of features at other studios trying to capitalize on its success, which consequently led to increased budgets, costs, and management interference. The level of success could not be repeated in later features such as *Pocahontas* (1995) and *Hercules* (1997), and marked a decline in the studio's feature production.

LITTLE NEMO. **Winsor McCay**'s first animated film based on his comic strip "Little Nemo in Slumberland," which first appeared in the *New York Herald* in 1905 and was released in 1911. Inspired by flip books, McCay worked for four years on *Nemo* before its debut in 1911 and it was first unveiled in a vaudeville act. The film consisted of 4,000 hand-colored drawings and was shot in 35 mm frames. There was no storyline to the film, just the characters who in speech balloons said "watch us move" and the movements showed examples of the common animation action "Squash and Stretch" (an example of one of the **Twelve Principles of Animation**). The film was well received and was shown in theaters.

LOONEY TUNES. Series of **shorts** produced by **Warner Brothers** studio that echoed the trend of the late 1920s and early 1930s for **music**-based series such as the **Disney Studio**'s *Silly Symphonies* and **Metro-Goldwyn-Mayer**'s later *Happy Harmonies*.

The *Looney Tunes* series was the first series of shorts created by duo Hugh Harman and Rudolph Ising from their **Harman-Ising** animation studio, produced by **Leon Schlesinger** to take advantage of Schlesinger's access to Warner's vast music library. The first short in the series was *Sinkin' in the Bathtub*, which was released in May 1930. The title is a play on a popular song title that featured in the introduction of the Warner Brothers' feature *The Show of Shows*. The first *Looney Tunes* featured the Bosko character starring in what amounted to a musical interlude with a few gags included. The inspiration was said to have come from **Mickey Mouse** and *Aesop's Fables*.

A second series was commissioned by Schlesinger in 1931, this time called *Merrie Melodies*, and had more focus on the music it used, rather than just using it in the background. The series was again run by Harman and Ising, but the pair gradually divided the workload among their respective teams. Harman and Ising left the studio in 1933, taking Bosko with them, but Schlesinger gave the series to **Friz Freleng** and his new animators to take over.

By the early 1940s, branded **cartoons** *Merrie Melodies* and *Looney Tunes* were produced simultaneously with little distinction between the two. *Looney Tunes* was later to be produced in full color and they used different theme tunes but they seemed to share characters.

Most of the best-known character "stars" of the Warner Bros. studio appeared in the series, including **Bugs Bunny**, Porky Pig, and Daffy Duck, though the *Looney Tunes* brand was the strongest and is the most frequently referred to. Even in later films, the character groupings were known as the Looney Tunes characters, such as *Space Jam* (1996) or *Looney Tunes: Back in Action* (2003).

LORD OF THE RINGS, THE. Adaptation of J. R. R. Tolkien's fantasy epic, featuring hobbits and wizards who inhabit Middle Earth and the quest for a magical ring, released in 1978 and directed by **Ralph Bakshi**. After the success of *Fritz the Cat*, Bakshi was able to secure funding (in part by United Artists) to produce an animated version of the trilogy. Despite planning the three films, however, he was only able to make the first one, due to the loss of funding after mixed reviews, despite being financially successful. The first installment was intended to be subtitled as part one, but this was removed

from publicity material and as a result many Tolkien fans felt that Bakshi had left out vital elements from the original text. He was also criticized for his extensive use of the **rotoscope**, which produced a visual quality different from his previous work.

LYE, LEN (1901–1980). Len Lye was born in Christchurch, New Zealand, and from an early age had an interest in drawing and movement. He was interested in representing kinetic energy and was inspired by aboriginal art. Lye moved to London, **Great Britain**, in 1926 and joined a **modernist** group of artists, the "Seven and Five Society." He exhibited work with the group but became more interested in animation than static art. His first film, *Tusalava* (1929), was created over a number of years, involving over 4,000 drawings. The film featured **abstract** images and shapes but was not well received and he found it difficult to support his work.

Lye made a **puppet** film, *Experimental Animation* (1933), with sponsorship from an exhibitor, and then joined the General Post Office (GPO) film unit where he was able to experiment with techniques while creating his films. He began to experiment with **cameraless animation** techniques, painting directly on the film. His first film with the GPO was *A Colour Box* (1935) and still managed to include his abstract shapes as long as the sponsor's message was within the film. The film was successful and Lye began to achieve some acclaim.

He began to experiment with technique, using even more silhouette or stencil patterns but always maintained a concrete symbol in the films. He produced the puppet film *Kaleidoscope* (1936) with Humphrey Jennings, and in *Trade Tattoo* (1937) he incorporated **documentary** footage with his abstract animation. His last film with the GPO was *N or N.W.* (1937), which took a slightly more conventional approach. After this, Lye made some **advertising** films and then during the war worked on **propaganda** films.

Lye moved to New York in 1944 and codirected a series of four educational films with I. A. Richards. At this point, he began experimenting with kinetic sculptures as well as continuing with his abstract films. He moved back to New Zealand in 1968, by which time his reputation as an important nonrepresentational artist had been founded.

– M –

MACHINIMA. *Machinima* is the use of computer game engines to create animation, often subverting the original intentions of the graphics or engine by creating a narrative where there was not one previously or changing what had been there before. A conglomeration of fan culture and **Web animation** culture, the games are re-edited and the graphics are modified creating animation. The creators are essentially hybrid authors with an interactive and creative approach to an existing game. This form of animation has become a growing phenomenon that has seen the creation of websites dedicated to showing the films. A frequently used game is the very popular *Halo* video game, which is a first-person shooter game where the player controls the protagonist's actions, but there are numerous other characters to allow multiple players.

The best example of *machinima* using *Halo* is the increasingly popular series ***Red vs. Blue***, which parodies the military nature of the game in a **sitcom**-like series. The series was created in 2003 and episodes are available to buy on DVD. The interactive software *Second Life* is also increasingly being used for *machinima*. The process has been described as "filmmaking within a real time 3D [**three-dimensional**] virtual environment, often using 3D video game technologies." It is a convergence of filmmaking, animation, and game development and can be controlled by script, humans, or computer artificial intelligence. The users describe it as a cost-effective and efficient way to make films. In March 2002, an Academy of Machinima Arts and Sciences was established in New York to offer support and credibility to members of the *machinima* community.

MANGA. The term *manga* has two distinct meanings. The word comes from the Japanese word for comic or print **cartoons**. These cartoons are often serialized and occasionally printed in black and white. The popular **television** series ***Astro Boy*** began as a manga series before it was an animated cartoon. The industry has increased over the years and has become successful with Western audiences, though often the original publications have to be adapted to suit this audience as the Japanese books are printed to be read from the right to left and back to the front, rather than front to back and left to right as in the West.

This increase in exposure in the West led to the term *manga* being used for any Japanese animation in place of **anime**.

Since 1994, Manga has also been the name of a publishing company that distributes anime in **Japan** and worldwide. Based in Tokyo, the company also has offices in Los Angeles and London, and it publishes films for the theatrical and home DVD market. It has distributed some critically acclaimed and award-winning anime, including *Ghost in the Shell* (1995). The company also hosts a website to market the films and is a division of Starz Media, which is a wholly owned subsidiary of Liberty Media Group.

MCCAY, WINSOR (?–1934). His date of birth is listed in various sources as either 1867 or 1871. Winsor McCay began his career as a newspaper cartoonist, with his longest position at the *New York Herald* (1904–1911), and was known for the strip "Little Nemo in Slumberland" (1905). He was inspired by flip books and the films of **J. Stuart Blackton** (Blackton directed the live-action sequences for McCay's first film).

McCay's first animated film was based on the "**Little Nemo**" cartoons and was released in April 1911. The film comprised 4,000 drawings all hand-colored by McCay. The film was very popular and was followed by *The Story of a Mosquito* in 1912. McCay's next film was possibly his best known, *Gertie the Dinosaur* (1914), and consisted of 10,000 drawings on the one-reel film. The films were presented by McCay in a similar style to the chalk talks used by Blackton and **Émile Cohl**, but differed from them in featuring the actual animated films within the larger film and McCay interacted with the film as part of the routine. *Gertie* was shown as part of a tour where McCay would bet the viewers that he could make a dinosaur come alive.

McCay also made (arguably) the first animated **documentary**, *The Sinking of the Lusitania* (1918), describing the events of the ill-fated liner. After leaving the *Herald*, he worked for William Randolph Hearst, who largely controlled his tours and output, and McCay continued to produce **cartoon** strips for Hearst's papers. He moved away from animation in 1920 and in 1924 left Hearst to return to what was now the *Herald Tribune*. He tried to revive "Little Nemo" but that only lasted two years. He spent the remainder of his life drawing editorial cartoons at the *American*, a Hearst paper.

MCLAREN, NORMAN (1914–1987). Born in Stirling, Scotland, Norman McLaren has been described as one of the most significant **abstract** filmmakers in **Great Britain**, in the interwar period. He is also well known for work he produced in Canada later in his life. McLaren attended Glasgow School of Art (1932), where he produced his first film, a stylized documentary on dance, *Seven Till Five* (1933), which showed his influence by Sergei Eisenstein; in his next film, *Camera Makes Whoopee* (1935), he began to experiment further with techniques including **pixilation** and abstract animation.

McLaren won Best Film at the Scottish Amateur Film **Festival** in 1935 for *Colour Cocktail* and attracted interest by Scottish filmmaker John Grierson, who invited him to work with the General Post Office (GPO) Film unit for whom he began to produce films, including *Love on the Wing* (1938), an animation promoting the postal service.

McLaren moved to the **United States** in 1939 and in 1941 moved to Canada, where he was invited again by Grierson to join the **National Film Board** (NFB). where he spent most of his career. There, McLaren put together the board's first animation team. His first films for the board were to support the war effort, but he was given enough freedom to be able to make his experimental films as well. He was interested in exploring new techniques in creating animation and also experimented with sound and dance.

McLaren made 59 films over his career; among the most notable were *Boogie Doodle* (1940), **Begone Dull Care** (1949), *Neighbours* (1952), *Blinkity Blank* (1954), and *A Chairy Tale* (1957). His last film was *Narcissus/Narcisse* in 1983.

Many of his techniques emphasized synchronization of sound, and he was interested in the relationship between sound and image. He used **cameraless animation**, where he painted directly onto the film surface or scratched out the images.

McLaren worked closely on several films with **Evelyn Lambart**, who was said to share his artistic sensibilities. He is often quoted for his fairly profound view on animation, which has become something of a definition: "Animation is not the art of drawings-that-move, but rather the art of movements-that-are-drawn" (Solomon 1987, 11). McLaren is suggesting that what happens between the frames was more important than what happened on each frame.

MÉLIÈS, GEORGE (1861–1938). Born in Paris, Georges Méliès began his career as an illusionist. He bought the Robert Houdin Theatre

and became an artist, an impresario of magic and variety shows. As a prospective client of the Lumière brothers, Méliès was invited to a screening at the Salon des Indiens on 28 December 1895, after which he was inspired to go into directing and producing film.

Méliès was a leader in his field for 10 years, as the first filmmaker to use cinema as a tool for imagination; he made 520 films. He often kept the movie camera stationary and suggested that the action occurred like an "animated **puppet** theater." Méliès is included here for his role in the origins of cinema and the related techniques in animation, particularly his innovative use of special effects and time-lapse dissolves. Méliès also used hand-painted color. His most famous film was *A Trip to the Moon* (1902), which uses some animated techniques with the live action to create a dreamlike moonscape. By the mid-1900s, Méliès' techniques were no longer viable as they required painstaking attention to detail, and exhibitors required quicker turnaround due to the increasing demand for films. *See also* FRANCE.

MESSMER, OTTO (1892–1983). Born in New Jersey, Otto Messmer was interested in drawing and film early on. He was taught the basics by Hy Mayer, a cartoonist animator, in 1914 and they began to create **advertising** films together. In 1915, Messmer was hired by **Pat Sullivan**, with whom he collaborated for 20 years. He produced *Twenty Thousand Laughs under the Sea* (1917), a **short** inspired by the release of Jules Verne's story.

In 1919, Messmer created the character **Felix the Cat** for Paramount Pictures' newsreel *Screen Magazine*. The films were well received and the rights were patented by Paramount, though these rights were later acquired by Sullivan and the films were instead distributed by Margaret Winkler. Messmer directed the *Felix* **cartoons**, though Sullivan's name appeared on them, but he also drew the "Felix" cartoon strip. After Sullivan died in 1933, Messmer stopped producing *Felix* due to rights issues and retired from filmmaking to concentrate on comics and illustrations. Messmer briefly worked for **Famous Studios** in the 1940s but never made any more animated films. He was recognized for his pioneering work with Felix in 1967.

METRO-GOLDWYN-MAYER (MGM). Metro-Goldwyn-Mayer has been described as the "Tiffany's of motion picture studios" due to the quality of its output, particularly in the Golden Age of the studio system. Although the studio had no **cartoon** releases in the **silent era**,

it became interested in the medium following the success of **Walt Disney**. It was rumored that MGM wanted to try to hire Disney in 1929 but did not want to negotiate with his distributor, Pat Powers. However, it later secured a deal with **Ub Iwerks** to distribute a series of *Flip the Frog* cartoons; their relationship lasted four years.

In 1934, MGM signed with Hugh Harman and Rudolph Ising. The pair had been involved in a dispute with **Leon Schlesinger** at **Warner Brothers** the year before and as a result MGM was able to hire other Warner Bros. staff who had been sympathetic to the duo. They produced 8 to 12 **shorts** a year in their *Happy Harmonies* series, an attempt to rival Disney's *Silly Symphonies*. **Harman-Ising** produced high-quality personality animation but the costs overran and in 1937 MGM decided to open its own animation studio to reduce the cost of contractors. **Fred Quimby** was installed as the head of the studio and hired many of Harman-Ising's staff, including **William Hanna** as a director. MGM also hired several former **Terrytoons** employees from New York, including **Joe Barbera**, and also in 1937 **Friz Freleng**.

The studio attempted to make a series, *The Captain and the Kids*, based on a comic; however, the series failed and the budgets were too high with the top staff. Harman and Ising were brought back in for a few years to save the department but Freleng left and returned to Warner Brothers. In 1939, the studio produced its first *Barney Bear* cartoon, which was successful, as was Harman's film *Peace on Earth*.

Ising's unit produced *Puss Gets the Boot* in 1940, which was the first *Tom and Jerry* cartoon, created by Bill Hanna and Joe Barbera, who would become the studio's most successful pair, and *Tom and Jerry* became the leading stars. Bill and Joe won an **Academy Award** for the cat-and-mouse duo in 1943 for *Yankee Doodle Mouse*, which was the first of seven. Harman and Ising left the studio in the early 1940s and **Tex Avery** was brought in. The work blossomed under his direction and he introduced some new characters.

In 1944, Gene Kelly, who was under contract with MGM, wanted to feature an animated section in his film, but was turned down by his first choice, the **Disney Studio**. Instead, he turned to the animation studio within MGM and one of the most famous sequences, featuring Gene dancing with Jerry Mouse, appeared in the musical *Anchors Away*.

Avery left the studio in 1950 for a break until returning in 1951. In the 1950s, the characters Droopy, the wolf from *Red Hot Riding*

Hood, and Screwball Squirrel arrived. Changes in the industry saw rising costs and the adoption of CinemaScope in 1954. The designs had to be changed to fit the new format. In 1954, Avery left, this time for good, and in 1955 Quimby retired. Hanna and Barbera were the successors who continued to produce Tom and Jerry from 1955 to 1956. However, in 1956, MGM decided to close the animation division and all of the staff were laid off, including Hanna and Barbera, who went on to form their own studio in partnership. In 1961 and 1962, MGM contracted **Gene Deitch** to produce new *Tom and Jerry* films for theaters. In 1964, this task was passed to **Chuck Jones**, who went on to produce a number of other films for MGM with his own staff, including *How the Grinch Stole Christmas!* (1967). Despite the lack of a dedicated animation studio, MGM continued to distribute animated films.

MICKEY MOUSE. Walt Disney's most enduring character and one of the most famous **cartoon** characters in the world; Mickey Mouse is the image of the Golden Age of animation and Disney's corporate image. The character originated after Disney had a disagreement with **Charles Mintz** over the distribution of another character. In an attempt to come up with something new, Disney drew a mouse figure and it has been suggested his wife named him Mickey. The character was then drawn by **Ub Iwerks**, though he received little credit for the actual design. Mickey's first appearance was in the film *Plane Crazy* (1928) with Mickey as a pilot, which was supposed to capitalize on the Lindbergh craze. It was Mickey's third appearance in *Steamboat Willie* (1928) that made him a star, as he featured in the first sound-synchronized animated cartoon. It only took a few years for Mickey to become famous internationally, and in 1930 he became the star of his own comic strip by Floyd Gottfredson (it ran until 1975) as well as countless items of merchandise, such as T-shirts, combs, watches, and dolls.

Despite his continuing success, Mickey only appeared in Disney's films until 1953, after 121 films, with the exception of *Mickey's Christmas Carol* in 1983. He was surrounded by sidekicks in his films, such as Pluto the dog and Goofy, who would fulfill the **comedy** gag element of the cartoons, but eventually they became stars in their own rights. Mickey was seen as "good" and it was up to his sidekicks to play the naughty or mischievous role in the films. He is

accepted as a boy/mouse with human qualities and **realism**. His success brought in enough money for Disney to be able to experiment with other projects such as *Fantasia* (1940), though Mickey starred in the "Sorcerer's Apprentice" sequence in the elaborate film. Disney was awarded a Special **Academy Award** in 1932 for his creation that remains popular into the 21st century.

MINNIE THE MOOCHER. Directed by Dave **Fleischer**, *Minnie the Moocher* (1932) has been noted as a masterpiece of the Fleischer studio. The film is based on the song of the same title by Cab Calloway, who appears in the opening scene. This was due to his contract with Paramount Pictures and the Fleischers' good relationship with the studio at the time. The film also features **Betty Boop** and Bimbo. **Koko the Clown** makes an appearance from the inkwell as Betty writes a note to her parents to tell them that she is leaving home. Her dog, Bimbo, goes with her but as they approach the woods it gets darker and more sinister. They become afraid of ghosts, who start to appear, and they then encounter a walrus as Cab Calloway sings and dances to "Minnie the Moocher." Calloway's performance was **rotoscoped** for this section, as was Betty's and the dancing skeletons that appear. The imagery in the film is very dark and includes a section where ghost prisoners go to the electric chair and skulls move around. In the final scenes, a ghost chases them out of the woods and they run home to safety. It has been suggested that these visions are allusions to sex and danger, and the dance is a dance of death.

MINTZ, CHARLES (1896–1940). Charles Mintz became involved in the animation business through his wife, Margaret Winkler, who was one of the key distributors of animation in the **silent era**, and of particular support to **Pat Sullivan** and the **Fleischer brothers**. As the business grew, Charles became increasingly involved, eventually becoming her successor. One popular story surrounding Mintz was his wresting the control of the *Oswald the Lucky Rabbit* series from **Walt Disney**, who, forced to find a new character, came up with **Mickey Mouse**.

By taking control of Oswald, Mintz was able to build a studio that was staffed by some of the best animators of the time. In the 1920s, Mintz continued to distribute the Krazy Kat series of **shorts**, which came under the banner of Charles Mintz's **Screen Gems**. He moved

the studio from New York to Los Angeles and was known for allowing the animators to retain autonomy over their creations.

Mintz signed a deal with **Columbia** in 1930, with them eventually taking over due to financial difficulties. He ran the studio with them until 1939, when poor health forced him to step down. He died in 1940, shortly after Columbia took over full control.

MIYAZAKI, HAYAO (1941–). Born in Tokyo, **Japan**, Hayao Miyazaki is considered to be one of Japan's foremost animation directors. Miyazaki began his career as an assistant and later animator at the studio Toei Doga, where he developed a keen drawing ability and suggested many film ideas. In 1971, Miyazaki moved to A Pro, where he began to work with Isao Takahato, a collaboration that would endure throughout his career.

In 1973, Miyazaki moved to Nippon Animation, where he worked on the *World Masterpiece Theatre* **television** series for five years. His directorial debut was the television series *Conan, the Boy in the Future* (1978). He moved to Tokyo to work at Movie Dhinsha in 1979, where he directed his first feature, *Lupin III: The Castle of Cagliostro*.

In 1984, Miyazaki was commissioned to **adapt** his **manga** *Nausicaä of the Valley of the Wind* for cinema. In order to undertake such a project, he enlisted Takahato; the success of this relationship led to their formation of **Studio Ghibli**, whose films have been critically and commercially successful.

Miyazaki (and Studio Ghibli) is perhaps best known and internationally acclaimed for his **feature-length** animation, or **anime**, films *Princess Mononoke* (1997) and *Spirited Away* (2001), the latter of which won the **Academy Award** for Best Animated Feature in 2003. He continues to draw manga and direct feature films. Other notable films include *Porco Rosso* (1992), *Howl's Moving Castle* (2004), and *Ponyo on a Cliff* (2008).

MODERNISM. Art movement of the pre–World War I period, extending from the late 19th century into the early 20th, which began with a rejection of traditional forms of art and architecture. The movement emerged alongside industrialization, the rise of the scientific method, and modern capitalism. Its proponents questioned traditional hierarchies and the movement is particularly evident in the art of Pablo

Picasso, Piet Mondrian, and the architecture of Frank Lloyd Wright and Mies van der Rohe. Design was more concerned with the function of an object than the aesthetic, seen in the German Bauhaus designs.

Stylistically evidence of modernism is seen in the animation of post–World War II, typified in the **United States** by **United Productions of America** (UPA). It included a rejection of **Walt Disney**'s **realist** style during the 1950s, and a desire to move beyond slapstick gags and routines and "instead use the language of animation to convey contemporary ideas and themes" (Amidi 2006). The animation was influenced by modernist artists such as the cubists, **surrealists**, and expressionists. The result was highly stylized and "designed" with an often **abstract** approach, particularly in the background designs. The advent, and increasing use of, **television** affected the scale and scope of the output as well as the increasing use of animation in **advertisements**.

Other U.S. studios that favored the modernist style are **Columbia and Screen Gems**, late output from **Warner Brothers**, Academy Pictures, Creative Arts Studio, Elektra Films, **Fine Arts** Films, **Hanna-Barbera**, John Sutherland Productions, Playhouse Pictures, **Shamus Culhane** Productions, **Terrytoons** after the CBS purchase, and **Walter Lantz**, to name a few.

MOTION CAPTURE. Computer animation technique where sensors are placed, typically, on a body to record the movement of the body or object. It is perhaps closer in this respect to live action than animation though the recorded image can be manipulated as the recorded movements are mapped onto a computer model frame, or skeleton. The computer-driven system allows directors to rehearse and direct movements of a **three-dimensional** (3D) **cartoon** character. It can be used by puppeteers to manipulate "models" or actors connected to the sensors for "lifelike" movement. The technology was originally used by the military in the 1970s and began to be used in **television** production from the 1990s, particularly in children's television.

Motion capture is also often used to record **realistic** movement for video games. It was used very effectively in the special effects for the live-action **science fiction** movie *T2* and is used in the animated television series *Reboot* for facial expressions. There are some limitations in the technique, though technological advances are improving its applications. It is similar in some respects to the **rotoscope**.

MULTIPLANE CAMERA. Animation tool developed by **Walt Disney** and first used in the introduction sequence of his film *The Old Mill* (1937). The camera cost $70,000 dollars to make and was mounted in a frame that measured 14 feet tall. A moveable camera was mounted in a frame that allowed it to capture the image at the bottom through a series of backgrounds, or planes, that achieved the perception of depth in the film. **Ub Iwerks** had developed something similar in the early 1930s that was horizontal and had a fixed camera, but it had never been as successful in capturing intricate details. The camera maintained sharp focus, and illumination could be controlled on seven levels. The tool was used to great effect and was instrumental in the success of Disney's *Snow White and the Seven Dwarves* (1937), the first **feature-length** animation in the **United States**. The multiplane was patented in 1940 and the technique is still used in contemporary animation.

MUPPET SHOW, THE. Series starring **Jim Henson**'s **puppets**, the Muppets, debuted in 1975. The series was created after Henson's Muppets were successful on *Sesame Street*. He felt that the characters would appeal to a wider audience than the children that *Sesame Street* was aimed at. He tried to sell the idea in the **United States** for several years until finally receiving backing from English **television** producer Lew Grade. As a result, the initial production began at Grade's London-based ATV studios.

The main characters were Miss Piggy, a feisty starlet; Fozzie Bear, an aspiring but terrible comedian; Animal, a wild drummer; the Great Gonzo, of unknown species but all-around entertainer; and Scooter, the assistant. The show was set in a theater with most of the action happening backstage as host Kermit the Frog tried to organize a show each week. The house band was led by Dr. Teeth and was accompanied on piano by Rolph, the dog. Each week a human guest star would appear alongside the Muppets and perform in their show.

Stars lined up to be on the show and ranged from Gene Kelly to Steve Martin. The sketches in the show were generally parodies of popular film and television, including *Pigs in Space* as a *Star Trek* spoof and *Veterinarians Hospital* for the long-running soap opera *General Hospital*. The success of the show led to the creation of a succession of Muppet movies such as *The Muppet Movie* (1979), *The Great Muppet Caper* (1981), *Muppets Take Manhattan* (1984), and *The Muppet Christmas*

Carol (1992). The series ran from 1976 until 1981 with 120 episodes. The series was revived as *The Muppets Tonight* in 1996 and was hosted by the character Clifford. This series ran until 1998.

MUSIC. Animation and music have gone together since the invention of the form, when music accompanied the "lightning sketch" performances of the first animators. The music was always used to accompany and lead the narrative, and with **Walt Disney**'s *Steamboat Willie* in 1928 the sound era had begun. The next two decades saw several music-themed **cartoon** series, including Disney's *Silly Symphonies* and **Warner Brothers'** *Merrie Melodies* and *Looney Tunes* series. These **shorts** would typically be named for the song that they accompanied and, in the case of Warner Bros., was a good use of the back catalogue of the studio; the studio also produced some of the major singing stars of the time. Music became a driving part of features, and like live action, the **musical** genre emerged and increased in popularity and production.

Although music was often used to accompany the animation, experimental artists such as **Oskar Fischinger**, **Hans Richter**, and **Norman McLaren** were interested in the relationship between sounds and movements, essentially creating animation "in time" to their chosen music. A new practice of "visual music" emerged and many animators over the years would experiment with sound. This practice developed with new technology, as video and later computers would make it easier for animators to record the images and sound together. **John Whitney** developed computer technology to aid his experiments in creating and composing such work as *Catalog* (1961). His work was very influential to the development of animation technology.

In the late 1930s, Walt Disney took a different approach to music in his films and set about making *Fantasia* (1940), which was divided into segments, each using a different piece of classical music as its inspiration and accompaniment (Fischinger was initially hired to work on the project but later left). In this instance, the relationship of the music and image was as important to Disney as to the experimental filmmakers, but was essentially the first time to be done on such a scale in the mainstream. Unfortunately, the film was not a box-office success, though in later years, the film was re-released to a more receptive audience. This was partly due to the success of the music-based *Yellow Submarine* (1968), which used the music of the Beatles as its focus.

In the 1980s, a new relationship between music and animation emerged with the launch of the **television** network **Music Television (MTV)**. MTV initially launched in the **United States** but soon had international variations and supported the development and broadcast of music videos, many of which were animated. It also commissioned animated advertisements and idents as well as supporting new animated television series. A new generation of contemporary animators began their careers in music videos, just as their predecessors had done with **advertising**.

MUSIC TELEVISION (MTV). Music Television or MTV began in 1981 in the **United States** as a cable channel dedicated to playing **music** videos. The channel is worthy of mention here with respect to the animation shown and the animated music videos that have frequented the channel over the years. The success of the channel materialized very quickly and it was soon an important part of the popular music industry and youth culture. The station commissioned a variety of animators to create idents, **shorts** that would reinforce the corporate image. Among these were a series by **Bill Plympton** that provided the animator with a showcase for his work. Animation continued to have a home on the network and from 1993 to 1997 it was home to **Mike Judge**'s *Beavis and Butthead* series, which combined animation and music video. The success of this series led to Judge's long-running animated **sitcom** *King of the Hill* (1997–) and the *Beavis and Butthead* spin-off *Daria*, which also appeared on MTV.

In 1995, the channel broadcast a series of **short** films, including *Aeon Flux*, as part of its animation showcase "Liquid TV." From 1998 to 2002, the **clay** animation series *Celebrity Deathmatch* aired in its late-night lineup, a parody of pro wrestling and celebrity culture. The channel broadcast *Ren and Stimpy* from 1995 to 1998 (2002 in **Great Britain**) in reruns. As well as providing an alternative to network **television** for animation, the channel has provided a platform for animated music videos from A-ha's *Take on Me* and Dire Strait's *Money for Nothing* to the **Aardman**-produced *Sledgehammer* video for singer Peter Gabriel. Since the early 2000s, there has been a resurgence in animators making music videos; despite fewer music videos being shown in favor of reality TV programming, particularly in the late 1990s, the channel provides a place for the medium to flourish.

MUSICAL. Although animation and **music** have a long relationship, in terms of the **genre** "musical," it could be argued that one of the first musicals in the modern sense of songs driving the narrative and revealing plot was the **Fleischer brothers**' version of the Snow White fairy tale starring **Betty Boop**. In *Snow White* (1933), Betty takes on the titular role, with a major part of the action taking place in the musical number sung by a **rotoscoped** Cab Calloway. The **Disney Studio** developed this further with its version, *Snow White and the Seven Dwarves* (1937), which was one of the first **feature-length** animated films, as well as being a musical. This would be a major element of Disney's features over the next few decades. The studio would later alter its presentation of musicals by producing the mixed live-action and animation films such as the popular and multiple **Academy Award**–winning *Mary Poppins* (1964) and *Bedknobs and Broomsticks* (1971). The revival of Disney features in the early 1990s saw the return of the song-led narrative and a new trend of major stars of the music world contributing songs to and in promotion of the films such as *Beauty and the Beast* (1991) and *The Lion King* (1994).

 Trey Parker and Matt Stone's *South Park: Bigger, Longer and Uncut* (1999), intended as a feature version of the **anicom television** series, was generically a musical, as musical numbers drove the narrative and revealed the plot, though it was not explicitly marketed as a musical. *See also FANTASIA.*

MUTT AND JEFF. Comic strip created by Bud Fisher that first appeared in the *San Francisco Chronicle* in 1907 and was believed to be one of the first daily comic strips. It was produced as an animated **cartoon** series in 1916 by Charles Bowers, though Bowers was kicked off the project in 1919 (he would later return as an independent contractor). **Raoul Barré** initially worked with Bowers on the series. The first two episodes were drawn by Bud Fisher, *Jeff's Toothache* and *The Submarine*. The films were snappy and entertaining and reflected the other comedies of Barré and his team, in particular *Soda Jerks* (1920). The characters were Augustus J. Mutt, who was tall and lanky, and his friend Edgar Horace Jeff, who was short. They were an easygoing pair who enjoyed gambling, particularly horse racing, and drinking. They were often unsuccessful in their pursuits but were quite jovial. The production of the series ended in 1927.

– N –

NATIONAL FILM BOARD OF CANADA (NFB). Founded by the **documentary** filmmaker John Grierson, who aimed to build and train a Canadian Film Industry. The board was established in 1939, and the start of World War II led to the production of patriotic films. In 1940, the board signed a commercial distribution agreement with Columbia Pictures for English-language films and with France-Film for French-language versions.

The government of Canada merged the Canadian Government Motion Picture Bureau with the NFB in 1941 and **Norman McLaren** was hired to organize an animation division. They began to distribute the films to rural areas, factories, and unions, and they opened offices in New York, Chicago, and London; in 1943, the films became available in diplomatic posts. In 1944, McLaren and his team began *Let's All Sing Together* and newsreels were produced.

As well as production and distribution, the NFB was an innovator in technology and in 1947 invented the world's first RGB (red-green-blue) additive light film printing machine. Over the next few years, the divisions were reorganized, and in 1951 McLaren began working with a **three-dimensional** (3D) camera and produced *Around Is Around*, *Now Is the Time*, and in 1952, *Neighbours* with the aid of government grants. By 1955, films were being made for **television** and they continued producing films in English and French.

The 25th anniversary in 1962 saw continuing work and development of technology, and in 1977 it began to experiment with computer animation in cooperation with the National Research Council. The first Computer Animation Centre opened in 1981, and in 1989, on their 50th anniversary, the NFB received an honorary **Academy Award** for its contribution to film. The board has continued to support and develop animation since then and still produces award-winning films, including an Oscar in 1995 for *Bob's Birthday* by Alison Snowden and David Fine.

NEIGHBOURS. *Neighbours* (1952) was directed by **Norman McLaren** and produced while working at the **National Film Board of Canada** (NFB). Using real actors in a real environment, McLaren uses **pixilation** to create the animation, which has a mechanistic appearance

and is accompanied by mechanical noises. The film features two neighbors who, in the beginning of the film, respect and like each other until the matter of property boundaries arises. A beautiful flower grows in between the two gardens and after admiring it, each man claims it as his own. They each attempt to shift the boundaries to claim the flower but the situation escalates into increasing **violence** and destruction.

The film is described by the NFB as "a parable about two people who come to blows over the possession of a flower. A film without words." The message is antiwar and refers to human greed and egotism; the film won an **Academy Award**. The actors were required to continually jump in the air so a frame of film could be exposed each time. The film is very physical in that respect, and the background is filmed on location with chairs and a scale fence that end up, like the flower, being broken during the escalating fight.

NETHERLANDS. See WESTERN EUROPE.

NEW ZEALAND. *See* AUSTRALASIA.

NIGHTMARE BEFORE CHRISTMAS, THE. Directed by **Henry Selick** and written by **Tim Burton** with music by Danny Elfman, *The Nightmare before Christmas* was released in 1993. Burton's story was based on a poem he had previously written and illustrated. Animated using **puppets** in **stop motion**, the film features Jack Skellington, the Pumpkin King of Halloween Town. He discovers Christmas Town but does not understand the different place. He decides to try to spread Christmas joy to his world but his well-meaning mission puts Santa Claus, or Sandy Klaws as Jack mistakes him, in jeopardy, which results in a nightmare for children around the world. Jack has to help rescue Christmas. He finds his way to the different world through a tree in the woods that has doors on it, all leading to different holiday worlds, and ultimately saves the day and the holiday. The film was rereleased in a **three-dimensional** (3D) version by the **Disney Studio** in 2006.

NORSTEIN, YURI (1941–). Russian animator Yuri Norstein originally trained in cabinet making and drafting before he joined So-

juzmultifilm at the age of 20 to work as an artist and art director. Norstein worked on a variety of projects, including *Who Has Said Meow?* (1962) and *My Green Crocodile* (1966). His directorial debut was with *25th October, The First Day* (1968), which was a comment on the October Revolution. The film featured paintings by avant-garde artists and was very successful.

Norstein went on to codirect *The Battle of Kerzhents* (1970) with Ivan Ivanov-Vano, a colleague from the studio, and won the highest recognition at the **Zagreb** Film **Festival** in 1972. He directed his first solo film, *The Fox and the Hare*, in 1973, which followed the Soviet requirement to be a children's film based on folklore but managed to maintain a sense of originality within it. His next film, *The Heron and the Crane* (1974), was also based on a popular tale but was not made for children. In 1975, Norstein made *The Hedgehog in the Fog*, which was said to have a "thin plot" but the creative visuals made up for any lack of action.

In 1979, Norstein released *Tale of Tales*, which is considered by many to be his masterpiece, as well as a masterpiece of Soviet animation. The film lasts 27 minutes and is described as a mental association of images, a mixture of fantasy and memory in various sequences that have a dreamlike quality. Each sequence was created as he went through the filmmaking process.

It has been suggested that Norstein produced his best work while under the constraints of a company, but his artistic talents have reinforced his reputation for presenting Russian culture in a skilled and creative way. He is also described as one of the "most accomplished cutout animators" who even designed his own version of the **multiplane** camera to create his work. Norstein animates all of his own work, often mixing live action and rear projection with animation. *See also* SOVIET UNION.

– O –

OSCARS. *See* ACADEMY AWARDS.

OSHII, MAMORU (1951–). Born in Tokyo, **Japan**, Mamoru Oshii began his career in **television** animation before making his name with

feature-length anime, his best known in the West being *Ghost in the Shell* (1995). Oshii has a reputation for making darker films with a specifically adult audience in mind than does his contemporary **Hayao Miyazaki**, whose work has a shared audience of adults and children. While Oshii does not have the same popularity as Miyazaki, he is regarded as one of Japan's major animators. Thematically complex, Oshii's films are often ambiguous in narrative or closure with protagonists often facing internal dilemmas as in *Ghost in the Shell*.

His work in television began on the long-running series *Urusei Yatsura* in 1983, and he made his commercial and critical breakthrough in 1984 with *Urusei Yatsura 2: Beautiful Dreamer*, which—like Miyazaki's *Nausicaä*, released in the same year—was based on Japanese mythology and folklore.

Oshii's first major project was *Angel's Egg* (1985), which was described as a variation of a Holy Grail–type quest, though it was not commercially successful and remains obscure in Japan. Although he had some success with eight other films in between, one of his most important and acclaimed films is the feature-length *Ghost in the Shell*. Oshii has also worked in live action and produced *Avalon* (2001), a "Polish language blend of sepia-toned live-action and computer-generated artifice" (Suchenski 2004), which was shown at the Cannes Film **Festival** in 2001. In 2004, Oshii released *Innocence*, which is a partial sequel to *Ghost in the Shell*, but less interested in technology than how it changes the human experience. Despite a long gap in production between *Ghost in the Shell* in 1995 and *Avalon* in 2001, when he concentrated on writing, Oshii has released a new film approximately every year since 2004, with *Sukai kurora* (*The Sky Crawlers*) released in 2008.

OUT OF THE INKWELL. Series of animated **shorts** by the **Fleischer brothers** that ran as part of a regular theatrical "magazine" series from 1915 to the early 1920s in the **silent era**. The series starred **Koko the Clown**, who was a character brought to life by Max Fleischer. The films always started with Max in live action at his drawing board; as he began to draw, Koko would emerge from the ink. He was always trying to get out of the inkwell and into a real form but at the end of each film he returns to the inkwell once more.

Other studios were increasingly using **cels** as their production technique, which would speed the process and reduce costs. The Fleischers were also trying to mix mediums and techniques, including one example using **clay** in *Modeling* (1921). The audience would experience behind-the-scenes action in the studio and enjoy the slapstick antics of Koko, who goes between his animated background and the live action of Max in the studio. This mixture of live action, **stop motion**, and cel animation enabled the studio to advance the characters beyond the traditional **cartoon** worlds.

Some of the best known of the series include *Perpetual Motion* (1915 and 1920), *Koko in 1999* (1924), and *Koko's Earth Control* (1928). The narrative was fairly fixed and allowed experiments in technique. The audience was familiar with Koko's perpetual struggle and enjoyed seeing the variations of his escape attempts. The film's self-reflexive nature was highly influential in animation. The films were animated by and starred Max and were directed by Dave. They were distributed by Margaret Winkler.

– P –

PAL, GEORGE (1908–1980). Born György Pal Marczincsak in Hungary, George Pal traveled the world and collaborated with many well-known animators during his life, including **Hans Richter**, **Oskar Fischinger**, and **John Halas**. Pal's career began as a scene designer in Budapest, **Hungary**, at the Hunnia Studio, where he worked alongside John Halas. Pal went on to join the Universum-Film-Aktiengesellschaft Studios (UFA) in Berlin, where he made his first **puppet** film. In 1934, he worked for the Philips Corporation in Eindhoven, **Netherlands**, working in a studio creating the *Philips Broadcast* (1938) series with puppets. The series consisted of at least 10 *Puppetoons* between 1934 and 1939 and featured carved wooden puppets that used Pal's own invention of the "replacement technique," separate puppet parts for each motion rather than hinged parts. His work was stylistically similar to live action and Pal was known for technical ability and timing. He also made **advertising** films for **Great Britain**.

In 1940, Pal moved to the **United States**, where he worked under contract for Paramount to create an animated puppet series of *Puppetoons*, for which he is well known. He later went on to work in special effects for live-action **feature-length** films, which over the years won him five **Academy Awards**. He was involved in *War of the Worlds* (directed by Byron Haskins, 1953) and *The Time Machine*. Following this success, Pal went on to direct and more often produce features, including *Doc Savage: The Man of Bronze* (directed by Michael Anderson, 1975).

PARAMOUNT CARTOON STUDIOS. Formed in 1956 out of the dissolved **Famous Studios**, which had previously been Fleischer Studios before Paramount Pictures took over and got rid of the **Fleischer brothers**. The staff and budgets were cut, which was evident in the quality of the **cartoons** produced. In 1957, the *Popeye* series ended as a theatrical subject and the entire post-1950s back catalogue was sold to **television**. The catalogue was purchased by a publishing firm, the Harvey Company, which acquired the rights to all of the characters in perpetuity and turned them all into comic books.

Attempts at Paramount to create new characters failed, and repetitive stories about space travel were not successful. Seymour Kneitel was in charge and was to supply packages of cartoons for television, including *Krazy Kats* and new *Popeye* films. The work was divided among studios in Los Angeles and New York and due to budget constraints animation was reused, which reduced the quality. The studio returned to producing work for theatrical release but in 1964 Kneitel died and was replaced by Howard Post, who wanted to increase the use of **music**. He was replaced in 1965 by **Shamus Culhane**, who attempted to revitalize the studio. Producer Steve Krantz wanted to produce a *Spiderman* series for television but the studio heads refused. Culhane left and **Ralph Bakshi** moved from **Terrytoons** in May 1967, but in December of that year the studio finally closed.

PARK, NICK (1958–). Nicholas Winston Park, born in Preston, England, made his first film at age 13; his animated **short** *Archie's Concrete Nightmare* (1975) appeared on the **British Broadcasting Corporation** (BBC). Park studied communication arts at Sheffield

Polytechnic and then went on to the National Film and Television school, where he began to make the short *A Grand Day Out* using **clay stop-motion** techniques; this would be his first film featuring **Wallace and Gromit.**

Park joined **Aardman Animation** studios in Bristol in 1985, where he was able to finish his student film. There he worked on the well-known Peter Gabriel **music** video *Sledgehammer.* He made *Creature Comforts* as part of the studio's series for **Channel 4.** Park won a British Academy of Film and Television Arts (BAFTA) award and an **Academy Award** for *A Grand Day Out* (1989). This was followed by *The Wrong Trousers* (1993) and *A Close Shave* (1995).

His first **feature-length** film was *Chicken Run* (2000), which was codirected with Peter Laird. Park supervised the *Creature Comforts* series for **television** in 2003. His second theatrical feature film starring Wallace and Gromit, *The Curse of the Were-Rabbit*, was released in October 2005 and won the Best Animated Feature Oscar in March 2006. Park was awarded a CBE in 1997.

PARKER, TREY, AND STONE, MATT. Trey Parker (1969–) and Matt Stone (1971–) are the creators and executive producers of the award-winning **television** series *South Park*. The pair met while studying at the University of Colorado. Their first film together was a Christmas greeting they made at the university that featured the characters who would later star in *South Park*. The card was circulated and they were offered a TV series on the cable network **Comedy Central**. *South Park* is their best-known project and focuses on four irreverent fourth-grade schoolchildren in the quiet, dysfunctional town of South Park, Colorado, using a technique of computer animation that looks like it has been cut out of paper. The pair also provides most of the voices for the main characters. The series debuted in 1998 and in 1999 they produced a **feature-length** film version of the series, *South Park: Bigger, Longer and Uncut*, that was produced by Paramount Pictures. The film was critically acclaimed and led to an **Academy Award** nomination and several awards. In 2001, they created *That's My Bush*, a live-action parody **sitcom**.

Paramount again released their next animated feature, ***Team America, World Police*** (2004), this time animated using **puppets**. They have also written, directed, and starred in the live-action feature-length

comedies *BASEketball* (1998) and *Orgazmo* (1997). *South Park* began its 12th season in 2008.

PERSEPOLIS. Released in 2007, *Persepolis* is a **feature-length** animated **adaptation** of Marjane Satrapi's autobiographical comic book about growing up in Iran; the title refers to the city of the same name. Directed by Marjane Satrapi and Vincent Paronnaud, the film is mostly in black and white with a distinct graphic visual style that emulates the original drawn comic. The plot follows a young girl coming of age during the Iranian Revolution in 1979 and struggling to deal with the changes imposed on society. She rebels in a variety of ways and ends up having to leave the country in exile. The film received international acclaim and was nominated for the Best Animated Feature at the **Academy Awards** in 2008. It won the Jury Prize at the Cannes Film **Festival** in 2007. The dialogue is in French, though in some regions has been dubbed into English.

PHILIPPINES. *See* ASIA.

PIXAR. American animation studio founded by Ed Catmull, Steve Jobs, and **John Lasseter** in 1986, named for the computer system used in creating the digital animation. When Lasseter left the **Disney Studio** to join George Lucas' Lucasfilm in 1984, he joined the computer graphics division, which had been formed to create special effects for Lucas' live-action films. This division was purchased by Jobs for $10 million and established as an independent company. Ed Catmull, who had been with Lucasfilm since 1979, was named as cofounder and they employed 44 people.

Their first film, *Luxo Jr.*, premiered at the computer graphics expo Siggraph in 1987 and was followed by *Red's Dream* in 1988, by which time *Luxo Jr.* had been nominated for an **Academy Award** for Best Animated **Short**. In 1989, *Tin Toy* premiered at Siggraph and won the Oscar. Following these successes, the company moved to bigger premises and began to make commercials. In 1991, Pixar teamed up with Disney to develop, produce, and distribute three **feature-length** animated films.

Over the next four years, Pixar made 15 commercials, which won numerous awards. In 1985, the company went public on the stock mar-

ket, made 12 commercials, and released *Toy Story*, directed by John Lasseter and was the first fully **computer-generated imagery** (CGI) feature-length animated film, and the highest grossing film of 1995. The film was hugely successful and in 1996 Lasseter was awarded a Special Achievement Oscar for the film. The company expanded again in 1997, now with 3,785 employees, and released *Geri's Game*, which won the Academy Award for Best Animated Short in 1998. The company released their second feature, *A Bug's Life*, which was the highest grossing film in 1998. *Toy Story 2* was released in 1999 and was the first film ever created, mastered, and exhibited digitally and made more money at the box office than the first installment of the film.

In 2000, the company moved premises again and won awards for *Toy Story 2*. In 2003, Pixar released *Finding Nemo*, which won the Oscar for Best Animated Feature in 2004. This was followed in 2004 by *The Incredibles*, which was directed by **Brad Bird** and won the Oscar in 2005. John Lasseter directed *Cars* in 2006. Brad Bird directed the Oscar-winning feature *Ratatouille* in 2007.

PIXILATION. Animation technique that comes under the category of **three-dimensional** (3D) animation, and though it is close to live action in practice, it falls within the realm of animation. Where **clay** and **puppet** animators move inanimate objects incrementally before a camera and shoot frame by frame, with pixilation, the animator shoots "live" objects, generally people, frame by frame, using the people as **stop-motion** models. Some of the best examples of pixilation can be found in the work of **Norman McLaren** in such films as *Two Bagatelles* (1952), *A Chairy Tale* (1957), and perhaps most famously, *Neighbours* (1952). The technique is not widely used in commercial animation, though this is probably due to the difficulty in directing such disciplined performances from live actors and the highly stylized look of the film. Another good example of the technique is the British Bolex brothers' 1993 film *The Secret Adventure of Tom Thumb*, which was produced as a **feature-length** film. Many critics describe the finished films as having a sense of "the uncanny" due to the odd, slightly unsettling style of movement it creates.

PLYMPTON, BILL (1946–). An independent filmmaker born in Portland, Oregon, Plympton studied at Portland State University, where

he joined the film society and attended **festivals**, becoming interested in animation. He moved to New York in 1968 to attend New York University and studied at the School of Visual Arts. Plympton started his career as a newspaper cartoonist and illustrator for New York's many publications, including "Plympton" for the *Soho Weekly News*, a **political cartoon** strip that was syndicated by Universal Press into over 20 papers in 1981.

In 1983, he was approached to animate the film *Boomtown* and rediscovered his previous love of animation (he had submitted drawings to the **Disney Studio** at age 13 and though he was told he had promise, he was too young). He demonstrated his energetic humor and lively crayon-drawing style in *Your Face* (1986) and *One of Those Days* (1987). His next film, *Drawing Lesson #2*, took a long time to produce but in 1988 it was nominated for an **Academy Award** for Best Animated **Short**.

Plympton's popularity quickly increased as he attended festivals, and his series of *Microtoons* appeared on **Music Television** (MTV). He self-financed his first **feature-length** film, *The Tune*, which won several awards on the festival circuit. He produced the live-action **comedy** *J. Lyle* (1994) and though he continued to dabble in live action, he released *I Married a Strange Person* in 1998, which was entirely self-drawn and -financed. His 2001 film, *Mutant Aliens*, won the Grand Prix at the Annecy Animation Festival and was released in theaters in 2002. He followed these films with *Hair High* (2004) and *Guard Dog*, which was nominated for an Oscar in January 2005. His 2008 feature *Idiots and Angels* received critical acclaim and success at several festivals.

POLAND. *See* EASTERN EUROPE.

POLAR EXPRESS, THE. Feature released in 2004, *The Polar Express* is an **adaptation** of books by Chris Van Allsburg that follows a young boy as he travels to the North Pole to meet Santa. Directed by Robert Zemeckis, who had previously found great success directing *Who Framed Roger Rabbit*, the film was shot in live action and animated using a full **three-dimensional** (3D) **computer-generated imagery** (CGI) technique known as "performance capture" where, like the **rotoscope**, the live actor is used as a model to animate on

top of. The technique attempts to capture a photorealistic rendering of the actor—in this case, Hollywood star Tom Hanks, who played multiple roles; however, this resulted in mixed reviews. The technique does not have the "painterly" aesthetic of rotoscoping or its modern equivalent, "Rotoshopping," the proprietary technique used by **Bob Sabiston**. The performance capture does not fully animate the eyes, which results in a "dead" expression in the characters. This is said to give them an unsettling, uncanny feel, which many viewers were uncomfortable with. Though the film was fairly successful at the box office, it is often cited in animation studies and criticism as an example of unsuccessful CGI, despite being nominated for three **Academy Awards**.

POLITICS. Politics can be seen in various forms in animation, from political satire in the tradition of newspaper **cartoon** strips to commentary of social and political situations in films, such as the films of **John** and **Faith Hubley**. Political critique and **subversion** can appear in seemingly innocent films such as **Jiri Trnka**'s *Ruka (The Hand*, 1965). Animation has also been used for political support, such as the campaign film created for Franklin D. Roosevelt by John Hubley and the founders of **United Productions of America** (UPA). Political ideology appeared as **propaganda** in the films of the World War II effort, such as the training films featuring *Private Snafu*, which were designed to encourage the mood of servicemen. In **Great Britain** during the 1980s, political satire was the main theme of the puppet-animated series *Spitting Image*.

POPEYE. Character created by cartoonist Elzie Segar in 1929, he was the basis for the animated series from the **Fleischer** studio. The character was first introduced in a **Betty Boop** cartoon before appearing in his film *Popeye the Sailor* in 1933. Popeye was an angular, grouchy, selfish, and difficult-to-understand man. He was surrounded by supporting characters, including Wimpy, Olive Oyl, and the bully Bluto.

By 1935, Popeye was more popular than **Mickey Mouse** and his character was refined by Jack Mercer. He was able to perform great feats of strength with the aid of cans of spinach that would give him Herculean strength and often come to the rescue of Olive, who would

typically be harassed by Bluto. The act of eating the spinach was shown with a literal transformation of his muscles into some sort of weapon such as a hammer with which he could "pound" his enemy. In 1943, **Famous Studios** took over production of the series and produced them in Technicolor. The series was retired as a theatrical **cartoon** in 1957 and the back catalogue was sold to **television**, where it would continue in rerun form.

PRAXINOSCOPE. Close in design to the **zoetrope**, the praxinoscope consists of a cylinder that is lined inside with sequential images. When the cylinder is spun, the observer looks in at mirrors that are attached to the core of the machine and sees the illusion of moving pictures. Such machines were considered as novelties or toys, and the praxinoscope was patented by **Émile Reynaud** in 1877. After some success with the smaller praxinoscopes, Reynaud began to develop the device into something for larger audiences. In 1889, he patented a new version, the Théâtre Optique, which used a magic lantern to project the images from a larger praxinoscope. In this version, the images were not on individual short strips but instead on long canvas on a spool, as a precursor to film. The machine was cumbersome and expensive and Reynaud had to act as the projectionist. He received a contract for the machine in 1892 but did not develop it much beyond this model. These machines were the forerunners and inspiration for the animation that would develop later. *See also* FRANCE.

PRIESTLY, JOANNA. Portland, Oregon, based animator whose interest in animation began as a child. Joanna Priestly studied painting and printmaking at the Rhode Island School of Design and the University of California–Berkeley, where she received a bachelor of arts degree with honors. She then went on to attend the **California Institute of the Arts** where she received her master's degree in film and video and was awarded the Louis B. Mayer Award.

Priestly has directed, animated, and produced 16 films through her company, Priestly Motion Pictures, and won numerous awards and fellowships. Her films include *The Rubber Stamp Film* (1983), *Times Square* (1986) codirected with **Jules Engel**, *After the Fall* (1991), *Hand Held* (1995), *Utopia Parkway* (1997), and *Surface Dive* (2001), and she has experimented with a variety of animation techniques. She

has been the co-coordinator of the Northwest Film and Video **Festival**, editor of *The Animator*, and founding president of **Association Internationale du Film d'Animation** (ASIFA) Northwest (now ASIFA Seattle), among others.

Priestly has run an apprenticeship program since 1986 and has taught animation and cinema history at Pacific Northwest College of Art and at Volda College in Norway; she is currently on the faculty of the Art Institute of Portland. As well as making films, she attends conferences to highlight the status of animation in academia, museums, galleries, and the media.

PRINCESS MONONOKE. Feature-length anime produced by **Studio Ghibli** and directed by **Hayao Miyazaki**, one of **Japan**'s foremost directors. *Princess Mononoke* (1997) was one of the studio's first films to break into the international market, though they had previously enjoyed great success in Japan.

The story follows Ashitaka, a prince of the disappearing Ainu tribe, who has been cursed by a demonized boar god. He must journey to the west to find a cure from the Forest Spirit. Along the way, Ashitaka encounters San, the Princess Mononoke, a young human woman, fighting to protect the forest, and Lady Eboshi, who is the head of Tatara Ba (Iron Town). Ashitaka is forced to find a middle ground between the two ambivalent forces.

Based on Japanese folklore, *Princess Mononoke* touches on subjects such as war, ecology, morals, and principles. The film was critically and commercially successful and is one of the studio's best-known films in the West. Hand-drawn with the exception of some digitally created special effects to enhance the backgrounds, the film is representative of the quality and style of animation that Studio Ghibli produces.

PRIVATE SNAFU. *Private Snafu* was a character in a series of wartime **cartoons** produced by **Warner Brothers**, as part of the American *Army-Navy Screen Magazine*, which was shown to U.S. servicemen during World War II. The soldier was named Private Snafu (the army's acronym for "Situation Normal, All Fucked Up") to appeal to average soldiers but also to demonstrate how to act, or rather how *not* to act, in particular situations. The storyboards for the series had to be approved by the Pentagon before the cartoons could be produced.

The production of the series was carried out by a variety of staff, including at one time **Frank Tashlin, Chuck Jones,** Ted Geisel (Dr. Seuss), and Phil Eastman. As the series was commissioned for the armed forces, there was a certain amount of swearing and sexual content allowed, a "barracks-room humor," to appeal to heterosexual males. The three- to four-minute films would show what would happen if a regular recruit did not do his job properly. The series began in 1943. *See also* POLITICS.

PROPAGANDA. Animation has been used for the purposes of propaganda almost as long as the form has existed. In many cases, government support for the development of the industry had implied regulation on the content, which was not to be critical of the government. This form of propaganda was frequently seen in communist countries such as **China** or those in the **Soviet Union** or **Eastern Europe,** such as Poland, North Korea, and Vietnam's state-sponsored Hanoi Film Studio, with controlled output. Despite a lack of creative control for the animators, it was often the case that the industry relied on the state funding to survive and as such considered a trade-off; however, it was possible for animators to subvert the meanings of their work through the animated form. In some cases, the propaganda was seen as a means of boosting patriotism and support against a specific enemy as seen in the animation of **Japan** and China in the 1930s, which contained antienemy messages about each other. This was designed to increase support from the public.

During World War II, the Western Allied countries used propaganda to gain support as well as to inform the public and troops of appropriate wartime behavior, though these films were sponsored by ministries of information and not referred to as propaganda as such. Many well-known animators and studios were involved in this work, in some cases simply to keep their studios running, as was the case for **Walt Disney.** Several **Warner Brothers** animators such as **Frank Tashlin** and **Chuck Jones** worked for the *Army-Navy Screen Magazine,* which was shown to **U.S.** servicemen. Their *Private Snafu* series of **shorts** were part of a package of information and entertainment for the troops. The **United States** also sponsored anticommunist films to be produced in Thailand. In **Great Britain,**

Halas and Batchelor produced films for the war effort in order to keep their studio and to allow **John Halas** to remain in the country. *See also* CENSORSHIP; POLITICS.

PUPPET. Three-dimensional (3D) animation that uses models of figures, akin to theater string-manipulated marionettes. Although marionette puppets are controlled by string, rod, or hand in a live performance setting, puppets in animation are filmed using **stop motion** to capture the images and often to disguise the form of manipulation to only show the resulting movements.

The technique has a strong connection to the practice in **Eastern Europe**, exemplified in the work of **Jiri Trnka** and his film *Ruka* (*The Hand*, 1963), who is considered to be a master of the form and had previously trained as a puppeteer in the theater. His studio released many celebrated Czech films. It has been suggested that these Eastern European puppet films have been able to "smuggle" **subversive** content and ideology within them due to the perception that the form is children's entertainment.

George Pal brought puppets to Hollywood from his native Hungary with his *Puppetoons* series (1940–1949) that he created for Paramount. Together with **Ray Harryhausen**, Pal became known for creating effects for live-action films, particularly in creatures for the **science fiction** and fantasy **genres**.

Puppet animation has also been widely used in children's **television**, particularly in **Great Britain**, and can be seen in such series as **Camberwick Green, Smallfilms'** *Bagpuss* and *The Clangers*, and recently in **Cosgrove Hall's** *Fifi and the Flowertots*. Puppets in Britain have also appeared in the adult television series such as the **political** satire *Spitting Image* (1984–1996).

More recently, the use of puppets has been seen in the work of **Jan Svankmajer**, the **Quay brothers** (particularly their *Street of Crocodiles*, 1986), and **Barry Purves'** *Rigoletto* (1993). **Henry Selick** brought puppets to mainstream Hollywood once more in *The Nightmare before Christmas* (1998). All of these films feature puppets in stop motion with the manipulation of the figures invisible. However, there are also puppet animations that are filmed "performances" such as **Gerry Anderson's** *Stingray* (1964) or *Thunderbirds* (1965).

This method of filmed puppetry was recently used (and parodied) in **Trey Parker and Matt Stone**'s **feature-length** film *Team America, World Police* (2004).

Another type of performance puppet animation is **Jim Henson**'s Muppets as seen in *Sesame Street* and the *Muppet Show*. These puppets are manipulated by hand and filmed "live."

PUPPETOONS. Puppet animation series created by the Hungarian-born animator **George Pal**, which began as a short series for the Philips Company in the **Netherlands** from 1934 to 1939. In 1940, Pal was contracted to create the series in the **United States** for Paramount; the series lasted until 1949. The series featured carved wooden puppets that used Pal's own invention of the "replacement technique," using separate puppet parts for each motion rather than hinged parts. The stories often featured Jasper, a young black boy who was based on American black vaudeville stereotypes that were heavily criticized after World War II for racism and "perpetuated the misconception of Negro characteristics" (Cohen 1997, 58).

Pal's *Puppetoons* were the first animated characters that Paramount licensed into a comic book range, which was very popular. Unfortunately, the production costs rose dramatically from prewar to postwar and Paramount refused to continue to fund the series, ending it in 1949.

PURVES, BARRY. British animator Barry Purves has produced a wide variety of animation for film, **television**, **advertisements**, and title sequences, and he frequently conducts workshops. His career began in stage management and occasionally acting, mostly in theaters in **Great Britain**. His work largely consists of **puppet** animation, and he has worked with a variety of companies throughout the world.

In the late 1970s and early 1980s, Purves worked for **Cosgrove Hall** as a director and animator on such television programs as *Chorlton and the Wheelies*, *Danger Mouse*, and *The Wind in the Willows*. In 1989 he directed, wrote, and animated *Next: The Infinite Variety Show* for **Aardman Animation** and **Channel 4**, which featured the complete works of William Shakespeare in five minutes.

He has gone on to **adapt** other "classics" such as *Rigoletto* (1993), based on Verdi's opera, and perhaps his best-known film, *Achilles*

(1995), which has been described by the animator as "a passionate look at the relationship between Achilles and Patroclus" and "a masterpiece of eroticism" (Morris 2001) based on the Greek mythology. He also re-created a **Japanese** Noh play with an 11-minute film, *Screen Play*, from 1992.

In 1995, Purves worked in Hollywood on **Tim Burton**'s *Mars Attacks!* as animation director, though his puppets were reportedly not used, after which he returned to Britain and Cosgrove Hall. He has continued contributing material to the studio while working on independent films such as *Gilbert and Sullivan: The Very Models* (1998) and *Hamilton Mattress* (2001), as well as advising on *King Kong* (2003) and continuing to hold workshops for new animators around the world.

Purves' puppets and sets are always very elaborate, and the puppets themselves animated with a particular attention to detail, as though he were directing live actors, which results in very dramatic and moving films. He has won over 60 major awards and been nominated for **Academy Awards** and BAFTAs.

– Q –

QUAY BROTHERS (1947–). Steven and Timothy Quay, identical twin brothers, were born near Philadelphia and attended the Philadelphia College of Art, where they studied illustration and graphics. After winning a scholarship to the Royal College of Art, the brothers moved to London. They studied at the School of Film and Television and began to make **short** films. With fellow student Keith Griffiths, they produced *Nocturna Artificialia* (1979) with support from the British Film Institute Production Board.

At Konick Studios, the brothers worked with Griffiths producing and creating various animated films featuring **puppets**. They have also produced work for **television** and **advertisement** but are best known for their puppet films, which are **surreal** and unusual.

The brothers are influenced by **Jan Svankmajer** and create films with a similar eerie sense of uncanny as the Czech animator's films, even making a tributary film, *Cabinet of Jan Svankmajer*, in 1984. They often use found objects and dolls in their films and draw heavily

from European literary and visual culture, notably Franz Kafka, as well as Svankmajer. One of their best-known films, *Street of Crocodiles* (1986), is based on the novel by Bruno Schulz and is set in a mythical representation of prewar Poland. This was their first film to be shot on 35 mm film and features an assortment of found objects to create a mechanical, underground world.

The Quay brothers have continued to produce films in this style, including *The Comb* (1990) and *De Artificiali Perspectiva* (1991). In 1995 they produced their first live-action film, *Institute Benjamenta*, inspired by the Swiss novelist Robert Walser. Despite its live-action status, the film follows similar themes as *Street of Crocodiles* and has a similar aesthetic. They continued to work on live action with *The Piano Tuner of Earthquakes* (2005) and often collaborate with others, but concentrate most on their animation.

QUIMBY, FRED (1886–1965). Born in Minneapolis, Minnesota, Fred Quimby is notable for his long-held position at **Metro-Goldwyn-Mayer** (MGM). After a successful career as a film salesman and executive, MGM hired Quimby to install a new in-house animation studio after it decided that Harman and Ising were becoming too expensive to continue production with. Quimby was said to have had no sense of humor and was disliked by many of his staff but he ran the department until his retirement in 1955.

Quimby's first task was to organize the staff, which he did by hiring much of the talent away from **Harman-Ising** and **Terrytoons**, including **Bill Hanna**, **Joe Barbera**, and later **Friz Freleng** from **Warner Brothers**. One of the first series under his responsibility was *Captain and the Kids,* which was unsuccessful; the budgets were high and the concepts poor. In order to rectify this, Quimby went back to Harman-Ising and contracted them to produce films for him again. In the meantime, Freleng returned to Warner Bros. and the department tried to find new ideas for a series. Hanna and Barbera began to work together and came up with a "cat and mouse series" that Quimby was reported to have found rather unimpressive. However, he allowed the pair to proceed and *Tom and Jerry* became one of the biggest series for the studio, with the biggest stars, and earned them several **Academy Awards**, all of which Quimby shared with his "producer" credit.

There were several changes in Quimby's department over the years, including the arrival and later departure of **Tex Avery** and his impact on the output of the studio. In 1955, Quimby retired, and MGM closed the animation studio in 1957.

QUINN, JOANNA (1962–). English animator born in Birmingham, she started her career as an illustrator and graphic designer after studying graphic design at Middlesex University. Her first film, *Girls Night Out*, was shown in line-test form at her graduate degree show in 1985 and was completed after she moved to Cardiff in 1986, where she still lives and works. She was given funding from **Channel 4** and the Welsh network S4C to complete *Girls Night Out*, which she describes as "for women by a woman"; it was released in 1987 and won several awards.

In 1987, Quinn founded her own production company, Beryl Productions International, with producer Les Mills. The operation is based in Cardiff but some of the work is carried out in Spain. Her second film, *Body Beautiful* (1990), also featured the character Beryl, who had appeared in her debut film. The character and the environment depicted in her films are a reflection of Wales and represent female images and experiences.

Her films have strong narratives that are advanced by dialogue, humor, and her representational drawing style. Her third film, *Elles* (1992), features Toulouse Lautrec's models taking a break from their posing. Much of her work has won awards internationally and includes such films as *Britannia* (1993), *Famous Fred* (1996), and *Wife of Bath* (1999). As well as **short** films, Quinn also makes **advertisements**, notable examples of which were for Charmin and United Airlines. *See also* GREAT BRITAIN.

– R –

REALISM. It has been suggested that definitions of realism relating to any image-making practice are open to interpretation (Wells 1998); animation is no different. It is generally understood that filmmaking practices provide authentic representations of reality, particularly seen in such forms as nonfiction films, travelogues, **documentary**,

and neorealist films. Although animation does not share the same methods and approaches of the live-action film (though this is sometimes the case), it can prioritize its capacity to resist "realism" as a mode of representation and uses various techniques to create numerous styles that are "about realism" (Wells 1998). Animation often aspires to the creation of realistic image systems that echo the "realism" of live action; this is termed "hyperrealism." This was typified by the **Disney Studio** through conventions of the physical laws of the real world, source, construction of body movement, and behaviors.

As **computer-generated imagery** (CGI) techniques have improved, studios have been attempting to create CGI "actors" as real, examples of which are *Final Fantasy: The Spirits Within* (2001) and *The Polar Express* (2004). However, these films failed to an extent as the realism was incomplete and instead instilled a sense of the uncanny in the characters. These films strive for photorealism and demonstrate what the computer is capable of, but the characters lack emotion and thus the realism is not there.

REBOOT. *Reboot* (1993–) was the first fully animated computer-generated **television** animation and was produced by British animators Ian Pearson, Gavin Blair, and Phil Mitchell, who set up their studio in Canada. The series features the characters of Bob, Enzo, and their friend Dot Matrix in the city of Main Frame. The world is the interior of a computer system and sees the friends battle with "viruses" Megabyte and Hexadecimal.

The original concept was created in the late 1980s, inspired by the movie *Tron*. The characters were designed to reflect the technology and inside of the computer. The season was critically acclaimed and the first season ran for 16 episodes, which included 320 minutes of **computer-generated imagery**, whereas *Toy Story* (1995) had 80 minutes. Two episodes were created every six weeks. In 1994, the **American Broadcasting Company** (ABC) network wanted the character Dot's sexy figure toned down and in 1997 the characters were remodeled to be more "lifelike." Three seasons were produced, after which two movies were made and were broadcast as a fourth season. The series was revived in 2007 in a new film trilogy.

RED HOT RIDING HOOD. Directed by **Tex Avery** and animated by Preston Blair for **Metro-Goldwyn-Mayer** (MGM) studios, this 1943 film is part of a collection of six works featuring the "voluptuous" Red, who is clearly aware of her sexuality and who in this instance performs a sexy dance as a nightclub singer in front of a lascivious wolf. The story begins with the traditional story of Little Red Riding Hood and the narrator is telling the story; however, the wolf breaks the convention and complains about the "boring" old story. The action is then transposed to Hollywood where Red is a nightclub singer, Wolf a very excited patron, and Grandma appears as a sexually voracious society dame. After watching Red, the wolf takes a cab to Grandma's house where she turns the tables by pursuing him and wanting to marry him. Unable to cope with her advances, the wolf shoots himself in the head and his spirit ends up whistling at Red instead.

The film was fairly controversial in its depiction of sex, with the wolf getting very excited by Red's performance as his eyes popped out of his head and repeatedly banged on the table of the club. There were also issues regarding the grandmother's lust for the wolf and her desire to marry him, as there were suggestions of bestiality; in the original ending, they married and had children, with a scene of them all in the theater box watching Red. The gags are in the reversal of the traditional roles. However, the Production Code Administration (PCA; the body responsible for **censorship**) made them change the ending to the wolf shooting himself. The film is often cited as one of Avery's best and the character of Red was said to have inspired the design of Jessica Rabbit in Robert Zemeckis' **Who Framed Roger Rabbit** (1988).

RED VS. BLUE. *Red vs. Blue* is a **Web animation** series created using *machinima*. The series uses the video game *Halo* as the basis for a **comedy** series that spoofs the **science fiction** adventure game. The series is produced by Rooster Teeth Productions and has proved so successful since its launch in 2003 that it has been distributed on DVD as *RVB* or *Red vs. Blue: The Blood Gulch Chronicles*.

The original series was intended to be short but was expanded due to overwhelming popularity. The series' creators—Burnie Burns,

Matt Hullum, and Joel Heyman—originally met while studying at the University of Texas, Austin. Their first project together was the film *The Schedule*, though with limited success, and Hullum and Heyman then moved to Los Angeles. Burns met Gustavo Sorok and Geoff Fink and together they ventured into the Internet by creating drunkengamers.com, featuring films of games being played while they provided amusing commentary. This provided the basis for *Red vs. Blue*, which they were inspired to create after they were contacted by *Computer Gaming World Magazine* for permission to use clips of their "work" on a DVD. At this point, Hullum and Heyman became involved and they all worked together to produce the series.

The series features red and blue teams of soldiers and their attempts to capture the other team's flag but are reluctant to fight (opposite to the purpose of the original video game). There is a variety of characters in the series and many are voiced by the creators. The scripts and outlines are generally prepared in advance; within the first day of the first post, they had 20,000 downloads. The group cites influences from other parody **television** shows such as *Mystery Science Theatre 3000* and the Web animation *Homestar Runner*.

The *Halo* video game creators are said to enjoy the series, which released its 100th episode in June 2007 and spawned a spin-off in 2008.

REINIGER, LOTTE (1899–1981). German animator Lotte Reiniger began working in film at an early age, after being inspired at a lecture by actor and champion of German cinema Paul Wegener. She joined an acting school attached to his theater and drew attention to herself from the cast by creating silhouettes of them in their roles. They were well received and a book of the images was published in 1917. Her professor, Max Reinhardt, liked the cutouts and allowed Reiniger to go on stage, even though students were not normally permitted to do so, and she eventually met her hero Wegener. He was also impressed by Reiniger's cutouts and asked her to create extra for his films. She created the captions for his 1918 film *Der Rattenfänger von Hamelin* (*The Pied Piper of Hamelin*).

In the summer of 1919, Reiniger was introduced to a group of young men from an experimental animation studio; among them were Carl Koch and Berthold Bartosch. Dr. Hans Curlis formed the

Institute for Cultural Discovery with them and encouraged Reiniger to make her first film, *Das Ornament des Verliebten Herzens* (*The Ornament of the Enamored Heart*), in 1919.

Reiniger was invited to make a **feature-length** film by Louis Hagen, a banker from Berlin, and so she set about making the *Die Geschichte des Prinzen Achmed* (*The Adventures of Prince Achmed*, 1926). She was aided by Carl Koch, whom she had married, and their friend Bartosch. Reiniger had seen the films of **Walther Ruttman** in Berlin and asked him to collaborate on the project. Though he was said to be unhappy with the length of time it took, he created the backgrounds for Reiniger's animation. The film was released in 1926 and is one of the world's first feature-length animations, a credit usually given to **Walt Disney**'s *Snow White and the Seven Dwarves*, even though *Prince Achmed* was 11 years earlier.

Following the success of *Prince Achmed*, Reiniger and her husband worked all over Europe, including **Germany**, **Italy**, and **Great Britain**, where they were invited to contribute films to the General Post Office (GPO) film unit, as **Halas and Batchelor** and **Len Lye** had also done. The couple made 26 films for the unit before World War II, including *Papageno*, based on Mozart's *Magic Flute*. When the war broke out, Reiniger was in Italy so she returned to Germany with her husband.

In 1948, Reiniger returned to Great Britain and in the 1950s opened Primrose Productions, where she made 15 films. After the death of her husband, she continued to work and moved to Canada in 1976, where she joined the **National Film Board** (NFB) and made *Aucassin et Nicolette*. As well as filmmaking for the NFB, she gave seminars. Reiniger died in Dettenhausen, Germany, in 1981. She was a highly praised and inspirational animator and was considered to be very influential to women animators.

REN AND STIMPY. **Television** series *The Ren and Stimpy Show* was created by **John Kricfalusi** in 1988 and sold to Nickelodeon for broadcast. The series stars a bad-tempered Chihuahua dog named Ren and his roommate, Stimpy the cat. The style, and occasionally the content of the show, is reminiscent of classic 1950s **cartoons** by animator **Bob Clampett**, whom Kricfalusi cites as an influence. The era was often spoofed in the series, which was set up like a domestic

sitcom and included **advertisements** and television shows within the episodes in the 1950s style. The episodes were often violent, particularly in Ren's treatment of Stimpy, but the over-the-top style was also similar to that of **Warner Brothers'** *Looney Tunes* or **Metro-Goldwyn-Mayer**'s classic *Tom and Jerry.*

The show, produced by Kricfalusi's company Spumco, aired from 1991 until 1992 when Kricfalusi was fired. He was accused of pushing boundaries on the children's network with extreme **violence** and gross-out body humor. He constantly battled with the network over its demands to alter content and in the end it was too much for them. The series remained on the network, produced by Games Animation from 1993–1996; however, the quality was not the same and the series was not as successful. In 2003, Kricfalusi revived the series as *Ren and Stimpy's Adult Party Cartoon* for the cable network Spike and released the series on DVD.

REYNAUD, ÉMILE (1844–1917). Émile Reynaud was a French moving-image pioneer who invented the **praxinoscope**. Reynaud learned about optics from working in a mechanics shop as a child and put this knowledge to use in creating machines that could project moving images. His praxinoscope, which he patented in 1877, earned him an Honorable Mention at the Paris World Exhibition, which led to the manufacture of his machines throughout Europe, though they were generally considered as toys. He has previously been described as "the father of the animated **cartoon**" though animation historians refute this and suggest that, although the praxinoscope advanced the development of the moving image, he was not as influential on early animators such as **Winsor McCay**, who were known to have been influenced by flip books. However, other early filmmakers and lightening-sketch artists such as **J. Stuart Blackton** were impressed by other demonstrations of the moving image, and as such Reynaud is worth acknowledging as being part of the early process.

RICHTER, HANS (1888–1976). German filmmaker Hans Richter is probably best known as an experimental filmmaker rather than as an animator. He started his artistic career as a painter, said to have been inspired by cubism, and was later one of the artists involved in the founding of the Dada art movement in Switzerland. The movement

railed against what the participants saw as the "emptiness of static painting." Richter was keen to develop from this and was interested in movement and the rhythm of **music**. By breaking down his work into "rhythmic" components, he began experimenting with Swedish artist Viking Eggeling. They created paintings on rolls of paper, like rolls of film, and created a continuity of movements that led to the production of *Horizontal-Vertical Mass* in 1919.

Realizing the potential in the cinema, Richter created three **short** films between 1920 and 1925, using animation of cut-out shapes. The films, entitled *Rhythmus 21*, *Rhythmus 23*, and *Rhythmus 25*, featured the captured motion of squares and triangles. These films were influential to experimental animators, even though his later work only used minimal animation.

Richter continued making films of "visual rhythm" and, having learned more about lenses and cameras, made *Filmstudie* in 1926. Between 1927 and 1928, he made *Vormittagsspuk* (*Ghosts before Breakfast*), which was seen as a move away from making image through music, as it had more of a sense of a clear narrative.

After making *Rennysymphonie* in 1929, Richter worked on **advertising** films in **Germany** before moving to the **United States** in 1940. He continued to make experimental films throughout the 1940s and 1950s but rarely used animation. He is included here as an early pioneer of experimental animation techniques, particularly those that involved sound.

ROCKY AND BULLWINKLE. Created by **Jay Ward** and Alex Anderson, produced by Jay Ward Productions, the **television** series featuring the characters Rocky and Bullwinkle was produced by veterans of the **United Productions of America** (UPA) studio, which provided the series with a particular modernist aesthetic as well as the credence of artistic integrity due to its UPA heritage. *Rocky and His Friends* (1959–1961) and *The Bullwinkle Show* (1961–1964) were targeted for children and adults. The series were based on *The Frostbite Falls Revue* of forest animals, including Rocket J. Squirrel and Canadian B. J. Moose (Bullwinkle). The lead writer, Bill Scott, was joined on the project by Allan Burns and they began production on the pilot episode, *Ready the Flying Squirrel*, in 1958. Voice actors included June Foray and Paul Frees. The series aired in reruns until 1973.

The premise saw the two leads constantly battling against the Cold War–style spies Natasha Fatale and Boris Badenov, agents from Pottslyvania. The series was structured like a radio serial with narration and cliff-hangers between acts. The **shorts** were book-ended with others and packaged together with *Dudley Do-Right of the Mounties*, *Peabody's Improbable History*, and *Fractured Fairy Tales*. A live-action/animated **feature-length** film *The Adventures of Rocky and Bullwinkle*, using **computer-generated imagery** to create the animation, was released in 2000 to a mixed reception.

ROTOSCOPE. The process of tracing over live-action film (as reference) frame by frame to accurately capture human and live movement that, when the images are retraced, provides a guide to create "lifelike" animation. The technique has been used since the late 1800s but the rotoscope was patented by Max Fleischer in 1917. Patent illustrations show the technique of the artist tracing over film footage then refilming the drawings. The technique allows for a high degree of **realism** on movement. The **Fleischer brothers** used the rotoscope frequently in the *Koko the Clown* series (1917–1929) and *Betty Boop*; it was particularly well used in *Minnie the Moocher* (1932). A distinctive example from the studio was in the **feature-length** film *Gulliver's Travels* (1939). Fleischer used the rotoscope sparingly, only to capture lifelike movement.

The **Disney Studio** also used the process for the human characters in *Snow White and the Seven Dwarves* (1937). **Ralph Bakshi** used the rotoscope in his films *Wizards* (1977) and *The Lord of the Rings* (1978). Max Fleischer also developed the rotograph, a variation of his earlier design, where rotoscoped painted **cels** could be overlaid back onto live-action footage and thereby have animation interact with the real world as Koko the Clown did in *Bedtime* (1923). The process was developed digitally by **Bob Sabiston**, naming the technique Rotoshop, using photographic reproduction tools, such as the software Photoshop, to create a similar effect on the computer, examples of which can be seen in his films *Waking Life* (2001) and *A Scanner Darkly* (2006). However, these films trace the entire film, not only the lifelike movement the Fleischers used it for.

RUSSIA. *See* SOVIET UNION.

RUTTMAN, WALTHER (1887–1941). Walther Ruttman was a German **abstract** filmmaker who began his career painting and engraving. He had initially studied architecture in Zurich before moving on to study **fine art** in Munich. Between 1912 and 1918, his paintings and engravings developed into an interest in abstraction, which became an interest in abstract film.

Ruttman served in World War I, though afterwards he became ill. He later became more interested and involved in filmmaking and in 1921 produced *Lichtspiel Opus I* accompanied by Max Butting's **music**. The film, one of the first public screenings of an abstract film in Berlin, was successful both at home and abroad.

Ruttman continued his filmmaking and collaborated with animator **Lotte Reiniger** on her 1926 film, *The Adventures of Prince Achmed*, by creating the background scenery. He then moved away from creating abstract film and became interested in rhythmic motion and image. In 1927, he made *Berlin: Die Symphonie der Großstadt* (*Berlin: Symphony of a Big City*), a **documentary** that included an animated opening sequence. He continued making documentaries in this rhythmic style, working for a short time in **Italy**.

He died in Berlin in 1941 after succumbing to injuries he sustained as a war correspondent. Though his work in animation was very limited, he is said to have been a great influence to many animators, such as **Hans Richter**, **Oskar Fischinger**, and **Norman McLaren**, particularly in his use of abstract rhythms and movements.

– S –

SABISTON, BOB (1967–). Austin, Texas, based animator, a graduate of the Massachusetts Institute of Technology Media Lab with both a BSc and an MSc in computer graphics research. Sabiston founded his production company, Flat Black Films, in 1997 and has produced independent **shorts**, including *Grasshopper* (2004), *Snack and Drink* (2000), and *Roadhead* (1999), which have helped popularize animation as a medium for **documentaries**. The films have a painterly approach that gives computer animation a hand-drawn feel. Sabiston uses a proprietary **rotoscoping** technique, Rotoshop, which has been used to create the features *Waking Life* (2001) and *A Scanner*

Darkly (2006), both directed by Richard Linklater as well as the film directed by Lars Von Triers, *The Five Obstructions* (2003). The films all have a distinctive look, which Sabiston has used in commercials and other short films. As well as filmmaking, Sabiston is developing portable paint and animation programs for the computer games company Nintendo.

SCHLESINGER, LEON (1884–1949). A native of Philadelphia, Leon Schlesinger was chief of Pacific Art and Title, which specialized in creating the main titles and credits for movies. A good working relationship with **Warner Brothers** led to a position as producer of animated film. At Pacific Art, he had expressed a commercial interest in **Harman-Ising**'s *Bosko* series. Schlesinger was not an artist but a money man and entrepreneur with a good sense for investment. He helped Warner Bros. in backing *The Jazz Singer* (1927) and became involved in the distribution and production.

Schlesinger was involved in the idea that they could promote popular songs and **music** publishing with **cartoons**, which led to the *Looney Tunes* and *Merrie Melodies* series. In 1930, he brought Harman-Ising to the studio with *Bosko* and was instrumental over the years in bringing in talent to the studio. Schlesinger formed his own unit within Warner Bros. in 1933 and appointed **Bob Clampett** as head. He employed 200 staff. In 1944, he sold his studio to Warner Bros. for $700,000 and retained 25 percent of the profits from merchandising of characters.

SCIENCE FICTION. Science fiction (or sci-fi) is a **genre** characterized by futuristic and/or space settings, often featuring alien characters and worlds but reflecting contemporary social and political concerns. This was particularly the case during and after the Cold War in the **United States**, where the genre was increasingly popular. In literature, the genre was made famous by authors such as H. G. Wells and Arthur C. Clarke, who were influential in the film and **television** boom of the late 1950s and early 1960s.

In animation, notable examples of sci-fi include **Hanna-Barbera**'s *The Jetsons* (1962), a family animated **sitcom** akin to *The Flintstones* but set both in the future and in outer space with futuristic gadgets,

and **Gerry Anderson**'s *Stingray* (1964), *Thunderbirds* (1965), and *Captain Scarlet and the Mysterons* (1967). In the 1970s and 1980s, Hanna-Barbera produced a number of action-adventure series, among which were the sci-fi shows *Birdman and the Galaxy Trio* and *Space Ghost* (Space Ghost and characters from the series were revived in late 1990s and early 2000s). Other television sci-fi from the same era includes *Battle for the Planets* (1978), a Westernized version of a popular **Japanese** series, and *The Fantastic Four*, based on the Marvel comic book series.

Sci-fi has been a dominant genre in Japanese animation, both cinematic and television, for many years. Examples of this include *Nausicaä and the Valley of the Wind* by **Hayao Miyazaki** and other well-known features such as *Akira* (1988), *Ghost in the Shell* (1995), and *Final Fantasy: The Spirits Within* (2001). Popular Japanese television sci-fi originated with *Astro Boy* (1963–1966) and continues with shows such as *Dragonball Z* (1983–2003).

More recently, **Matt Groening**'s *Futurama* uses sci-fi generic characteristics to satirize the human "development" in the year 3000 from the point of view of a man who had been frozen in the year 2000. Despite its nostalgic appearance, **Brad Bird**'s *The Iron Giant* (1999) could arguably be classed as sci-fi.

SCOOBY DOO. Iconic character who featured in series produced by **Hanna-Barbera** and premiered in 1969. The character was designed by **Iwao Takamoto** and first appeared in *Scooby Doo, Where Are You?* It was the first animated **television** series to deal with the supernatural and Scooby Doo is one of the most enduring, popular characters of the past 50 years and still appears on television. The series was designed to be exciting and thrilling, but also funny and nonviolent. Fred Silverman, head of CBS Children's Programming, wanted a show like the mystery plays on the radio. The network rejected ideas for straightforward ideas so when he approached Hanna-Barbera it suggested a dog sidekick would make a good **comedy** star. Scooby Doo was part of "Mystery Inc.," which consisted of teenagers Fred, Daphne, Velma, and Shaggy. Scooby and Shaggy always teamed up together and were always scared of whatever they were supposed to be chasing; however, with their cowardly actions they always inadvertently caught the villains.

Takamoto's design was of a Great Dane breed of dog, but with his features greatly exaggerated and he was named after the Frank Sinatra ad lib "scooby dooby doo" from the song *Strangers in the Night*. He was fond of "Scooby snacks" and of eating in general, and he and Shaggy often snuck off in search of food. Scooby was voiced by veteran voice actor Don Mesick, and the series ran until 1976 on CBS before it moved to **American Broadcasting Company** (ABC), where it ran until cancellation in 1986.

The show inspired numerous spin-offs and the addition of other characters, including Scrappy Doo, Scooby's nephew, and Scooby Dum. The series was revived by the **Cartoon Network** in 1993 in reruns after the successful re-release of the 1988 series *A Pup Named Scooby Doo*, which demonstrated the character's continuing popularity. *What's New, Scooby Doo* (2002–2005) was produced by **Warner Brothers**, which had absorbed Hanna-Barbera in 2001. In 2006, the **feature-length** film *Shaggy and Scooby Get a Clue* was released as one of several straight-to-video films between 1998 and 2007. A live-action feature and a sequel featuring a **computer-generated** animated Scooby were released in 2002 and 2004. In the 2004–2005 *Guinness Book of World Records*, the series was named for the most episodes of any animated television series with 12 series overall, though this has now been surpassed by the animated **sitcom** *The Simpsons*.

SCREEN GEMS. *See* COLUMBIA AND SCREEN GEMS.

SELICK, HENRY (1952–). American animator, well known for his **stop-motion** animation and his collaborative work with director **Tim Burton** on *The Nightmare before Christmas* (1993). Selick studied at Rutgers University and St. Martin's College in London, before moving to California to attend the **California Institute of the Arts**, where he studied with **John Lasseter** and **Brad Bird**. He worked for the **Disney Studio** in the late 1970s and early 1980s, where he collaborated on *The Fox and the Hound* (1981) and *Return to Oz* (1985).

Selick started his own company in 1986, Selick Productions, which was renamed Twitching Image Inc. in 1994, and produced spots for **Music Television** (MTV) and commercials for Pillsbury.

He has been heavily influenced by **Ray Harryhausen**, which can be seen in the style of his films. He first gained attention as a director in 1991 with *Slow Bob in the Lower Dimensions*, before working with Burton (who was the writer) on *The Nightmare before Christmas* in 1993, which has become one of his best-known films.

Selick went on to direct an **adaptation** of Roald Dahl's *James and the Giant Peach* in 1995, which won him the top award at the Annecy Animation **Festival** in 1997; his company changed names again about this time and was operating as Skellington Productions, after the lead character Jack Skellington in *The Nightmare before Christmas*. Selick's studio closed in 1997, though records on this are vague, and he directed *Monkeybone* in 2001, produced by 20th Century Fox.

Selick worked on the effects for the live-action film *The Life Aquatic with Steve Zissou* (2004), after which he moved to Portland, Oregon, to join **Will Vinton**'s studios (after Vinton was forced out), which was renamed Laika Inc. His later films include *Moongirl* (2005), his first **computer-generated imagery** (CGI) film, and *Coraline* (2009), which is based on a Neil Gaimen graphic novel.

SESAME STREET. Founded by **documentary** maker Joan Cooney, who in 1966 started to develop the Children's **Television** Workshop and *Sesame Street*, educational programming that could inform as effectively as **advertising**. The show, which began airing in 1969, had four educational objectives: symbolic representation, cognitive processes, physical environment, and social environment. **Jim Henson**'s Muppets were to appear in some pretaped segments but the children lost interest in the street-only segments so the creators decided to integrate the humans with the Muppets. The cast was chosen by children, and real children (not actors) were also chosen to appear in the show. Numerous guest stars have appeared over the years (over 250 celebrities) on the **U.S.** public service network PBS, and the show has won over 100 awards.

There is a successful merchandise line in both educational books, toys, and DVDs of popular episodes. The series appears in over 140 countries worldwide and there are 19 international "local" versions. The series has produced some well-loved stars and was the starting point for the popular Kermit the Frog, who became the host of the *Muppet Show*. The series also features a good **comedy** writing team

and musicians, which have contributed to the series' continuing success for over 35 years.

SHORT. This refers to the length of the film and is used as a description of the form of animation. Until **Walt Disney**'s *Snow White and the Seven Dwarves* in 1937, all animated films were short format and could be anything between 2 and 10 minutes in length. Even after Disney's breakthrough **feature-length** animation, studios continued to produce the short forms, which were distributed as part of a theatrical film bill, a larger time slot that showed a variety of short pieces, typically a newsreel, a **cartoon**, and a travelogue along with the main feature. From the 1910s to the late 1950s and early 1960s, the form remained popular in theaters.

When animation began to be shown on **television**, shorts were packaged together to fill 30-minute time slots, which was the common format of television, and suited the **advertisers**. In 1960, **Hanna-Barbera**'s *The Flintstones* was the first half-hour prime-time animated **sitcom** that was produced to fit the television format rather than the theater. Shorts are still produced as individual films, commonly in the independent and experimental sectors, and recently as part of the bill with **Pixar** films, as a showcase for its own films.

SHREK. Released in 2001, *Shrek* is a satirical take on the traditional animated fairy tale. The titular character (voiced by comedian Mike Myers) is an ogre in danger of losing his home to an evil prince. He reluctantly leads a crusade against the prince, aided by a wise-cracking donkey, and ultimately falling in love with the beautiful Princess Fiona, who in a typically postmodern twist actually turns from beauty to so-called beast at nightfall. It turns out that Fiona is an ogre just like Shrek and the pair finds true love together. The film was produced by DreamWorks SKG, in partnership with digital animation studio Pacific Data Images (PDI) and was the second digitally produced feature by the partnership (the first was the moderately successful *Antz*, 1998). Attempting to replicate **Pixar**'s success, the studio worked to create some of the most advanced digital animation of the time. Indeed, the film was very successful financially and critically, with *Shrek* winning the first **Academy Award** for Best Animated Feature in 2001. The film led to an increase in digitally produced features

from other studios trying to capitalize on the success, and two sequels to *Shrek*. The **comedy** was pitched at both children and adults, creating the potential for a wider audience, with several "in jokes" about the **Disney Studio**, as a reference to DreamWorks' founder Jeffrey Katzenberg's former employer. A fourth sequel is due to be released in 2010.

SILENT ERA. From the first animations of **Émile Cohl** and **J. Stuart Blackton** until **Walt Disney**'s *Steamboat Willie* in 1928, animation was silent, though it was accompanied by **music** and often used cards to display the dialogue as in live-action cinema, or it used speech bubbles within the animation in the style of a printed comic strip used in the *Krazy Kat* series. The era includes animation by **Winsor McCay, John R. Bray, Earl Hurd, Raoul Barré**, the **Fleischer brothers, Otto Messmer**, and initially Disney. By 1930, synchronized sound was vital to production and many of the aforementioned animators finished production at this time, either due to poor translation of their films once sound had been added, or as in the case of **Pat Sullivan** with *Felix the Cat*, a disinterest in the technology and refusal to change. The Fleischers quickly adapted as Disney continued to pioneer technologies and ultimately the change to sound increased the prosperity of animation.

SIMPSONS, THE. The Simpsons* was created by **cartoonist Matt Groening** and began as 30-second "interstitials" (short segments surrounding the commercials) for the *Tracey Ullman Show* in 1987. It first appeared in its half-hour form as a pilot episode in December 1989 and began in a prime-time slot in January 1990.

The Simpsons focuses on the Simpson family, which consists of parents Homer and Marge and their "2.5" children. At the head of the family is Homer, a rather lazy and overweight buffoon who often gets into crazy schemes (the source of a great deal of the slapstick **comedy** in the show) but ultimately cares about his family. His wife, Marge, acts as the moral center of the family; she has a strange blue beehive hairdo, is much slimmer than her husband, and is usually content with her role as housewife. Their relationship is reminiscent of that of many **sitcom** couples of the past, including *The Flintstones*. The other members of the family are 10-year-old Bart, who

is the epitome of the rebellious youth figure in **U.S.** culture (though never as bad as some of his schoolmates). Eight-year-old daughter Lisa is the brain of the family and with her mother tries to uphold its moral fiber. The stereotypical "nuclear" sitcom family is completed by the 0.5 child, baby Maggie, who never speaks but constantly sucks a pacifier. They also have both a cat and dog with which they live in their "middle" American detached house. *The Simpsons* is set in the fictional location of Springfield, an "average" American town.

The series has been immensely popular and is credited with not only the return of animation to prime-time **television** but also a resurgence in adult animation and interest in animation in general. *The Simpsons'* humor is derived from physical **comedy**, a mixture of slapstick and visual gags, as well as satirical references to American culture, both popular and **political**. Part of the appeal of the show is the ability to reach a wide range of audiences from children who enjoy slapstick comedy but don't understand the political references to the keenly observant adult who is familiar with the popular culture references. This broad appeal is the reason why in 2007 the series was named as the longest running sitcom on U.S. television.

The **feature-length** *Simpsons Movie* was released in 2007 and was very successful commercially. The film was surrounded by a vast marketing and merchandising campaign and reinforced the mainstream popularity the show has gained since it began in 1989.

SINKING OF THE LUSITANIA, THE. Directed by **Winsor McCay**, *The Sinking of the Lusitania* (1918), considered to be the first animated **documentary**, is based on the World War I incident of the sinking of British ship *Lusitania* by a German submarine in 1915. The incident was instrumental in causing the **United States** to join the war; in all, 1,198 passengers died, 124 of them U.S. citizens. The outraged McCay created a dramatic and highly detailed film that had the style of a newsreel. McCay's style gave the film even more dramatic undertones, and at one point in the film the head of a child can be seen surfacing in the waves. The film included a very lifelike depiction of the human form on a large scale.

SITCOM. The animated sitcom, or **anicom**, first appeared on **U.S.** television in 1960 when **American Broadcasting Company** (ABC)

aired *The Flintstones*, produced by **Hanna-Barbera** (HB). The series had been commissioned to include more programming suitable for the whole family. HB decided to use the popular live-action sitcom *The Honeymooners* as a model for its new **cartoon** series, and after some modifications, it released the Stone Age version of the popular family domestic sitcom. The show was so successful that the studio followed with *Top Cat* (said to be loosely based on live-action sitcom *The Phil Silvers Show*) and *The Jetsons*. They later returned to the format with *Wait 'til Your Father Gets Home* in the 1970s.

By utilizing the generic characterizations of narrative structure, character, and location, the studio established a new **genre** for animation. **Comedy** had been widely used in variety, sketch, slapstick, and vaudeville formats but never before the increasingly popular sitcom, which had essentially developed with **television**. These series were successful with adult audiences as well as children and were shown in a prime-time slot initially.

By the 1980s, **cartoons** had returned to children's television time slots and the genres of the shows reflected this. However, in 1989, the new cable network Fox broadcast a new anicom, **Matt Groening**'s *The Simpsons*, which had been spun off from a series of **shorts**. Like *The Flintstones* before it, *The Simpsons* aired in a prime-time slot and found success with a mixed audience, but significantly a new adult audience that had grown up with animation on television.

This led to a whole new generation of anicoms, including shows such as *The Critic*, *Futurama*, *King of the Hill*, *Duckman*, *The PJs*, *The Tick*, *Dr. Katz: Professional Therapist*, *South Park*, *Family Guy*, and *Home Movies*; however, many of these new shows were short lived. The shows that stood out in the genre were *The Simpsons*, *King of the Hill*, *South Park*, *Family Guy*, and *Futurama*, which all lasted into 2009 (though *Family Guy* and *Futurama* had been cancelled and then reinstated on cable). In 2007, *The Simpsons* was recorded as the longest running sitcom in U.S. television history.

SLASH SYSTEM. An animation production method (also known as the slash-and-tear system) introduced by **Raoul Barré** in the early 1910s. The background would be drawn and laid over another sheet that contained the moving elements and a space would be cut out so the images on the sheet underneath could be seen. This was done in

progressive phases of movement. Retracing was required for any figures that moved, but the backgrounds could be reused, which saved time and the work of having to retrace every image. The system was used at several studios throughout the 1920s and worked as a variation of **John R. Bray**'s method of overlaying images on **cel**s or translucent paper.

SMALLFILMS. Smallfilms, based in **Great Britain**, has produced some of the best-known British **television** animation of the 1960s and 1970s. It was founded by Oliver Postgate (1925–2008), who had been an inventor, actor, writer, and television production assistant before he decided to try children's story-telling as a career. His first animated series was *Alexander the Mouse* for LIVE television in 1958, for which he asked Peter Firmin (1928–), a freelance illustrator and part-time teacher, to provide background drawings and cutouts. Their partnership has lasted for 50 years.

Working together with very small budgets and using simple equipment and materials in the old barns on Firmin's farm, Postgate wrote scripts, narrated, and animated films using Firmin's drawings and cutouts. They initially produced drawn animation in black and white and were successful with *Ivor the Engine* (1958–1963) for ITV and *The Saga of Noggin the Nog* (1959–1965) for BBC. These series were both later remade in color.

The premises were restored and developed so that stop-frame animation could be made using **puppets** on large sets. Firmin made most of these puppets with the help of his wife, Joan, who even used hand-knitting for *The Clangers*.

Postgate's first series using this method was *Pingwings* (ITV, 1962–1963) for which Firmin's sister Gloria knitted the puppets. He was offered backing by Talbot Television, which sold their films abroad, though they preferred to keep the operation small. In 1968, they moved into color production and created their best-known series, *The Clangers* (BBC, 1968–1971) and *Bagpuss* (BBC, 1973–1974). Smallfilms continued production into the 1980s, including *Tottie—The Story of a Doll's House* (BBC, 1982) from a book by Rumer Godden and *Pinny's House* (BBC, 1986) based on a series of books for preschool children by Firmin.

SNOW WHITE. The **Fleischers'** version of the classic Brothers Grimm fairy tale, released in 1933, preceded that of the **Disney Studio**'s by four years and starred **Betty Boop** and **Koko the Clown**. Like their previous hit *Minnie the Moocher* (1932), the film also featured Cab Calloway as the band leader. The film was a **musical** number set to "St. James Infirmary Blues," with the ghost of Calloway singing. The **surreal** nature of the film was compared to the Luis Buñuel and Salvador Dali film *Un Chien Andalou* (1929).

The film opens in the Royal Palace as the queen looks in the mirror and asks, "Who is the fairest?" Betty arrives to meet her "stepmama" the queen and is welcomed by sentries Koko and Bimbo. The queen is jealous of Betty as she is proclaimed to be the fairest, and the queen demands, "Off with her head!" Bimbo and Koko try to trick the queen by faking a grave but Betty ends up encased in an icelike coffin and lands at the seven dwarves' cottage. The dwarves then take her on to a mystery cave. The queen finds out and follows them. Koko sings "St. James Infirmary Blues" and turns into a ghost whose figure changes to reflect the lyrics of the song. When the queen again asks the mirror, it declares she is the fairest but transforms her into a dragon, which then chases the fleeing Koko, Bimbo, and Betty (now freed from her ice coffin). Bimbo saves the day as he turns the dragon inside out by pulling its tongue. The film is considered to be one of the Fleischers' most surreal and dark films.

SNOW WHITE AND THE SEVEN DWARVES. **Walt Disney**'s version of the classic Brothers Grimm fairy tale, which was the first **feature-length** animation in the **United States**, took several years of planning before its release in 1937. The preliminary work began in August 1934 with a lot of time spent on the planning. The venture was risky for the studio, as it was a more daring project than anything it had previously done in terms of scale and budget. There was also the added complexity of the number of characters, with each of the seven dwarves requiring its own detailed personality, which along with their names was subject to a variety of changes during the preliminary stages. This put a great deal of pressure on the production team, which included Art Babbit and Grim Natwick. They attempted to keep the fairy tale simple and the human characters were largely

rotoscoped, though there was some criticism over the quality of the finished item, particularly of the prince. After a huge amount of work and staff, the film opened in December 1937 and was a big hit between 1937 and 1938, earning over $8 million around the world. The film originally had a budget of $250,000 though the final cost was $1.5 million. There was some initial skepticism over the dramatic nature of the film, with audiences used to their animation being largely comedic, but the universal success proved that the medium could be used for more. The risk Disney took with this film—the studio almost went bankrupt—paid off with its painstaking attention to detail in animation, characterization, and **music**.

SOCIETY FOR ANIMATION STUDIES (SAS). The SAS is an international organization dedicated to the study of animation history and theory and was founded by **U.S.** academic Dr. Harvey Deneroff in 1987. The society holds annual conferences in different locations around the world each year, where members can present their research and discuss current debates in the field. The SAS members pay an annual fee to join, which gives them access to the directory of animation experts, a biannual newsletter, and an online peer-reviewed journal, *Animation Studies*. Like **Association Internationale du Film d'Animation** (ASIFA), the SAS has a mixed membership of theorists, historians, practitioners, and educators. The members elect a president to oversee the running of the society for a three-year term, assisted by a board of directors. As well as encouraging scholarship in animation studies, the SAS presents an annual award for scholarly writing in essay form and published books. The society has grown in number and scope over the past 20 years, with its 20th annual conference held in 2008 in Bournemouth, **Great Britain**.

SODA JERKS. Part of the *Mutt and Jeff* series produced by **Raoul Barré**, *Soda Jerks* (1920) is a good example of the early **cartoon** form and how it developed from the newspaper cartoon strip. Bud Fischer's characters were **adapted** from print to the animated film and are characterized by comic gags of role reversal. The animated form reinforces the slapstick visual **comedy** and the manipulation of the expected outcomes, but the cartoon is familiar to audiences and,

by retaining the speech bubble for dialogue, it is easily translated into the silent film. This episode features Mutt as a soda parlor owner with Jeff as his underdog employee. The cartoon uses Barré's **slash system** to produce the animation.

SOUTH PARK. *South Park* first aired in the **United States** in August 1997 and currently airs on the cable network **Comedy** Central. Unlike its animated **sitcom** counterparts, *South Park* is not broadcast in a prime-time slot but in an evening slot due to the adult nature of the comedy, which is often **subversive** in nature. The creators explicitly state that this show is not suitable for children and even include a disclaimer at the start of the credit sequence each week, though this forms part of a gag by saying that the show is not actually suitable for anyone.

South Park originated as an animated **short** film made as a Web Christmas card that, after achieving a great deal of interest from **television** executives, was developed into a full-length sitcom format. Creators **Trey Parker and Matt Stone**, who also voice many of the characters, produced an **anicom** like no other in production at the time. The animation has the appearance of crudely cut out paper figures, in the style of something a child might produce as opposed to the traditional **cel** style used in other anicoms (with the notable exception of *Dr. Katz: Professional Therapist*), which complements the themes and humor of the show. Initial observations of the show, with four schoolchildren as central characters, give the impression of something childlike; however, the animation and humor, as well as the themes and plots of the show, are revealed to be far more sophisticated. The animation is produced digitally, though designed to have a distinctly handmade appearance.

The show features eight-year-olds Stan, Kyle, Cartman, and Kenny (all voiced by Trey Parker and Matt Stone) and their relationships with each other and their families. Best friends Stan and Kyle often join forces against Cartman, a rather overweight kid who seems to hang around with the others despite his constant attacks on them; Kenny usually joins with Cartman. The four tend to argue a lot, generally picking on how fat Cartman is or how poor Kenny's family is. There are also a number of supporting characters who occasionally feature as the focus of episodes. The general themes of the episodes

are fairly diverse and often **political**. They range from such issues as euthanasia, **censorship**, religion, and drug use to globalization. These issues are examined using the device of the innocence of the children who question the, to them, odd and often illogical rules that the adults in their town are governed by. This allows the creators to address controversial issues. A **feature-length** film of the series, *South Park: Bigger, Longer and Uncut*, was released in 1999 and addressed much of the criticism of bad language and **violence** that the show (and others) is accused of. In 2008, the show began its 12th season on Comedy Central.

SOVIET UNION. The Soviet Union entry is largely dominated by Russian animation, which shaped much of **Eastern Europe** and modern Russian animation. The pioneering Russian-born puppeteer Ladislas Starevitch (1882–1965) has been compared to **Winsor McCay** in terms of his significant contribution to the development of animation. He established **stop motion**, beginning his career making films of the habits of insects for a museum using preserved specimens, such as *The Battle of the Stag Beetles* (1910). He first used **puppets** in *The Fair Lucanida* (1910) and developed a method of wire and wood frames for the puppets. He fled Russia during the revolution and continued his filmmaking in **France**.

During the 1920s, animation in the Soviet Union was marginalized, though Ivan Ivanov-Vano (1900–1987) directed *The Adventures of Baron Münchausen* (1928), one of the first Soviet animated **adaptations** of folk and classic stories. The most famous film of the time was *Post Office* (1929) by Mikhail Tsekhanovsky, popular outside the Soviet Union as well as within. The Soviet State Film Committee was dedicated to promoting communism and produced its first animated film, *Soviet Toys*, in 1924. The stereotypes of workers, peasants, and capitalists were then seen throughout Soviet animation for the next 70 years. Animation was the main route for delivery of the state's message to the public.

Another state-run studio, Soyuzmultfilm, was founded in 1936 and started by trying to emulate **Walt Disney** by adapting fairy tales. The first director of the studio was Alexander Ptushko, whose first film was *It Happened in the Stadium* (1928). In 1935, he made *The New Gulliver*, a combination of live action and stop-motion animation,

though he later went on to direct live-action films. Soyuzmultfilm was influenced by Hollywood during the 1930s with little distinction between its films and Disney's. During this time, Ivan Ivanov-Vano and Lev Atamanov emerged as the most significant directors. By the late 1930s, the studio was producing 20 films a year and began to make them in color.

Soyuzmultfilm made patriotic **shorts** following the Nazi invasion in 1941. The urgency for the these films continued for a short time into the war, but eventually most projects were put on hold until after the war. Following the war, the films continued to be produced largely for children and were still very similar to Disney, as they had been in the 1930s.

The majority of Soviet animation was produced on **cels**, with a "social **realism**" mandate. Many beautiful films were made in the 1950s, such as Ivanov-Vano's *The Twelve Months* (1956) and *The Snow Queen* (1957) by Lev Atamanov. Other notable animators of the period were the Brumby sisters and Boris Diskin.

Arguably one of the most important animators working in the 1960s and 1970s, **Yuri Norstein** reflected the political changes in the Soviet Union at the time with *25th October, the First Day* (1968) and the masterpiece *Tale of Tales* (1979). However, when communism and the Soviet Union collapsed, the state funding largely went with it and many animators were out of work.

Estonian director Elbert Tuganov (1920–2007, born in Azerbaijan), hailed as the father of Estonian animation, began his career in **Germany** before working at the state film studio Tallinfilm for 11 years, where he developed new techniques and technologies for filmmaking. This led to the formation of a puppet animation division in the studio. The first film from the new Nukufilm was *Little Peter's Dream* (1957). Animation production grew over the next few years and the number of staff also increased. This led to the hiring of Heino Pars as the second director of the division, making *Little Motor Scooter* in 1962.

Estonian Rein Raamat (1931–) established a cel animation division at Tallinfilm and was one of the first animators there to be internationally recognized. His masterwork is considered to be *Hell*, made in 1983. After the re-independence of the country in 1991, new animators emerged, creating something of a new Golden Age,

including Mati Kütt, Janno Põldma, Hardi Volmer, and Riho Unt. With them, a new style of animation with less **censorship** and more adult themes emerged. By the early 1990s, Soyuzmultfilm's influence had faded and in 1993 its most prominent animators (including Norstein) left to establish an animation school, Sher. One of the leading studios since is Pilot, which produced Alexander Petrov's **Academy Award**–nominated *The Mermaid* (1996). *See also* PROPAGANDA.

SPAIN. *See* WESTERN EUROPE.

SPIRITED AWAY. **Feature-length anime** directed by **Hayao Miyazaki** and produced by **Studio Ghibli**, *Spirited Away* (2001) is one of the studio's most internationally successful films to date, winning the **Academy Award** for Best Animated Feature in 2003. The film is a fantasy tale, essentially aimed at children age 10 and older, but with an appeal to adults. The visual production is of a very high quality, as is the **musical** accompaniment. The film has been compared thematically to *Alice in Wonderland*, particularly due to use of food and drink to magically transform the body.

The story follows 10-year-old Chihiro who, while traveling to a new home with her parents, becomes trapped in a forbidden world of gods and magic. They are transported after traveling through a tunnel and arrive in another world inhabited by spirits. Chihiro must take on work in order to survive as well as find a way to save her parents, who have been turned into pigs. Ultimately they escape, Chihiro having completed a rite of passage of sorts, and return to their own world, back through the tunnel, her parents having no memory of what occurred. There are many elements adapted from **Japanese** folklore and culture as well as a strong environmental theme. *Spirited Away* was redubbed into English for the North American DVD market.

STEAMBOAT WILLIE. Inspired by the sound synchronization of the first "talkie," *The Jazz Singer* (1927), **Walt Disney** used a makeshift system to create the synchronized **music** for *Steamboat Willie* (1928), which was the first to do so and marked the end of the **silent era**. It was the third film to feature **Mickey Mouse**, with the title of the film taken from the song "Steamboat Bill." There were some technical

problems in its development but it premiered at the Colony Theater in New York on 18 November 1928 and was very successful.

The plot consists of Mickey working as a pilot of a river boat. He has trouble with a villain named Peg Leg Pete (though it is unclear if he is meant to be a crew member) and Minnie Mouse. The story was only constructed to synchronize with the music. The characters and the boat dance with the music, using farm animals as instruments (a cow's teeth are played like a xylophone). The film was animated by **Ub Iwerks** with music by Wilfred Jackson and composed by Carl Stalling. In order to get the synchronization exactly right, the bar sheets of the music were prepared almost simultaneously with the exposure of the animation.

STONE, MATT. *See* PARKER, TREY, AND STONE, MATT.

STOP MOTION. Stop motion is the technique of filming small increments of movement that, when put together, give the illusion of movement. The process is very time consuming and painstaking, as the increments are very small, frame by frame. **Three-dimensional (3D) stop-motion** animation has two distinct histories. The European tradition is of the (often individual) artist creating a film by stop motion for **short, feature-length**, or children's **television**. The second is the Hollywood tradition that emerged through the special effects that were created for live-action films.

Either process can be accomplished using a variety of 3D models, from **clay** and **puppets** to found objects and artifacts, or even humans in **pixilation**. Examples of stop-motion animation include Arthur Melbourne Cooper's *Dreams of Toyland* (1908) from **Great Britain**, Ladislas Starevitch's *Tale of the Fox* (1930) from the **Soviet Union**, and Willis O'Brien's creature effects in *King Kong* (1933) from the **United States**, which influenced the work of **Ray Harryhausen**. Other animators who typically use stop motion include **Henry Selick, Barry Purves, Jiri Trnka, Jan Svankmajer**, the **Quay brothers, Will Vinton**, and **Aardman Animation**.

STREET OF CROCODILES. Directed by the **Quay brothers**, *Street of Crocodiles* is one of the brothers' best-known films and appeared in 1986. The story is based on a subject by Polish author Bruno

Schulz and is animated using **stop motion** and **puppets**. It was the first film they shot in 35 mm film. The story features a museum keeper who spits into the eyepiece of an ancient peep show, which sets the old machine in motion. This takes the viewer into a nightmare, and the caretaker into a netherworld of bizarre puppet rituals among dirt and grime. The map on the machine indicates the Street of Crocodiles and the internal mechanisms are released with the movement into a permanent flux. The eyeless puppets that inhabit the other world act as tailors, manipulating the caretaker and altering his body to be doll like and mechanical. The imagery has been described as uncanny due to the unsettling sense of horror the film presents with the inanimate objects coming to life. The film shows the **Eastern European** influences of **Jan Svankmajer** whose films used similar techniques and images.

STREET, THE. Caroline Leaf's multiple-award-winning film *The Street* (1976) was largely responsible for her international success. The film—painted onto glass, using glycerin to slow the drying process—is based on a story by Jewish writer Medecai Richler about a family in which the grandmother is dying and the grandchild is trying to make sense of what is happening. The child's sense of loss is confused with the desire for his own room, which he will inherit after the grandmother dies. The 10-minute film took Leaf a year and a half to complete and deals with the subject in a thoughtful way with small movements reflecting behaviors and observations. The fluid nature of the paint allows for metamorphosis of images and creates a moving film.

STUDIO GHIBLI. Japanese animation studio that specializes in traditional hand-drawn animation, though in recent years has been incorporating a partial use of computer graphics. Studio Ghibli is very successful in the production of feature animation in **Japan** (or **anime** to use the term that refers specifically to Japanese animation) and since the late 1990s worldwide. Despite less focus on **television** animation than many other major Japanese studios, it is considered to be Japan's top animation studio.

The worldwide success was particularly evident when one of the studio's top directors, **Hayao Miyazaki**, won the **Academy Award**

for Best Animated Feature for 2001's *Spirited Away*. Miyazaki works with senior colleague and mentor Isao Takahata, a working relationship that has existed since the 1970s when they collaborated in television production. In 1982, Miyazaki was asked to adapt his **manga** *Nausicaä of the Valley of the Wind* (1984) for cinema. With Takahata's aid, they produced the film, the success of which led the pair to found Studio Ghibli. Their first film under the new studio was *Laputa Castle in the Sky* (1986), and the studio continues to produce a feature approximately every two years, including *Kiki's Delivery Service* (1989), *Porco Rosso* (1992), *Pom Poko* (1994), and *Tales from Earthsea* (2006).

There has been a gradual increase in digital techniques used in their films, though the biggest international hits, *Spirited Away* and **Princess Mononoke** (1997), were drawn by hand with only limited digital special effects.

SUBVERSION. The language of animation allows it to be used as a device that can disguise and essentially redefine the everyday. By not simply capturing the live action, animation can subvert our accepted notions of reality and challenge our understanding. By being able to do so to represent and give "life" to anything, animation can be used in any way the animator chooses. It can represent the real in **documentary** or have no narrative function in **abstract** animation, all of which can be used to subvert the perceived meaning. **Comedy** in animation can be used as a subversive tool to insert **political** criticism and can be seen in **Jan Svankmajer**'s work as well as that by **Ralph Bakshi** and **Trey Parker and Matt Stone**. Often opportunities for subversion arise due to the perceptions of animation as children's entertainment and, as a result, the content of the form is often dismissed as unimportant. *See also SIMPSONS, THE*; *SOUTH PARK*; *REN AND STIMPY*.

SULLIVAN, PAT (1887–1933). Born Patrick O'Sullivan in Australia to an Irish family, Pat Sullivan traveled around as a boxer and an artist, and ended up working at a newspaper in the **United States** as assistant to cartoonist William F. Marriner. Sullivan inherited Marriner's strips after Marriner died in 1914 and decided he would like to turn them into an animated **cartoon**. He approached **Raoul Barré**, who taught him animation techniques and let him use his studio.

Sullivan opened his own studio in 1915 and released *Sambo and His Funny Noises* as the animated series *Sammy Johnsin* in 1916. Sullivan had met **Otto Messmer** at Universal's New Jersey studio and hired him. They worked closely together until Sullivan's death in 1933.

Sullivan produced a series of animated cartoons about Charlie Chaplin, and in 1919 began to produce animated **shorts** for Paramount's *Screen Magazine*. In 1919, Messmer created "**Felix the Cat**" for the magazine that Sullivan produced, and took full credit for in the titles of the films. In 1921, he left Paramount and signed with Margaret Winkler to distribute the films. Sullivan promoted *Felix* heavily around the world, which contributed to the series' great success. In 1922, he secured the rights to *Felix* from Paramount and Messmer continued to animate them at Sullivan's studio. He capitalized on *Felix*'s success with merchandise and was one of the first to do so.

Sullivan left Winkler in 1925 after several disagreements and signed with Educational Films for distribution. They began producing new films every two weeks to meet demand. However, in 1928, when studios began converting to sound, Sullivan expressed his disinterest in the technology and the expense and problems involved in converting, and Educational did not renew their contract for 1928–1929.

In 1930, he changed his mind and went to California to attempt to set up another studio to produce *Felix* cartoons but poor health prevented him from completing the venture. Both Sullivan and his wife were hard drinkers and in 1932 his wife died after falling from their apartment window; Sullivan never got over the tragedy. In 1933, he died of pneumonia. The studio was left in disarray with legal problems that took a long time to resolve and as a result was closed.

SUPERMAN. Fleischer brothers–animated series based on the character created by Jerry Siegel and Joe Schuster that first appeared in *Action Comics*. The brothers were approached by Paramount to create the series but they were reluctant to do so and, in an attempt to put them off, told the studio it would cost $100,000, but Paramount agreed and heavily promoted the series. It was very successful, but the production required a lot of preparation as everything had to be laid out very carefully due to the high costs. Some **rotoscoping** was

used but they largely relied on the animators to capture the appearance of the comic. Very detailed modeling, background, and foreground work was required and pencil tests were used for every film. Lighting effects were created using double exposure. The result was one of the Fleischers' finest achievements. The series consisted of 17 episodes in total between 1941 and 1943, with nine at Fleischer and eight produced by **Famous Studios**.

SURREALISM. Art movement beginning in 1924 and including such artists as Max Ernst, Paul Klee, Salvador Dali, Marcel Duchamp, René Magritte, Marc Chagall, and Joan Miro, among others. The movement came into being after the French poet Andre Breton published his *Manifeste du Surréalisme* in 1924. It suggested that rational thought was repressive to the powers of creativity and imagination and inimical to artistic expression. He was an admirer of Sigmund Freud, and such theories of the subconscious and the meaning of dreams began to feature heavily in the artwork. Examples of surrealism's influence in animation can be seen in Dali and the **Disney Studio**'s *Destino*, and in the work of the **Quay brothers** and **Jan Svankmajer**, who was a member of the Prague Surrealist Group in the late 1960s. The influence of the movement can also be seen in experimental animation.

SVANKMAJER, JAN (1934–). Czech animator well known for his work in a wide range of **three-dimensional** (3D) materials, including **puppets**, **clay**, and **pixilated** humans, his films are diverse and intriguing. Svankmajer studied at the Academy of **Fine Arts** in Prague and began his artistic career as a painter, sculptor, and engraver before moving to cinema in 1964. His first film was *The Last Trick* (1964) and much of his early work displays stylistic choices seen from his earlier career, notably the sculptural textures and use of found objects. His film *Byt* (*The Hat*, 1968) sees an old man struggle against his furniture and in *Alice* (1988), based on the Lewis Carroll story, Svankmajer makes use of old toys. His aesthetic is rooted in horror and unsettling images of dreams and nightmares. The content is often symbolic to escape Czech **censorship** and he has been affiliated with the Prague **Surrealist** Group since the late 1960s. One particularly notable film is the trilogy *Moznosti dialogu* (*Dimensions*

of Dialogue, 1982), which features sculpted heads. In the first part, the heads are made of food and other metallic objects and fight each other; in the second part, two Plasticine torsos are consumed by an ever more destructive love for each other; and in the third section, two clay heads give each other objects. He has acknowledged the influence that 16th-century mannerism and surrealist art had on his work, in both his animation and the live-action films he has made. His work has particularly inspired the **Quay brothers**.

SWEDEN. Swedish **cartoonist** Victor Bergdahl (1878–1939) was inspired by **Winsor McCay**'s *Little Nemo* films and in 1915 made *Trolldrycken*. He created a series, *Captain Grogg's Adventure*, which ran for 13 episodes from 1916 until 1922, stopping when he felt that **U.S.** animation was overwhelming the market. Another Swede, Viking Eggeling (1880–1925), was pivotal in developing experimental animation. He traveled around Europe in his youth and was a founding member of the Dada art movement in Zurich, Switzerland. His experiments in animation including the series, *Horizontal-Vertical Orchestra* (1919–1920) (the first of which, *Horizontal-Vertical Mass*, was made with **Hans Richter** in 1919) and *Diagonal-Symphonie* (1923), were unfortunately never released and he died early, aged 45, in 1925.

The Swedish animation industry was slow to develop, though in the 1950s groups such as Gunnar Karlsson's GK Film and Stig Lasseby's Team Film formed to produce animation. GK Film was particularly known for its **puppet**-animated series *Patrik and Putrik*. In the 1960s, the long-running and extremely popular series featuring Bamse, a bear cub, was created by Rune Andreasson. The character returned in the early 1970s and again in the 1980s. The first **feature-length** animation made in Sweden was Per Åhlin's *I huvet på gammal gubbe* (*In the Head of an Old Man*), produced by GK Film in 1969. After the release of this film, Åhlin formed his own production company, Penn Film, and went on to produce **short** films as well as the 1989 feature *Resan till Melonia* (*Journey to Melonia*), an **adaptation** of William Shakespeare's *The Tempest*.

The 1970s saw an increase in demand for children's **television**, and several young animators found new opportunities in the industry. The main focus of much of Sweden's animation was on children's

films with educational and often social issues included. There was less of an emphasis on the creation on art films or large studio-based features as in their European neighbors. The Team Film studio produced the popular television series *Agaton Sax and the Max Brothers* in 1972, the success of which led to spin-off specials. The studio was one of the largest producers throughout the 1970s and 1980s, with some of the top animators such as Jan Gissberg creating several series and films.

In the 1980s, several new animators contributed to the development of the industry, including a shift toward more artistic productions, such as Karl-Gunnar Holmqvist, who won several awards for his feature *Alban* (1981) and later *Johnny Kat and the Waltz of the Pirates* (1986). In television production, Gilbert Elfström made several popular series throughout the 1970s and 1980s. The award-winning animator Birgitta Jansson used the modeling clay Plasticine to create her animated pseudo-documentary *Vacation House* (1981). Other animators of note include Peter Kruse, Marja Seilola, Olle Hedman, and Peter Larsson, to name a few.

– T –

TAIWAN. *See* ASIA.

TAKAMOTO, IWOA (1925–2007). Japanese-American animator born in Los Angeles, California, he was sent to Manzanar internment camp during World War II, where he learned illustration from other detainees. He joined the **Disney Studio** in 1947, where he worked on *Cinderella*, *Peter Pan*, *Lady and the Tramp*, *Sleeping Beauty*, and *101 Dalmatians*. During the production of *Sleeping Beauty*, he was able to work with Tom Oreb, previously of **United Productions of America** (UPA). He learned from Oreb's minimalist style and design, which helped and influenced his work. He went to work at **Hanna-Barbera** in 1961, where he created his most famous character (though the character is undoubtedly better known than Takamoto), **Scooby Doo**. He also worked on *Jonny Quest*, *Josie and the Pussycats*, and *The Jetsons*. As well as Scooby, he created Mutley, Astro, Penelope Pitstop, and the Great Gazoo in *The Flintstones*.

In 1973, he codirected the **feature-length** animated adaptation of *Charlotte's Web*.

Takamoto was awarded the **Winsor McCay** Lifetime Achievement Award in 1996 from the Animators Guild. His last position before retirement was as vice president of creative design and special projects at **Warner Brothers**, where he storyboarded the 2005 *Tom and Jerry* short *Karateguard* and created the character Krypto.

TASHLIN, FRANK (1913–1972). Born in New Jersey to a French-German family, at age 15 Frank Tashlin became an errand boy at the **Fleischer brothers'** studio in New York. He later became an animator for **Van Beuren**. He moved to Los Angeles in 1933, where he worked for **Leon Schlesinger** at **Warner Brothers** until 1935 and worked on such characters as Porky Pig. He was said to have been more interested in fast-paced **cartoons** than **Tex Avery** and had a strong cinematic approach and interest in film techniques. From 1934 to 1936, he also drew a comic strip, "Van Boring," for the *Los Angeles Times*.

Tashlin returned to Warner's from 1936 to 1938, where he directed 21 films (13 featuring Porky Pig). Between 1938 and 1941, he worked for the **Disney Studio** before moving on to Screen Gems. He ran the studio for a time after **Charles Mintz**'s death and when **Columbia** took it over, he recruited staff from Disney. He returned to Warner Brothers in 1942 but in approximately 1945 gave up animation to become a script writer for live-action comedies. He also wrote and illustrated children's books.

Tashlin wrote gags for stars such as the Marx Brothers and Lucille Ball and scripts for such films as *Son of Paleface* (1951) starring Bob Hope and *Artists and Models* (1955) starring Jerry Lewis. His animation career influenced his filmmaking, which had previously influenced his animation techniques. His live-action film career went beyond writing and he was quite a prolific director, including *Will Success Spoil Rock Hunter* (1957). With such a varied career, Tashlin was said to have left a mark on each sector he worked in.

TEAM AMERICA, WORLD POLICE. Animated feature directed and produced by **Trey Parker and Matt Stone**, the duo responsible for the long-running **anicom** *South Park*. Their first animated feature,

South Park: Bigger, Longer and Uncut (1999), was a spin-off from their successful **television** series and was animated in the same style. For *Team America, World Police* (2004), the pair chose to animate the film using **puppets**, very similar to that of **Gerry Anderson**'s super-marionettes from *Thunderbirds*. The themes of a daring (not so) secret rescue organization are included here and parodied, right down to the use of various transportation devices from motorbikes to jet planes, in a satirical look at U.S. **politics** and foreign policy.

The tag line for the film—"Putting the 'F' back in freedom"—reflects the tone and the content of the film, which is strictly for adults, demonstrated in the frequent use of swearing and a deliberately long sex scene involving puppets that drew great criticism from **censors** and gave the film an R rating.

The synopsis outline describes Team America as an international police force "dedicated to maintaining global stability." When we see them in action at the start of the film, they are causing more damage than they resolve, a theme that continues throughout. The North Korean dictator Kim Jong Il has joined forces with terrorists around the world in a plot to destroy it. Team America recruit top actor Gary Johnston to try to infiltrate the group and help them stop the plot.

The film satirizes **U.S.** foreign policy, media coverage of terrorist activity, terrorist groups, and Hollywood actors who voice their opinions on political issues, criticizing them all equally and includes many **musical** sequences. The film won a variety of awards internationally, including a **Music Television** (MTV) award.

TELEVISION. Animation has appeared on television since the inception of the technology. The first animated series to appear in the **United States** was *The Comic Strips of Television* by **Jay Ward** and Alexander Anderson in 1949. In the United States in the late 1950s, animation on television was typified by the repackaging of theatrical **shorts** into lengths appropriate for the television format. Early examples include **Warner Brothers'** *The Bugs Bunny Show* and **Hanna-Barbera**'s *Huckleberry Hound*. These new shows took the format of variety shows with shorts compiled together into half-hour segments. In **Great Britain**, it was common for **puppets** to be used either in fully animated series such as *The Flower Pot Men* or accompanying live human hosts in *Muffin the Mule*.

These shows were very successful and as TV executives recognized a children's audience, new series were commissioned to appeal. The **American Broadcasting Company** (ABC) was keen to capture a family market and commissioned Hanna-Barbera to create a prime-time series, the result of which was *The Flintstones*, followed by *Top Cat* and *The Jetsons*, among others. Throughout the 1960s and 1970s, the market expanded to include more shows in a variety of time slots, including Saturday morning and after school, to fully capture the younger market. In the mid-1970s, the U.S. market was keen to reach the teen market and Hanna-Barbera responded with shows based on **music**, including *Josie and the Pussycats* and *The Archies*.

By the 1980s, in part due to a changing political environment and the television market in general, the shows produced were keenly marketed and heavily merchandised, which led to a great deal of criticism of animation in general as a lower form of entertainment. In Great Britain, the market had seen variations in animation style from the puppet animation of **Gerry Anderson** in *Thunderbirds* and from **Smallfilms** to the drawn 2D animation from **Cosgrove Hall** or **Bob Godfrey**.

In the late 1980s and early 1990s, largely due to the introduction of *The Simpsons*, the new prime-time animated **sitcom** from **Matt Groening**, animation on television became more popular and saw a resurgence with a new variety of shows and audiences. This has continued with the emergence of new adult audiences being specifically catered to with shows such as *South Park* and the **Adult Swim** initiative on the **Cartoon Network**.

While the reputation of television animation in the West has been quite poor, television animation in **Japan** enjoys a greater status as a cultural form. Animation is generally a more prevalent form of entertainment there, with different types and **genres** as well as very specific markets, separate for children and adults.

One of the criticisms of television animation from its inception was the use of **limited animation** in its production. The quality was deemed to be much lower than the full animation of Warner Brothers, **Metro-Goldwyn-Mayer** (MGM), and **Disney** that had preceded it. Its use was necessary due to budget and time constraints. This is no longer such an issue, particularly as new digital animation techniques aid the creation

of the products. As well as aiding 2D animation, digital animation in the form of full **computer-generated imagery** (CGI) has been used to create full television series, first seen with the Canadian series *Reboot*. Many other series since have followed that format, though the technique is generally used for **science fiction** and fantasy adventure series.

As new broadcast methods have increased with the use of the Internet, television animation is still broadcast in the mainstream, but new producers are able to reach new audiences worldwide. The technology has been changing the animation created just as the new television animation changed that which had been shown in cinemas previous to the advent of television.

TERRY, PAUL (1887–1971). Born in San Mateo, California, the youngest of five children, his mother died when he was one year old. Paul Terry lived in San Francisco and after high school went to work as an office boy for the *San Francisco Bulletin*. He then became a photographer for the *Chronicle* and was there during the earthquake and fire of 1906. Terry then traveled around until he ended up in New York in 1911.

After seeing **Winsor McCay** and *Gertie the Dinosaur* in 1914, Terry began working in the animation industry. His first film was *Little Herman*, after which he was contracted by Hearst to make a pilot for *Mutt and Jeff* with Bud Fisher. He made a deal with **John R. Bray** to make a series of *Farmer Al Falfa* and was one of the first animators to adopt the Bray **cel** process.

Terry had a break from animation in 1917 when he went into the army to film medical history. After the war, he returned to New York where he formed a company with **Earl Hurd**, Frank Moser, Hugh (Jerry) Shields, Leighton Budd, and his brother, John Terry, but they soon broke apart. He continued creating the *Al Falfa* series for Paramount Pictures in 1920 and a series of *Aesop's Fables* (1921–1929) that was so successful they were produced one a week for eight years at his "Fables Studios." In 1928, Terry's films were distributed by the new **Van Beuren** studio. Terry's *Dinnertime* (1928) use of sound led to his claims of the first sound **cartoon**, but it fell short of the full sound synchronization in *Steamboat Willie*.

In 1929, Van Beuren took over Fables Studios because Terry was reluctant to convert to sound too quickly. In 1929, Terry started his

own studio, **Terrytoons**, with Moser, which ran until Terry sold the studio to CBS in 1955. The studio had success with the series *Mighty Mouse* and *Heckle and Jeckle*. In 1952, Terry sold the cartoons to CBS for **television** but then in 1955 sold the entire studio and its assets. He retired and lived until the age of 84.

TERRYTOONS. Studio created by **Paul Terry** in 1929 that produced the popular series *Mighty Mouse*, originally known as Super Mouse, in 1942 and *Heckle and Jeckle* in 1946. Terry sold the studio and its assets to CBS in 1955, after which it only took CBS two years to recover its investment. It was able to utilize the **cartoon** library and take advantage of merchandise opportunities, which Terry had rarely ventured into. CBS retained the original staff and continued to produce theatrical **shorts** as well as other projects. It hired **Gene Deitch** from **United Productions of America** (UPA) in 1956 as artistic supervisor and he remained at the studio for two years. Unfortunately, attempts to revitalize the studio were resisted by Terry's staff. Eventually, new staff were brought in to introduce new characters. There was a new design and style present in these new films, but they were unsuccessful due to a lack of humor.

In 1958, Bill Weiss fired Deitch and took over control of the studio. He had over 30 years of studio experience and a good business sense. He did not like Deitch's cartoons so he dropped his characters and brought back some of the old Terrytoons, such as *Mighty Mouse* and *Heckle and Jeckle*. He switched the studio from Technicolor to Deluxe Color to save money and wanted to break into the **television** business with new characters. *The Deputy Dawg Show* began in 1960 and consisted of 104 episodes.

New staff was brought in for television production, including **Ralph Bakshi**, who joined in 1956, aged 18. By 1966, Bakshi was directing his own cartoons, having worked his way up through the studio and produced *Mighty Heroes*, new Mighty Mouse episodes. After 26 episodes, however, Bakshi left to become a director at **Paramount Cartoon Studios**. Aging skeleton staff led to a decline in production and output, and the plant in New Rochelle, New York, closed down. Studio activity did not entirely cease. Bill Weiss went to Viacom, which took ownership of all Terrytoons films through

CBS Films and continues to broadcast and distribute for foreign markets.

TEZUKA, OSAMU (1928–1989). Born in Osaka, **Japan**, Osamu Tezuka began his early career as a comic-strip artist, which earned him the reputation of a living legend. His work was influenced by his interests in Charlie Chaplin, **Walt Disney**, and the **Fleischer brothers**. He attended medical school from 1947–1952 but retained his interest in art.

In 1947, Tezuka published *Shin Takar Jim* (*The New Treasure Island*), which sold half a million copies. His comic book success made him something of a celebrity. Tezuka went into animation in 1959 when he was hired by Toei Doga. In 1961, he founded his own production company, Mushi Production Company Ltd., and produced its first animated film in 1962, *Stories on a Street Corner*. The company moved into **television** production and Tezuka created *Astro Boy* in 1963, which was so successful that it was syndicated in the **United States** later that year, and was essentially responsible for the new Japanese television animation industry.

Tezuka continued to produce work for television but also worked in **feature-length** animation as well as exhibiting short independent films. Notable **shorts** include *Jumping* (1984), *Broken Down Film* (1985), and *Legend of the Forest* (1987).

THAILAND. *See* ASIA.

THREE-DIMENSIONAL (3D). Three-dimensional (or 3D) animation refers to animation that is created with solid objects, generally **puppets, clay**, found objects, or **pixilation** using **stop-motion** techniques. The objects are filmed and manipulated in small increments to create the illusion of movement. With the increasing use of **computer-generated imagery** (CGI), animation can be created to appear 3D without having to physically make models to film; the "models" are created by computer. This can be seen in such films as **Pixar**'s *Toy Story* (1995) or in *Final Fantasy: The Spirits Within* (2001). The increasing success of this type of film—particularly from Pixar, which uses the technique in most of its films—has potentially led to the

decline in traditional 2D (or drawn) animation. The **Disney Studio** stopped producing drawn animation in 2004 despite its long history in 2D animation and, indeed, much of the pioneering work from the studio in the early days of animation.

THUNDERBIRDS. Created by **Gerry Anderson**, the *Thunderbirds* series was one of his most well known and enduring. The **puppet**-animated series originally ran on British **television** from 1964–1965 and took the form of a **science fiction**/action adventure series in which a family, the Traceys, ran a global rescue service from a secret island base. The series was set in the year 2065 and featured five high-tech vehicles and rockets. The series was very popular, lasting 26 episodes of 50 minutes in length each.

In 1966, a second series of six episodes was produced that continued to focus on International Rescue, but this time included a London-based agent, Lady Penelope Creighton-Ward, and was set in 2067. The series was followed by a **feature-length** film, *Thunderbirds Are Go* (1966), that saw the agency called to supervise the arrangements for the launch of a manned mission to Mars.

Anderson followed up the success of *Thunderbirds* with other series in the same style but the original has remained popular with renewed repeat broadcasts since the 1990s and the creation of a live-action feature film in 2004. The merchandise from the series has also continued to be popular with record sales of a particular toy, "Tracy Island," performing as the top-selling Christmas toy in 1993 and again in 2000.

TOM AND JERRY. Characters introduced by **Bill Hanna** and **Joe Barbera** at **Metro-Goldwyn-Mayer** (MGM) in 1940; they first appeared in the **short** *Puss Gets the Boot*, though in this film Tom was named Jasper. The series of **cartoons** featuring the pair was so successful it ran for 15 years and was nominated for several **Academy Awards** over the period of the run, and won seven. The series featured a mischievous mouse, Jerry, and an angry put-upon cat, Tom. Over the life of the series, the episodes became faster paced and more violent, with Tom always trying to catch Jerry, who always got away.

The **music** was scored by Scott Bradley and the compositions used were always of a high quality, which was important due to a lack of

dialogue; the action of the chase drove the narrative. In 1943, Bill and Joe won their first Oscar for *Yankee Doodle Mouse.* The best output of the series was in the 1940s, and the influence of **Tex Avery**, who was in control of the studio, can be seen in many of these films. Success of the series was said to be due to good characters, good stories, and good gags. Jerry (the mouse) appeared in a now-famous dance sequence with Gene Kelly in the live-action **musical** *Anchors Away* (1944) and with Esther Williams in *Dangerous When Wet* (1953). In the 1950s, new characters were introduced, including a duckling and a bulldog named Spike (and later, Spike's son). In 1957, MGM closed its animation studios and Bill and Joe went on to form their own studio, **Hanna-Barbera.**

After an animation revival on **television**, MGM decided to release new *Tom and Jerry* cartoons; in 1961 and 1962, they hired **Gene Deitch** to produce them from his Czech studio. **Chuck Jones** was later brought in and redesigned the characters, with more expressive features and less chase and **violence.** Eventually, MGM ended the series and old episodes were shown on television on Saturday mornings.

Hanna-Barbera proposed a new series in 1975 but was told that the violence would not be acceptable any more. They tried to produce the cartoons with Tom and Jerry as friends instead of enemies, but they were not of the same quality and the pair was not the same; however, the series ran into the 1980s and is still popular in reruns.

TOY STORY. *Toy Story* (1995) was the first fully computer-generated **feature-length** film and was directed by **John Lasseter** of **Pixar** and distributed by the **Disney Studio.** Though the film uses full **computer-generated imagery** (CGI), the development of the film was all hand-drawn and storyboarded. The film is the story of Woody, a toy cowboy, who is the favorite toy of a young boy, Andy. The toys come to life when the humans are out of the room and we see that they have virtually a full society in Andy's bedroom. This was inspired by Lasseter's earlier **short** film *Tin Toy* (1988). When Andy receives a new "Buzz Lightyear, Space Ranger" doll/action figure for his birthday, Woody is worried that he will be replaced in Andy's affections. Woody tried to get Buzz out of the way, but Buzz does not realize he is a toy and thinks he is the actual space ranger.

In a fight between the two toys, they end up falling out of Andy's house and into the back yard of the neighbor Sid, a child who likes to torture and take apart his toys. By working together, they manage to escape and resolve the situation. They also then accept each other and their place in Andy's life. The story and dialogue are very good, which very much added to the success of the animation. The film was very successful and in 1999 a sequel, *Toy Story 2*, was released. There has also been a spin-off **television** series, *Buzz Lightyear*, and a vast amount of merchandise for the films.

TRNKA, JIRI (1912–1969). Born in Pilsen, **Czechoslovakia**, Trnka was thought of as a master of animation due to his skill. His art teacher was Josef Skupa, a puppeteer who encouraged him and took him on as an assistant. During this time, Trnka learned the art of carving **puppets**, which—due to a long tradition of puppetry—was very popular in Czechoslovakia after World War I. Trnka initially made his name as a painter and satirical illustrator with an interest in book illustration and theater. He founded the Wooden Theatre and following World War II made a transition from puppet theater to animated cinema. *Grandfather Planted a Beet* (1945) was his first film and used animated drawings that demonstrated his artistic skills. *Darek* (*The Gift*) (1946) was a **surrealist** film; *Zvíratha a Petrovští* (*The Animals and the Brigands*, 1946) was a rendition of a popular tale; and *Pérák a SS* (*The Springer and the SS Men*, 1946) was an anti-Nazi film. Trnka complained that all of these films had been made with "too many middlemen" and he changed from animating with drawings to using puppets.

His puppet films were even better than his previous films as he was able to present expressive "performances" from his puppets, aided by skillful framing and lighting. His first feature was *The Emperor's Nightingale* (1948), based on the Hans Christian Andersen tale. Many of his films were **adaptations** of Czech folktales and his last **feature-length** film was based on William Shakespeare's *A Midsummer Night's Dream* (1959). The rest of his works were **shorts** after he had experimented with a variety of genres.

Trnka became pessimistic and his work became bitter, which can be seen in his final film, *Ruka* (***The Hand***, 1965). Ill health prevented him from working and he became depressed due to this inability to

work. He died in Prague in 1969 aged 57 but has been heralded as a national poet who brought his love of nature and faith in people's traditions to his films.

TRON. Directed by Steven Lisberger for **Disney Studios,** *Tron* (1982) was a live-action feature film with digital animation sequences. Despite poor reception and box-office takings, the film was a breakthrough in computer animation in motion pictures. The film includes 235 computer produced scenes, totaling over 15 minutes of **computer-generated imagery** (CGI), which was more than any previous film, and the production involved four leading computer graphics companies. The poor takings affected the prospects of any other films using CGI but the film was highly influential on a number of people, including **John Lasseter** of **Pixar,** who saw early scenes of *Tron* in production and decided that CGI was the future of animation.

Jeff Bridges plays a computer programmer who makes games in his spare time while working for a large company, Encom. After he is double-crossed by a colleague, he tries to investigate and ends up inside the computer mainframe and has to play the games to get back out. The section inside the computer is digitally created with digital renderings of the people Bridges worked with in the system; the film also stars Bruce Boxleitner. The film was influential on the **television** series *Reboot* (1993).

TWELVE PRINCIPLES OF ANIMATION. The Twelve Principles of Animation are a set of guidelines developed by the **Disney Studio** in the 1930s to guide the animation staff in the design of the animated movements of characters. They are outlined in the book *Disney Animation: The Illusion of Life* (1981) by Frank Thomas and Ollie Johnston, two of **Walt Disney**'s "Nine Old Men."

1. Squash and stretch
2. Anticipation
3. Staging
4. Straight ahead action and pose to pose
5. Follow through and overlapping action
6. Slow in and out
7. Arcs

8. Secondary action
9. Timing
10. Exaggeration
11. Solid drawings
12. Appeal

These rules devised for animators to work by are still used in the industry and as a teaching tool for animation students. They are particularly used for two-dimensional drawn animation, though the principles can be used as a rough guide in creating computer animation or **computer-generated imagery** (CGI).

– U –

UNITED PRODUCTIONS OF AMERICA (UPA). The United Productions of America studio, commonly known as UPA, was a critical and popular success in the early 1950s. Its reputation was based on its style, which was a radical departure from **Walt Disney**, and most of its staff had been employed by the **Disney Studio** at some point. New talent from art schools had been snapped up by Disney in the early 1930s, but these new employees clashed with the older staff who had no **fine art** background, and as a result they did not share the new artists' artistically progressive sensibilities. The leaders of the strike in 1941 were active in the newly formed Screen Cartoonists Guild and wanted to use animation as an expressive medium. When **Frank Tashlin** hired the strikers, the group that formed became the basis for UPA.

Some made war pictures but Zachary Schwartz of Screen Gems and Dave Hillberman rented a Los Angeles office space to paint and got an opportunity to produce a film strip on air safety. United Auto Works approached the Screen Cartoonists Guild to produce a pro-Roosevelt campaign film. To do this, **John Hubley** got together with Phil Eastman and Bill Hurtz. Other studios felt it was too **political** so the company, Industrial Films and Poster Services, was formed to make it. *Hell Bent for Election* was heralded as a major success and the company grew, changing its name to UPA, formed with Schwartz, Hillberman, Steve Bosustow, and **Jules Engel**. They were

commissioned to make more safety films, but there was a change of ownership after the war. The studio produced *Robin Hoodlum* (1949) and *The Magic Fluke* (1949, featuring one of its star characters, Mr. Magoo), which were **Academy Award** nominated, and Columbia agreed to distribute the films, guaranteeing the success of the company.

UPA's first major popular success after *Mr. Magoo* was with ***Gerald McBoing Boing***, reinforcing the studio's reputation when it was released in January 1951. The films reflected a modernist style and used a **limited animation** technique that would influence many other animators in the 1950s and beyond. Despite the success, the studio ran into financial problems with films going over budget. In order to solve this, it began to produce **advertisements**, which essentially saved the studio. During the 1950s, the studio had a good output with *Madeline*, John Hubley's *Rooty Toot Toot* (1952), *The Telltale Heart* (1953), and the animated credit sequence for the live-action film *The Four Poster* (1952), which was shown in Europe and said to be influential on the **Zagreb** School. In 1956, CBS commissioned a *Gerald McBoing Boing*, which was the first animated series made for network **television** and ran from 1956–1958.

A second studio opened in New York and was equally successful. It hired **Gene Deitch** and soon the studio had become the name for style. In 1959, Jules Engel and others left to form their own studio with some employees leaving to join **Jay Ward**; only Bosustow remained. The studio was sold to Henry G. Saperstein, who went into TV production with *Mister Magoo* and a series of *Dick Tracey*. In 1962, the film *Gay Puree* was produced, but this was the last. The studio's aesthetic style was highly influential around the world.

UNITED STATES. The United States has been the dominant country in terms of the origin and development of animation since the early days of the form. Though there was a great deal of technological innovation and development in Europe in creating moving images, and specifically moving drawings, the United States with Thomas Edison's vitascope has been a major part in the success of the form.

When **J. Stuart Blackton**, an Englishman by birth, opened his company with Edison's technology, he sought to create animation just as the French had been doing. Others in New York were impressed

by the technology and the desire to move from newspaper **cartooning** to moving, animated drawings created a burgeoning new industry. Pioneers like **Winsor McCay, J. R. Bray**, and **Earl Hurd** developed their skills with a view to making the process of animating quicker and more cost effective. By developing **cel** animation and registration systems, these early animators were quickly joined by the likes of **Pat Sullivan, Ub Iwerks**, the **Fleischer brothers, Otto Messmer**, and **Walt Disney**. The success of the latter is well known but it undoubtedly helped put the United States in the lead as the top producer of animation.

Hollywood's dominance in the cinema business continued and was joined by animation at the top, with continual success for **Metro-Goldwyn-Mayer, Warner Brothers, Disney, Terrytoons**, and **Walter Lantz**, among others. Of course, the United States had an advantage over Europe, which since the early part of the 20th century had either been at war or recovering from it. It was not until World War II that the U.S. market suffered any effects with the loss of the overseas market.

With the U.S. position as a world power increasing in the postwar period, there was an increasing interest in its exports, particularly entertainment, and especially in **Great Britain**. This success continued and as technology developed, the United States had the staff and money to develop with it, the best example of which is the **Pixar** studio. Though many of the most innovative animations were coming from **Eastern Europe, political** conditions kept them from distribution as such. Equally, the increasing ubiquity of **television**—and with it television animation—has seen a dominance of U.S. production. Though in Britain, for example, a large part of children's television animation is produced within the country, it mostly imports prime-time or adult animation.

As globalization and technological developments worldwide have opened markets, more diverse animation is available, and likewise is influencing the U.S. animation industry. The country remains one of the major producers of animation, though in recent years a new interest in **Japanese** animation in the United States and the West in general has perhaps influenced some of the output. *See also* ACADEMY AWARDS; CARTOON NETWORK; MUSIC TELEVISION; SITCOM.

URUSEI YATSURA. **Japanese anime**, adapted from a **manga** series, was produced as a series of six films as well as a long-running **television** series. The television series ran from 1981 until 1986, containing 195 episodes. One of the directors of the series was ***Ghost in the Shell*** director **Mamoru Oshii**. The series was dubbed in **Great Britain** and the title was changed to *Lum the Invader Girl* after one of the main characters, though the original Japanese title is a pun, roughly translated as "those obnoxious aliens." The story follows a young man named Ataru Morobishi, who is described as the "unluckiest and most lecherous young man alive" who is chosen to defend the Earth when it is attacked by aliens. Though he will save the world if he wins the battle (a game of "tag"), he is inspired to fight by the apparent promise of winning the marriage (and, more importantly, the marriage night) of his girlfriend if he can defeat the invaders. After a battle lasting 10 days, Ataru makes a mistake in his declaration of victory and marriage when he catches the curvaceous alien Princess Lum, and it is she he becomes "married" to.

The series' success led to its broadcast in a variety of countries worldwide, including versions in French, Italian, and Spanish. The series also inspired a range of video games, the last of which was released in 2005; this combined with the release of the series on DVD suggests a lasting popularity.

– V –

VAN BEUREN. Production studio of Armadee J. Van Beuren (1879–1937) and probably the least-known studio in the **United States** in the 1930s. It took over the Fables Studio from **Paul Terry** in 1928 and decided to produce all of the *Aesop's Fables* in sound, though the studio had to cut production rates from 52 films a year in order to cope with the production demands. The studio attempted to introduce new characters, including a boy and girl mouse pair, but **Walt Disney** filed an injunction due to the resemblance to *Mickey Mouse*. The first original characters produced by the studio came in the series *Tom and Jerry*, featuring two *Mutt and Jeff* type (human) friends. They later introduced another new character, Cubby Bear, but the series was not very successful. The studio had a high turnover of staff, with employees frequently being

fired. However, a number of talented, successful animators passed through, including **Frank Tashlin**, **Joe Barbera**, and Burt Gillett, who had directed Disney's *Three Little Pigs*. The studio was eventually successful in 1935 when it was responsible for the revival of *Felix the Cat*. It also secured a contract with RKO, but the studio closed in 1936 and Van Beuren died in 1937 of a heart attack. In 1940, the **cartoons** were sold to Official Films and later sold for home movie rentals and **television** broadcast.

VIETNAM. *See* ASIA.

VINTON, WILL (1947–). American animator born in Oregon, Will Vinton studied at the University of California–Berkeley, where he produced **shorts**, both animated and live action. His live-action experience was helpful as he began to produce **three-dimensional** (3D) animation for models in his architecture studies. He was also interested in the classic **Walt Disney** style of animation as well as the architecture of Antoni Gaudi. He graduated in 1971 and began to work as a freelance filmmaker. In collaboration with Bob Gardiner, he made his first **clay** animated short, *Closed Mondays* (1974), which won the **Academy Award** for Best Animated Short in 1975. The film was about a drunken man who enters a closed museum and reacts in a disorderly way to paintings, and objects come alive.

Vinton patented his Claymation process, which gave new prominence to the technique. This **clay** technique offered the ability to create metamorphosis and **surrealism** and Vinton left the partnership to found his own studio, Will Vinton Studios Inc., in Portland, Oregon. He made a variety of shorts between 1978 and 1985 including *Martin the Cobbler* (1976), *Rip Van Winkle* (1978), and *The Little Prince* (1979). For **television**, he created *The California Raisins*, which began as an **advertising** campaign and then became a television series, *The California Raisins Show*.

Vinton produced the prime-time series *The PJs* for **Warner Brothers** and *Gary and Mike* for UPN, using foam for modeling instead of clay. He also created the M&Ms characters using **computer-generated imagery** (CGI) instead of his Claymation. In 2002, he lost control of his studio, which was taken over by Laika, who dismissed

Vinton and hired **Henry Selick**. Vinton set up a new studio, Freewill Entertainment.

VIOLENCE. The introduction of the Production Code Administration (PCA, also known as the Hays Code) in the **United States** in 1934 was essentially the beginning of **censorship** in the film industry. A set of rules was established that could affect the content of a film or stop distribution if the film failed to meet the standards. The code was increasingly enforced as talking pictures became popular and animation content was altered, with the lengthening of **Betty Boop**'s skirt being one notable example. The PCA was abandoned and replaced by the Motion Picture Association of America (MPAA) in the 1960s that provided certification for films. While the PCA and MPAA were censoring content, the debates began surrounding the violence in **cartoons** and the effects it might have on young viewers. **Warner Brothers** had produced numerous cartoons with violent content, particularly in the *Road Runner* series, which featured repeated violence done to Wile E. Coyote in his pursuit of the Road Runner. Likewise **Metro-Goldwyn-Mayer**'s (MGM) *Tom and Jerry* series was little more than a constant chase and fight scenario, with Tom bearing the brunt of most of the violence inflicted upon him by Jerry. Despite the extreme violence, it was presented in a slapstick, **comedic** way and there were no real repercussions or effects on the characters, who were always restored in the next scene.

The increase in **television** animation brought a change in the viewing habits of the (often) young audiences who could now watch cartoons repeatedly and often without supervision. This was viewed as potentially damaging, as it was felt that children would mimic what they saw. Over the years, television became more conservative with the rise of parents groups, religious groups, and the Federal Communications Commission (also formed in 1934), which acted in a similar manner to the PCA for television. **William Hanna** said that they tried to make new *Tom and Jerry* cartoons in the 1970s but due to stricter codes on violence they could not be made in the same way, and it was suggested that had those codes existed when the series was originally produced it would not have been released.

A variety of studies have been carried out over the years to prove and disprove the effects of cartoon violence on children but with no coherent conclusion. The issue has been satirized in *The Simpsons* and *South Park*, themselves subject to complaints about content. **Japanese** cartoons are more violent than their U.S. counterparts and have been for many years, but these are marketed at different age groups and are perhaps more appropriate. One of the key issues in this debate is the suitability of animation for children, but often the perception of animation as a children's entertainment medium ignores the vast array of other, adult animation.

– W –

WAKING LIFE. Directed by Richard Linklater, *Waking Life* (2001) is an animated feature film with art direction and animation by **Bob Sabiston** using his digital proprietary **rotoscope** technique, Rotoshop. The film tackled the question of "Are we sleepwalking through our waking state or wake-walking through our dreams?" The main protagonist, Wiley Wiggins, searches for answers to life and the nature of reality in a variety of sequences and discussions. The Rotoshopped technique lends a dreamlike quality to the aesthetic of the film, the success of which brought attention to Sabiston and the animation process. The pair later collaborated on the feature *A Scanner Darkly* (2006), an **adaptation** of a Philip K. Dick novel.

WALKING WITH DINOSAURS. Produced by and broadcast on the **British Broadcasting Company**'s **television** channel, the series *Walking with Dinosaurs* (1999) was trying to recreate an accurate portrayal of prehistoric animals not previously seen on screen. The series was produced by Tim Haines and Jasper James, and developed by Andrew Wilks. By combining fact with what they termed "informed speculation" and state-of-the-art **computer-generated imagery** (CGI) and animatronics, the series, which took two years to make, was highly successful. The series was narrated by actor Kenneth Brannagh when the series was broadcast on British television in 1999, but when it aired in the **United States** on the Discovery Channel the narration was changed and featured Avery Brooks. *The Guin-*

WARD, JAY • 207

ness Book of World Records reported that the series was the most expensive **documentary** series per minute ever made. It consisted of six episodes, each 30 minutes long, and covered the Triassic to late Cretaceous periods. The series won three Emmy Awards including Best Animated Program. The success of *Walking with Dinosaurs* led to the production of the spin-off series *Walking with Beasts* and *Walking with Monsters. See also* GREAT BRITAIN.

WALLACE AND GROMIT. Characters created by **Aardman Animation**'s **Nick Park**. The characters of the man (Wallace) and his dog companion (Gromit) are animated in **clay** and first appeared in the **comedy** *A Grand Day Out* (1989), which won an **Academy Award** for the Best Animated **Short**. This film was followed by *The Wrong Trousers* (1993), *A Close Shave* (1995), and the **feature-length** *The Curse of the Were-Rabbit* (2005), which won the Academy Award for the Best Animated Feature. All of the films won BAFTA awards in Britain. Wallace is described as an eccentric cheese-eating inventor, with a particular fondness for Wensleydale cheese, and is rather naïve. His dog Gromit is the brains in the partnership. Though Gromit does not speak, he uses expressive facial movements that communicate (to the audience at least) his thoughts. In their first film, they went to the moon in search of cheese in a rocket they built themselves. In their second film, Wallace created mechanical trousers that were used to foil the plans of the villainous penguin, who was also their lodger. The visual puns and gags are very successful and include spoofs of movies. The films are aimed at audiences of all ages and the quality of the animation has raised the standards for **clay** animation. A spin-off from the third film featured character Shaun the Sheep and was developed in **shorts** for the **British Broadcasting Company**'s children's channel CBBC.

WALT DISNEY PRODUCTIONS. *See* DISNEY STUDIO.

WARD, JAY (1920–1989). California native Jay Ward attended the University of California–Berkeley and was awarded an MBA at Harvard Business School. Ward was working in real estate when he was approached by Alexander Anderson (nephew of **Paul Terry**) to invest in Anderson's animation business. As partners, they created

The Comic Strips of Television in 1949, the first animated **television** series in the **United States**. The series featured Ward's creations Crusader Rabbit and Dudley Do-Right and used **limited animation** techniques. In the late 1950s, Ward founded Jay Ward Productions and was joined by several veterans of **United Productions of America** (UPA), including Bill Scott.

In 1958, *Rocky and His Friends* was produced, launching the popular characters **Rocky and Bullwinkle**. Ward also created the Capt'n Crunch character, who is still a cereal box mascot, and the **cartoon** character of George in *George of the Jungle*. The old cartoons are still broadcast in reruns and the studio continues production. Several of Ward's cartoon characters have been transferred into live-action feature films, including *Boris and Natasha* (1992), *George of the Jungle* (1997), and *The Adventures of Rocky and Bullwinkle* (2000), which combines live action and animation.

WARNER BROTHERS. Film production studio founded in 1918, with the animation division arising out of the work produced by **Harman-Ising**, which was distributed by Warner Bros. **Leon Schlesinger** had previously worked with Warner Bros. on *The Jazz Singer* (1927) and sold the idea of a **cartoon** series, *Bosko*, created by Harman-Ising, by claiming that they could promote popular **music** from its films and publishing companies in the cartoons. The first production of the new *Looney Tunes* series was *Sinkin' in the Bathtub* (1930). The second series commissioned was *Merrie Melodies*, which was to specifically feature songs from Warner's back catalogue; this series was well liked but never lived up to the potential success of the *Looney Tunes* series.

Schlesinger's animation studio began by imitating the **Disney Studio** and hired many of Disney's staff, though by the mid-1930s many of those staff had left. A new group joined, which initiated a distinctive style and format that had little in common with **Walt Disney**. The animation was bold, brash, innovative, and funny in a way that Disney had never been. It never tried to compete with Disney on **feature-length** animations, instead concentrating on the production of **shorts**.

The studio had a remarkable track record and dominated the industry for over 20 years. It had more lasting cartoon "stars" than

any other studio, including Porky Pig, Daffy Duck, **Bugs Bunny**, the Road Runner, Wile E. Coyote, Tweety, Sylvester, Elmer Fudd, Yosemite Sam, Pepe le Pew, Foghorn Leghorn, and Speedy Gonzales. The studio also launched the careers of many of the best—and best-known—animators, for example, **Chuck Jones**, **Bob Clampett**, **Tex Avery**, **Friz Freleng**, and **Frank Tashlin**, giants in animation history. By 1933, Harman and Ising had moved to **Metro-Goldwyn-Mayer** (MGM) and Freleng, Clampett, and Jones became the new guard whose new style emerged in 1934. At this point, the animation division was referred to as "Termite Terrace."

Warner Bros. served as a Rooseveltian stronghold during World War II and this was reflected in the films. The *Private Snafu* series was created to help the war effort on behalf of the **U.S.** government for military audiences.

In 1944, Schlesinger sold his studio directly to Warner Bros. and Clampett and Jones began to direct even more films. The 1950s were a particular high point for Jones and included *Duck Amuck* (1953) and *What's Opera Doc?* (1957). In 1960, with the increasing popularity of **television** animation, *The Bugs Bunny Show* was broadcast and consisted of old shorts repackaged into a television-friendly half-hour format. In 1963, Warner closed the in-house animation studio. However, in 1996 it returned to animation with the live-action/animated feature *Space Jam*, which starred basketball player Michael Jordan with Bugs Bunny and several of the *Looney Tunes* alumni. In 1999, it released *The Iron Giant*, which was directed by **Brad Bird**, though it was not commercially successful. Likewise, *Looney Tunes: Back in Action* (2003) failed to capture attention.

Attempts were made at the television market once more in 1990 with *Tiny Toon Adventures*, in collaboration with director Steven Spielberg, which was created in homage to the classic cartoons. After years of mergers and takeovers, Warner Bros. Entertainment took over Turner Broadcasting, which had previously purchased the **Hanna-Barbera** library. With the combined libraries, the cartoons began broadcast on the **Cartoon Network**.

WEB ANIMATION. Web animation refers to the use of the Internet, or Web, as a platform for distribution of animation. The increasing development and popularity of the Web has enabled a vast explosion

of animation, from animated GIFS and logos in **advertising** to amateur filmmakers using **Flash, *machinima*,** or **brick films**. The Web can be used as an outlet for reaching audiences with little creative, financial, or bureaucratic restrictions, or the **censorship** that the **television** and feature animation can be subject to through networks and government bodies.

Animation can reach international audiences that may be beyond conventional broadcasting, but while the market is essentially freely open, in terms of content and creativity, there is also no quality control. The platform can also offer interactivity and can develop series for animation, such as ***Homestar Runner*** and others that may have the potential to move to television. Web animation can also provide support for existing animation, theatrical or television, by showcasing the product.

Another good example of the potential for Web animation is the series ***Red vs. Blue***, which uses *machinima* animation and began in 2003, and received 20,000 downloads on its first day. The series' success has seen the expanded development of more series and spinoffs. The series has also moved beyond its Web platform to being distributed on DVD. This success demonstrates how the Web can be used to launch animation that may not have been seen elsewhere.

WESTERN EUROPE. Western Europe has produced much of the earliest and most experimental animation, particularly that of **France, Germany,** and **Great Britain,** and as such they have their own entries. Elsewhere in the continent, the early animators were being inspired to create their own films from the northern Scandinavian regions, such as **Sweden,** to the Mediterranean coastal countries such as Spain and **Italy**.

The Dutch animation industry is said to have begun in the 1930s with a **puppet** film made with silhouette cutouts by Otto Van Neijenhoff and Frans ter Gast. The puppet form was traditional and became a dominant feature in the animation industry. Hungarian animator **George Pal** established his ***Puppetoons*** in the Netherlands with a contract from the electronics firm Philips. After he left for the **United States,** the company commissioned Johan Geesnik to create new works. He formed his own company, which produced numerous films throughout the 1950s and 1960s, eventually moving into

television, though in 1971 the company went bankrupt. The studio was sold to Cinecentrum, who had already bought out other studios and in 1973 produced the popular television series *Barbapapa*. In the 1980s, Dutch art cinema was developing and new animators working in this area included Ronald Bijlsma, Gerrit van Dijk, and Nick Reus. Independent animator Paul Driesson (1940–) was invited early in his career to work with **George Dunning** at TVC on *Yellow Submarine* (1968), which he followed by making his own film, *Het Verhaal von Klein Yoghurt* (*The Story of Little John Bailey*, 1970). In 1972, he immigrated to Canada and joined the **National Film Board** (NFB), and he has won over 50 international awards.

The early Spanish animation industry was centered in the Catalan city of Barcelona, though Madrid played a small part as a center for puppet animation. As in France, the very earliest animation took the form of trick film and effects creation, though the civil war halted the development of the industry somewhat. In the postwar period, much of the animation produced was connected to comic book art with artists working between crafts and with most of the focus on children's entertainment. The main studios were Hispano Gráfic Films and Dibsono Films (which later merged to form Dibujos Animados Chamartín), Diarmo Films, and Estela Films. These studios produced a variety of films in the late 1930s and 1940s. The 1950s saw a decline in the production of Spanish animation, with the industry essentially sustained by the **advertising** industry, though the increasing popularity of television led to new productions in that sector. Several adaptations were made by Madrid-based studios, including *Cantinflas* by Estudios Moro and the internationally successful *Don Quijote de la Mancha* by Cruz Delgado's self-named studio. Barcelona remained a key area for animation production, and in the 1960s, 1970s, and 1980s more independent animators were producing **feature-length** films. Francesc Macián's *El mago de los sueños* (*The Magician of Dreams*, 1966) is considered to be one of the finest animated films produced in the region since the war. Jordi "Ja" Amorós founded the Equip Studio, producing **shorts** and advertisements as well as a feature for adults, *Historias de amor y massacre* (*Stories of Love and Massacre*, 1976). Independent animators of note from this period include José Antonio Sistiaga, Rafael Ruíz Balerdi, and Gabriel Blanco.

212 • WESTERN EUROPE

Ireland's relatively small animation industry was given a boost in 1985 when **Don Bluth** left the **Disney Studio** and established a new studio in Dublin, the Sullivan Bluth Studios in partnership with Morris Sullivan. The most notable Irish animator is Aidan Hickey, who created the popular television series *A Dog's Tale* (1981) and *An Inside Job* (1987).

Belgium's animation industry began in the 1920s with a father-and-son team, the Houssiaus, who began producing advertising films. Like many other European countries, puppet animation became a dominant form, though not always liked by **censors**. There was some disruption during World War II due to the German occupation but Paul Nagant founded a studio and produced several short films. After the war, there was an increase in production, particularly for television, including the **adaptation** of the popular *Tintin* comic by author Hergé. Belvision, founded in 1955, was devoted to productions featuring the *Tintin* characters, including a series of 104 television episodes in 1960. In the mid-1960s, the company produced *Tintin* features as well as those featuring the popular French comic character **Astérix**. In the 1970s, animators began producing shorts with a less commercial focus and more experimental approaches, such as the **cameraless animation** produced by Louis Van Maelder, Aimé Vercruysse, and Raymond Antoine, who produced a number of films in the 1960s and 1970s. Other notable animators include Gerald Frydman, Véronique Steeno, and perhaps one of the best known, Raoul Servais, whose work used a variety of techniques and formats. His best work is considered to be *Harpya* (*Harpy*, 1978).

Although the countries that make up the geopolitical region of Western Europe have their own distinct styles, there are commonalities in the development pace in many of these countries. By the turn of the century, the animation industry was developing worldwide and Western Europe was no exception. By the year 2000, European feature animation had increased production with the aid of more available funding. Spain became the highest producer of animation after France and Britain, due to lower production costs. Animation **festivals** increased in number and scope, including one of the major festivals, Annecy, in France. There was also an increase in collaboration between countries. Breakthrough films include the French fea-

ture *Kirikpou and the Sorceress* (2000) directed by Michel Ocelot; *Momo: The Conquest of Time* (2000) directed by Enzo d'Alo, which was a joint venture between Italy and Germany; *El Cid: The Legend* (2003) is a Spanish feature by director José Pozo. Other notable contemporary animators include Gerrit Van Dijk, Steffen Schaeffer, and Andreas Hykade. One of the most successful features in 2004, *Les Triplettes de Belleville* (***Belleville Rendezvous***), directed by **Sylvain Chomet**, was coproduced by France, Belgium, and Canada, and was nominated for an **Academy Award** for Best Animated Feature.

WHAT'S OPERA DOC? Perhaps **Chuck Jones'** greatest film, *What's Opera Doc?* (1957) sees **Bugs Bunny** starring with Elmer Fudd in this animated version of Richard Wagner's 14-hour *Ring Cycle* in six minutes. Bugs plays the role of Brüunhilde with Fudd as Seigfried chasing him. The dialogue is sung and uses some of Wagner's **music**, with the rest of the soundtrack in the same style. The backgrounds and visuals were designed to portray the dramatic nature of the epic story. A total of 104 backgrounds were made for the film rather than the usual 60 for a six-minute film.

The film made use of the full **Warner Brothers** orchestra and was designed by Maurice Noble, who worked at the studio as a layout artist. The complete soundtrack was recorded in advance of the animation. The final scene of Bugs' death with Elmer tentatively picking him up and carrying him off in regret of his actions sees Bugs deliver his trademark last word as he addresses the audience with the line, "Well, what did you expect in an opera? A *happy* ending?" *What's Opera Doc?* often rates as one of the best animated films of all times.

WHITNEY, JAMES (1921–1982). At the beginning of his animation career, **U.S.** animator James Whitney collaborated with his brother **John** and their first films were the result of experiments. James had an interest in painting and craftsmanship rather than **music** and technique, like his brother. Instead, he devoted himself to the study of Oriental philosophy, yoga, poetics, and quantum physics. He withdrew from the world and chose a life of meditation in a small **Japanese**-style house that had been adapted by some friends, and from it he was able to observe the changing seasons.

From the early 1950s until his death in 1982, Whitney only made five films but these are considered to be of such high quality that he has a reputation as one of the best creators of nonobjective cinema and a great visionary. He attempted to create a visual alphabet that would be a basic element and in *Yantra* (1955), whose title was derived from Sanskrit, he conceived a "spiritual experience" with only optical images and no soundtrack, although one was added in later distribution.

His paintings were similar in form to his films, and his film *Lapis* (1965) took three years to make, created manually on **cels** but with his brother's help on the computer. His last project was a trilogy that examined the natural elements of fire, water, air, and earth; however, it remains unfinished. He directed one segment, *Kang Jing Xiang*, but never edited the film; it was completed by his nephew Mark Whitney and William Moritz on his instruction.

WHITNEY, JOHN (1917–1995). Often considered to be the father of computer animation, **U.S.** animator John Whitney began his animation career when he changed his interests from **music** to science, specifically astronomy. He approached frame-by-frame cinema through this interest in astronomy after recording the evolution of an eclipse with an 8 mm camera.

Whitney became interested in **abstract** filmmaking with his brother **James** and the two set up a small laboratory to carry out experiments that combined John's musical knowledge with James' pictorial interests. John invented an optical printer for their 8 mm camera and made several **short**, experimental films, including *Twenty-Four Variations* (1940) and *Film Exercises* (nos. 1 to 5, 1943–1944). The films have been described as the most stimulating and complete abstract films ever made. They would put a light source in front of the camera and derive an image from masks above the light. The sound accompaniment was created with a system of pendulums that John invented.

The brothers then parted ways and John continued to develop and experiment with new techniques such as filming a luminous surface covered in oil and tracing images out with his finger, creating soft edges and subtle effects. This technique was used in *Mozart Rondo* (1949), *Hot House* (1949), and *Celery Stalks at Midnight* (1951). However, during the 1950s, he lost interest in these methods and

began experimenting more with sound and image, trying to compose visual music in *Catalog* (1961). He would create the effects using a computer and made *Permutations* in 1968, which was the first film he felt was complete. Whitney was hired by the computer company IBM in 1966 as a research consultant. He created a series of films, *Matrix* (1971–1972) and *Arabesque* (1975), using computer-generated lines. While he was known to be dissatisfied with much of his own work, it has been very influential in the development of animation technology and techniques. His sons John Jr. (1947–), Mark (1951–), and Michael (1948–) have continued his work and updated some of his computer techniques.

WHO FRAMED ROGER RABBIT. Directed by Robert Zemeckis and animated by Richard Williams for **Disney Studios.** Following the Disney tradition of mixing live action with animation (such as *Mary Poppins*), *Who Framed Roger Rabbit* (1988) is a noir detective story set in 1947. Marvin Acme has been murdered and Roger Rabbit is the main suspect. Claiming to have been framed, he appoints private detective Eddie Valiant, played by Bob Hoskins, in live action. Valiant dislikes "toons," as his brother was killed by a piano falling on his head, but reluctantly takes the case.

Roger is a suspect due to incriminating photographs of his wife, Jessica, with Acme, though he trusts her story and did not take the revenge the police accuse him of. Jessica is an animated human designed with *Red Hot Riding Hood* in mind and **Tex Avery**'s influence can be seen throughout the film. With Acme dead, Toon Town is in danger of being bulldozed to make way for a new highway, at the instruction of Judge Doom, who turns out to be a toon disguised as a human. Eddie solves the case and helps Roger, at the same time helping all of Toon Town, as Acme's will is found, in invisible ink, and he has left the town to all of the toons.

The film plays on classic animation history and Hollywood studio conventions and uses familiar jokes and characters to develop the story. The film was released at a time when commercial animation was not very successful, but the success of *Who Framed Roger Rabbit* demonstrated the potential for animated features to attract an adult audience as well as children.

– Y –

YELLOW SUBMARINE. Directed by **George Dunning** and designed by Heinz Edelman, produced by United Artists. *Yellow Submarine,* released in 1968, is based on the **music** of the Beatles and featured the voices of the band as well as the British actor Dick Emery. The story has the Beatles accompanying Captain Fred in his yellow submarine on its journey to Pepperland to free it from the music-hating Blue Meanies. The film used **limited animation** and was groundbreaking with its stylized design, movement, and psychedelic imagery. The original story was written by Lee Minoff and was based on the song by John Lennon and Paul McCartney. The film has effectively set pieces to a variety of Beatles songs with in jokes and references to the band. The film's success led to the **Disney Studio**'s reissue of *Fantasia*, marketed to the audience that had enjoyed the "psychedelic" experience of *Yellow Submarine.*

– Z –

ZAGREB. The Croatian (formerly Yugoslavian) city of Zagreb is included as an entry due to its significance in European animation. After World War II, there was little background in animation as production was not sponsored by the state, but there were a few Zagreb-based enthusiasts, including Sergije Tagatz (1898–1973), who had trained in the **Soviet Union,** the Maar brothers from **Germany,** and Fadil Hadzic, who created the satirical **short** *Veliki Miting* (*The Big Meeting,* 1951). Hadzic formed Duga Film, with a group of 100 developing artists who used **Czech** animation and **Walt Disney** as examples to train. Zora Film, which produced educational films, collaborated with Duga (which became defunct), and success led to the incorporation of the group as Zagreb Film in 1953.

In 1955, it developed a **limited animation** style similar to that of **United Productions of America** (UPA). Success and support continued and in 1958 the entire animation section of Zagreb Film was praised at the Cannes Film **Festival.** Work from the group became known as the Zagreb School and can be divided into two periods. The first, from 1957 to 1964, was dominated by Vakatic, Mimica, and

Kristle, who legitimized the limited animation style and had a tendency toward avant-garde style. The subject matter dealt with the anguish and horrors of existence and became almost a trademark of the animators. By 1963, the leaders of the school had moved on and the second phase was characterized by art cinema and filmmakers writing, directing, and drawing their own films. A new style prevailed but avoided a collective model and strived toward the individual animators' styles. The new generation of Zagreb Film gained prestige as one of the major artistic powers in world animation and their animation spread to other cities. The company now operates in three locations and since 1953 has received more than 400 awards around the world, including **Academy Awards**. Over 600 animated films have been produced. As well as continuing production in film and **television**, the annual film festival showcases the best new animation in the world.

ZEMAN, KAREL (1910–1989). Czech-born **stop-motion** animator who was said to have been inspired by his contemporary **Jiri Trnka**. His debut film was *The Christmas Dream* (1943) and he produced five **shorts** featuring the character Mr. Prokouk, which were very popular with children. He went on to make the beautifully crafted *Inspirace* (*Inspiration*, 1948) and the satire *Král Lávra* (*King Lávra*, 1948) adapted from the novel by Karel Harlicek Borovsky, using **puppets**. Zeman went on to produce the features *The Treasure of Bird Island* (1952) and *A Journey into Prehistory* (1954), the latter featuring animated models of dinosaurs, though the rest of the film was in live action.

Zeman again combined live action with animation, this time drawings and models in *Vynález Zkázy* (*The Deadly Invention*, 1958), which took two years to complete. The film was based on Jules Verne's novel *Face the Flag* and was critically successful. He followed up with another **adaptation**, this time *Baron Prásil* (*Baron Munchausen*, 1961) based on Gottfried Bürger's novel and the engravings of Gustave Duré.

Zeman continued making films of this type, including *On the Comet* (1970), *Sinbad the Sailor* (1972), *The Sorcerer's Apprentice* (1977), and *Karel Zeman for Children* (1980). His films evoke fantasy brought to life and his work became an influence on later **Eastern European** animators.

ZOETROPE. Also known as the "Wheel of Life," the zoetrope was adopted from the notion of persistence of vision that was established in 1829. Scientists around the world (though mostly in Europe) developed models to demonstrate the phenomenon using discs with slots cut out and images behind, which when spun would give the illusion of movement to the still images. Variations on this were developed until, in 1834, William George Horner proposed a device that consisted of a spinning drum with an open top into which was placed a hand-drawn sequence of pictures on a piece of paper. The pictures were placed around the inside of the drum and could be viewed through slots on the outside of the drum. The illusion of movement was given when the drum was spun. This machine was referred to as a *daedalum* but was forgotten about until 1887 when the machine was patented by William Lincoln in the **United States** and M. Bradley in England as the zoetrope. This machine led to the development of animation and the moving image in general.

Appendix:
Academy Award Winners

SHORT SUBJECT (CARTOON)

1931–1932 (5th) *Flowers and Trees*—Walt Disney, Producer
1932–1933 (6th) *Three Little Pigs*—Walt Disney, Producer
1934 (7th) *The Tortoise and the Hare*—Walt Disney, Producer
1935 (8th) *Three Orphan Kittens*—Walt Disney, Producer
1936 (9th) *The Country Cousin*—Walt Disney, Producer
1937 (10th) *The Old Mill*—Walt Disney, Producer
1938 (11th) *Ferdinand the Bull*—Walt Disney, Producer
1939 (12th) *The Ugly Duckling*—Walt Disney, Producer
1940 (13th) *The Milky Way*—Metro-Goldwyn-Mayer, Fred Quimby and Rudolph Ising
1941 (14th) *Lend a Paw*—Walt Disney, Producer
1942 (15th) *Der Fuehrer's Face*—Walt Disney, Producer
1943 (16th) *The Yankee Doodle Mouse*—Frederick Quimby, Producer
1944 (17th) *Mouse Trouble*—Frederick Quimby, Producer
1945 (18th) *Quiet Please!*—Frederick Quimby, Producer
1946 (19th) *The Cat Concerto*—Frederick Quimby, Producer
1947 (20th) *Tweetie Pie*—Edward Selzer, Producer
1948 (21st) *The Little Orphan*—Frederick Quimby, Producer
1949 (22nd) *For Scent-imental Reasons*—Edward Selzer, Producer
1950 (23rd) *Gerald McBoing Boing*—Stephen Bosustow, Producer
1951 (24th) *The Two Mouseketeers*—Frederick Quimby, Producer
1952 (25th) *Johann Mouse*—Frederick Quimby, Producer
1953 (26th) *Toot, Whistle, Plunk and Boom*—Walt Disney, Producer
1954 (27th) *When Magoo Flew*—Stephen Bosustow, Producer
1955 (28th) *Speedy Gonzales*—Edward Selzer, Producer
1956 (29th) *Mister Magoo's Puddle Jumper*—Stephen Bosustow, Producer

1957 (30th) *Birds Anonymous*—Edward Selzer, Producer
1958 (31st) *Knighty Knight Bugs*—John W. Burton, Producer
1959 (32nd) *Moonbird*—John Hubley, Producer
1960 (33rd) *Munro*—William L. Snyder, Producer
1961 (34th) *Ersatz (The Substitute)*—Zagreb Film
1962 (35th) *The Hole*—John Hubley and Faith Hubley, Producers
1963 (36th) *The Critic*—Ernest Pintoff, Producer
1964 (37th) *The Pink Phink*—David H. DePatie and Friz Freleng, Producers
1965 (38th) *The Dot and the Line*—Chuck Jones and Les Goldman, Producers
1966 (39th) *Herb Alpert and the Tijuana Brass Double Feature*—John Hubley and Faith Hubley, Producers
1967 (40th) *The Box*—Fred Wolf, Producer
1968 (41st) *Winnie the Pooh and the Blustery Day*—Walt Disney, Producer (posthumous win)
1969 (42nd) *It's Tough to Be a Bird*—Ward Kimball, Producer
1970 (43rd) *Is It Always Right to Be Right?*—Nick Bosustow, Producer

Category Name Changed to Short Subjects (Animated Film)

1971 (44th) *The Crunch Bird*—Ted Petok, Producer
1972 (45th) *A Christmas Carol*—Richard Williams, Producer
1973 (46th) *Frank Film*—Frank Mouris, Producer

Category Name Changed to Short Films (Animated Films)

1974 (47th) *Closed Mondays*—Will Vinton and Bob Gardiner, Producers
1975 (48th) *Great*—Bob Godfrey, Producer
1976 (49th) *Leisure*—Suzanne Baker, Producer
1977 (50th) *Sand Castle*—Co Hoedeman, Producer
1978 (51st) *Special Delivery*—Eunice Macauley and John Weldon, Producers
1979 (52nd) *Every Child*—Derek Lamb, Producer
1980 (53rd) *The Fly*—Ferenc Rófusz, Producer
1981 (54th) *Crac*—Frédéric Back, Producer

1982 (55th) *Tango*—Zbigniew Rybczynski, Producer
1983 (56th) *Sundae in New York*—Jimmy Picker, Producer
1984 (57th) *Charade*—Jon Minnis, Producer
1985 (58th) *Anna & Bella*—Cilia Van Dijk, Producer
1986 (59th) *A Greek Tragedy*—Linda Van Tulden and
 Willem Thijsen, Producers
1987 (60th) *The Man Who Planted Trees*—Frédéric Back, Producer
1988 (61st) *Tin Toy*—John Lasseter and William Reeves
1989 (62nd) *Balance*—Wolfgang Lauenstein and
 Christoph Lauenstein
1990 (63rd) *Creature Comforts*—Nick Park
1991 (64th) *Manipulation*—Daniel Greaves
1992 (65th) *Mona Lisa Descending a Staircase*—Joan C. Gratz
1993 (66th) *The Wrong Trousers*—Nick Park
1994 (67th) *Bob's Birthday*—Alison Snowden and David Fine
1995 (68th) *A Close Shave*—Nick Park
1996 (69th) *Quest*—Tyron Montgomery and Thomas Stellmach
1997 (70th) *Geri's Game*—Jan Pinkava
1998 (71st) *Bunny*—Chris Wedge
1999 (72nd) *The Old Man and the Sea*—Aleksandr Petrov
2000 (73rd) *Father and Daughter*—Michaël Dudok De Wit
2001 (74th) *For the Birds*—Ralph Eggleston
2002 (75th) *The Chubb Chubbs!*—Eric Armstrong
2003 (76th) *Harvie Krumpet*—Adam Elliot
2004 (77th) *Ryan*—Chris Landreth
2005 (78th) *The Moon and the Son: An Imagined Conversation*—
 John Canemaker and Peggy Stern
2006 (79th) *The Danish Poet*—Torill Kove
2007 (80th) *Peter and the Wolf*—Suzie Templeton and
 Hugh Welchman
2008 (81st) *Les Maison en Petits Cubes*—Kunio Kato

BEST ANIMATED FEATURE

2001 (74th) *Shrek*—Aron Warner
2002 (75th) *Spirited Away*—Hayao Miyazaki
2003 (76th) *Finding Nemo*—Andrew Stanton

2004 (77th) *The Incredibles*—Brad Bird
2005 (78th) *Wallace and Gromit: The Curse of the Were-Rabbit*—
Nick Park and Steve Box
2006 (79th) *Happy Feet*—George Miller
2007 (80th) *Ratatouille*—Brad Bird
2008 (81st) *WALL-E*—Andrew Stanton

Bibliography

CONTENTS

The dominance of the West—in particular, the United States—has largely influenced the progression of much of the animation industry, particularly in the early days and what has commonly become known as the Golden Age of Hollywood animation. The literature has reflected this and although the main focus in the history texts has been on the United States, there is a wider scope in the reference works that can cover more general aspects of animation. The vast majority of the books that are included are in the English language, and indeed largely concentrate on Western animation. However, Helen McCarthy has attempted to redress the balance with her work on Eastern Asian animation, specifically the increasingly popular anime (*The Anime Encyclopedia*, *Anime: A Beginner's Guide to Japanese Animation*, and *The Anime Movie Guide*). There are a number of general guides to animation, particularly cartoons, but

in *The Fundamentals of Animation*, Paul Wells goes beyond the guide format to include histories, animation techniques, and even industry models. This most recent text is indicative of a shift to close a perceived divide between animation history and animation practice.

Though these guides are becoming more widely available, there is still a significant emphasis on the history of animation. The most notable and most widely regarded (and useful) text in this area is Giannalberto Bendazzi's thorough account of the history of animation cinema (*Cartoons: 100 Years of Cinema Animation*). The book covers a global history in such depth that there has been little attempt to replicate the precise nature of Bendazzi's work. With the obvious limitations of writing such books such as time scale, a great companion to this is Jerry Beck's (ed.) *Animation Art*, which essentially picks up where Bendazzi leaves off and also examines the global development of animation. His text not only goes further by being able to cover more up-to-date animation but also includes television animation, an area largely neglected. Beck's book is also an update of Leonard Maltin's *Of Mice and Magic*, another fairly in-depth account of the history of animation, but with its main focus in the United States and the pretelevision era.

This Golden Age created an enormous amount of animation and undoubtedly had a worldwide impact, not least the vast success of (and subsequent dominance by) the Walt Disney Studio. This is an area covered in many of the books on Walt Disney himself, and the studio, particularly in Michael Barrier's excellent overview of this successful period in the United States (*Hollywood Cartoons: Animation in Its Golden Age*). This nostalgia for the 1930s and 1940s dominated the literature for a long time before Donald Crafton (*Before Mickey: The Animated Film 1898–1928* and *Emile Cohl, Caricature, and Film*) and Eric Smoodin (*Animating Culture: Hollywood Cartoons from the Sound Era*) provided in-depth accounts of both Disney's contemporaries and, indeed, what had preceded Disney. During this period in animation history, the form began to be subject to the same regulations as live-action film from censors, who had previously largely ignored animation. This is explored in some detail in Karl Cohen's excellent *Forbidden Animation: Censored Cartoons and Blacklisted Animators in America*. It is one of the few texts to look at a hidden aspect of animation history.

Just as the United States and the Golden Age have dominated the literature on the history of animation, cinema animation has also been

subject to most study. The few texts to look at television animation in a historical context almost fall into the nostalgic guide category, looking back at shows watched in childhood, such as in Timothy and Kevin Burke's *Saturday Morning Fever*. As will be seen below, the majority of the work on television has been in the theoretical examination of the form.

As animation became a more successful industry, a number of names stood out, not necessarily as auteur directors—though in the case of Tex Avery, Chuck Jones, and Bob Clampett this was, to a certain extent, the case—but also in terms of the successful businesses these studios had become. The largest volume of written work in animation is therefore on the people and studios that created it; like any art form, this is generally the case, and as a growing field, the scope for study is getting wider. Many of the studio biographies examine the legacy of the "stars" and production teams, and again, there is a particular focus on the popular U.S. animation from the Warner Brothers studio, as well as the excellent and moving account of working in the industry by Chuck Jones (*Chuck Amuck: The Life and Times of an Animated Cartoonist*) and by William Hanna (*A Cast of Friends*) and his longtime business partner and friend Joe Barbera (*My Life in 'Toons: From Flatbush to Bedrock in Under a Century*).

These autobiographies lend a personal perspective to the numerous accounts of the people who made the animation industry so successful by such authors as John Canemaker (*Winsor McCay: His Life and Art, Felix: The Twisted Tale of the World's Most Famous Cat*, and *Tex Avery: The MGM Years, 1942–1955*); Joe Adamson (*Tex Avery: King of Cartoons, The Walter Lantz Story: With Woody Woodpecker and Friends*, and *Bugs Bunny—Fifty Years and Only One Grey Hare*); William Moritz (*Optical Poetry: The Life and Work of Oskar Fischinger*); and more recently, Terence Dobson (*The Film Work of Norman McLaren*).

Insights into the creative process from animators are useful to historians and scholars of animation and, in addition to biographies on individuals, there are number of key texts that examine entire studios. One of the most notable works in this area is Frank Thomas and Ollie Johnston's *Disney Animation: The Illusion of Life*. Two former animators of the studio provided a rare insight into the studio's work at the time. This has led to a number of other interesting accounts of the inner workings of the industry.

Although the historical accounts of the animation industry have a fairly long history (though several early and out-of-print works are not included here), the establishment of a body of literature in the theory and criticism of animation has only recently started to develop. One of the earliest texts to address this gap is Alan Cholodenko's (ed.) *The Illusion of Life: Essays on Animation*, which came out of one of the first international conferences to examine animation studies as a separate discipline from film studies. The essays look at individual films using critical methodologies and provide a basis for the development of the area of study. Indeed, the increase in conference activity stimulated the increase in literature, such as Jayne Pilling's (ed.) *A Reader in Animation Studies* and Suzanne Buchan's (ed.) *Animated Worlds*, and gave many scholars an opportunity to address the form in a way that had previously been only recognized in the more established film studies.

Probably one of the most important texts in this area is Paul Wells' *Understanding Animation*, which has become one of the most valuable in the field as a starting point to more theoretical approaches, and indeed one of the most often cited. Wells' follow-up books (*Animation and America* and *Animation: Genre and Authorship*) have reinforced his earlier work and have provided many with the opportunity to take the area further in recent years, and in turn develop the literature. Another key text in this area of introduction to animation is Maureen Furniss' *Art in Motion: Animation Aesthetics*, which combines historical and theoretical approaches with a consideration of aesthetics of the form and its status as an art form.

Critical approaches to understanding and analysis of animation have also seen a shift away from the dominance of Disney and the Golden Age of Hollywood, as these areas are well represented in historical accounts. Newer studies are more international in scope, which in turn has allowed the area to widen as awareness of animation on a global scale increases. As well as critical approaches such as those taken by Esther Leslie (Hollywood Flatlands, 2002) and continued by Alan Cholodenko, the theoretical side of animation research has developed to include examinations of representation and gender issues in the content of animation, in Sean Griffin ("The Illusion of Identity: Gender and Racial Representation in *Aladdin*") and Elizabeth Bell, Lynda Haas, and Laura Sells (eds.) (*From Mouse to Mermaid: The Politics of Film, Gender, and Culture*). There has also been some interest in the producers

of the films. Jayne Pilling (*Women in Animation: A Compendium*) and Marian Quigley (*Women Do Animate: Interviews with 10 Australian Animators*) looked at the producers of animation often neglected in the biographies of individuals in an industry dominated largely by males. Meanwhile, there has been an increase in the study of television animation from the effects of the medium on children to the specific cultural elements of U.S. or Japanese television. Carol Stabile and Mark Harrison's (eds.) *Prime Time Animation: Television Animation and American Culture* began the process of examination of a particular group of television shows and genres that is gradually being built upon.

Beyond the criticism and history of animation, there exists a fairly large volume of work on the art of the animation, from the mainstream cartoon to the avant-garde. John Canemaker is one of the most prolific authors in this area (*Storytelling in Animation: An Anthology*, *Before the Animation Begins: The Art and Lives of Disney Inspirational Sketch Artists*, *Paper Dreams: The Art and Artists of Disney Storyboards*, *Walt Disney's Nine Old Men and the Art of Animation,* and *The Art and Flair of Mary Blair: An Appreciation*). Many of these books rely heavily on illustration to demonstrate the skill of the animator and aesthetic quality of the films.

As much of the understanding of animation is as a technique for making a particular type of film, separate from live action, the largest collection of literature is instructional in the variety of techniques and technologies in animation. These range from the basics of drawing and creating storyboards to writing scripts for animation, model making, and with the increasing use of new digital technology, accompanying guides for using computer-generated imagery in animation. These tend to be of most use to the practitioner of animation, though they can provide an insight into the skills and work required to produce animation, particularly those books written by well-known animators such as John Halas (*How to Cartoon for Amateur Films*, *Design in Motion*, *Computer Animation*, *Film Animation: A Simplified Approach*, *Visual Scripting*, *Graphics in Motion: From the Special Effects Film to Holographics*, *Masters of Animation,* and *The Contemporary Animator*).

There are fewer periodicals for animation than film studies, as again there is often more emphasis on the practice, and thus, industry magazines such as *Imagine*. A number of new academic journals have emerged in recent years to support the previously lone *Animation Journal*, such as *Animation: An Interdisciplinary Journal* and *Animation*

Studies, but many of these publications are online, like the excellent *Animation World Magazine.*

The Internet has become a vast support network for the distribution of animation, which enables independent animators to reach audiences worldwide, though due to the temporal nature of the Web, it is impossible to list all sites in one bibliography. Those included are among the most reliable.

REFERENCE WORKS

Beck, Jerry. *The Animated Movie Guide.* Chicago: Chicago Review Press, 2005.

Clements, Jonathan, and Helen McCarthy. *The Anime Encyclopedia.* Rev. exp. ed. Berkeley, Calif.: Stone Bridge Press, 2006.

Edera, Bruno. *Full-Length Animated Feature Films.* London: Focal Press, 1977.

Gottlebe, Sylke. *100 German Short Films.* Dresden: AG Kurzfilm, Bundesverband Deutscher Kurzfilm, 2004.

Grant, J. *Masters of Animation.* London: Batsford, 2001.

Hoffer, Thomas W. *Animation: A Reference Guide.* American Popular Culture Series. Westport, Conn.: Greenwood Press, 1981.

Kilmer, David. *The Animated Film Collector's Guide: Worldwide Sources for Cartoons on Video and Laserdisc.* London: J. Libbey, 1997.

Korkis, Jim, and John Cawley. *Cartoon Confidential: Everything You Always Wanted to Know about Animation but Didn't Know You Wanted to Know It.* Westlake Village, Calif.: Malibu Graphics, 1991.

———. *The Encyclopedia of Cartoon Superstars.* Las Vegas, Nev.: Pioneer, 1990.

Ledoux, Trish, and Doug Ranney. *The Complete Anime Guide: Japanese Animation Video Directory & Resource Guide.* Issaquah, Wash.: Tiger Mountain Press, 1995.

Lenburg, Jeff. *The Encyclopedia of Animated Cartoons.* 2nd ed. New York: Facts on File, 1999.

———. *Who's Who in Animated Cartoons: An International Guide to Film & Television's Award-winning and Legendary Animators.* New York: Applause Theatre & Cinema Books, 2006.

Lent, John A. *Animation, Caricature, and Gag and Political Cartoons in the United States and Canada: An International Bibliography.* Bibliographies and Indexes in Popular Culture, no. 3. Westport, Conn.: Greenwood Press, 1994.

———. *Animation in Asia and the Pacific*. Eastleigh, U.K.: John Libbey, 2000.
———. *Comic Art of Europe through 2000: An International Bibliography*. Bibliographies and Indexes in Popular Culture, no. 10. Westport, Conn.: Praeger, 2003.
———. *Comic Books and Comic Strips in the United States through 2005: An International Bibliography*. Bibliographies and Indexes in Popular Culture, no. 13. Westport, Conn.: Praeger, 2006.
Mangels, Andy. *Animation on DVD: The Ultimate Guide*. Berkeley, Calif.: Stone Bridge Press, 2003.
McCarthy, Helen. *Anime! A Beginner's Guide to Japanese Animation*. London: Titan, 1993.
———. *The Anime Movie Guide*. London: Titan, 1996.
McCarthy, Helen, and Jonathan Clements. *The Erotic Anime Movie Guide*. Woodstock, N.Y.: Overlook Press, 1999.
McCloud, Scott. *Understanding Comics: The Invisible Art*. Northampton, Mass.: Tundra, 1993.
Monaco, James. *The Dictionary of New Media: The New Digital World: Video, Audio, Print: Film, Television, DVD, Home Theatre, Satellite, Digital Photography, Wireless, Super CD, Internet*. New York: Harbor Electronic, 1999.
Napier, Susan J. *Anime from Akira to Howl's Moving Castle, Updated Edition: Experiencing Contemporary Japanese Animation*. New York: Palgrave Macmillan, 2005.
———. *From Impressionism to Anime: Japan as Fantasy and Fan Cult in the Mind of the West*. New York: Palgrave Macmillan, 2007.
Peary, Danny, and Gerald Peary, eds. *The American Animated Cartoon: A Critical Anthology*. New York: Dutton, 1980.
Pilling, Jayne, ed. *That's Not All, Folks: A Primer in Cartoonal Knowledge*. London: British Film Institute, 1984.
Queiroz, Rida, and Julius Wiedemann. *Animation Now! Anima Mundi*. Koln: Taschen, 2004.
Russett, Robert, and Cecile Starr, eds. *Experimental Animation: Origins of a New Art*. Rev. ed. New York: Da Capo Press, 1988.
Schodt, Frederik L. *Manga! Manga! The World of Japanese Comics*. Tokyo: Kodansha, 1983.
Travis, Lucinda, and Jack Hannah. *Animation*. Fact File no. 9. 2nd ed. Los Angeles, Calif.: American Film Institute, Education Services, 1986.
Webb, Graham. *The Animated Film Encyclopedia: A Complete Guide to Animated Shorts, Features, and Sequences 1900–1970*. Jefferson N.C.: McFarland, 2000.
Wells, Paul. *The Fundamentals of Animation*. Lausanne, Switzerland: AVA, 2006.

HISTORY

General

Beck, Jerry, ed. *Animation Art: From Pencil to Pixel, the Illustrated History of Cartoon, Anime & CGI.* London: Flame Tree, 2004.

———. *The 50 Greatest Cartoons: As Selected by 1,000 Animation Professionals.* Atlanta: Turner, 1994.

Beckerman, Howard. *Animation: The Whole Story.* Mattituck, N.Y.: Amereon House, 2001.

Bendazzi, G. *Cartoons: 100 Years of Cinema Animation.* Bloomington: Indiana University Press, 1994.

Cohen, Karl. *Forbidden Animation: Censored Cartoons and Blacklisted Animators in America.* Jefferson, N.C.: McFarland, 1997.

Faber, L., and H. Walters. *Animation Unlimited: Innovative Short Films since 1940.* London: Laurence King, 2004.

Frierson, Michael. *Clay Animation: American Highlights 1908 to the Present.* Twayne's Filmmakers Series. New York: Maxwell Macmillan, 1994.

Gifford, Denis. *British Animated Films, 1895–1985: A Filmography.* Jefferson, N.C.: McFarland, 1987.

Goldmark, Daniel. *Tunes for 'Toons: Music and the Hollywood Cartoon.* Berkeley: University of California Press, 2005.

Gunning, T. "The Cinema of Attractions: Early Film, Its Spectators and the Avant-Garde." In *Early Cinema: Space, Frame, Narrative,* ed. T. Elsaesser. London: BFI, 1990: 56–62.

Hendershot, Heather, ed. *Nickelodeon Nation: The History, Politics, and Economics of America's Only TV Channel for Kids.* New York: New York University Press, 2004.

Klein, Norman M. *Seven Minutes: The Life and Death of the American Animated Cartoon.* London: Verso, 1993.

Lenburg, Jeff. *The Great Cartoon Directors.* New York: Da Capo Press, 1993.

Maltin, Leonard. *Of Mice and Magic.* 2nd ed. New York: Plume, 1987.

McCall, Douglas L. *Film Cartoons: A Guide to 20th-Century American Animated Features and Shorts.* Jefferson, N.C.: McFarland, 1998.

Robbins, Trina. *A Century of Women Cartoonists.* Northampton, Mass.: Kitchen Sink Press, 1993.

Robinson, Chris. *Estonian Animation: Between Genius and Utter Illiteracy.* Eastleigh, U.K.: John Libbey, 2006.

Sito, Tom. *Drawing the Line: The Untold Story of the Animation Unions from Bosko to Bart Simpson.* Lexington: University Press of Kentucky, 2006.

Smoodin, Eric. *Animating Culture: Hollywood Cartoons from the Sound Era.* New Brunswick, N.J.: Rutgers University Press, 1993.

——, ed. *Disney Discourse: Producing the Magic Kingdom.* New York: Routledge, 1994.

Solomon, Charles. *Enchanted Drawings: The History of Animation.* New ed. New York: Random House Value, 1994.

Woolery, George W. *Animated TV Specials: The Complete Directory to the First Twenty-Five Years, 1962–1987.* Metuchen, N.J.: Scarecrow Press, 1989.

——. *Children's Television: The First Thirty-Five Years, 1946–1981.* 2 vols. Metuchen, N.J.: Scarecrow Press, 1983.

Pre-1960s

Amidi, Amid. *Cartoon Modern: Style and Design in Fifties Animation.* San Francisco: Chronicle, 2006.

Barrier, Michael. *Hollywood Cartoons.* New York: Oxford University Press, 1999.

Chanan, Michael. *The Dream That Kicks: The Prehistory and Early Years of Cinema in Britain.* 2nd ed. London: Routledge, 1995.

Cohen, Karl. "The Development of Animated TV Commercials in the 1940s" and "A Guide to Studios." *Animation Journal* (Fall 1992): 34–61.

Crafton, Donald. *Before Mickey: The Animated Film 1898–1928.* Chicago: University of Chicago Press, 1982.

——. *Emile Cohl, Caricature, and Film.* Princeton, N.J.: Princeton University Press, 1990.

Gifford, Denis. *American Animated Films: The Silent Era, 1897–1929.* Jefferson, N.C.: McFarland, 1990.

Goldmark, Daniel. *Tunes for 'Toons: Music and the Hollywood Cartoon.* Berkeley: University of California Press, 2005.

Moritz, William. "Resistance and Subversion in Animated Films of the Nazi Era: The Case of Hans Fischerkoesen." *Animation Journal* (Fall 1992): 4–33.

Shull, Michael S., and David E. Wilt. *Doing Their Bit: Wartime American Animated Short Films, 1939–1945.* 2nd ed. Jefferson, N.C.: McFarland, 2004.

Sigall, Martha. *Living Life inside the Lines: Tales from the Golden Age of Animation.* Jackson: University Press of Mississippi, 2005.

Post-1960s

Burke, Timothy, and Kevin Burke. *Saturday Morning Fever.* New York: St. Martin's Griffin, 1999.

Erickson, Hal. *Television Cartoon Shows: An Illustrated Encyclopedia, 1949 through 1993*. Jefferson City, N.C.: McFarland, 1995.

BIOGRAPHY

Individuals

Adams, T. R. *Tom and Jerry*. New York: Crescent Books, 1991.

Adamson, Joe. *Bugs Bunny—Fifty Years and Only One Grey Hare*. London: Pyramid Books, 1990.

———. *Tex Avery, King of Cartoons*. The Big Apple Film Series. New York: Popular Library, 1975.

———. *The Walter Lantz Story: With Woody Woodpecker and Friends*. New York: Putnam, 1985.

Allen, Robin. "Sylvia Holland: Disney Artist." *Animation Journal* (Spring 1994): 32–41.

Andrae, Thomas. *Carl Banks and the Disney Comic Book: Unmasking the Myth of Modernity*. Jackson: University Press of Mississippi, 2006.

Bacon, Matt. *No Strings Attached: The Inside Story of Jim Henson's Creature Shop*. New York: Macmillan, 1997.

Barbera, Joseph. *My Life in 'Toons: From Flatbush to Bedrock in Under a Century*. Atlanta: Turner, 1994.

Barrier, Michael J. *The Animated Man: A Life of Walt Disney*. Berkeley: University of California Press, 2007.

Beck, Jerry. *Pink Panther: The Ultimate Guide to the Coolest Cat in Town*. 1st American ed. New York: DK, 2005.

Beck, Jerry, and Will Friedwald. *Looney Tunes and Merrie Melodies*. New York: Henry Holt, 1989.

Blanc, Mel, and Philip Bashe. *That's Not All, Folks*. New York: Warner Books, 1988.

Brion, Patrick. *Tom and Jerry: The Definitive Guide to Their Animated Adventures*. 1st American ed. New York: Harmony Books, 1990.

Bryman, A. *Disney and His Worlds*. London: Routledge, 1995.

Byrne, E., and M. McQuillan. *Deconstructing Disney*. London: Pluto Press, 1999.

Cabarga, L. *The Fleischer Story*. New York: Da Capo Press, 1988.

Canemaker, John. *Felix: The Twisted Tale of the World's Most Famous Cat*. New York: Da Capo Press, 1996.

———. *Tex Avery: The MGM Years, 1942–1955*. 1st American ed. Atlanta: Turner, 1996.

———. *Winsor McCay, His Life and Art.* New York: Abbeville Press, 1987.

Cawley, John. *The Animated Films of Don Bluth.* New York: Image, 1991.

Dill, Jane Ann. "Jules Engel: Film Artist: A Painterly Aesthetic." *Animation Journal* (Spring 1993): 50–65.

Dobson, Terence. *The Film Work of Norman McLaren.* Eastleigh, U.K.: John Libbey, 2006.

Hanna, William, with Tom Ito. *A Cast of Friends.* New York: Da Capo Press, 2000.

Eliot, M. *Walt Disney: Hollywood's Dark Prince.* London: Andre Deutsch, 1994.

Finch, Christopher. *Disney's Winnie the Pooh: A Celebration of the Silly Old Bear.* New York: Disney Editions, 2000.

———. *Jim Henson: The Works: The Art, the Magic, the Imagination.* New York: Random House, 1993.

———. *Walt Disney's America.* New York: Abbeville Press, 1978.

Fleischer, Richard. *Out of the Inkwell: Max Fleischer and the Animation Revolution.* Lexington: University Press of Kentucky, 2005.

Furniss, Maureen, ed. *Chuck Jones: Conversations.* Jackson: University Press of Mississippi, 2005.

Grandinetti, Fred. *Popeye: An Illustrated Cultural History.* 2nd ed. Jefferson, N.C.: McFarland, 2004.

———. *Popeye: An Illustrated History of E. C. Segar's Character in Print, Radio, Television, and Film Appearances, 1929–1993.* Jefferson, N.C.: McFarland, 1994.

Grandinetti, Fred, and Dan Braun. *I Yam What I Yam: The Works of Jack Mercer, Popeye's Voice.* Watertown, Mass.: F. Grandinetti, 2002.

Harryhausen, Ray, and Tony Dalton. *An Animated Life: Adventures in Fantasy.* London: Aurum, 2003.

———. *Ray Harryhausen: An Animated Life.* New York: Billboard Books, 2004.

Iwerks, Leslie, and John D. Kenworthy. *The Hand behind the Mouse: An Intimate Biography of the Man Walt Disney Called "The Greatest Animator in the World."* New York: Disney Editions, 2001.

Jackson, Kathy Merlock. *Walt Disney, a Bio-bibliography.* Popular Culture Bio-Bibliographies. Westport, Conn.: Greenwood Press, 1993.

———. *Walt Disney: Conversations.* Jackson: University Press of Mississippi, 2006.

Jones, Chuck. *Chuck Amuck: The Life and Times of an Animated Cartoonist.* New York: Farrar, Straus & Giroux, 1989.

———. *Chuck Reducks: Drawings from the Fun Side of Life.* New York: Warner Books, 1996.

Kaplan, Louis, and Scott Michaelsen. *Gumby: The Authorized Biography of the World's Favorite Clayboy.* New York: Harmony Books, 1986.

Kenner, Hugh. *Chuck Jones: A Flurry of Drawings.* Portraits of American Genius. Berkeley: University of California Press, 1994.

Kitson, Claire. *Yuri Norstein and the Tale of Tales: An Animator's Journey.* Eastleigh, U.K.: John Libbey, 2005.

Langer, Mark. "Introduction to the Fleischer Rotoscope Patent." *Animation Journal* (Spring 1993): 66–73.

———. "The Disney–Fleischer Dilemma: Product Differentiation and Technological Innovation." *Screen* 33, no. 4 (Winter 1992): 343–60.

Lye, Len. *Figures of Motion: Len Lye, Selected Writings.* Auckland: Auckland University Press, 1984.

McCarthy, Helen. *Hayao Miyazaki: Master of Japanese Animation: Films, Themes, Artistry.* Berkeley, Calif.: Stone Bridge Press, 1999.

Merritt, Russell, and J. B. Kaufman. *Walt Disney's Silly Symphonies: A Companion to the Classic Cartoon Series.* Gemona (Udine), Italy: La cineteca del Friuli, 2006.

———. *Walt in Wonderland: The Silent Films of Walt Disney.* Rev. ed. Baltimore: Johns Hopkins University Press, 2000.

Morris, Gary. "The Puppet Artistry of Barry Purves." *Bright Lights Film Journal* 33, 2001. www.brightlightsfilm.com/33/barrypurves.html

Moritz, William. *Optical Poetry: The Life and Work of Oskar Fischinger.* Bloomington: Indiana University Press, 2004.

Mosley, Leonard. *Disney's World: A Biography.* 1st Scarborough House pbk. ed. Chelsea, Mich.: Scarborough House, 1990.

O'Konor, Louise. *Viking Eggeling 1880–1925. Artist and Film-Maker, Life and Work.* Acta universitatis Stockholmensis. Stockholm Studies in History of Art, 23. Stockholm: Almqvist & Wiksell, 1971.

Place-Verghnes, Floriane. *Tex Avery: A Unique Legacy (1942–55).* Eastleigh, U.K.: John Libbey, 2006.

Plympton, Bill. *Hair High.* New York: NBM, 2003.

Priestley, Joanna. "Creating a Healing Mythology: The Art of Faith Hubley." *Animation Journal* (Spring 1994): 23–31.

Richard, Valliere T. *Norman McLaren, Manipulator of Movement: The National Film Board Years, 1947–1967.* Newark, N.J.: University of Delaware Press, 1982.

Schickel, Richard. *The Disney Version: The Life, Times, Art, and Commerce of Walt Disney.* 3rd ed. Chicago: Ivan R. Dee, 1997.

Scott, Keith. *The Moose That Roared: The Story of Jay Ward, Bill Scott, a Flying Squirrel, and a Talking Moose.* New York: St. Martin's Press, 2000.

Solman, G. "Bringing Things to Life by Hand: An Interview with Henry Selick." In *Projections 5*, ed. J. Boorman and W. Donohue. London: Faber and Faber, 1996.

Suchenski, Richard. "Mamoru Oshii." In *Senses of Cinema*. 2004. http://ar
chive.sensesofcinema.com/contents/directors/04/oshii.html

Trimble, Marian Blackton. *J. Stuart Blackton: A Personal Biography by His
Daughter*. Filmmakers no. 7. Metuchen, N.J.: Scarecrow Press, 1985.

Trudeau, G. B., John Hubley, and Faith Hubley. *John & Faith Hubley's A
Doonesbury Special: A Director's Notebook*. Kansas City, Kan.: Sheed An-
drews and McMeel, 1978.

Walz, Eugene P. *Cartoon Charlie: The Life and Art of Animation Pioneer
Charles Thorson*. Winnipeg: Great Plains, 1998.

Studios

Allan, Robin. *Walt Disney and Europe: European Influences on the Animated
Feature Films of Walt Disney*. London: John Libbey, 1999.

Beck, Jerry. *Looney Tunes: The Ultimate Visual Guide*. 1st American ed. New
York: DK, 2003.

———. *Outlaw Animation: Cutting-Edge Cartoons from the Spike & Mike Fes-
tivals*. New York: H. N. Abrams, 2003.

Beck, Jerry, and Shalom Auslander. *I Tawt I Taw a Puddy Tat: Fifty Years of
Sylvester and Tweety*. 1st American ed. New York: H. Holt, 1991.

Beck, Jerry, and Will Friedwald. *Looney Tunes and Merrie Melodies: A Complete
Illustrated Guide to the Warner Bros. Cartoons*. New York: H. Holt, 1989.

Cabarga, Leslie. *The Fleischer Story*. Rev. ed. New York: Da Capo Press,
1988.

Cohen, Karl. "The Importance of the FBI's Walt Disney File to Animation
Scholars." *Animation Journal* (Spring 1995): 67–77.

Davies, Amy. M. *Good Girls & Wicked Witches: Women in Disney's Feature
Animation*. Eastleigh, U.K.: John Libbey, 2006.

Friedwald, Will, and Jerry Beck. *The Warner Brothers Cartoons*. Metuchen,
N.J.: Scarecrow Press, 1981.

Goldschmidt, Rick. *The Enchanted World of Rankin/Bass*. Issaquah, Wash.:
Tiger Mountain Press, 1997.

———. *The Making of the Original Rankin/Bass Holiday Classic Rudolph the
Red-Nosed Reindeer*. Bridgeview, Ill.: Miser Bros. Press, 2001.

Grant, John. *Encyclopedia of Walt Disney's Animated Characters*. 1st U.S. ed.
New York: Harper & Row, 1987.

Halas, Viviene, and Paul Wells. *Halas & Batchelor Cartoons: An Animated
History*. London: Southbank, 2006.

Hollis, Tim, and Greg Ehrbar. *Mouse Tracks: The Story of Walt Disney Re-
cords*. Jackson: University Press of Mississippi, 2006.

Mallory, Michael. *Hanna-Barbera Cartoons*. London: Virgin, 1999.

Maltin, Leonard. *The Disney Films.* 4th ed. New York: Disney Editions, 2000.

Martin, Len D. *The Columbia Checklist: The Feature Films, Serials, Cartoons, and Short Subjects of Columbia Pictures Corporation, 1922–1988.* Jefferson, N.C.: McFarland, 1991.

———. *The Republic Pictures Checklist: Features, Serials, Cartoons, Short Subjects, and Training Films of Republic Pictures Corporation, 1935–1959.* Jefferson, N.C.: McFarland, 1998.

Pata, Nenad. *A Life of Animated Fantasy.* Zagreb: Zagreb Film, 1984.

Penkoff, Diane W. "Slipping 'Em a Mickey: A Content Analysis of Drinking in Disney Animated Films." *Animation Journal* (Spring 1993): 28–49.

Sennett, Ted. *The Art of Hanna-Barbera: Fifty Years of Creativity.* New York: Viking Studio Books, 1989.

Solomon, Charles. *The Disney That Never Was: The Stories and Art from Five Decades of Unproduced Animation.* New York: Hyperion, 1995.

Thomas, Bob. *Building a Company: Roy O. Disney and the Creation of an Entertainment Empire.* New York: Hyperion, 1998.

———. *Disney's Art of Animation: From Mickey Mouse to Hercules.* 2nd ed. New York: Hyperion, 1997.

Thomas, Frank, and Ollie Johnston. *Disney Animation: The Illusion of Life.* New York: Abbeville Press, 1981.

———. *Too Funny for Words: Disney's Greatest Sight Gags.* New York: Abbeville Press, 1987.

Wasko, J. *Understanding Disney.* Cambridge: Polity Press, 2001.

THEORY AND CRITICISM

Allen, R. C., and D. Gomery. *Film History: Theory and Practice.* New York: McGraw Hill, 1985.

Barker, Martin, with Thomas Austin. *From Antz to Titanic: Reinventing Film Analysis.* London: Pluto Press, 2000.

Bell, Elizabeth, Lynda Haas, and Laura Sells, eds. *From Mouse to Mermaid: The Politics of Film, Gender, and Culture.* Bloomington: Indiana University Press, 1995.

Benshoff, Harry M. "Heigh-ho, Heigh-ho, Is Disney High or Low? From Silly Cartoons to Postmodern Politics." *Animation Journal* (Fall 1992): 62–85.

Bouldin, Joanna. "Bodacious Bodies and the Voluptuous Gaze: A Phenomenology of Animation Spectatorship." *Animation Journal* (2000): 56–67.

Buchan, Suzanne, ed. *Animated Worlds.* Eastleigh, U.K.: John Libbey, 2006.

Cholodenko, Alan, ed. *The Illusion of Life: Essays on Animation.* Sydney: Power Institute of Fine Arts, 1991.

———, ed. *The Illusion of Life II: More Essays on Animation*. Sydney: Power Institute of Fine Arts, 2007.

Davies, P., and P. Wells, eds. *Cinema and Society in America*. Manchester: Manchester University Press, 2001.

Dobson, Nichola. "Nitpicking 'The Simpsons': Critique and Continuity in Constructed Realities." *Animation Journal* (2003): 84–93.

Drazen, Patrick. *Anime Explosion! The What? Why? & Wow! of Japanese Animation*. Berkeley, Calif.: Stone Bridge Press, 2003.

Eisenstein, Sergei. *Eisenstein on Disney*. Trans. Alan Upchurch. London: Methuen, 1988.

Floquet, Pierre, ed. *CinémAnimation*. Condé-sur-Noireau: Corlet, 2007.

Furniss, Maureen. *Art in Motion: Animation Aesthetics*. Sydney: John Libbey, 1998.

Giroux, Henry A. *The Mouse That Roared: Disney and the End of Innocence*. Culture and Education Series. Lanham, Md.: Rowman & Littlefield, 1999.

Griffin, Sean. "The Illusion of Identity: Gender and Racial Representation in *Aladdin*." *Animation Journal* (Fall 1994): 64–73.

———. *Tinker Belles and Evil Queens: The Walt Disney Company from the Inside Out*. New York: New York University Press, 2000.

Hames, P., ed. *Dark Alchemy: The Films of Jan Svankmajer*. Trowbridge: Flicks Books, 1995.

Hendershot, Heather. *Saturday Morning Censors: Television Regulation before the V-Chip*. Durham, N.C.: Duke University Press, 1998.

Hodge, Bob, and David Tripp. *Children and Television: A Semiotic Approach*. Stanford, Calif.: Stanford University Press, 1986.

Inge, Thomas M. *Perspectives on American Culture: Essays on Humor, Literature, and the Popular Arts*. Locust Hill Literary Studies, no. 16. West Cornwall, Conn.: Locust Hill Press, 1994.

Kinder, Marsha. *Playing with Power in Movies, Television, and Video Games: From Muppet Babies to Teenage Mutant Ninja Turtles*. Berkeley: University of California Press, 1991.

Kline, Stephen. *Out of the Garden: Toys, TV, and Children's Culture in the Age of Marketing*. London: Verso, 1993.

Lawrence, Amy. "Masculinity in Eastern European Animation." *Animation Journal* (Fall 1994): 32–43.

Leab, Daniel J. *Orwell Subverted: The CIA and the Filming of Animal Farm*. University Park: Pennsylvania State University Press, 2007.

Lehman, Christopher P. *American Animated Cartoons of the Vietnam Era: A Study of Social Commentary in Films and Television Programs, 1961–1973*. Jefferson, N.C.: McFarland, 2006.

———. *The Colored Cartoon: Black Representation in American Animated Short Films, 1907–1954*. Amherst: University of Massachusetts Press, 2007.

Lent, John A. *Animation in Asia and the Pacific.* Eastleigh, U.K.: John Libbey, 2000.

Leslie, Esther. *Hollywood Flatlands: Animation, Critical Theory and the Avant-Garde.* London: Verso, 2002.

Levi, A. *Samurai from Outer Space: Understanding Japanese Animation.* Chicago: Open Court, 1996.

Leyda, L., ed. *Eisenstein on Disney.* London: Methuen, 1988.

Lindvall, Terry, and Matthew Melton. "Toward a Postmodern Animated Discourse: Bakhtin, Intertextuality and the Cartoon Carnival." *Animation Journal* (Fall 1994): 44–63.

Midhat, A. *Animation and Realism.* Zagreb: Croatian Film Club, 2004.

Mittell, Jason. *Genre and Television: From Cop Shows to Cartoons in American Culture.* New York: Routledge, 2004.

Patten, Fred. *Watching Anime, Reading Manga: 25 Years of Essays and Reviews.* Berkeley, Calif.: Stone Bridge Press, 2004.

Pilling, Jayne, ed. *A Reader in Animation Studies.* London: John Libbey, 1997.

———. *Women in Animation: A Compendium.* London: BFI, 1992.

Quigley, Marian. *Women Do Animate: Interviews with 10 Australian Animators.* Victoria: Insight, 2005.

Robinson, Chris. *Unsung Heroes of Animation.* Eastleigh, U.K.: John Libbey, 2005.

Sandler, Kevin S., ed. *Reading the Rabbit.* New Brunswick, N.J.: Rutgers University Press, 1998.

Seiter, Ellen. *Sold Separately: Children and Parents in Consumer Culture.* Rutgers Series in Communications, Media, and Culture. New Brunswick, N.J.: Rutgers University Press, 1993.

Stabile, Carol, and Mark Harrison, eds. *Prime Time Animation: Television Animation and American Culture.* London: Routledge, 2003.

Steinberg, Shirley R., and Joe L. Kincheloe. *Kinderculture: The Corporate Construction of Childhood.* 2nd ed. Boulder, Colo.: Westview Press, 2004.

Watts, S. *The Magic Kingdom: Walt Disney and the American Way of Life.* New York: Houghton Mifflin, 1997.

Wees, William C. *Light Moving in Time: Studies in the Visual Aesthetics of Avant-Garde Film.* Berkeley: University of California Press, 1992.

Wells, Paul. *Animation and America.* Edinburgh: Edinburgh University Press, 2002.

———. *Animation, Genre and Authorship.* London: Wallflower, 2002.

———. "Art of the Impossible." In *Film: The Critics' Choice*, ed. G. Andrew. London: Aurum Books, 2001.

———. *Understanding Animation.* London: Routledge, 1998.

ART AND ANIMATION

Beck, Jerry, ed. *Animation Art: From Pencil to Pixel, the World of Cartoon, Anime and CGI.* London: Flame Tree, 2004.

Canemaker, John. *The Art and Flair of Mary Blair: An Appreciation.* New York: Disney Editions, 2003.

———. *Before the Animation Begins: The Art and Lives of Disney Inspirational Sketch Artists.* New York: Hyperion, 1996.

———. *Paper Dreams: The Art and Artists of Disney Storyboards.* New York: Hyperion, 1999.

———, ed. *Storytelling in Animation: An Anthology.* The Art of the Animated Image, vol. 2. Los Angeles: American Film Institute, 1988.

———. *Walt Disney's Nine Old Men and the Art of Animation.* New York: Disney Editions, 2001.

Deneroff, Harvey. *The Art of Anastasia.* New York: HarperCollins, 1997.

Finch, Christopher. *The Art of the Lion King.* New York: Hyperion, 1994.

———. *The Art of Walt Disney: From Mickey Mouse to Magic Kingdoms.* New York: Portland House, 1988.

Finch, Christopher, and Linda Rosenkrantz. *Sotheby's Guide to Animation Art.* New York: H. Holt, 1998.

Harryhausen, Ray, and Tony Dalton. *The Art of Ray Harryhausen.* New York: Billboard Books, 2006.

Kanfer, Stefan. *Serious Business: The Art and Commerce of Animation in America from Betty Boop to Toy Story.* New York: Scribner, 1997.

Miyazaki, Hayao, and Sutajio Jiburi Kabushiki Kaisha. *The Art of the Princess Mononoke.* Ghibli the Art Series. Tokyo-to Koganei-shi: Tokuma Shoten, 1997.

Morra-Yoe, Janet, and Craig Yoe, eds. *The Art of Mickey Mouse.* New York: Hyperion, 1991.

Poš, Jan, Howard Beckerman, and Jeffrey Wechsler. *Krátký Film: The Art of Czechoslovak Animation.* New Brunswick, N.J.: Jane Voorhees Zimmerli Art Museum, Rutgers, 1991.

Schneider, S. *That's All Folks: The Art of Warner Bros. Animation.* New York: Henry Holt, 1988.

Sibley, Brian, ed. *Wallace & Gromit: A Close Shave Storyboard Collection.* London: BBC, 1997.

Solomon, Charles, ed. *The Art of the Animated Image: An Anthology.* Los Angeles: American Film Institute, 1987.

———. *The Prince of Egypt: A New Vision in Animation.* New York: Harry N. Abrams, 1998.

Withrow, S. *Toon Art.* Lewes: Ilex, 2003.

ANIMATION PRACTICE

Beauchamp, Robin. *Designing Sound for Animation.* Amsterdam: Elsevier, 2005.

Beckerman, H. *Animation: The Whole Story.* New York: Allworth Press, 2004.

Blair, Preston. *Animation: Learn How to Draw Animated Cartoons.* How to Draw Books, no. 26. Laguna Beach, Calif.: Foster Art Service, 1949.

———. *Cartoon Animation.* Tustin, Calif.: W. Foster, 1994.

———. *How to Animate Film Cartoons.* How to Draw and Paint Series, no. 190. Laguna Hills, Calif.: Walter Foster, 1999.

Canemaker, John, ed. *Storytelling in Animation.* Los Angeles: American Film Institute, 1989.

Cawley, John, and Jim Korkis. *Cartoon Superstars.* Las Vegas, Nev.: Pioneer Books, 1990.

———. *How to Create Animation.* Las Vegas, Nev.: Pioneer Books, 1990.

Corsaro, S., and Parrott, C. J. *Hollywood 2D Digital Animation.* New York: Thomas Delmar Learning, 2004.

Culhane, John. *Disney's Aladdin: The Making of the Animated Film.* New York: Hyperion, 1992.

———. *Fantasia 2000: Visions of Hope.* New York: Disney Editions, 1999.

———. *Special Effects in the Movies: How They Do It.* New York: Ballantine Books, 1981.

———. *Walt Disney's Fantasia.* New York: H. N. Abrams, 1983.

Culhane, Shamus. *Animation from Script to Screen.* New York: St. Martin's Press, 1988.

———. *Talking Animals and Other People.* New York: St. Martin's Press, 1986.

Enticknap, Leo, and Douglas Graham. *Moving Image Technology: From Zoetrope to Digital.* London: Wallflower, 2005.

Finch, Christopher. *Special Effects: Creating Movie Magic.* New York: Abbeville Press, 1984.

Greene, Joyce, and Deborah Reber, eds. *Drawing Insight: Communicating Development through Animation.* Penang: Southbound, 1996.

Halas, John. *Computer Animation.* Visual Communication Books. New York: Focal Press, 1974.

———. *The Contemporary Animator.* London: Focal Press, 1990.

———. *Film Animation: A Simplified Approach.* Monographs on Communication Technology and Utilization, no. 2. New York: Unipub, 1976.

———, ed. *Graphics in Motion: From the Special Effects Film to Holographics.* New York: Van Nostrand Reinhold, 1984.

——. *Masters of Animation.* Topsfield, Mass.: Salem House, 1987.

——. *Visual Scripting.* The Library of Animation Technology. London: Focal Press, 1976.

Halas, John, and Roger Manvell. *Design in Motion.* Visual Communication Books. New York: Hastings House, 1962.

Halas, John, and Bob Privett. *How to Cartoon for Amateur Films.* A Focal Moviebook. London: Focal Press, 1951.

Harryhausen, Ray. *Film Fantasy Scrapbook.* 3rd ed. San Diego: A. S. Barnes, 1981.

Hart, Christopher. *How to Draw Animation.* New York: Watson-Guptill, 1997.

Hart, John. *The Art of the Storyboard: Storyboarding for Film, TV, and Animation.* Boston: Focal Press, 1999.

Hedgpeth, Kevin, and Steven Missal. *Exploring Drawing for Animation.* Design Exploration Series. Clifton Park, N.Y.: Delmar Learning, 2004.

Holman, Bruce L. *Puppet Animation in the Cinema: History and Technique.* South Brunswick: A. S. Barnes, 1975.

Hooks, Ed. *Acting for Animators: A Complete Guide to Performance Animation.* Rev. ed. Portsmouth, N.H.: Heinemann, 2003.

——. *Acting in Animation: A Look at 12 Films.* Portsmouth, N.H.: Heinemann, 2005.

Jones, Angie, and Jamie Oliff. *Thinking Animation: Bridging the Gap between 2D and CG.* Boston: Thomson Course Technology, 2007.

Krasner, Jon S. *Motion Graphic Design, Fine Art Animation: Principles and Practice.* 1st American paperback ed. Boston: Elsevier/Focal Press, 2004.

Lasseter, John, and Steve Daly. *Toy Story: The Art and Making of the Animated Film.* New York: Hyperion, 1995.

Laybourne, Kit. *The Animation Book: A Complete Guide to Animated Filmmaking—From Flip Books to Sound Cartoons to 3-D Animation.* New digital ed. New York: Three Rivers Press, 1998.

Lord, P., and B. Sibley. *Cracking Animation: The Aardman Book of 3D Animation.* London: Thames & Hudson, 1999.

Michael, Alex. *Animating with Flash 8: Creative Animation Techniques.* Boston: Elsevier, 2006.

Neuwirth, Allan. *Makin' Toons: Inside the Most Popular Animated TV Shows and Movies.* New York: Allworth Press, 2003.

Noake, Roger. *Animation: A Guide to Animated Film Techniques.* London: Macdonald Orbis, 1988.

——. *Animation Techniques: Planning and Producing Animation with Today's Technologies.* Secaucus, N.J.: Chartwell Books, 1988.

Patmore, Chris, and Finlay Cowan. *The Complete Animation Course: The Principles, Practice and Techniques of Successful Animation*. London: Thames & Hudson, 2003.

Pettigrew, Neil. *The Stop-Motion Filmography: A Critical Guide to 297 Features Using Puppet Animation*. Jefferson, N.C.: McFarland, 1999.

Rickitt, Richard. *Special Effects: The History and Technique*. London: Arum Press, 2006.

Russett, Robert. *Hyperanimation: Digital Images and Virtual Worlds*. Eastleigh, U.K.: John Libbey, 2008.

Scott, Jeffrey. *How to Write for Animation*. Woodstock, N.Y.: Overlook Press, 2002.

Serkis, Andy, and Gary Russell. *The Lord of the Rings: Gollum: How We Made Movie Magic*. Boston: Houghton Mifflin, 2003.

Shaw, Susannah. *Stop Motion: Craft Skills for Model Animation*. Boston: Elsevier Focal Press, 2003.

Simon, Mark. *Producing Independent 2D Character Animation: Making and Selling a Short Film*. Focal Press Visual Effects and Animation Series. Amsterdam: Focal Press, 2003.

——. *Storyboards: Motion in Art*. 3rd ed. Burlington, Mass.: Focal Press, 2006.

Street, Rita, ed. *The Best New Animation Design 2*. Motif Design. Rockport, Mass.: Rockport, 1997.

Subotnick, Steven. *Animation in the Home Digital Studio: Creation to Distribution*. Focal Press Visual Effects and Animation Series. Boston: Focal Press, 2003.

Taylor, Richard. *Encyclopedia of Animation Techniques*. Philadelphia, Penn.: Running Press Book, 1996.

Webber, Marilyn. *Gardner's Guide to Animation Scriptwriting: The Writer's Road Map*. Fairfax, Va.: GGC, 2000.

Webster, Chris. *Animation: The Mechanics of Motion*. Oxford, Mass.: Elsevier Focal Press, 2005.

Whitaker, Harold, and John Halas. *Timing for Animation*. London: Focal Press, 1981.

White, Tony. *Animation from Pencils to Pixels: Classical Techniques for Digital Animators*. Burlington, Mass.: Focal, 2006.

Williams, Richard. *The Animator's Survival Kit*. London: Faber, 2001.

Winder, Catherine, and Zahra Dowlatabadi. *Producing Animation*. Focal Press Visual Effects and Animation Series. Boston: Focal Press, 2001.

Wright, Jean. *Animation Writing and Development: From Script Development to Pitch*. Burlington, Mass.: Focal Press, 2005.

PERIODICALS

Animation: An Interdisciplinary Journal (2006–)
Animation Journal (1991–)
Animation Studies (2006–)
Animation World Magazine (1996–)
Cartoons: The International Journal of Animation (2006–)
Imagine (2005–)
Screen (1959–)

WEBSITES

Animation Resources: www.toonhub.com
Animation World Network: www.awn.com
Anime News Network: www.animenewsnetwork.com
ASIFA: http://asifa.net/
BFI Screenonline: www.screenonline.org.uk
Cartoon Brew: www.cartoonbrew.com
National Film Board of Canada: www.nfb.ca
Origins of American Animation: http://memory.loc.gov/ammem/oahtml/
 oahome.html
Society for Animation Studies: http://gertie.animationstudies.org/
US AnimatedCartoons Reference: www.toonarific.com
UK Animated Cartoons Reference: www.toonhound.com

About the Author

Nichola Dobson was born in Scotland, Great Britain. She obtained her BA (Hons) from Napier University, Edinburgh, in graphic communications management. She then changed discipline and moved on to media and cultural studies, and animation studies. She completed her PhD in the animation genre and, more specifically, her dissertation on "The Fall and Rise of the Anicom: The U.S. Animated Sitcom 1960–2003" at Queen Margaret University, Edinburgh. Visiting lectureships have been held at Queen Margaret University and Glasgow Caledonian University in a variety of subjects such as media studies, cultural studies, discourse and ideology, and media language. In 2006, she was a researcher on a joint project between Glasgow Caledonian University and Universitat Rovira i Virgili Tarragona, Catalonia (Spain), on national identity in television soaps. Her research interests are divided between animation and television studies and genre, reflected in a range of publications in journals and book chapters. A member of the Society for Animation Studies since 2001, she is the founding editor of their journal *Animation Studies*. She is currently an independent scholar based in Edinburgh.